Who's Your Daddy?

AND OTHER WRITINGS ON QUEER PARENTING

W0009174

EDITED BY

Rachel Epstein

SUMACH
PRESS

WOMEN'S ISSUES PUBLISHING PROGRAM

SERIES EDITOR BETH McAULEY

LIBRARY AND ARCHIVES CANADA CATALOGUING IN PUBLICATION

Who's your daddy? : and other writings on queer parenting /
Rachel Epstein, editor

Includes bibliographical references.
ISBN 978-1-894549-78-3

1. Gay parents. 2. Gays—Family relationships.
3. Children of gay parents.
I. Epstein, Rachel, 1956–

HQ75.27.W56 2009 306.874086'64 C2009-900282-5

Edited by Lisa Rundle & Beth McAuley
Designed by Liz Martin

Original cover photo by Sarah Leslie
Back cover photo:
International Women's Day, Vancouver B.C., 1979

*Sumach Press acknowledges the support of the Canada Council
for the Arts and the Ontario Arts Council for our publishing program.
We acknowledge the financial support of the Government of Canada
through the Book Publishing Industry Development Program
(BPIDP) for our publishing activities.*

 ONTARIO ARTS COUNCIL
CONSEIL DES ARTS DE L'ONTARIO

Printed and bound in Canada

Published by

SUMACH PRESS
1415 Bathurst Street #202
Toronto ON Canada M5R 3H8

sumachpress@on.aibn.com
www.sumachpress.com

To my parents,
Marilyn Golub and Norman Epstein,
who raised me on social justice;

To Dorrie Brannock,
queer mom like no other;

And to my kids:
Aaron, Aziza, Tarik,
and, of course, the one, the only, Sadie Rose.

With love.

CONTENTS

II From Queer to Paternity: Queering the Family Tree

III Handing Out Cigars: History, Visibility, and Social Change

IV All Our Roots Need Rain:

Parenting Dilemmas in the Day to Day

V Houses Full of Love: What We Offer Our Children

Acknowledgements

It takes a team to make an anthology. I am deeply indebted to the many people who contributed to this book.

The kind, smart, funny, wise Sally Keefe-Cohen fell into my life at exactly the right moment and got the project off the ground.

Lisa Bryn Rundle not only contributed her enormous editorial talents, crafting thoughtful, constructive, and astute notes to authors, but was an invaluable collaborator. She understood from the start what the book was about, offered fabulous insights and opinions, and was delightful to work beside.

Mary Daniel, starting with a conversation on a snowy ride in northern Ontario, was my sounding board from the very beginning to the very end. She read and re-read pieces, helped edit interviews, mulled every question and dilemma I put to her, and celebrated with me each of the book's milestones.

This book would not be in your hands were it not for Beth McAuley, senior editor at Sumach Press. She believed in the book and took on the project, even knowing how much work an anthology entails. She took care of a thousand details, assisted Lisa with the editing, managed many personalities, and somehow kept us all on track. Alongside Beth, the staff at Sumach Press brought their years of publishing experience to this project, and produced a beautiful book. Lois Pike managed marketing, Dayle Furlong organized publicity, Jennifer Day assisted with editing, and Liz Martin did the book design.

I'd like to thank Allison Eady for transcribing the interviews; Michelle Walks, Christina Yager, Mariko Tamaki, barb findlay, David Rayside, Fiona Kelly, Kelly Jordan and Joanna Radbord, for their research; Lorna Homuth and Regan McClure for lending their images; and Chris Veldhoven, Dorrie Brannock, Holly Wagg, Larry Riesenbach, Lee Rose, Mona Greenbaum, Paul Carr, and Sarah Leslie for helping with supplementary materials and photographs.

Carol Anne O'Brien, Jess Abraham, Joyce Zonana, Lois Fine, Mariko Tamaki, Mary Daniel, Penny Goldsmith, Peter Marmorek, Robin Kelly, and Sadie Epstein-Fine read pieces of the book and offered valuable

feedback. Marusya Bociurkiw had the idea to use the title of Laurie Bell's piece as the title for the book. Andrea O'Reilly planted the seed of the project by suggesting that I edit an anthology on queer parenting.

Many friends and family — categories often blurred in the queer family I call mine — provided ongoing practical and emotional support. Lois Fine continued to be the best across-the-street co-parent and friend anyone could ask for; Amy Gottlieb, Maureen Fitzgerald, and Lorie Rotenberg were, as always, just around the corner; Hershel Russell cheered from across town. Jess Abraham (aka Super Organizer) helped to organize the initial submissions and took notes at interviews. She and Pat Rayman kept track of me as I disappeared into the project. Graham Jackson provided a place of comfort. My dad, Norman Epstein, kept track of my progress on the book, periodically expressing his affection by nagging me about pending deadlines. Sadie Rose Epstein-Fine continued to be her marvellous self, offering incisively clear opinions on the book's content, whenever asked, and responding to my lack of availability with patience and a sense of humour.

I am blessed to be surrounded by a group of colleagues whose values and commitment to the work they do inspires me every day. In particular, I'd like to thank my past and present managers, Anna Travers and Bev Lepischak, at the Sherbourne Health Centre, for encouraging and supporting a work environment that nurtures creativity; and Lori Ross, Chris Veldhoven, and the other community partners I am privileged to work with daily. I am also grateful for the huge network of queer parents and prospective parents of which I am a part, in particular, the past, present, and future participants in Dykes Planning Tykes, Daddies & Papas 2B, and Trans Fathers 2B, whose journeys have been such a source of inspiration.

Finally, I'd like to extend my deep thanks to the authors and inter-viewees whose work and words appear in these pages. I am honoured to provide this vehicle for the sharing of your stories and thoughts. The book is what it is because of your willingness to take risks, to share your important work and, in many cases, deep parts of yourselves. Much love to you and to your families, in all of their glorious queerness.

RACHEL EPSTEIN
March 2009

INTRODUCTION

Rachel Epstein

THIS BOOK IS SANDWICHED BETWEEN TWO PHOTOGRAPHS. ON THE back cover is a photo of my good friend Dorrie Brannock's daugter, taken thirty years ago at an International Women's Day march in Vancouver. They were marching with the Lesbian Mother's Defence Fund, a feminist group that defended lesbians who were fighting custody battles to keep their children. On the front cover is a cooler, sexier, edgier photo of a somewhat gender-ambiguous person with a soother clipped on her/his belt, presumably a parent (childcare worker? club kid?). The photographs are emblematic of the vast changes we have witnessed in North American in thirty years of queer parenting history — a shift from a social and political climate that forced queer people to deny huge parts of themselves in order to keep their children, to one where we can increasingly claim our sexual and gender identities *and* our right to parent. This book is about respectfully holding that history while we open and give space to new conversations.

The change that marks this history is staggering. Thirty years ago, 88 percent of lesbians courageous enough to fight for judicial custody of their children in the U. S., lost (Chesler, 1986). Many, understanding the legal climate of the time, chose to relinquish custody in favour of liberal access (Rayside, 2008). In Canada, the climate was not dissimilar, with courts distinguishing between "good" and "bad" lesbian mothers (and gay fathers); the good ones being those who were not visible, militant, or sexual (Arnup, 1995). In 1977, Francie Wyland wrote, "Only once in Canada, and fewer than a dozen times in the United States, has a known lesbian mother been granted unconditional custody of her children" (cited in Mackay, 1982: 16). When I think about the women and men who have lost custody of their children, my heart breaks.

In contrast, in Canada, 2007, an Ontario court recognized three people (a lesbian couple and the man they are parenting with) as legal parents of a child (London, Ontario, case popularly known as AA/BB/CC). Lesbian, gay, bisexual, and trans parents in Canada today enjoy unprecedented legal and social recognition. Our presence and our activism has spurred monumental change in the areas of law and policy, access to fertility clinics, sperm banks and reproductive technologies, and social attitudes. Gay men, lesbians, bi, trans, and queer folk of all sorts are creating families and transforming the landscapes of their neighbourhoods, schools, and communities. At the same time, in some places in North America — Prince Edward Island and Arkansas to name two — queer people continue to be denied the right to parent through laws that prohibit LGBTQ adoption or that prevent non-biological parents from legally adopting their own children through second-parent adoption. Many still fear that their children will be taken away from them and struggle with questions about their own legitimacy as parents. These tensions underlie the writings in this book — the tensions between our history and current realities, between the enormous gains we have achieved and the ways our right to parent continue to be undermined, and how these dual realities affect our daily lives, our consciousness, and our sense of entitlement to bring children into our lives.

The legacy of our path to social change continues to affect us. In the 1970s and 1980s custody cases were based on a series of arguments designed to prove that lesbians and gay men were unfit parents. When lesbian and gay parents (and their lawyers) were in court rebutting these arguments, they had no choice but to respond within the framework they were offered. They had to prove that they were "fit" to be parents — that their kids would understand traditional gender roles and behaviours, that the children were no more likely to be gay themselves, that they would not be damaged by the teasing and discrimination they might face, and that they would be "just like" kids growing up in heterosexual families. The research carried out during this period helped to bolster these arguments. (For a summary of this research, see Patterson, 2005.) In these struggles, which involved enormous loss and heartbreak, lesbian and gay parents were pushed to present themselves and their children as "just the same as" and "just as good as" an ideologically based notion of the heterosexual nuclear family — itself an artificial construction that never in reality looked or worked like it was supposed to.

Much as we would like to leave behind this framework that puts us on

the defensive, the political and social context within which we parent does not fully allow us to do so. In 2002, an Alabama court decision denied a lesbian mother custody of her children in favour of a violent father. In his judgement, the chief justice wrote that the mother's lesbian relationship made her an unfit mother and that homosexuality is "abhorrent, immoral, detestable, a crime in Alabama, a crime against nature, an inherent evil, and an act so heinous that it defies one's ability to describe it" (CLGRO Newsclippings on Adoption and Parenting Issues). The recent 2008 ballot measure in Arkansas effectively denies queer people the right to adopt or foster children. And in Canada, queer parents continue to live in a social environment in which, as recently as 2001, close to half the population believed they should be denied the right to parent (Leger poll 2001, CLGRO Newsclippings). We cannot take for granted our right to become parents or to maintain custody of our children.

Despite massive social change and the creation of new possibilities, queer parents and their children continue to feel pressured to conform in order to be accepted and to present as "poster families" and as "poster children." Abigail Garner, in her groundbreaking 2004 book *Families Like Mine*, writes about the resulting reluctance on the part of children of LGBTQ parents to expose the not-so-presentable aspects of their lives. The sanitized version of their families they feel pressured to present does not include parents struggling with depression, alcoholism, or domestic abuse, or those times when the kids don't like their parents, or feel ambivalent about their parents' sexual orientation, or long for a parent of the other gender. In this version, "Nobody is in trouble at school. Nobody throws tantrums or threatens to run away. Nobody is experimenting with drugs. Ever. Did I mention that the kids think their parents are the coolest?" (Garner, 2004: 22). There is a dearth of spaces where queer parents and their children can converse honestly about the full breadth of their realities. (See Evans and Hill-Meyer in this volume.)

Many of us, and many of our children, are tired of this. We have been forced into a narrow conversation that insists that we prove our "sameness" and that we deny or ignore "difference," however difficult or interesting. Stacey and Biblarz in their landmark 2001 article "(How) Does the Sexual Orientation of Parents Matter?" refuse this conversation and insist on exploring differences, drawing on fifteen years of research on children with lesbian moms. The differences they highlight in children growing up with

lesbian/gay parents include less traditional gender-typing; higher self-esteem and better mental health; more egalitarian, shared parenting; more closeness and communication between parents and children; and increased awareness and empathy in children towards social diversity. While the differences they point out are fascinating, the most exciting contribution they make is the shift from a limiting framework of defensiveness to one of exploration, curiosity, and possibility. This shift is made possible by the social and legal recognition and security queer parents, in some places, have achieved.

Who's Your Daddy? builds on this shift in framework by offering the reader a window into some of the histories, diversities, richness, creativity, complexities, difficulties, and joys of queer families. Moving from a place of defensiveness, we can ask more interesting questions and enter into new kinds of conversations. We can talk more frankly about our daily realities, dilemmas and places of uncertainty, about our family creation processes, about sexuality, gender, childrearing, and the jolts and bumps of living in our families. The underpinnings of this book are the questions — there are no definitive answers. My hope is that readers will come away having been touched by the diversity and the honesty of the writing and pondering personal, social, political, and ethical questions they may not have previously considered, inspired to interrogate what "family" is all about and how and by whom it gets defined.

A Personal Queer Parenting History

I grew up in Vancouver, British Columbia, and was active in the women's movement there in the late 1970s. In those days we attended a lot of demonstrations, and at just about every one, a few women would show up carrying signs in support of custody rights for lesbian mothers. They were the Lesbian Mother's Defence Fund (LMDF). In recent years, as queer parenting has become the focus of my personal, activist, and work life, I often think back to those women — I didn't realize then how important they were — they were defending the rights of women who were losing their children. (See Hart in this volume.)

When I left Vancouver to move east in 1986, a small group of lesbians, calling themselves the Lavender Conception Conspiracy, were meeting together to share information and to support each other in their desire to become parents. There were no places to go for information, no organized groups or programs or courses. When I myself got pregnant in 1991 through

a fertility clinic in Toronto, the doctor who inseminated me routinely required lesbians to write a "letter to the doctor" to convince him to provide access to sperm and insemination services. There were other doctors and fertility clinics that required lesbians to undergo psychiatric assessments in order to gain access to donor sperm, others simply denied access. Non-biological lesbian parents had no legal right to their children — women were courageously committing themselves to children with no guarantees that they would be protected in their parenting roles. Gay fathers, in some instances, were choosing to stay in heterosexual marriages for fear of societal homophobia and the loss of their families. Those who were visible were struggling with disclosing their sexual orientation to children and spouses, with the consequences of a homophobic legal system, and with their own identities. Trans and bisexual parents were virtually invisible — and where trans people were visible as parents, they were subject to excruciating discrimination.

My daughter Sadie was born at home in 1992, surrounded by a dozen close friends and family members, including Lois Fine, Sadie's other mom, my partner at the time and now my committed co-parent who lives across the street. I was supported through labour by a team of people, organized in true dyke style. Besides the midwives, there were cooks, contraction timers, a documentarian, an information officer and even a bouncer. Sadie's birth, while a high point in my life, did not mark my beginnings as a queer parent. When Lois and I got together in 1987, she was already parenting two-year-old Aaron, her son from a previous relationship. Aaron became my stepson and then Sadie's big brother, and was with us every second weekend. Before Sadie was born, a friend's two children, Tarik and Aziza, three and four years old at the time, found their way into our home and our hearts. They visited regularly for barbecued chicken and Pippi Longstocking, and became part of the family. Sadie was born into a room packed with love, and many of those present at her birth remain in her life today. For years she spent a night a week at Amy and Mo's, who became her other parents, and their son Sami, her younger brother. Sadie has a large, loving, extended family.

When Lois and I tried to register Sadie's last name as Epstein-Fine, our application was rejected. It was not possible in 1992 to give a child a hyphenated surname made up of the family names of two women. Sadie's official last name became Epstein, but she used Epstein-Fine at school, on

her health card, and in her everyday life. Lois had no avenue open to her to be legally recognized or protected as Sadie's parent.

When I was pregnant, I had gone back to university and, as part of a research project, visited lesbian moms in their kitchens and living rooms to ask them about their lives and about who did what in their homes (Epstein, 2003). I wanted to know what their children called them, how they divided labour in the home, about their couple dynamics and their relationships with their families of origin. When a close friend and non-biological parent was denied access to a child she had parented since birth, I interviewed other non-biological lesbian parents and became acutely aware of the vulnerabilities attached to this position. I became more and more fascinated with queer parenting — as my child got older, I researched the school experiences of kids with queer parents (Epstein, 1999). My long-standing admiration of butches led to interviews with butch-identified women who chose to give birth (Epstein, 2002). My work as a professional mediator led to mediations and planning sessions with queer parents and prospective parents who were attempting to work out the inevitable issues that arise whenever two or more people try to do anything together, let alone something as complex as parenting.

In 1997, Kathie Duncan (our midwife at Sadie's birth) asked me to plan and co-facilitate a course for lesbian/bi/queer women considering parenthood as part of the Queer Exchange, a community-education program sponsored by the Centre for Gay and Lesbian Studies. We called it "Dykes Planning Tykes." Twenty dykes wanting to plan tykes arrived at the doors of the University of Toronto's International Student Centre — excited, eager for information, and for community. We talked about fertility, insemination, adoption, and co-parenting; we brought in a lawyer, a midwife, and panels of lesbian parents. We role-played how you might respond to a doctor who denies you reproductive services. We laughed a lot, and we all got a little choked up when people came in with babies.

Since 1997, over 400 people have taken Dykes Planning Tykes, and it continues to be at the heart of my involvement with queer parenting. I never cease to be touched watching people find the confidence and the practical knowledge they need in order to bring children into their lives. In 2001, I ditched my PhD studies for the opportunity to develop the LGBTQ Parenting Network, possibly the first program in Canada to receive funding to provide resources, information, and support to lesbian, gay,

bisexual, transsexual, and transgender parents, prospective parents, and their families.

Dykes Planning Tykes has spawned Daddies & Papas 2B, a course for gay/bi/queer men considering parenthood, and Trans Fathers 2B, a similar course for trans men. The courses are run jointly by the LGBTQ Parenting Network at the Sherbourne Health Centre, where I work, and Queer Parenting Programs at The 519 Community Centre, both in Toronto. My colleague Chris Veldhoven and I continue to expand the courses each year. We've added a "Fertility Fair" and a session with an adoption expert, we address more directly and consciously the complexities of class, race, and racism that are raised in our family creation processes, and we hear from teenagers with LGBTQ parents.

These years of passionate engagement with the world of queer parenting have taken me to some fascinating places. I have found myself driving on snowy roads in far-reaching parts of northern Ontario to interview LGBT adoptive parents; addressing groups of gay men as they consider, sometimes for the first time, that they could become parents; sitting in court with my teenage daughter and co-parent listening to lawyers from the Attorney General's office argue against the recognition of non-biological parents; participating in the politics of the Father Involvement movement; offering training sessions to fertility clinics and sperm banks, including, with my trans colleagues, helping them think through their approach to the trans men who are entering their clinics. Recently, I found myself in the board room of the Assisted Human Reproduction Agency presenting the concerns of LGBTQ communities in relation to the 2004 *Assisted Human Reproduction Act* (AHRA), federal legislation designed to regulate fertility clinics and sperm banks (see Ross et al., 2006; AHRA/LGBTQ Working Group, 2008). Who knew in the days of the Lavender Conception Conspiracy that this is where we'd be in 2009?

Each expansion of possibilities, whether in the area of reproductive technologies, legal protections or social attitudes, has brought with it fresh opportunities, new family configurations, and new and different questions, dilemmas, and controversies.

Those early days of lesbian conception were characterized by a feminist, self-help, empowerment model of women's health. We believed in taking control of our bodies and our reproduction and set out to do so. Many lesbians in the 1970s and 1980s got pregnant at home, relying on knowledge

of cervical mucous, known sperm donors or donors known to third parties, and syringes (not typically the mythical turkey baster, though it remains iconic). While many continue to embrace home insemination and the do-it-yourself model, in recent years more and more queer women and trans men are relying on the consumer-based, highly medicalized process of conception available through sperm banks and fertility clinics (for an excellent discussion of this, see Mamo, 2007; and Pelka in this volume). Who is profiting from our use of reproductive technologies and what are the implications when some of the methods we use to create families are extremely costly and involve invasive medical procedures and physical risk? Where do queer voices fit in the current debate about anonymous sperm donation?

Inclusive adoption policies and access to reproductive technologies have expanded parenting possibilities for gay men. As Schacher, Auerbach, and Silverstein argue in their 2005 paper "Gay Fathers: Expanding the Possibilities for All of Us," the fact that gay/bi/queer men are parenting, in many cases, without women and without mothers, is a radical challenge to notions of gender essentialism and who can parent. Facing culturally entrenched stereotypes of gay men as pedophiles and the iconic nature of motherhood, the expansion, in the last decade, of possibilities for gay men to become parents is one of the most exciting, interesting, and potentially radical developments in queer parenting. At the same time, parenting is perhaps the only area where men have historically been less privileged than women because the courts and social attitudes have favoured women as parents. What are the implications of these historical power dynamics when men in larger numbers become primary parents? (See "Daddies & Papas 2B" interview with Chris Veldhoven and Thom Vernon in this volume.)

Trans parents have until very recently and for the most part been invisible and marginalized. Many have lost contact with their children as part of a transition process that involved angry, hurt, transphobic spouses. Recent years have seen an upsurge of trans activism and visibility, including an insistence on the right to parent. Some trans people are becoming non-biological parents; trans men are walking through the doors of fertility clinics to access cycle monitoring and donor insemination; and some trans men and women are freezing embryos or sperm before they transition. There is still so much we don't know about hormones and reproduction — and so much research and education required to work against the deeply embedded transphobia that permeates the culture. (See Ryan and Ware in this volume.)

In Canada, the legal and policy changes we have achieved in the areas of relationship recognition, adoption, second-parent adoption, and birth registration are unprecedented. Canadian queer parenting activists have had the luxury of remaining removed from the struggle for same-sex marriage because in Canada, unlike many parts of the United States, parenting rights are not linked to marriage. (For a U.S.–Canada comparison, see Rayside in this volume.)

However, in this new era of legal rights and protections, there are still questions to be asked: Which families get legally recognized and which not? What happens to the families that don't fit the nuclear model? What about the issues of class and access to financial resources that are raised when costly legal procedures are required in order to secure parenting status (see Bogis, 2001)? Is it still a choice to not pursue state-sanctioned legal protections? For example, lawyers have suggested that if a non-biological parent chooses to not pursue a second-parent adoption, courts might interpret this as a lack of commitment to the child (see Dalton, 2001). We achieve legal victories that sometimes seem to lead to more and more legal requirements and bureaucratic processes.

In the face of this, I have to admit I have some nostalgia for the old days — the days before legal protections when we had to count on love, good will, trust, and commitment in our parenting arrangements. I write this fully aware of both my legal and social privilege as a biological parent, and I know only too well the suffering that has been endured by parents and their children due to the lack of protections for non-biological parents. I remember in my early days of parenting Sadie when it suddenly dawned on me that I was giving up my role as the "only" mother in choosing to "share" mothering with another woman. I was struck both by the profundity of that choice and by the courage of non-biological mothers who were committing themselves wholeheartedly (in the true sense of the word) to children, without legal rights or protection. I began to think of this exchange as a profound mutual gift. While some might argue that this romanticizes legal inequalities that can lead to complicated, messy, and hurtful parenting battles, a part of me misses the days of feminist self-help, the days when we wanted to keep our relationships as far away from the state as possible. So although I always cry at weddings, I'm not quite ready to let go of my reluctance to have the state determine the status of my relationships.

When I contemplate the queer parenting history of the past thirty years,

I feel first and foremost a deep love and appreciation for *all* queer parents who, in the face of social and legal restrictions, refuse to deny themselves the joys (and the pains) of parenting. From early on and to the present, those writing about queer parenting have debated the radical nature of LGBTQ people becoming parents (see Polikoff, 1987; Lorde, 1987; Copper, 1987; Weston, 1991; Lewin, 1993, 1995; Walters, 2001; Mamo, 2007). How do our families challenge, and how do they recreate, the conventional model of the heteronormative nuclear family and traditional notions of family, biology, blood, and kinship? It is clear to me that we do both. We cannot parent outside of the cultural norms and discourses that shape our lives; and at the same time the existence of queer families, in all our diversity, cannot help but disrupt the heterosexual matrix.

When I reflect on my personal history, my involvement in queer parenting activism, and, in particular, my involvement with Dykes Planning Tykes and its companion courses for men, I am struck by several things. One is how popular these courses are. People are hungry for information about how to become parents and for community to accompany them as they embark on this journey. I am aware, too, of how our sense of entitlement to become parents has changed. While we have to take care not to assume that all queer or gender-variant people want to have children, or even want to think about it, developments over the past thirty years have made having children more possible as an option for more people. Our courses are packed — people sometimes have to wait years to get in. For many the question is not *can* I have kids but *when* do I have kids?

And yet I am consistently surprised by how many course participants are still not confident that becoming parents as LGBTQ people is really okay. People come to the courses not knowing other queer parents, feeling isolated, and lacking information. Recently, I ran into a couple of men who had just completed the Daddies & Papas 2B course. They said that until they had heard the panel of teenagers speak, they were still not completely sure about the okayness of their decision to parent — still not sure that the kids really would be all right. Seeing and hearing the panel of well-spoken, thoughtful, and all-round delightful teenagers changed their minds. The day after the panel they began an adoption process. To me, this speaks to the very deep ways we continue to carry fear, shame, and a sense of needing to validate our worth, as well as to the power of our children's voices. Like it or not, they become the ambassadors for queer parenting — they are its product and

our right to parent is judged through them. As Garner (2004) has stressed, this is not always an enviable or desirable position. For many of our kids, the fact that they are the children of queer parents is a relatively small part of who they see themselves to be — it is other people who make it a big deal.

This was brought home to me in 2005 when Sadie, Lois, and I were parties in the Charter Challenge that resulted in changes to birth registration in Ontario (see Fine in this volume). Sadie was the only child in the case who was old enough to articulate her experience. At one point she and I sat down with a lawyer to prepare her affidavit. The lawyer wanted Sadie to describe the ways that the lack of legal recognition of one of her moms had been a hardship for her over the fourteen years of her life. Sadie was hard pressed to come up with anything. She just couldn't think, really, of anything that had been difficult. With some digging, she eventually realized that legal recognition of her other mom would mean legal recognition of a whole side of her family — her aunts and uncles and cousins would be officially part of her "family tree." She realized, too, that crossing international borders would be made easier, she wouldn't have to lie about her family, and that she would *finally* get a name change; the name she had been using all her life, Epstein-Fine, would be made official.

The experience was an interesting one for me; it led me to reflect not only on how we develop narratives of victimization in order to make change but also on the ways heterosexism becomes such an everyday part of our lives that we don't recognize how it is affecting us. As Lois writes in her piece in this book, legal recognition makes no difference in the day to day, and yet it touches something very deep; we often don't realize how our invisibility and lack of recognition affect us until we experience their opposites. This story, too, is about the tensions that frame this book and that frame the lives of queer families — the need to present ourselves in particular ways in response to our inextricable link to a social and political context, and the desire to speak honestly.

Who's Your Daddy? A Reader's Guide
RED ROCK BABY CANDY: BEGINNINGS ...

Who's Your Daddy? opens appropriately with the voice of queer spawn Melissa Hart. In California in 1979 Melissa's mother, Maggie, came out as a lesbian and, in a custody dispute with her ex-husband, lost custody of Melissa and her two younger siblings. The judge declared Maggie mentally

ill. According to Melissa: "Homosexuality had just been removed from the DSM III (American Psychiatric Association's Diagnostic and Statistical Manual of Mental Disorders) a few years before, and a homophobic psychologist in Ventura County caused more than one lesbian mother to lose her children." Melissa's piece represents a crucial and significant chapter in queer parenting history.

The essays that follow are about the thoughts, feelings, and dilemmas that come with bringing children into our lives. Emma Donoghue writes about the frequent, and often painful, experience when one half of a couple wants to parent more than the other. Reminding us that not all queer (or straight) people unequivocally embrace the desire to parent, she describes her partner grappling with the ways that parenthood can collide with queer identity. Chris Veldhoven, designer and facilitator of the Daddies & Papas 2B course (a twelve-week course for gay/bi/queer men who are considering parenthood), and Thom Vernon, a past participant in the course, reflect in an interview on the issues of entitlement, gender, power, and gay politics that arise when gay/bi/queeer men become parents.

Syrus Marcus Ware, a member of the working group who developed the Trans Fathers 2B course in Toronto and a trans man currently trying to get pregnant, courageously writes about becoming a patient at a fertility clinic and of the clinic's response to him. Syrus' story is a reminder of how much time, energy, thought, and money can go into our journeys to parenthood. What about when it doesn't work? Shira Spector, "an infertile homosexual," addresses this crucially important, and often forgotten, issue.

Suzanne Pelka raises interesting questions about the significance of biology to queer parents. What values underlie the language we use to talk about our families? What is the difference between "donor sperm" and a "sperm donor"? If "love makes a family," why do some of us choose to carry out costly (physically and financially) procedures in order to create children to whom we are biologically related?

To close the section, award-winning writer and actor Ann-Marie MacDonald tells us about the process of bringing children into her life through open adoption and about the influence that parenting has on her writing.

FROM QUEER TO PATERNITY: QUEERING THE FAMILY TREE

The second section of *Who's Your Daddy?* broadens popular conceptions of who can be a parent and highlights the ways that queer families, sometimes simply by who we are and how we structure our families, challenge traditional

notions of "family." This section includes two interviews — one with three men who, in the 1980s, 1990s, and 2000s, respectively, donated sperm to enable others to become parents; and a group interview with members of a support group for queer single moms. Aviva Rubin and Derek Scott write about their choices to co-parent outside of a conjugal relationship, and we hear from Rebecca Trotzky-Sirr and Maura Ryan about the concerns and realities of two mostly undocumented groups of queer parents: queer youth and trans men.

While adoption in many provinces and states has opened up to gays and lesbians, we know that adoption processes go more smoothly when adoption workers can understand their lesbian and gay clients through a heteronormative lens. Lesbian and gay couples who resemble the familiar heterosexual couple are easier to make sense of. In the essay "To Bi or Not to Bi" by Allison Eady, Lori E. Ross, Rachel Epstein, and Scott Anderson, we learn perhaps for the first time something about the particular challenges that bisexual people face in the adoption system.

All of the family structures presented in this section expand conventional definitions of "family," and yet Anika Stafford points out how even progressive children's picture books designed to challenge gendered assumptions about families can fall into the trap of heteronormativity. She calls for playful, non-didactic images, words, and cultural productions that reflect the realities and diversities of families.

Handing out Cigars: History, Visibility, and Social Change

The third section of this book captures some of the political and social history of queer parenting in Canada and the United States. Nancy Nicol begins with an analysis of the struggle for queer parenting recognition in Quebec. She emphasizes the hugely significant role the grassroots Lesbian Mothers' Association played in mobilizing public opinion to support the development of the civil code. Lois Fine, one of the co-applicants in the Charter Challenge in Ontario that made it possible for two women to register as parents from the time of their baby's birth, reflects on what that legal recognition means for her, and David Rayside takes us through a comparison of the ways that queer parenting rights have been fought for and developed in Canada and in the United States.

Moving from the macro to the institutional, Diane Flacks recounts her and her partner's experience in the Hospital for Sick Children where they virtually lived for the first year of their son's life. Becky Idems, Adinne

Schwartz, and Rachel Epstein put together a piece based on interviews with queer spawn about the homophobia and heterosexism they experience at school. Both of these pieces delineate the tensions between legal/policy change and attitude/practice change — often individual attitudes and institutional practices lag behind social policy. An unenforced equity policy sitting on a shelf does not help the elementary school student who is being homophobically harassed, but sometimes punching someone out does. What are the implications of this for those who work in the education system and for parents and teachers who want to be helpful? This section ends with Jamie Evans's "Queer Spawn Manifesto," a political manifesto written from the perspective of a queer spawn who is thinking globally about what she wants from the world.

All Our Roots Need Rain: Parenting Dilemmas in the Day to Day

The fourth section of the book addresses the complexities of the day to day and the artificiality of constructing our lives simply as a series of overlapping identities. The first pieces share the themes of geography and dislocation. Karleen Pendleton Jiménez's honest and powerful piece "Little White Children: Notes from a Chicana Dyke Dad" weaves together 100 years of colonialism with her personal history as a mixed-race gender queer person growing up in California and then moving to Canada to become part of a very white family. Cindy Holmes and Anne Fleming, a white butch-femme couple living in a small urban centre in the interior of British Columbia, share with us an email exchange detailing their concerns, anxieties, and dilemmas about raising their daughter in a community "known for its conservatism, its fundamental churches, its racism, and its miles of malls." The section as a whole takes its title from N. Gitanjali Lena who writes about the diasporic terrain of living as a Sri Lankan queer parent in Canada. She raises heartfelt and difficult questions about culture and parenting, about attempting to instill in our children a solid sense of their histories, roots, and cultures, while we ourselves must delicately negotiate the multiplicity of our lives.

Tobi Hill-Meyer, the donor-conceived trans daughter of a lesbian couple living in an interracial family, identifies clearly and directly some of the issues of race and racism that she believes are essential for LGBTQ people to grapple with as they think about becoming parents. Serena Patterson writes honestly, and painfully, about her inability to bridge the gulf that was

created between her and her daughter due, in part, to homophobia. Julie Mooney-Somers and Eamon Somers, a gay father–dyke daughter pair, confront the supposed "worst nightmare" of queer parenting — the queer kids of queer parents, sometimes referred to as the Second Generation. Julie and her dad Eamon tell a story, not of shame, but of mutual respect, tinged with a bit of quizzicality that is perhaps based in generational difference — the difference between being a Radical Fairy and a Lesbian Avenger. Makeda Silvera rounds out this section with a reflection on her current fostering of a young Black teenager, juxtaposed with her memories of a time of robust Black lesbian feminist community. She reminds us that, indeed, all our roots need rain and that issues of race and class cannot be sidelined in queer parenting communities.

Houses Full of Love: What We Offer Our Children

In this final section of the book, new layers of meaning are added to "Love Makes a Family" — the phrase that has become emblematic of queer parenting. The section takes its title from Alex Iantaffi's report on her interviews with parents who are polyamorous. She addresses the anticipated and recurring question, "But what about the children?"

The writings in this section raise questions about what it means to parent queerly. Is it simply about identity (i.e., being lesbian, gay, bi, trans, or queer and a parent), or is parenting "queerly" about something more intentional and/or radical?

The section opens with Elizabeth Ruth who generously shares a letter she wrote to her baby in utero — when sex and gender were unknown. She imagines what her relationship will be to this child, and leads us into the discussion about what it means to parent queerly. christina starr's tongue-in-cheek "In the Best Interests of the Child" turns the issue of queer parenting on its head. Shelley Park attempts to define what it means to parent queerly and ponders the possibilities of doing so.

The attacks on our right to have families have sometimes led us to want to be "normal," to fit in and be accepted "just like" everyone else. Myself and others have expressed fears about the potential dangers of this striving to be "normal," including the fear that we can end up denying parts of ourselves and our communities as we present an image of ourselves, our children, and our families that is non-threatening, recognizable, and sometimes desexualized (see Warner, 1999; Malone and Cleary, 2002; Epstein, 2005; Riggs,

2007). Jaime Grant writes explicitly about her own family and about sex. Her first child was raised in a "village," and her second in a more traditional family structure. She writes about how queerness and sexuality fit into all of this.

Joanna Radbord takes the discussion to a different place. As a lawyer who has been centrally involved in the key queer family recognition cases in Canada, she takes this opportunity to talk about what it was like fighting those cases while being the brunt of criticism and attack from her own community. Speaking both to people like me (those who advocate "resisting normal" in queer parenting) and to some feminists (who believe devoting oneself to one's children is somehow an abandoning of self), Radbord presents her own viewpoint on the significance of queer family recognition cases and speaks honestly and personally about her own desires as a parent and about the need to recognize and affirm *all* of our desires.

Laurie Bell raises important questions about gender, in her case, about how butch-identified lesbians influence masculinity in their sons. The issue of "male role models" has been central to critiques of queer parenting (see Silverstein and Auerbach, 1999; Clarke, 2005; Hicks, 2008) and Bell's piece complicates what are often simplistic, heternormative, biologically based assumptions about what men and women offer children. And finally, the collection ends with another piece which, like Melissa Hart's that opens the book, never fails to make me both laugh and cry. In "I Am My Father's Son," Jonathan Feakins writes about being the son of a trans woman, and celebrates both his father and the things he has learned from his father. In its refusal of political correctness and its celebration of one queer parenting experience, I can't think of a more fitting end to this book.

VOICES OF QUEER SPAWN

Stefan Lynch, the first director of COLAGE (Children of Gays and Lesbians Everywhere) has coined the terms "queer spawn" and "culturally queer" to describe young people with queer parents. As our kids get older many of them seek a place in queer communities. They have grown up here. As my probably straight sixteen-year-old daughter says of herself, "I was born queer." Our children are challenging us to create spaces in our communities that are welcoming to them — particularly those who are, in Lynch's terms, erotically straight but culturally queer. I am delighted that queer spawn are well represented in this book. (See the essays by Hart, Evans, Hill-Meyer, Mooney-Somers, and Feakins.) Their opinions, perspectives, and critiques

are vital to any conversation about queer parenting. The queer spawn in this book write about identity, belonging, and politics; about custody cases, race and racism, and the benefits of being raised by queer and trans parents. We are privy to a dialogue between a gay man and his dyke daughter, and are offered some insights into the strategies queer spawn use when confronted with homophobia and heterosexism at school.

Putting the Book Together

The process of selecting the pieces for this book was, at times, excruciating. The initial call for papers brought in over 100 submissions. In the end we have included thirty-two of them along with four interviews. I wish there was more space. Clearly we need more books, more collections, and more opportunities to hear the voices of queer parents and their children. Decisions about inclusion and exclusion were not easy. While questions of identity, geography, and family configuration were important, the criteria for inclusion became more about which pieces unsettled my assumptions, inspired me to think differently or about something new, engaged or disturbed my thoughts or emotions, made me laugh or cry. At some point I made the decision to leave out poetry, to say no to pieces that were similar to others, and to keep the book primarily focused on North American experience. There are volumes to be written about queer parenting in other parts of the world. While I believe the writings in this book are rich in diversity and theme, I know there are many exclusions. These are the limits of one book, compiled, for the most part, from submissions. I look forward to future volumes that will continue to broaden this ever-evolving dialogue.

When All Is Said and Done

It is our longing to protect our children that leads us to want them and our families to be "normal." We want them to have regular lives, to not always be seen through the lens of "the kid with queer parents." In our desire to protect, we can become the eyes of the dominant culture, policing them as the culture does, wanting them to do well, to fit in, to conform to gender and other norms. This feeling of wanting to protect is familiar and almost ever-present for me as a parent. But I am learning that it is impossible to protect our children from hurt, we can only help them learn to cope and offer our love when the world rejects.

Hidden in queer parents' desires to protect our children are the shreds of ways that we still believe that our sexual and gender identities will be a negative factor in their lives, that they will suffer because of who we are. However, our children, as they are the first to remind us, are complex human beings — their identity as children of queer parents is only one aspect of their beings. Our desire to do well by them also means we tend to overestimate the impact of our parenting and to assume a direct and conscious relationship between what we do and how they turn out. Much of the legacy we leave our children is unconscious, most of the time we are not aware of all they learn from us, nor of all the significant and influential factors in their lives.

When all is said and done, we need to value what we offer our children. We need to turn away from romanticized depictions of our families that deny our pains and challenges and complexities and move towards deeper, fuller accounts of our families. When I read the pieces in this book I am moved by the risks the authors take to speak openly about their experiences of queer parenting, about their families, their children, their parents, and about their hopes, fears and dilemmas. My hope is that bringing together such a varied group of honest and thoughtful writings will help turn on its head the notion that our children are running a deficit by having us as parents. Not by proving that really they turn out okay or "the same as" other children, but by recognizing and celebrating the richness that is forged from our courage to be all of who we are. This richness is what we offer our children, not in spite of, but because of, who we are.

REFERENCES

A.A. v. B.B. and C.C., 2007 ONCA 2.

AHRA/LGBTQ Working Group. *The Assisted Human Reproduction Act* and LGBTQ Communities, 2008. More information is available from parentingnetwork@sherbourne.on.ca.

Arnup, K. *Lesbian Parenting: Living with Pride and Prejudice.* Charlottetown, PEI: Gynergy Books, 1995.

Bogis, T. "Affording Our Families: Class Issues in Family Formation. " In M. Bernstein and R. Reimann, eds., *Queer Families, Queer Politics: Challenging Culture and the State.* New York: Columbia University Press, 2001.

Chesler, P. *Mothers on Trial: The Battle for Children and Custody.* New York: McGraw-Hill, 1986.

Clarke, V., and C. Kitzinger. "We're Not Living on Planet Lesbian: Constructions of Male Role Models in Debates about Lesbian Families." *Sexualities* 8, no. 2 (2005): 137–152.

Coalition for Lesbian and Gay Rights in Ontario (CLGRO). Newsclippings on Adoption and Parenting Issues, October 1989–May 2002. Available online at the CLGRO website, www.clgro.org.

Copper, B. "The Radical Potential in Lesbian Mothering of Daughters." In S. Pollack and J. Vaughan, eds., *Politics of the Heart.* New York: Firebrand, 1987.

Dalton, S. "Protecting Our Parent–Child Relationships: Understanding the Strengths and Weaknesses of Second-Parent Adoption." In M. Bernstein and R. Reimann, eds., *Queer Families, Queer Politics: Challenging Culture and the State.* New York: Columbia University Press, 2001.

Epstein, R. "Queer Parenting in the New Millennium: Resisting Normal." *Canadian Woman Studies/les cahiers de la femme*, Special Issue, *Lesbian, Bisexual, Queer, Transsexual/Transgender Sexualities* 24, nos. 2/3 (2005): 7–14.

—. "Our Kids in the Hall: Lesbian Families Negotiate the Public School System." In Andrea O'Reillly, ed., *Mother Outlaws: Theories and Practices of Empowered Mothering.* Toronto: Women's Press, 2004.

—. "Lesbian Families." In M. Lynn, ed., *Voices: Essays on Canadian Families.* Toronto: Nelson Canada, 2003.

—. "Butches with Babies: Reconfiguring Gender and Motherhood." *Journal of Lesbian Studies* 6, no. 2 (2002): 41–57.

Garner, A. *Families Like Mine: Children of Gay Parents Tell It Like It Is.* New York: HarperCollins, 2004.

Hicks, S. "Gender Role Models ... Who Needs 'Em?!" *Qualitative Social Work* 7, no. 1 (2008): 43–59.

Lewin, E. "On the Outside Looking In: The Politics of Lesbian Motherhood." In F. Ginsburg and R. Rapp, eds., *Conceiving the New World Order.* Berkeley: University of California Press, 1995.

—. *Lesbian Mothers: Accounts of Gender in American Culture.* Ithaca, NY: Cornell University Press, 1993.

Lorde, A. "Turning the Beat Around: Lesbian Parenting 1986." In S. Pollack and J. Vaughn, eds., *Politics of the Heart.* New York: Firebrand, 1987.

MacKay, L. *Children and Feminism.* Vancouver: The Lesbian and Feminist Mothers Political Action Group, 1982.

Malone, K., and R. Cleary. "(De)sexing the Family: Theorizing the Social Science of Lesbian Families." *Feminist Theory* 3, no. 3 (2002): 271–293.

Mamo, L. *Queering Reproduction: Achieving Pregnancy in the Age of Technoscience.* Durham, NC: Duke University Press, 2007.

Patterson, C. "Lesbian and Gay Parents and Their Children: Summary of Research Findings." In *Lesbian and Gay Parenting: A Resource for Psychologists*, 2nd ed. Washington, DC: American Psychological Association, 2005.

Pollack, S., and J. Vaughn. *Politics of the Heart: A Lesbian Parenting Anthology.* New York: Firebrand, 1987.

Polikoff, N. "Lesbians Choosing Children: The Personal Is Political." In S. Pollack and J. Vaughn, eds., *Politics of the Heart.* New York: Firebrand, 1987.

Rayside, D. *Queer Inclusions, Continental Divisions: Public Recognition of Sexual Diversity in Canada and the United States.* Toronto: University of Toronto Press, 2008.

Riggs, D.W. *Becoming Parent: Lesbians, Gay Men, and Family.* Teneriffe, QLD, AUS: Post Pressed, 2007.

Ross, L., L. Steele, and R. Epstein. "Lesbian and Bisexual Women's Recommendations for Improving the Provision of Assisted Reproductive Technology Services." *Fertility and Sterility* 86, no. 3 (2006): 735–738.

Schacher, S., C.F. Auerbach, and L.B. Silverstein. "Gay Fathers: Expanding the Possibilities for All of Us." *Journal of GLBT Family Studies* 1, no. 3 (2005): 31–52.

Silverstein, L.B., and C.F. Auerbach. "Deconstructing the Essential Father." *American Psychologist* 54 (1999): 397–407.

Stacey, J., and T.J. Biblarz. "(How) Does the Sexual Orientation of Parents Matter?" *American Sociological Review* 66 (2001): 159–183.

Walters, S.D. "Take My Domestic Partner, Please: Gays and Marriage in the Era of the Visible." In M. Bernstein and R. Reimann, eds., *Queer Families, Queer Politics: Challenging Culture and the State.* New York: Columbia University Press, 2001.

Warner, M. *The Trouble with Normal: Sex, Poitics, and the Ethics of Queer Life.* New York: The Free Press, 1999.

Weston, K. *Families We Choose: Lesbian, Gays, Kinship.* New York: Columbia University Press, 1991.

Wyland, F. *Motherhood, Lesbianism and Child Custody.* Toronto: Wages Due Lesbians, 1977.

I RED ROCK BABY CANDY:

Beginnings ...

THE SQUEAKY ANIMAL HAT CLUB:
A Queer Spawn Comes Out

Melissa Hart

THE HAT WAS PINK AND FURRY, RESEMBLING THE TOP OF A PIG'S HEAD. Two fuzzy ears protruded — one with the requisite adorable flop — and two plastic eyes appeared to crinkle with laughter. But its *pièce de résistance*, the feature I found so heartbreaking when denied to me, was the snout. Set just below the eyes with their ironic twinkle, it let loose a high-pitched squeal when squeezed.

The sound resonated in the bedroom my mother shared with her girlfriend in their California bungalow. Mom rushed in from the dining room, where she'd been sewing doll clothes with my younger sister. "That's mine!" She snatched the hat and held it to her chest, red-faced. "I know it sounds silly, honey, but you can't touch this."

It was a child-sized hat. An adult could only balance it precariously on top of her head, rather than wearing it snug and proper around the crown. I scowled with twelve-year-old indignation. "Mommy, that's a kid's hat."

My mother shook her head and attempted to explain the significance of her *chapeau* with a solemn, earnest patience I found maddening. "This hat is a sort of … well … a uniform for a club I belong to. Adults only. Each of us has a different animal on our hat, and our cardinal rule is that no child must touch them."

She placed the pig on a high shelf in her closet and shut the door.

"What club?" I fumed. "It sounds stupid."

My mother shrugged. "Some of my girlfriends like to get together for a few beers and wear these hats." Then she looked me in the eye and said

gently, "You know, honey, stupidity is highly underrated."

That was the end of our discussion. I never touched the pig hat again, but I continued to obsess over it privately. What did my mother's club do in their animal hats? Did they recite a motto — index and middle finger held nobly aloft — as I did in Girl Scouts? Did they have a secret handshake? Did they march in the Fourth of July Parade, flaunting their forbidden headgear?

I imagined my mother's friends sitting on her living-room futon or lounging on the striped floor pillows smelling of ancient cat piss, squeaking each other's proboscises on the weekends my siblings and I had to stay at our father's house. Why couldn't she see that I was worthy of membership in the Squeaky Animal Hat Club? My heart burned with the indignity of separatism.

*

In 1979, Mom came out as a lesbian in an insular and conservative Los Angeles suburb. I was nine years old. In a photo taken the year before her epiphany, she kneels with her three children on a manicured lawn, bound in a brown floral polyester dress with her hair teased high up on her head. At thirty-two, she looks tense and weary, perhaps because my explosive father wielded the camera.

There were no photos taken the year she herded us into her station wagon and fled from him. But shortly after the months' long child-custody battle, her new girlfriend Annie snapped a photo of my mom at a backyard barbecue.

The change in my mother is phenomenal. Her face glows with enthusiasm. She wears a bright blue blouse dotted with black triangles, and her hair is cropped in a hip New Wave bob. She doesn't look like a woman who has just lost custody of her children — a punishment handed down from a judge who echoed my father's outrage and questioned her mental health.

For years, I resented that photo, resented how happy she looked despite being allowed to see her children only two weekends a month. How could I know then what she had resolved to keep hidden from me — a crushing guilt and a suicidal depression that her own mother would reveal to me two decades later? "She didn't want to add to your own angst," my grandmother told me.

I don't begrudge the pleasure my mother took in discovering the gay community. I adored it, too, embracing camp and irony like long-lost siblings. Blake Edwards' *Victor/Victoria* became my favourite film; at eleven, I was fond of observing with Robert Preston's world-weary insight that "there's nothing more inconvenient than an old queen with a head cold."

I shared none of this with my friends in my father's city. There, my mother's sexuality seemed shamefully suspect. The boys in my class derided each other as "faggot" and "homo." The girls cried "dyke" on any female classmate whose hair hung shorter than shoulder-length.

"Why don't you live with your mother?" they asked me at the lunch table in sixth grade.

"She's a journalist," I lied smoothly. "She travels overseas a lot."

In truth, my mother had never ventured out of the country.

*

Shortly after I discovered the pig hat, Mom house-sat for two gay friends who were on vacation in Europe. I wandered through Stan and Mark's home as she ministered to their potted orchids and an ancient Shih Tzu. In the master bedroom, I discovered an antique bureau crammed full of stuffed bears. I was a rabbit aficionado myself, but I could appreciate their collection for what I thought it was. "Mommy, look!" I cried. "They love stuffed animals, too!"

My mother smirked. "Stan and Mark are bears."

I imagined in her preoccupation with the Shih Tzu's gourmet lamb and basmati-rice dinner that she'd confused her verbs. "You mean they have bears."

"No, honey, some men who have a lot of hair and wear leather ..." Here, she paused. "Well, never mind." (It would be twenty years before I understood that "bears" referred to hirsute, burly gay men.) These weekend revelations would have been something to share with the kids at school, if only I felt at liberty to discuss my mother and her fabulous new friends. But I sensed that my own peers, raised in traditional heterosexual households, might not echo my enthusiasm.

I kept from my comrades the details of my thrilling nightlife every other Saturday. One evening, my mother and Annie invited a friend over to watch *Poltergeist* with us on their new Beta Player. The woman, Sally, howled at Stephen King's overblown demons and exorcists. The potentially terrifying

maggot-infested pork chop was rendered impotent by laughter. When it began to crawl across the kitchen counter, Sally let out a whoop. "Well, fuck a duck!" she cried.

My sister and I stared at each other in shock and delight. "Well, fuck a duck!" we said. "Fuck a large, quacking duck."

My mother winced, likely praying to be sucked into the television with the hapless Carol Anne. "Wonderful." She rolled her eyes at Sally. "Are you going to explain to the kids' father when they repeat this at his dinner table?"

"Relax, sweetie." Annie put her arm around my mother. "Have another Budweiser."

My mother's friends drank beer out of bottles. They wore baggy blue jeans, comfortable shoes, and flannel shirts *sans* support garments. They possessed and knew how to use a table saw. They had master's degrees and full-time careers in the fields of mental health and journalism. Without kids, they travelled, took college courses for fun, and gathered on weekends and holidays for parties.

If her friends treated my mother differently because she'd once been a "breeder," I never noticed. Neither did I consider whether we might be a source of embarrassment as we accompanied her to pool parties and barbecues. "You kids are my priority, my life," she insisted.

I assumed that in the ten days between our visits, she worked overtime and came home to cry over our photos on her nightstand. But then I found the pig hat and realized what I'd never considered before. My mother inhabited a world vastly different from my own, lived a life she enjoyed thoroughly.

*

My father and his new wife Elsa drank white wine out of crystal glasses, and they never referenced fowl fornication. Elsa and her friends dressed in pastel sweatsuits, tidily shed to reveal leotards and matching tights. They knew how to use a melon baller. If they worked, their jobs were part-time. They cooked four-course meals every afternoon, and reapplied lipstick before their husbands came home from work.

Like the bewildered baby bird in the children's picture book, who hops from animal to animal asking "Are you my mother?" I searched for my identity in the wake of my parents' divorce. Whereas before, I could only hope to be a heterosexual housewife, now I had role models in the form of

professional women whose dishes went unwashed as they banded together with their lesbian sisters and strove to save the world.

On my thirteenth birthday, my mother and Annie gave me a red flannel shirt. I wore it braless with a pair of cut-off Levis until the collar frayed and the sleeves hung ragged at my elbows.

"Blair on *The Facts of Life* is so hot," I'd tell my mother and her friends, or "Don't you think Trixie from *Rocky Horror* is a total babe?"

The women chuckled indulgently, as one might when a child pretends to puff on a candy cigarette. I was amusing, but definitely not membership material.

At fourteen, I gave up and surrendered to bleak heterosexuality throughout high school and college. Humiliated to be straight, I courted gay boys and budding transsexuals in an attempt to gain entrance into my mother's world. At last, when my reluctant suitors abandoned me one by one for lovers of their own gender, she sat me down on her couch. "Honey," she took my hands in hers. "I don't want you to be gay. I wouldn't wish homophobia on anyone."

Unconvinced of my worth as a straight girl, I enrolled in graduate school.

Goddard College in Vermont attracts an unconventional crowd. In the MFA brochure for creative writing, several faculty members identified themselves as gay or lesbian. The demographic struck me as familiar and comforting.

The first night, I climbed the stairs in my dorm room to discover a militant blond woman marching naked down the hall past doorways full of gawking students. "That's my roommate," said the red-haired woman reading Elizabeth Bishop in the student lounge. "She's a little ... angry."

I considered my own roommate, a flaming heterosexual who in-formed me that she'd set our alarm for five each morning so she could"you know, like, take a shower, mousse, blow dry, and put on eyeliner and shit."

I studied the redhead in the lounge, stretched out on a couch in her blue flannel shirt and loose Levis. "There's an empty dorm room down the hall," I said. "Want to be roommates?"

She flashed me a sardonic smile and nodded. "This'll be amusing," she said. "I'm Sandy."

Graduate school, in which I'd enrolled for a deeper understanding of literature, instead provided me with a wealth of information about my mother's culture. My roommate introduced me to a new lexicon, which

included the words "gaydar," "pass," "strap-on," and "dyke baby boom." The latter term referred to the proliferation of gay women who birthed children during the 1980s. Apparently, lesbian moms were cutting edge. But while I'd grown up on the forefront of the movement, my sensibilities lagged decades behind.

"I don't see what the big deal is," I told Sandy. "My mom had three kids. So what?"

"Don't you get it?" she demanded. "We're talking about society's idea of contradictory identities — lesbian and mother — which dykes challenge every time they give birth, or adopt a child. Your mom committed the ultimate political rebellion by coming out with three kids."

"Really?"

I thought she'd simply left my father for a lover who didn't beat her up.

*

For all of my adolescence and early adulthood, I remained oblivious to my own demographic, while across the nation, children of same-sex parents organized themselves into a political force. In the late 1980s, Stefan Lynch, the straight son of a gay father and lesbian mother, coined the phrase "culturally queer, erotically straight" and founded COLAGE (Children of Lesbians and Gays Everywhere).

Many COLAGE members were kids from big cities, children who grew up riding in cars adorned with rainbow bumper stickers, marching alongside their parents in Gay Pride Parades and lobbying politicians about issues far more serious than being excluded from their mother's animal hat club.

As these kids grew into adults, they hosted their own radio programs, wrote PhD dissertations, and published books that explored the phenomenon of having same-sex parents. They found me via the Internet after an independent press published my graduate thesis as a memoir.

"You wrote a book about your mom coming out?" said a San Francisco COLAGE member over the phone. "That's great. We'll add it to our collection and host a reading."

And so, at thirty-five, for the first time in my life, I sat in a bookstore surrounded by a dozen of my peers, all of whom had one or more queer parents. They presented me with a pink T-shirt that read Queer Spawn. I gaped at the word.

"Did you think you were the only one?" someone asked me.

How could I admit that I'd believed there were only two others — my younger sister and brother? The adults sitting around me had grown up out and proud. None had been forced to watch their mother drive away every other Sunday night because a woman occupied her bed. To cover my confusion, I held up my book and delivered a hasty overview of the plot.

"She lost custody of you because she was a lesbian?" The woman next to me gasped. "Jesus Christ! My sixteenth birthday party with my father was a fag-fest. Every gay guy in Oakland showed up, and my mothers danced the Macarena naked with them."

She explained how she'd grown up bouncing merrily between two dads in one household and two moms in the other. Others shared their stories — these hip, savvy adults who might as well have grown up on another planet. "My mom's still kind of in the closet," I mumbled. No one at her work knows she's gay, and she wouldn't be caught dead marrying her partner or marching in a Pride Parade.

The woman beside me raised a pierced eyebrow. "Wow. You must think we're weird."

No, not weird. But not familiar, either. Although we all identified as queer spawn, I didn't feel a sense of kinship. Where once I'd been afraid to reveal my mother's sexuality to my friends, now I felt ashamed that we weren't flying our rainbow flags. I assumed in publishing a book that revealed the havoc that homophobia could wreak upon a family, I'd gain respect and legitimate entrance into this world for which I'd longed. But listening to the rest of the queer spawn planning a letter-writing campaign in favour of California same-sex marriage, I felt like an outsider.

The feeling intensified that weekend. My reading in the Mission District coincided with the San Francisco Writers' Conference at the Sir Francis Drake Hotel, which my mother and I attended together. Three factions converged at the Drake that weekend — the writers, the West Coast Coronation of drag queens, and the International Bear Rendezvous.

I recalled Stan and Mark's bear collection from my childhood as Mom pulled me past a flock of drag queens in their little black dresses and feathered pillbox hats. "Let's go, honey. It's cocktail hour."

Up in the Drake's elegant Starlight Room for drinks and hors d'oeuvres, Mom ordered a gin and tonic and began chatting with a gentleman who wrote mystery novels. When a young doctor/poet attempted to engage me

in an earnest debate over whether the self-addressed stamped envelope was passé, I fled.

The elevator, vacant except for me, paused on the eighth floor to welcome in a seven-foot drag queen sheathed in gold lamé and wrapped in a black feather boa. A blond beehive-wig balanced on her head. Size-thirteen gold pumps tapped impatiently as the elevator began its descent.

"Where's the party?" I asked.

She batted synthetic eyelashes and replied in a smoky baritone, "Second floor. Don't miss it, honey."

She sashayed out, and I shot back up to the Starlight Room.

"Mom!" I tugged my mother's sleeve, trying to distract her from the mystery writer's speculation that a chimpanzee could indeed solve the murder of a promising young zoologist. "There's a drag show in the hotel."

In an instant, my mother made the mental leap from literati to glitterati. "Drag show? Please excuse us."

She followed me down to the second floor, where two paunchy men who looked to be members of the Moose Lodge rather than denizens of the Royal Court sold us tickets to the Grand Ballroom.

I don't know what I expected. The invitation from the queen in the elevator had seemed to me highly personal, an indication that I'd be welcomed in with sequined arms. It's not that I felt myself to be unwelcome, as Mom and I wove between stately beauties in their coronation best, I was simply a non-presence. The queens regarded me not at all. But the instant my mother sat down at a table near the back of the ballroom, a man sporting a tuxedo and rainbow cummerbund dropped his camera into her lap. "Sugar, can you watch this for me? I've just got to go greet Ms. Mona Lott!"

My mother wore non-descript black pants, an innocuous black jacket, minimal silver jewellery, and lipstick. Yet all around us, queens nodded at her in recognition while I sat as if invisible. "Why don't they assume I'm a lesbian?" I fumed later in our hotel room. "I'm erotically straight but culturally queer, you know."

My mother regarded me with amusement. "Why don't they think you're a lesbian?" she replied. "Because you're not."

*

I returned home to Eugene, Oregon. I contented myself with laughing knowingly at the campy antics in *The Bird Cage* and *But I'm a Cheerleader*.

Inspired by the San Francisco queer spawn, I joined PFLAG and sat at meetings surrounded by parents of LGBT people, the LGBTs themselves, and two women with their articulate activist seventeen-year-old son who regarded me suspiciously.

"I read your book," he said. "All that stuff about being scared to tell your friends about your mom ... well, sorry, but it seemed kind of ridiculous."

I nodded. "It was."

Once again, I felt shame, deepened by a comment from the director of the national PFLAG chapter, in an article about my book. "Hart has such an important voice," Jody Huckaby told the *Statesman Journal*. "She can bring the story many don't want to hear."

I internalized only the latter part of the quote. Did the LGBT community and its allies resent me for telling my story?

The next week, as if in answer to my concern, I received an email from two lesbian filmmakers. They'd read my book, as well, and had found it inspiring. "We're making a documentary about the Lesbian Mothers National Defense Fund," they wrote.

"What's the Lesbian Mothers National Defense Fund?" I emailed back.

Their response slammed me into my office chair, my jaw dropped. The fund — LMNDF for short — offered legal and financial advice to lesbians in danger of losing child custody battles in the 1970s and early 1980s.

There were other families similar to mine? Where kids got *taken away* from their queer parents?

"Thousands," the filmmakers said over their speakerphone. "We don't know how many. Most mothers are so full of guilt and shame that they can't even talk about their experience. They don't want their kids to talk about it, either."

I gripped my phone. "I want to talk about it."

The filmmakers planned to meet me in Eugene with their cameras. In the meantime, I researched the story of the Defense Fund.

Seattle activists founded LMNDF in 1974, after Sandy Schuster and Madeleine Isaccson divorced their respective husbands and announced their lesbian relationship. A Washington judge ruled that the women could each keep their kids, but only if they didn't live together. Schuster and Isaccson compensated by renting apartments across the hall from one another.

Two years later, their ex-husbands attempted to sue for child custody. Enter LMNDF, which assisted Schuster and Isaccson in the fight to keep their

kids. The women ultimately won full child custody, and the Washington State Supreme Court lifted all restrictions on their living arrangements.

Did my mother, busy changing diapers and feeding babies, follow Schuster and Isaccson's case? Pregnant with my sister and rocking me to sleep, did she read Phyllis Lyon and Del Martin's book *Lesbian/Woman*, pausing over the chapter on lesbian mothers? Had she read *Ms.*, *The New York Times*, and *Newsweek* — all of which ran articles on lesbian moms? Was the extent of her political activism really confined to gatherings of females in funny hats, or did she and her girlfriends storm the state capital when I wasn't around? And, if she knew we weren't the only ones, why didn't she tell me and include me in the fight for civil rights?

"Our parents see us as allies," complained a queer spawn friend of mine, "not as a part of their gay community ... the community we grew up in."

The word "ally" implies separation from a valued perspective. I wished now that my mother and her partner had invited me to march in parades, wave the rainbow flags, and write letters to our congresspeople. I wish they'd presented me with books like Abigail Garner's *Families Like Mine: Children of Gay Parents Tell It Like It Is* and invited me to discuss LGBT issues, preferably while wearing a squeaky pig hat. Why hadn't they? Were lesbians and their straight children really so different from one another?

The filmmakers at my front door didn't think so. They dropped their cameras and lighting equipment to embrace me as one of their own. With their flannel shirts and no-bullshit attitudes, they resembled my mother's friends from long ago. "You look good. Relax." They positioned me on a chair and arranged their lights. "Ready when you are."

I answered their questions mechanically, studio lights burning my cheeks as I recounted how my father had appeared on the doorstep of the apartment my mother and her girlfriend shared in 1979, flanked by his social worker, two policemen, and a court order. I explained that my younger siblings and I were forced to get into our father's car, forced to leave our mother. "We cried and yelled at my dad," I recited into the camera.

The filmmakers asked me to repeat my story, and then to tell it once more. "We want a variety of takes to choose from," they said quietly.

By the fourth take, I collapsed, propelled back to the sensibilities of a nine-year-old girl who gazed disbelieving through a car window at her mother sobbing behind a patrol car. "She didn't do anything wrong," I cried as I recounted the moment. "I loved living with her. I wanted to stay ..."

"What was it like to see your mom only two weekends a month? How did you feel having to live with your dad? Did his homophobia affect how you felt about your mother?"

No one had ever asked me such questions. The answers had been irrelevant, my experience a shameful anomaly in the greater triumph of same-sex parenting. Now, I couldn't stop talking.

"I was nine when my mother came out," I said. "She'd been the leader of my Brownie troop, hostess of the best birthday parties in the neighbourhood. I couldn't understand why suddenly, I wasn't allowed to live with her. She'd drop us off at our father's house every other Sunday evening, and I'd pretend to be happy so he wouldn't be mad at me, but in my room, I cried myself to sleep. All I wanted was to be with her, and I lived for those two weekends a month."

At the end of the hour, the filmmakers asked me one final question. "Are you close to your mother now?"

I told them about how, as soon as I turned eighteen, I'd moved in with Mom and her partner. And how I lived next door to them for years before moving to Oregon, and how I'd met my mother in San Francisco where we abandoned the writers' conference for the far more fabulous drag show.

Then, the taller filmmaker set her camera on the couch and howled with laughter. "Well, fuck a duck!" her partner cried.

I stared at them in shock and delight. It wasn't a squeaky animal hat, but it would do. I threw my arms around both women. "Fuck a large, quacking duck," I replied.

BOX A

Celebrating Our Forerunners:
THE LESBIAN AND GAY PARENTING ACTIVIST GROUPS OF THE 1970S

The lesbian mother and gay father activist groups of the 1970s paved the way for LGBT families with children from the 1980s on. These groups, with virtually no resources, pro-vided financial, emotional and legal support to lesbian and gay parents fighting for custody of their children. LGBT parents in the new millennium owe much to the struggles of these early activists and their demands for full reproductive rights for all people.

In Canada, the Lesbian Mothers' Defence Fund (LMDF) was established in the late 1970s by a group known as Wages Due Lesbians. The LMDF was active in Vancouver, Calgary, and Toronto, and put out a newsletter called *The Grapevine*.

In the United States, activist groups included the Lesbian Mothers National Defense Fund (LMNDF) in Seattle, the Lesbian Mothers Union (LMU), and the Lesbian Rights Project (LRP) in San Francisco, Dykes and Tykes in New York City, and Custody Action for Lesbian Mothers (CALM) in Philadelphia. The LMNDF put out a newsletter called *Mom's Apple Pie*.

For more information, see the references below, which might be found at the National Lawyers' Guild (www.nlg.org); National Center for Lesbian Rights (formerly Lesbian Rights Project) (www.nclrights.org); Gay Fathers of Toronto (www.gayfathers-toronto.com); Canadian Gay & Lesbian Archives (www.clga.ca).

Anti-Sexism Committee of the San Fran-Bay Area National Lawyer's Guild. *A Gay Parent's Guide to Child Custody.* San Francisco: ASC, 1980.

Gay Fathers of Toronto. *Gay Fathers: Some of Their Stories, Experience, and Advice.* Toronto: Gay Fathers of Toronto, 1981.

Green, R. "Sexual Identity of 37 Children Raised by Homosexual or Transexual Parents." *American Journal of Psychiatry* 135, no. 6 (June 1978): 692–697.

Hitchens, D. *Lesbian Mother Litigation Manual.* San Francisco: Lesbian Rights Project, 1982.

Hunter, N.D., and N. Polikoff. "Custody Rights of Lesbian Mothers: Legal Theory and Litigation Strategy." *Buffalo Law Review* 25, no. 3 (1976): 691–736.

Laine, Jody, Shan Ottey, and Shad Reinstein, directors. *Mom's Apple Pie: The Heart of the Lesbian Mothers' Custody Movement.* Documentary. Includes a Study and Resource Guide. Distributed by Frameline. For more information: http://cart.frameline.org/.

Lesbian Rights Project. *Lesbian Mothers and their Children: An Annotated Bibliography of Legal and Psychological Materials.* San Francisco: Lesbian Rights Project, 1980.

Lynch, M. "Forgotten Fathers." *The Body Politic,* Issue 42, April 1978.

MacKay, L. *Children and Feminism.* Vancouver: The Lesbian and Feminist Mothers Political Action Group, 1982.

Stone, S.D. "Lesbian Mothers Organizing." In S.D. Stone, ed., *Lesbians in Canada.* Toronto: Between the Lines, 1990.

Wages Due Lesbians. *Motherhood, Lesbianism and Child Custody.* Toronto: Wages Due Lesbians, 1977.

Wyland, F. *Motherhood, Lesbianism and Child Custody.* Toronto: Wages Due Lesbians, 1977.

Zeitz, Janice. *Wages for Housework; Wages Due Lesbians; Lesbian Mothers' Defence Fund.* Prepared for the Archives and Special Collections, University of Ottawa Library, 2004.

Go On, You Choose:

The Ethics of Getting Pregnant by Nagging

Emma Donoghue

I wanted kids. My lover didn't.

If only she were a man, I could have done what so many straight women have told me (in whispers) they've done: waited for an accident, or tricked him into it. But as it was … well, I used to daydream. Whoops, sweetie, I happened to walk into a fertility clinic today, thinking it was the post office, and fell onto a vial of sperm!

Nice straight friends often assume that a lesbian couple, both being female, are both equally eager for motherhood. It's certainly true in the case of many of our circle, which makes women like Chris feel even more like freaks, even more backed into the corner by the transformation in lesbian and gay culture over the last decade. (Some call it civil rights, some assimilation; Chris and I tend to call it, ruefully, a bit of both.)

There's a technique familiar to most parents, because it works so well with toddlers: the false choice. Instead of telling a three-year-old that he must wear a long-sleeved top or else he'll get cold, you say, "Do you want your Thomas the Tank Engine shirt or your red hoodie?" If he shakes his head, you repeat yourself in a more seductive and urgent tone: "Thomas or hoodie. Go on, you choose!" Briefly dazzled by a sense of his own agency, he picks one. Your job is to hustle him into the garment before he remembers that he really wanted to stay in his Dora the Explorer T-shirt instead. Your reward is threefold – your child is warmly dressed, you've taught him about decision-making, and (ha ha!) you've fooled the little bugger.

Unfortunately for my purposes, Chris was not three but thirty-five when I (twenty-seven, and already ogling babies at airports) first raised the possibility of reproduction, and her mental arsenal was fully stocked. Unlike many — sometimes it seems like most — Westerners in their thirties, she was suffering from no confusion about whether or not she wanted children. She had never had a broody thought in her life, she told me — very gently, because she was already glimpsing how sad this news was going to make me. She didn't really notice children, she explained, except for a select few of whom she'd seen a lot of over the years because she was close to their parents. Despite what I saw as her wealth of nurturing qualities, she imagined pregnancy as an alien invasion and motherhood as a terrifying state of captivity. In fact, one reason for Chris's jubilation on discovering she was a lesbian in her twenties had been what seemed an inevitable side-effect: no kids. Instead she could be an intellectual, a biker, a friend and lover, a culture vulture, and stylish dyke-about-town.

She was all those things, and still is at forty-four, as much as she can manage, given that she is one of the mothers of our three-year-old son Finn, and I'm currently pregnant with our second child.

<p style="text-align:center">*</p>

I believe not only in the right to be child-free, but in the healthiness of that decision. So whenever well-intentioned friends would murmur, "Chris can't deny you kids if you're really longing for them," I would say glumly, "Oh yes she can, she has every right." On the many occasions when Chris told me, "Sorry, I'm sorry, but the answer's still no," I assured her that I understood and respected that answer, and though I might be sad for a while, it wasn't going to ruin our life together. I had lots of other means of fulfillment, I reminded her, not the least of which was writing novels and plays, living many other lives on the page. "I'm not holding a gun to your head," I'd repeat. "I'm not issuing an ultimatum. I wouldn't dream of leaving you over this; I'd rather have you than kids any day." Which was all true, sort of.

And then, a few weeks later, I'd take up my quiet campaign of flippant suggestions mixed with sensible arguments once more. (Just one little one. It'll make us laugh. We can still work; it'll go to daycare. Isn't life a bit too pleasantly samey right now? A child will make us grow in ways we can't imagine. We can still travel. We'll read it Harry Potter. Don't you want someone to visit you in the old folks' home?)

Looking back, I can see that I was trying to have it both ways — to bully my beloved into the most life-changing of decisions, while all the time holding up my clean hands and insisting that the choice was hers, the choice was free.

I don't mean to make the process sound too sinister. We continued to have a lot of fun during those years; we enjoyed our childlessness, went to movies on a whim, ate dinner at 10 p.m., jetted around the world. We drew up a list of pros (provided by me) and cons (provided by her):

heartwarming Christmases	v.	stuck at home every night
tickling games	v.	endless laundry
keeping up to date with slang	v.	contemptuous teenagers
festivity	v.	freedom
more love	v.	less time

We actually laughed a lot about our civilized little war. It'd be an adventure, I told her. She countered: A suicide mission.

It took me five years to wear Chris down.

She did quite a lot of therapy; she started telling friends, "Oh, Emma will probably get her way in the end, I should have known what was coming when I hitched up with an Irishwoman." Her final stipulations were quite concrete: I get to go running every three days, and have a drink with colleagues once a week.

I got pregnant at the first insemination (as if the gods knew that my lover could well change her mind if there was any shilly-shallying). Chris was cheerful until I was about six months on, when she went alarmingly quiet. I probed, and she said something that stuck in my head for a long time. She said, "This is not my story." It was a good story, she told me, just not one she'd ever meant to find herself in. Perhaps because I'm a writer, I was appalled by this metaphor, the stomach-churning sensation of finding yourself in the wrong plot. Like that bad dream so many people have, about being on stage in a play and not knowing the lines.

Finn came five weeks early. Chris drove me to the hospital in a state of sick panic, and went home the next day utterly in love with our wizened, five-pound, frog prince.

A happy-ending story, then? A conversion, almost?

In the early days, Chris (on six months of fully paid parental leave from

the university where she teaches, which helped) coped much better than I did; she'd had such grim expectations that the reality of sitting around with a snoozy baby on her shoulder wasn't too bad at all. (She'd feared she wouldn't like the child, that she'd have to spend the rest of her life faking it, she admitted now, gazing down at him with pupils dilated by adoration.) Whereas I, who had spent more than five years repeating positive propaganda about babies, went into shock when breastfeeding proved hellish, and felt so overwhelmingly responsible for this tiny creature that I was often woken up by aural hallucinations of his crying. I never once regretted having him for a moment, I just regularly indulged in a fantasy about a doctor telling me our baby had to be put in a pharmaceutically induced coma for a fortnight, so Chris and I might as well go to the Bahamas.

After the first six weeks, I decided that parenthood might be a mixed bag, but Finn was glorious. If "just one" was all we were going to have, thank heaven he was such a playful and charming one.

Chris (being half French) was officially Maman to my Mum, but thought of herself as more of a dad, which was fine by me. I went off on a book tour when Finn was nine months old, and when I got back she announced, on a sort of sleep-deprived high, "He has to have a sibling." I was surprised and thrilled.

Over that winter, Chris changed her mind again, but I didn't notice. Whenever she would say something more doubtful about the prospect of a second child — that it could push us over the line, so we'd become a stereotypical nuclear family, Stepford zombies — I'd laugh it off. She kept repeating a line she'd heard, one is like none, two is like ten. We didn't talk about it enough, I know now. It was hard to find the time, between work and baby, and of course, I didn't want to hear any second thoughts.

We were a week from insemination when Chris came into my office, her face contorted with distress, and said, "I'm sorry, I'm sorry, I just can't."

By the end of that year, I'd given away the baby clothes. After the outrage, after the grief, I was left with a hard-earned understanding of how Chris had already turned her sense of self inside out, as an act of love for me. One child, though not quite as many as I wanted, was a compromise between two and none that was entirely in my favour. I was already a mother. Two would be icing on the cake, I told friends, but it was still a fabulous cake. Two might be pushing my luck. We were an ideal one-child couple, friends assured me, with our trips and books and parties, and Finn had so many friends anyway,

who needed a sibling?

I thought I had come to terms. But when he was two and a half, I found myself beginning my campaign again. I couldn't quite believe what I was doing, but I didn't stop.

Wistful statements about my craving for another baby. Dark hints about the boredom and isolation that could face an only child (though the truth is that the "onelies" I know are as happy as anyone else). Reminders of the parents we knew who claimed two were easier than one, once they were old enough to keep each other company. Reckless offers to do more than the lion's share of mummy-work and say no to all solo travel. As before, all of this was prefaced by remarks that were meant to salve my conscience: It's fair enough if you say no, Chris, I'm so grateful for Finn, I'm only asking, if we don't do it by the time he's four I'll shut up about the whole subject, I promise ... I felt like a cliché of a nagging wife.

In the end, Chris stared down her fears and said yes, for Finn's sake as much or more than for mine. Again, giddy with urgency, I was lucky enough to get pregnant the first time. We're due in four months.

Some days, smugness predominates. (When I find Chris and Finn playing Scary Monsters behind the sofa, with underwear on their heads. When I hold her hand to my belly until she feels a vigorous kick, and she grins and says, "Soccer player, definitely.") But a guilty moment is always just around the corner. She looks exhausted; Finn is having a "Go away Maman, I want Mummy" hissy fit; she hasn't been on a bike trip all year; the house is full of parents discussing toilet training; there's guacamole all over the carpet; is it worth going clubbing if we'll only get three hours sleep?

These moments are all part of parenting, and I'd feel fine about them if only I could convince myself that Chris truly wanted this stained, routine, riotous, distracted life we're leading; this life I love to my fingertips. It's good for her, I tell myself. (Like when I sneak prune juice into Finn's apple juice.) Sometimes, if I'm tired and glum, I mentally snap, Pity about her! I moved to Canada for her, didn't I? I wanted kids, and she wanted me, and if she doesn't like it she can lump it, and fuck off on her motorbike into the sunset. (Hmm, just listen to how mature motherhood has made me ...)

Clearly there is no end in sight for this ambivalence of mine. Some days, over the next twenty or forty years, I will feel as if I have hung a millstone around my lover's neck, and I should get down on my knees and apologize (for the mess and hassle of parenthood, I mean, never for the kids

themselves). On other days, I will conclude that I've given Chris the best gift imaginable — two of them! — and she should get down on her knees thanking me. (Sorry about all this down-on-one's knees stuff; I notice that talking about babies brings out my old Catholic vocabulary.) Neither of us will ever, in fact, get down on our knees. Most likely we will lurch on, laden with gifts, weighted with millstones, guacamole-stained and still ourselves, still a couple, if a couple of mothers.

We live in the Province of Ontario, where the laws on queer families have changed a lot in just a few years. When Finn was born in 2003, we had to register him as my son, "father: information not available" (which made me feel rather like a slut), and then Chris had to go through a tedious and expensive procedure known as a same-sex spousal adoption. This time around, in 2007, the new "Statement of Live Birth" has boxes for "Mother" and "Father" or "Other Parent." In Instruction #4(b), it clarifies: "An 'Other Parent,' for the purposes of this form, must be another person who consents to be acknowledged as the parent, if the biological father is unknown and the child was born of assisted conception with an anonymous sperm donor." I find the form's dry neutrality a comfort. Consent, it seems, is all that's required from the Other Parent. Not an entirely free choice, perhaps, but a saying yes.

Chris has said yes twice, and I will always love her for it. Is it patronizing to her for me to keep fretting about that yes? She is an adult, and adults often say yes to things that are going to fill them with an ever-shifting cocktail of pleasure, frustration, comfort, and panic, from jobs to sports to houses. She lives with her choices, and perhaps it is time for me to make peace with them, too. Because the fact is, as she remarked after I showed her a draft of what you're reading, she could never wish this story unwritten.

Daddies & Papas 2B:
The Evolution of Possibilities

Daddies & Papas 2B is a twelve-week course for gay/bi/queer men considering parenthood. A joint project of Queer Parenting Programs at The 519 Community Centre and the LGBTQ Parenting Network at the Sherbourne Health Centre in Toronto, Canada, the course has been running for close to six years. Below Rachel Epstein talks with Chris Veldhoven, course designer and facilitator, and Thom Vernon, a past participant.

R: CHRIS, TELL US ABOUT *the beginnings of the course.*

C: Well, a friend saw an ad for a course designer/facilitator to develop a course for gay/bi/queer men considering parenthood, and I thought, this sounds like a perfect possible extension of my work as a queer community educator and developer, especially since part of my personal history is that I have a dad who came out when I was a kid. He's been with his male partner for thirty-four years. My dad was an immigrant. He'd come to Canada in the 1950s wanting to be the best citizen of the new country as possible, and he was torn. He wanted to be a parent in a time when homosexuality had yet to be decriminalized in Canada. So he found a woman with whom he could fall in love and raise kids. In the 1970s he just couldn't compartmentalize his life anymore — he couldn't continue to deny his sexual identity and desire in the face of homophobic pressures to stay closeted in order to keep his family. In those days there were few to no options. You got married — you hid, especially if you wanted kids, as in my dad's case.

And I was a queer kid growing up in a small town in Eastern Canada where everybody knew everyone else's business. I was teased about my father. The social pressures around it were complicated because I was also dealing with my own sexuality and my own gender difference, being more feminine-identified.

So the course was a wonderful opportunity to bring my personal and professional experiences together to create a space where gay/bi/queer men could feel comfortable to explore some of the emotional repercussions of the impact of prejudices on our desire to be parents. The course provides people with information to make complex choices, recognizing the social, emotional, ethical journeys they may be exploring. It was a wonderful challenge to combine intellectual and emotional facilitation so that a few goals were achieved: the guys were informed about the different options now open to them to become parents as out gay/bi/queer men; they could be inspired by hearing the stories of role models — those who became dads themselves after coming out; and participants were in a social/educational space where they could process and share whatever they felt they needed to about considering parenthood.

The course was modelled after Dykes Planning Tykes and we have some joint sessions with the women, so it's not just an isolated community of male-identified people. There are a lot of lessons to learn from and supports to give each other. One is developing an understanding of the social and biological journey of people who give birth. No matter how a child comes into your life there was a person with a body who invested a lot of energy and that's important to understand and honour.

T: It's interesting, I remember having to work out what I thought about abortion and reproductive rights. One of my best friends at the time who was female was so angry with me because I said, "Well, you know, if that were to happen to you and I, we would work it out." And she said "No, it's my body, I'll work it out. I have the final say." And it sparked this clarification process for me of, okay, the male choice is when you are giving your sperm, that's where our choice comes in. And from then on it's our job to support. And it is up to the woman whose body it is to decide whether or not to go forward with that pregnancy.

R: I've never heard it put quite like that — about the male choice being when you're giving your sperm ... Give us a brief summary of what the course looks like now.

C: Well, the first week we get to know each other, through conversations and exercises. And as a group we set guidelines for a respectful learning environment, so that we have a mutual understanding of how to speak

without unintentionally or intentionally offending people or judging what other people are doing. The first week is a lot about that, and then at the end we talk about commonly held beliefs about LGBTQ people becoming parents. In particular we disentangle a lot of beliefs around gay/bi/queer men having kids or being parents, and back this up with a few research findings.

R: And what are some of those?

C: Myths include the belief that we don't know how to emotionally nurture kids; that every family needs a woman/mother and a man/father; our kids will be confused about their sexual orientation or gender identities; and that gay/bi/queer men are predators and sexually obsessed. A big one is the conflation of sexual identity and sexual abuse — gay men as pedophiles.

R: What's it like when the men in the course start looking at those things?

C: I put them through an exercise and ask them to brainstorm the characteristics of the ideal parent. They generate a list, and then I ask them if they would add or change anything if they were to generate a list for the ideal mother or ideal father. Typically, there are no changes and we discuss honouring what individuals bring to parenting separate from the highly gendered context that we may have learned that tells us what we can or cannot do. This is often the first time guys have thought about this and gives them a bit of confidence about their own strengths.

R: And how about the pedophile stereotype? How do people talk about that, think about it, address it, feel about it?

C: Sometimes we talk about social circumstances where we feel judged. For example, I'm at a restaurant and there's this great little kid running free. Do I say hi? There's the fear that someone might make the assumption that I'm a predator. How do I be my friendly self in the face of this fear? Some of the participants have worked in the child care industry and have been told "we're not going to let you change the diapers on these babies because we think it's inappropriate." This can be devastating for these men, who go into this profession because they really care about children.

T: I can tell you that I work at a children's theatre and I think every gay man in that building is very careful about going into the washroom when

there are boys in there, you know?

C: Guys bring that up as well, what if we need to be with children in public places like change rooms or washrooms? If your child is having a temper tantrum, how do you prepare for those potential moments where you might be accused and have the confidence to say, "I'm having a parenting moment here."

And we discuss having daughters. How are you going to teach them to be confident women in the world — socially, politically — and to know their own bodies? What do you need to learn? What discomfort do you need to work through so you don't teach any shame to your daughters, and, in fact, teach them pride? Similar questions apply for supporting our children if they are trans.

R: It's interesting, the women are all downstairs going, "Okay, what if we have boys?" And the men are all going, "Okay, what if we have girls?"

Chris: I think some of the guys are still going through culture shock. Most of the women in Dykes Planning Tykes are considering the biological route and that course is very focused on that process. For the guys it's more about exploring if they want to become a parent, and if so, what do they need to ask themselves and learn about. What do they need to know about surrogacy, or adoption, or co-parenting? Some are not sure where they're headed exactly.

Historically men were generally taught not to be deeply involved in birthing and child rearing. When I recently talked to my mother about my brother and his female partner's profound sharing of parenting labour she said in her day that would almost never happen because there were explicit messages from her culture and time period. "That's women's work. Women change diapers. I'm not going to feed that kid, that's your job, woman." Behind this was the tyranny of this being viewed as "natural," you know, "naturally" men don't know how to do these things and women do, when in fact we all learn parenting skills, whether we are parenting alone or with partners — whatever our sex, gender, or sexual orientation. Many liberation movements have shifted how men and women may parent together or separately. There are tensions around changing family dynamics, questions around who goes out and works, who takes time off, who is best suited for what tasks. We are redefining roles based on who is best suited for a given task. Decisions are being made based on an individual's strengths and

practical circumstances. Our various families challenge the heteronormative model many of us have internalized.

T: What's so amazing about the course is that it sets up a critical space. I found myself questioning my opinions and values and beliefs about myself as a parent and about parenting in general. I think that we can draw a direct line from Dykes Planning Tykes and Daddies & Papas 2B, to the seventies and the early consciousness-raising sessions in feminism, right? The opportunity to be around a bunch of people who are in the same boat, that's what makes the shift that you're describing possible, in my view ... it's consciousness-raising. We become conscious of issues going on in ourselves and in other people.

R: What's the shift that you're referring to?

T: In gender roles, forty years ago men took a certain pride in not doing diapers, not being tender, not being nurturing. That made you male. That was a real tension for men. I don't think men were like, "Wow! This is fantastic, I don't get to ever be nurturing!" I think it was a bitch for a lot of men to not be able to show affection. So I think the experiences in these courses are the manifestation of a long history of consciousness-raising and shifting gender roles.

C: And feminists have opened up discussion about how to authentically explore emotions and joy, and how children can enrich your life in this way. We're seeing men opening up and saying, "I want a richer emotional life and connection with children." More men have a sense of entitlement that this is now possible and acceptable.

A few men in their fifties and sixties have come to the course because when they came out it was literally inconceivable that they would ever be parents or be entitled to be around kids, partially because the pedophilia myth was so strong. So we're seeing a transition from men like my dad who felt they had to hide in a traditional marriage in order to have children, towards men who can be out as gay/bi/queer men and then become parents.

People in the course are exploring how to become parents and asking questions like, "Am I ready yet? How strong is my desire to be a parent? If I am in a relationship are we on the same page about our desire to parent?" I am also hearing more queer guys ask, "Do you want to have kids or not?" as a screening question when dating. I don't remember hearing this type of dating conversation twenty years ago.

T: I don't want to pretend that queer communities are the only folks struggling with this. I think straight families are changing, too, women are having kids much later, people are adopting children, etc. It's kind of like a conversation between the queer community and the larger world that we exist in. I'm sure everybody in Daddies & Papas 2B and Dykes Planning Tykes have also seen non-queers do the unconventional or the non-traditional, so now we're going, "Hell, it's possible for us, too!"

R: Thom, what made you decide to take the Daddies & Papas 2B course?

T: I think we had always imagined that we would have kids. But we never really thought about it, really critically engaged with it, because frankly we didn't know what was going to happen with us, we didn't know where we were going to end up, there were too many unanswered questions. We had gone through a major upheaval coming to Canada and in our lives.

The story is that I'm American and my partner Vajdon is from Zimbabwe. We were living in Los Angeles and Vajdon's visa had run out so we had to find a place to go. Then in early 2005 we found out that Vajdon, because he is from Zimbabwe, could make a refugee claim in Canada. We had to basically prove there was a possibility that if he went back to Zimbabwe he would be persecuted and discriminated against because he's gay and because we're in a biracial relationship.

It's been a long process, but next week we have the interview for permanent residency. It's so emotional because it looks like it might actually be over. So now it might be possible for us to really think about becoming parents … We didn't want to bring a kid into a situation where there was that much instability.

R: What was taking the course like for you?

T: We really used it as an opportunity to ask questions, not an opportunity to make decisions, we didn't put that on ourselves. But we explored the idea of becoming parents, how we might do it, what would it mean to our lives. I didn't feel that anybody had a stake in where we ended up in this decision-making process. And that was really important for us. Each week had a theme, like surrogacy or co-parenting or adoption. There are people who have been in the course coming back and talking about their experiences which is very powerful, nothing like getting it from the horse's mouth.

You know, we all have busy lives, but my partner and I would talk, usually right after the class and maybe a little bit before and usually a bit between, and that was great. There were a couple of big issues that came up for us, one of them being money. There was a lot of fear, an expectation that you need a certain amount of money to be a parent. And also, am I too old? And you know, we're both artists, am I too self-absorbed to be a dad? *(laughter)* I think I realized the important thing is that there'll be issues at any age, if I'm twenty and I'm having a kid, I'm too young, if I'm fifty, I'm too old, you can't win. And with the money thing, you can never have enough money. Of course, it's easier to be a parent and have tons of resources, but people do it all the time.

I didn't even know that I had these prejudices against myself. It's a part of why I'm such an advocate for the course, it really strongly nudges you to move the silt away so that whatever it is that you think, feel, envision about yourself can sort of rise up and you have the space to examine it.

R: Let's go back to the course. Chris, can you give a brief outline of each week?

C: The second week we watch a documentary. I've used *Daddy and Papa* by Johnny Simon in the U.S., as well as *Fatherhood Dreams* by Julia Ivanova,which came out of Vancouver last year. Both films introduce different methods of becoming parents, spark insightful conversations for self-reflection, and help participants think about questions they may want to ask of guest speakers.

Week three we have a panel of dads who created their children through forms of surrogacy in different legal jurisdictions, and a woman who has been a traditional surrogate for a friend. We explore the ethics of gestational and traditional surrogacy. There are many complexities. I've heard women say, "It's my body, it's my choice, it's not up to the state to regulate what I do," and I've talked to women who think surrogacy is always a form of economic slavery. How do you make an ethical decision? How do you go into a surrogacy arrangement where you know everybody is respected? For some there is no simple answer. To be able to ask these questions and feel comfortable moving forward whatever your choice is part of the course.

We follow this with a session with Dykes Planning Tykes where representatives from fertility services come to provide information. There's a

related story that I can share about two grads of the course who went into a clinic and both wanted to be in the room, the masturbatorium, *(laughs)* together to, you know, ejaculate and create their samples to be used to fertilize the donor eggs being retrieved. The fertility clinic staff members were shocked. "We can't have two men in there ejaculating together. I mean, whose sperm will it be?" The guys were shocked when they were told they couldn't be together to share in this pivotal moment in their relationship. They asked if a wife could be with her husband and were told, "Of course." To which they asked, "Then why can't we be with *our* husbands?" It triggered policy, ethical, and liability issues that the clinic had never thought through before. At first they said "You can't do that!" and then they got it and said, "Ah, no, this is just about honouring this loving moment for this couple," and worked out the liabilities and practicalities, including the lack of gay erotica to help things along. This is a great example of the ongoing dialogue our communities are having with service providers.

T: I remember that our favourite night in the course was when we met the dykes. It was almost like two species coming together *(laughter)*. We're on our different floors and have our own issues, and then coming together was really interesting, finding out what they'd been talking about.

C: The joint sessions with Dykes Planning Tykes currently are the Fertility Fair, the Adoption 101 session, and an evening with a panel of young adults who grew up with LGBTQ parents.

T: Hearing from the teenagers was really important and valuable and educational.

C: Week five is about co-parenting — parenting children with someone with whom you are not romantically involved. It is an option for those seeking biological connection with their children, and was historically a path queer men and women could take in the days before adoption and surrogacy services were open to us. Our exploration includes thinking about the questions you would ask someone in this "non-conjugal" dating process.

We follow that with Adoption 101. Pat Fenton, previously the executive director of the Adoption Council of Ontario, and now in the Ministry of Children and Youth Services, gives a broad overview of private, public, and international adoption in Canada.

The week after that we have a panel of dads who have adopted, mostly

through public adoption, through the Children's Aid Society of Toronto, which is the most accessible and affordable route.

T: I remember on one of the panels there was a guy who was HIV positive and had adopted a child. I certainly didn't know Ontario was allowing people with HIV to adopt, so that certainly opened my eyes. I think it's really amazing and great.

C: This is related to advocacy skills and adoption. We hear that more adoption workers are viewing "coming out" and the advocacy skills often involved as potential strengths of LGBTQ applicants. We may be better prepared to advocate for our children, and to teach them to be advocates for themselves, especially in the face of myths and prejudices around adoption.

Next we explore notions of race, racism, and family planning. For many guys in the course it's the first time they've had a chance to talk about power and privilege in general, let alone in relation to bringing a child into their lives. We begin to unpack racism and the intersectionality of oppressions. How can white, economic, or education privilege affect one's experience? What do you need to consider about understand-ing and preparing for situations where your children are treated differently from you in a racialized way? If you're a biracial couple, how do you respond when someone sees one of you and says, "Obviously these kids aren't yours"?

The general goal of the course is to authentically integrate participants' many identities with their desire to parent. Whether sexual orientation, gender identity, racialized identity, cultural or spiritual identity — how do you move forward more confidently?

The following week we bring in an experienced lawyer to explain relevant Canadian family law and practical implications for our various family creation options and family life planning. We also discuss self-advocacy strategies, including such things as dealing with border crossings as men with a child with no "mother."

Then we have the panel of young adults with LGBTQ parents. They talk about their experiences in daycare and school systems, social situations and their relationships with their parents. It's a popular evening that reassures many participants that their own kids will be all right.

We end with a "putting it all together" potluck. We check in about what they found useful about the course, questions and feelings that remain, decisions they have made, suggestions for improving the course and other

services. We talk about support services such as our Queer Positive Pre-Natal Class, the Daddy, Papa & Me family resource program, the LGBTQ Parenting Network, and COLAGE. I also give them a homework assignment — to gather other resources to share with each other. I encourage the guys to bring an article, a parenting book, a kid's book, children's songs, a Web link, or information on a helpful business or service — whatever they think might be helpful. This course has a community-building aspect and people often continue to meet after the course is finished as it is rare to meet other gay/bi/queer men with similar goals ...

R: Thanks for that summary. Do either of you see any connections between the devastation of gay communities from HIV/AIDS and this new move towards parenting?

C: Well, I think we probably would have seen more out queer men parenting in North America and have had a stronger parenting movement sooner. There are men my age and older who have lost many of their friends. Our movement is behind because we lost so many dads and prospective dads over the past thirty years.

T: I also think there's a stigma. The prevailing popular stereotype is that if you're not positive now, you will be. People don't want to do that to a kid. I mean who wants to die on their kid? And so it takes a while to understand I'm not necessarily going to be positive, it doesn't mean death, you have to sort of unpack it.

C: I think that speaks to a bigger cultural, emotional, spiritual grief — whether it's conscious or not. Am I entitled to be a parent? What is my health status? Is gay culture all about partying and sex? So is it possible to have kids? How do I get through all the external and internalized prejudice to form a healthy, integrated, and confident identity and stance in the world? It's a bigger question about how do we define healthy ways of negotiating our pleasure. How does internalized homophobia still get in the way of self-care, and then the ability to take care of someone else? Part of doing this work is trying to unpack the ways that internalized and systemic prejudices have been damaging, and then how to help inspire people to see and achieve new possibilities for themselves. With respect to the AIDS pandemic, I think the privilege of living in Canada has meant that living with HIV or AIDS is not an automatic death sentence anymore; it is a chronic manageable illness. Some HIV positive queer people are now becoming parents. We are lucky

to live here and have this possibility open up. Regeneration is blossoming out of the devastation. This is exemplified by one of our dads who speaks about adopting his child, as a man who has lived with HIV for twenty years. Daddies & Papas 2B is part of bigger movements of hope. It tries to encourage queer men to honour themselves and their desire to parent, and to do this in ways that are important to them.

Also, I think some men don't think about becoming parents because family is still such a source of pain. The idea of bringing a child into a family where you've been rejected, whether you're living on the street or had to wait to come out, or never did come out and had to live a very compartmentalized life separate from your family of origin, speaks to a lot of psychological and spiritual pain. How do you consider parenting when you are barely aware of your own long-standing unmet needs? A few dads who push their strollers through the Church and Wellesley Village report instances of being gawked at. What does the image of queer men with kids trigger amongst other queer men?

R: What's your sense of that? Why are they getting gawked at as they walk through the Village with their strollers?

C: It's complicated when a community has grown centred on spaces for adults. One overlooked possibility is unconscious pain that's triggered by seeing someone who is explicitly gay or bi or queer, creating a loving family. If you haven't been able to heal relationships in your family of origin and there's no intergenerational possibility or connectivity, it's painful.

T: And we have two blocks, you know, how do we create public space so that it can include both party culture and parenting? The Daddies class gave me this idea to get high chairs in the Village, to get businesses to sponsor that. And people said, "Who says we need high chairs in the Village?" Somehow juxtaposing bar culture and high chairs was just too close. I think there's room; I just think the room has to open up in our heads first.

C: Queer male cultures — in contrast to female — are still in a state of early transition about the possibility of having kids in our community. Businesses in the Church and Wellesley Village are starting to shift. For example, dads attending our Saturday morning family resource program, Daddy, Papa & Me, often go as a group with their kids into the Village for brunch afterwards. And a few restaurants are starting to say, "Here's a high

chair, here's a bottle warmer, here's a colouring book and some crayons."

And the consciousness of people who don't identify as queer is also changing. I know some Toronto dads who have moved to other provinces, like Nova Scotia, where they have found urban and rural acceptance and support of their families. A few years ago, a woman came up after a workshop and told me that her son, who was nineteen, had just come out, and she wanted to know about his parenting options. I said, "He's only nineteen. Slow down!" *(laughter)* Then I gave her some info. But there is this shift in awareness of possibility. We may start experiencing pressures to have kids in order to be "proper" members of society. In the past many queer folk have escaped that pressure, for better or worse. So how do we honour our authentic desire to have kids, while defending against social pressure that devalues those who choose not to parent?

T: Also, for centuries queers have left their families and gone to urban, safer environments. This is new, that we could actually go to the urban environment, create a new family and take it back home to the old one. Of course it's going to change what's available in public spaces in new ways that folks like us who are over forty may not even recognize.

R: Any final words about the course or about any of the issues we've been talking about?

T: I would reiterate the importance of having a public opportunity to engage with these questions. Once you critically engage with this stuff in a sincere way, you can figure out where you stand. And then people can say whatever they want or the tapes can play in your head, but you keep your feet in your shoes and go forward.

C: For me it's been a privilege to help develop and implement this course, to see a broad range amongst the participants, from those in their early twenties to those in their eighties, people from different cultural and spiritual backgrounds, urban and rural locations, with differing sexualities and gender identities; to hold a space where people can ask questions and be affirmed, whatever their decisions are. This includes co-ordinating the development of our sibling course, TransFathers 2B. It has been an honour to be part of these cultural transformations. Not everyone has to go through the pain that people in my father's generation went through. There are many more options now. It's about the evolution of possibilities.

BOLDLY GOING WHERE FEW MEN HAVE GONE BEFORE:
One Trans Man's Experience

Syrus Marcus Ware

THREE MONTHS AFTER MY PARTNER AND I HAD OUR FIRST APPOINTMENT with a fertility clinic in Toronto, my identical twin sister had her second baby. I spent hours holding my beautiful new niece, Zora. She is an amazingly cute seven-pound bundle of wonder and joy who was, when I first began writing this story, three days old. Her face is a perfect combination of my brother-in-law's and my sister's; she has his widow's peak and my sister's cute little ears. I wonder, while looking at my sister's second born, what our baby will look like months from now. Of course, we won't be able to trace our child's facial features back to their genetic origins — donor 2350 listed many personal qualities, but ear shape and hair-line topography were not among them. Yet despite this, I am sure that we will still delight in seeing the little quirks and traits that will emerge from my partner and me in our kid, as I'm sure we will also take joy in the myriad of ways our children will seem utterly different from both of us.

All this feels very close but also very far away. As a trans man seeking to become pregnant and to parent in a world with so few other pregnant and parenting trans men as role models, there are a million unknowns that mark the beginning of our journey. After spending the first three days of Zora's life with her, Nik and I can't wait to hold our own baby for the first time. But the journey to get here — to becoming trans parents — is already one

well worth reflecting on, not only for myself but because it's something a-round which our society, and medical systems, still have a little growing to do.

Insemination, or "You Are Going To Stick What in Where?!"

Nik and I have decided to become parents through insemination; specifically through the insemination *of me*. It wasn't as complicated a choice as you may assume — I have always been curious about pregnancy and labour, and am happy to have the chance to experience them firsthand. We had a plan, we had a timeline, we had read countless books, and had even helped design a community course for trans fathers-to-be. We are ready ... I think.

A few months ago we had our first appointment with Dr. Baby Maker at the Baby Making Clinic (BMC). A week before the appointment, a nurse at the health clinic that referred us to the BMC called to let us know that our application had been red-flagged. The query: "How could two men be in need of insemination?" I'm not sure why I was surprised by this; fertility clinics are still very gender-specific places where men produce sperm and women carry babies, despite the reality that in this world this is only true some of the time. I wondered if the clinic would be prepared to help a trans woman with sperm immobility to successfully get her trans male partner pregnant despite his ovarian cysts. Perhaps, perhaps not. I worried that this early interruption in the process might be a warning sign for future complications, but Nik and I bravely decided to continue on and give the BMC another shot. Thankfully, the nurse who referred us did some pre-visit advocacy on our behalf. In addition, shortly after we began at the BMC, a group of queer parenting advocates did some great trans-specific training with the clinic staff to help get them up to speed on providing excellent care to their future trans clients. The clinic welcomed us, and set our first appointment date for early spring 2008.

We went to our first appointment full of anxiety and excitement. What could we expect? How long would it take? Would they call me "she"? Would I be recognized as the father, along with Nik? And, perhaps most pressing, would they have to (eep!) probe me? I had already decided that I was willing to put up with a certain level of confusion or misinformation about trans bodies if it would help us reach our goal: to get pregnant with our baby. Yet, as we sat in the waiting room, I wondered if I would be able to handle being "she'd" or having a frank discussion about my "ovaries" or menstrual cycles with a doctor. I felt confident that despite wanting to be pregnant, I was still

a man. But I worried about the staff's ability to recognize and respect my beliefs. I believe that, as a man about to carry our child, I have a lot to offer our child in terms of questioning gender rigidity in our society, and teaching the world about alternative ways of parenting. Perhaps it was this hope that got me through that time in the waiting room, unsure of what to expect.

The pre-visit advocacy clearly worked, because during the ultrasound, the technician asked me which washroom I would prefer to use. I explained that I used the men's washroom. She led me through a back door to the hallway by the elevator. "This is the only men's washroom on the floor," she said apologetically, as she led me through the twists and turns. "We don't have too many men getting ultrasounds in this clinic." This seemed like an extreme understatement. I would guess that I was one of the first men ever to be a client in that part of the clinic. As I entered the men's washroom in my blue paper gown, I couldn't help but laugh at the bizarreness of the situation. I surmised that perhaps I could be a bit of a teaching patient — sincerely hoping that, with good and open communication with our doctor and the clinic staff, things might go a little more smoothly for the next person in my shoes, and then even more smoothly for the person after that. At the very least, perhaps the washroom near the ultrasound area could be relabelled For Patients Only, instead of for one gender-of-ultrasound-patient only.

I left the clinic after that first visit with drugs that would help me to ovulate more regularly. The drugs were not hormones — those would come later — instead they would help to regulate my insulin levels and balance out my hormones indirectly, thus regulating my ovulation cycles. I felt victorious as if I had dodged a bullet. Having to take a series of "female" hormones at that point would have been too much for me to handle. Like many trans guys, I have never really enjoyed getting my period. Several years ago, before I'd started testosterone, my period cycles had become irregular, so that I was only menstruating a few times per year. I certainly wasn't complaining. When my doctor sent me for a routine ultrasound to assess and "fix" my problem, I threw the requisition in the trash. No more periods for me! Until we began trying to make a baby, that is. After that first visit at the BMC, I found myself checking all the time and actually feeling disappointed when *it* was still not here — another day of waiting before the insemination process could begin. Interestingly, when I did end up on estrogen, follicle-stimulating hormone injections, and human chorionic

gonadotrophin months later, just before our insemination, I didn't really mind. We were so close to making our baby at that point that I was willing to do almost anything to help bring this little one into the world!

Pregnant Man Claims He Is a Pregnant Man

My second encounter with the BMC was later in the spring of 2008 — a few weeks after Thomas Beatie burst onto the global scene with his story of insemination and pregnancy, becoming widely known as "the world's first pregnant man." Of course, there have been other pregnant trans guys before Beatie, but his decision to share his story brought to light the reality of male pregnancy for many people for the first time. Media headlines exclaimed, "The Pregnant Man: Is this a Hoax?" and "Man Claims He Is Pregnant" — as if this was clearly an impossible and preposterous idea. Even Oprah got in the mix with a long interview with Beatie. I suppose it is a mark of some progress that the headlines questioned the pregnancy, rather than the fact that Beatie was a man. Indeed, the headlines would have read very differently if they had exclaimed, "Pregnant Person Claims To Be a Man."

Beatie's story came out about a year after we ran the first session of Trans Fathers 2B (see TF2B information box on page 151). Trans Fathers 2B was an eleven-week parenting course for trans guys considering parenting, run through the Queer Parenting Programs at The 519 Community Centre and the LGBTQ Parenting Network at the Sherbourne Health Centre, in Toronto. The course was run by a trans man who had practised midwifery for years and was working as a labour and delivery nurse at a local hospital. There were seven people enrolled in the course. In a child-themed playroom at the Metro Central YMCA, we were a group of people bonded together by our desire to become parents. Our discussions focused on how to talk to other parents and family members about our decisions to parent, how to handle transphobia on the playground, and how to advocate for ourselves around our gender preferences and identity while, say, in the throes of labour. Despite what the mainstream media makes of it, we're human beings talking about making families, not oddballs who are trying to upset the world gender order. (Although perhaps some of us are doing this as well! The world gender order is in need of a shakeup.) However, at least for me, having kids is about something else — a desire to share my life with a new human being, to share love and support, and to nurture a beautiful addition to our communities and our planet.

Shortly after Beatie's interview on *Oprah*, the clinic sent me to the hospital for a hysterosalpinogram. This is a procedure in which a dye is injected through the cervix into the uterus and flushed through the fallopian tubes while being monitored on a large screen by the doctor. I tried to brace myself for the ultimate in female-geared medical terminology and treatment. Would it make a difference if Dr. Baby Maker called all my parts by my chosen names? Would it feel better or worse for him to call me "sir" during the procedure? Did I want them to call out "Mr. Ware" in the waiting room? I truly had no idea what to expect, and thus what I wanted or needed.

In the end, I felt very vulnerable during the whole experience. For starters, Nik was unable to get off work to come with me, something that seemed to distress him as much as it did me. Secondly, I had to have the procedure done at Women's College Hospital, where they specialize in *women's* health care. It is truly magical to watch what happens when a trans person produces an OHIP card at any medical visit. The "F" on the card miraculously erases any existing effects of testosterone, top surgery, dress, and name choice. According to the Government of Ontario, I *was* a woman. The receptionist at the intake desk simply followed the silent directive printed on my OHIP card, and told me, "Miss, there is a long delay today, so go with the technician to get changed and then have a seat with the other women at the end of the hall." And so it began: the feminization, the invalidation, the confusion, and the frustration.

We sat on beige melamine chairs all in a row, each wearing pale blue backless gowns, exposed to the world despite the second "safety" gown worn around our backs like a robe. We clutched our belongings, including our clothes, in our hands.

One by one, each woman entered the room at the end of the hall and one by one each re-emerged. Our doctor had explained that he would be conducting the procedure on us all in quick succession. In fact, we had all been given the same call time. So we waited; first-come, first-probed. This is one of the things that stands out the most about this baby-making process: the waiting. Waiting for a referral to a clinic, waiting for four hours during our first appointment due to an emergency with another patient at the clinic, waiting for my period to come, waiting for the pregnancy test to be ready so we could wait nine months more to meet our sweet new baby.

When it was my turn to enter, I walked gingerly over the trail of fresh

blood that stained the floor leading from the ultrasound table to the doorway. Clearly this was not going to be a walk in the park. My doctor tried to ease my mind while I tried to relax on the steel table. "We're going to put this dye into your uterus, and you'll get to see it on that screen over there." My UTERUS. Was this a good time to mention that I did not call it that? I didn't know what else to call it, but I knew that *uterus* wasn't my chosen word! I suppose I live in a bit of a sheltered world. Many of my closest friends are also trans people, and those who are non-trans are extremely well versed in trans stuff. For us it is not unusual at all to call parts of our bodies whatever we choose, and to expect that these choices will be respected. For my peers, and for the folks who took the Trans Fathers 2B course, it was not an oxymoron to be a *pregnant* man. So, too, was it perfectly conceivable for a trans man to have a uterus called something other than a uterus, and for him to give birth out of his "front hole" rather than his vagina. But for the rest of the world, this was perhaps folly, or at least never considered. What a treat it will be in the future when we are all asked, regardless of gender presentation, what terms we prefer used for our body parts before any physical or internal exam!

As I felt the winch that would open my "cervix" touch my inner thigh, I heard my doctor change the vein of his conversation. I felt the sharp pinch of the cervical spreader. I heard him say, "So! How about that other pregnant guy in the States? Have you been following his story?" Perhaps it would have been weird not to mention the fact that nearly every major news source in the past few weeks had been obsessed with a trans man's pregnancy, and here we both were, helping me, a trans guy, to get pregnant. Still, I wasn't at all prepared for the following exchange. It went something like this:

"Um, Thomas Beatie? Yes, it's pretty great." I didn't know what to say. I felt the abdominal pressure and cramping caused by the opening of my cervix. It hurt.

Smiling a broad smile, our doctor said, "*YOU* don't want that kind of publicity, do you?"

Gritting my teeth through the cramping, I replied, "Oh ... um. No ..."

"Great! Now look to your left! There is your uterus on the screen! See it! Great stuff!"

After being told that I was free to go, I slid off the table and added my own splotches to the collaborative mural spreading across the dirty floor. Oh, how I wish my partner had been there, to run to, outside the room!

In the months that followed this examination, and as I now begin the journey of pregnancy, I have realized that to be a pregnant man is to be a spectacle. Male or not, public attitudes about pregnancy render the pregnant person an object of public display. Every stranger you meet is likely to touch your belly without asking and give you a laundry list of suggestions for what you *should* be doing throughout your pregnancy. But being a pregnant man adds a new level of public-ness. Not only are you pregnant, but you might, like me, have a short beard. I've had top surgery, and have a man's name. When I meet other people who have been pregnant, they usually spend the entire conversation staring from my belly to my lack of breasts to my beard and back again, which can make for distracted exchanges. I'm really excited to be able to carry our child, but it is not without the challenge of feeling ultimately *different* in this world, connecting two puzzle pieces that don't belong together. I am torn between wanting to proclaim my pregnancy to the world, inevitably rendering me female to even my friends and family, and wanting to remain seen as masculine, thus seeming inevitably not pregnant. I suppose that's why I am so enamored and in awe of Thomas Beatie. His willingness to publicly announce his pregnancy has brought the concept of men being pregnant to the larger population. His publicity has now made pregnant and man no longer oxymoronic, but rather something that happens in this world. Of course, there were and are many men before him who became pregnant. He is not the first and is not the last pregnant man. But his very public-ness has created a shift in our understanding of who it is in this world who gets pregnant, and has made it easier for me to explain my situation to other people, simply answering their blank stares with the phrase, "You know, like Thomas Beatie, The Pregnant Man!"

Trans Advocacy, Trans Pride

It wasn't until a few weeks after the hysterosalpinogram that I realized how bizarre that conversation between me and Dr. Baby Maker had been. I am also aware that this may be only the first of many unusual and perhaps even inappropriate conversations, questions, and discussions that we will have during the course of my pregnancy. Despite the fact that I am not the first trans guy to be going through this, the world still sees trans male pregnancy as a highly unusual event. And I guess, at least at this moment in history, it's not the most common way to bring a child into the world. But that doesn't mean that the systems in place to help people have families should be any

less welcoming or prepared for trans parents-to-be. Over the past several months, Dr. Baby Maker has been a supportive and encouragingly optimistic part of our healthcare team. He may not fully grasp all the terminology and concepts related to trans bodies, but he has truly put all of his efforts into helping us begin our family. For this, I am eternally grateful.

I am thankful for the many sessions in the Trans Fathers 2B course in which we practised dealing with other parents, with strangers, with our families, and with other children who might not understand our genders or who might be critical of trans parenting. Through scenarios, discussions, and workshops on self-advocacy, I feel more prepared to deal with questions like, "Hey ... Is that your mom or your dad?" at our child's best friend's third birthday party. I am also thankful for the ever-changing, ever-growing network of trans parents out there who are sharing resources, support, creativity, and resilience; through face-to-face meetings, online forums, and courses like Trans Fathers 2B.

Despite the challenges, Nik and I tried to enjoy the process. There have been many funny moments through our journey (mixing up the donor number on the day of the insemination!), and my gender has been challenged in countless ways (injections of female hormones into my stomach every day! Trans-vaginal ultrasounds! A lack of man-ternity clothes!), but most importantly those closest to me see me for who I am: a trans man and soon-to-be dad. We have many more experiences to go through over the next nine months, but for now I am having rather gender-less and pretty common questions and concerns. These include: Will our baby be healthy? Will I be able to carry to term? Will I make it through labour? And, why did no one ever tell me that to be pregnant is to be gassy all the time? It seems, for now, that my gender has little to do with the immediate day-to-day experience of pregnancy and parent-to-be worries.

Since our insemination in early December, every week we have met or heard about trans parents resisting a conflation or simplification of their gender and identities, celebrating our families, and growing new communities built on love and new understandings of gender and society. We have heard about new advocacy and education happening all over North America to help break down myths and misunderstandings about trans parents, and about trans dads in particular. With much excitement, and even more trepidation, we look forward to our own journey of learning, sharing, and growing with our new baby! Now, if we can just figure out how to find out donor 2350's ear shape and hair line ...

Red Rock Baby Candy:
Infertile Homosexual Speaks!

Shira Spector

I read the following essay at a panel discussion called LGBTQ People Facing Fertility Challenges, sponsored by the LGBTQ Parenting Network in Toronto on November 15, 2007. I had been asked to speak about infertility from a personal perspective. The discussion, perhaps the first of its kind in Toronto, was a long time coming. Though no one knew what to expect on this dreary night in mid-November, every chair in the room was filled. The air was so charged with hope, longing, anger, sadness, and recognition, it felt like it might rain all over the plastic office furniture. Before reading my piece, I passed around a candy bowl of red rhinestones and asked everyone to take one. I reassured the audience that this would make sense by the end and told them this was also my hope for everyone who made it out to our meeting that night — a feeling of purpose and clarity for their troubles navigating the complex terrain of infertility and pregnancy loss.

I'M A COMMUNITY WORKER AND A VISUAL ARTIST. I AM ENTHRALLED WITH creativity — my pursuit of pregnancy springs from that. I'm a secular Jew, which means that in my culture babies are coveted, precious, and common as candy. Before I talk about my experience of infertility I want first to name some things that put me in a position of privilege — I am white-skinned, English-speaking, and university-educated. My family of origin is middle class, and I have access to *some* money for *some* treatments.

I am also a non-biological mom with a more than supportive partner. Though I have struggled with infertility, and Lord knows I've suffered, the fact is I have done so as I've been raising a child. During a period of

unwanted celibacy in my life, I joked that it was unfair for people to have multiple partners because it was causing a kind of glut in the system. So in some ways, it doesn't seem fair to complain about the ache of infertility when I am, in fact, already a mother.

I am speaking from a personal perspective tonight and I do not want for a minute to appear to be representing everyone's experience. If we look at facing reproductive difficulties like baking cakes — each of us would be sitting down to a unique recipe, combining medical obstacles, issues, and pathways with layers of additional complications and obstacles dependent on who we are and what forms of multiple discrimination we already face. Think burned infertility cake, iced with the struggles of among others: LGBT people, people of colour, single people, people with disabilities, low-income people, and non-biological expectant parents. There are simple cakes and there are very high and complicated ones. Here's a messy slice of mine.

The short version is this: I have been trying to get pregnant off and on for nine years. In that time I have been a patient of two fertility clinics, two gynaecologists, and one reproductive endocrinologist. I've been diagnosed with polycystic ovaries (that don't seem to be the problem) and garden-variety unexplained infertility.

To remedy this I have tried herbs, tinctures, tonics, teas, fertility dolls, clomid, wishing, begging the dead for help, dressing in lingerie and high heels during ovulation, putting it out to the universe, cycle monitoring with ultra-sound and blood work at 7 a.m. before work, in snowstorms, and heat waves, LH ovulation-predictor kits, basal body temperature charts, cervical-mucous observation, feigned indifference, inseminating based only on whim, insem-inating in moving vehicles, at night, in the morning, every day, every other day, positive thinking, pro-active behaviour, letting go, pulling up my socks, checking my cervical position, relaxing, forgetting about it, leaving town, org-asms, abstaining from soy products, and, finally, traditional Chinese medicine and acupuncture. But never sex with men because it is just too gruesome.

I've arranged sperm donations with three different men — wrote con-tracts and negotiated roles for each of them, connected other prospective queer parents with doctors, and doctors with resources for prospective queer parents, helped interpret the secret language of menstrual cycles and bodily secretions, successfully assisted countless friends in their quests to become parents and got my partner pregnant on the second try.

I have worked jobs I hated to make enough money to buy sperm

and intrauterine inseminations from clinics I hated. Desperation takes you to terrible places. Here's what I remember: the doctor who was having a bad day or hated women or dykes or all of the above who did an insemination procedure on me so roughly and with such silent hostility that I bled afterward and hoped it wouldn't work because I felt raped. I remember how I said nothing to anyone about it. I remember the well-respected midwife who told me I was miscarrying on the phone and then when I asked what emotional support existed for me she said there was none, anywhere, of any kind. *Which wasn't true!*

I remember every time I have laid in a cold ultrasound room wearing only an anxious cotton sheet, my naked legs open, with only fear and dread for company. I remember the tight-lipped silence of every grim ultrasound technician whose face could not be read in the dark. I remember the gynecologist with the "best reputation," at the "best hospital," who suggested that my at-home inseminations were a possible cause of my unexplained infertility because they were not "natural."

Of course I also remember the kindnesses: the nurse at the fertility clinic who offered assistance when the nasty receptionist would not, who told me how much respect she had for the bravery and determination of people undergoing fertility treatments, the sperm donors juggling their schedules and masturbating into tiny glass jars upon request at inconvenient times and in inconvenient locations, every doctor who spoke to my partner Rebecca and I with respect and compassion, the friends who kept asking, who'd been through it, too, who called every day, sent a card with Frida Kahlo (the great Mexican painter and multiple miscarriage survivor) on it, the queer and progressive doctors who went well out of their way to help however they could, my parent's relentless belief in possibility for me, my ex-lover (my attempts to get pregnant pre-date my current partnership) singing *The Power Rangers* theme song to vials of sperm as they defrosted because I thought they needed our encouragement, the infertility counsellor who knew all the technical terms and "got it" because she herself had survived it, the dyke therapist who didn't know any of the technical terms but listened to me until she got it, Rebecca's everyday love, and the women at the acupuncture clinic with its glossy green Ficus tree and wood floors where everything smells like mint and the opposite of force, who make me feel my body is worth loving, no matter what.

And then there was this. Three years ago, I experienced an extremely

rare kind of ectopic pregnancy. Ectopic pregnancies happen when egg and sperm fertilize outside the uterus, usually in the fallopian tubes. They must be surgically or medically terminated; otherwise, they eventually rupture and can cause life-threatening internal bleeding. I found out that very early pregnancy is a bit of a medical grey area where I seemed to be under no one's jurisdiction. Pregnancy-related health practitioners don't typically start to see clients until ten to thirteen weeks, and my difficulties began before I had a chance to even meet my midwife. My pregnancy fertilized outside of both my uterus and my fallopian tubes. It was in large part due to my own attention and knowledge of my body that it was detected at all. The whole ordeal made me into a medical anomaly and took nearly a month to diagnose.

Here's what I remember: I spent a lot of time visiting doctors and requiring ultrasounds, pelvic exams, and blood tests. Each day ended with a different theory of the mystery of my rising HCG (pregnancy hormone) and empty uterus — among them: that I was having a regular miscarriage, perhaps pregnant with twins (one ectopic, one in utero), or even just experiencing a viable pregnancy which was incorrectly dated — which of course was my favourite, but that theory only lasted a few hours.

Though an ectopic pregnancy had been ruled out several times, my HCG continued to climb, enough to suggest that I was still pregnant, but not enough for the pregnancy to be viable. That day, my GP (who followed where my midwife left off) sent me to the emergency room where Rebecca and I remained until the following day. Our eighteen-month old daughter was picked up at daycare and babysat in shifts by our friends — her first overnight away from us. I stayed perky and alert, a trick I learned from my mother in emergencies. I almost cheerfully filled out forms and answered questions. I didn't cry when a nurse came in with an IV drip in case I had to have surgery. By 4 a.m. it was determined that the pregnancy was still small enough to terminate with medication. They kept the IV in anyway. It made me feel cold on the inside, like spearmint gum was coursing through my veins. There were two other women in that night with ectopic pregnancies — but I was the only one who didn't get wheeled upstairs to the operating room.

I remember one of those other women sobbing, and then her husband sat alone wringing his hands while he waited for her to come back. It was 7 a.m. when the doctors realized that they had miscalculated my dose of medication and that it would have to be returned and reordered. Then we had to wait

until 9 a.m. for the pharmacy to open.

I dozed off once or twice but Rebecca never even closed her eyes. Finally, the correct dose of Methatrexate arrived to terminate my messed-up, hopelessly non-viable but much-wanted pregnancy. I remember that Rebecca never let go of my hand. I was lying on my stomach, everything was too bright and too white, I was too naked under my hospital gown, my legs were cold and the sound of my sobbing like someone was dying was filling up the world. It was then that the doctor who'd administered the drug, punctuated the worst moment of my adult life, by pointing to my lover and saying, "Don't cry. Your *mother* will take you home now." She was well-intended, but if I had had the strength to strangle her, I would have.

<center>*</center>

I have cried an ocean. No, make that nine oceans, over the baby who was supposed to be born on April 19, 2005. Over negative home pregnancy tests, negative blood tests, missed cycles, platitudes and ignorant comments, taking breaks, not knowing how or when to stop, all the pregnancy symptoms I somehow had when I wasn't pregnant, every long tricky cycle that makes you feel like you cannot trust anything (worst of all, your own body), periods arriving by surprise with terrible cramps, during job interviews, on the highway, at work, at children's birthday parties. I have stopped talking about it. I don't tell anyone anything because I am so ashamed and embarrassed of my naked desire, my never-ending reproductive quest. I have pulled the thick silence like a blanket over my head until I have felt that I might suffocate. When I do talk I am *so funny*. I have developed an indestructible sense of humour as a coping mechanism and also so that I will be entertaining enough that people will keep listening to me. I, who am well connected, supported, loved, and feminist, don't forget — who will not define women by their biology, and who was for years a staff member of the Queer Parenting Team at The 519 Community Centre, an LGTB centre in Toronto's queer village (for god's sakes!). I have felt like a terrible failure and a disappointment. I have felt deeply ashamed and embarrassed by my inability to conceive. I've compared myself to an addict, a hope junkie, a woman in an abusive relationship with herself. And though I am not in this place anymore, I have seriously considered suicide.

I am a dyed-in-the-wool, the personal-is-political dyke, and pro-choice

feminist. The truth is that the experience of pregnancy loss was one of the most anguished ordeals of my life to date. Here are some things that I worry about: that publicly claiming the pain and loss I've felt about a pregnancy that ended at ten weeks — that the very words "unborn child" — could somehow align me with the agenda of the far Right and threaten a women's right to reproductive choice. (I will not allow this fear to silence me; I hope instead that I am able to make my distinctions clear.) I worry about the invisibility of my partner Rebecca, during this time of profound loss. The aftermath of my ectopic pregnancy forced me to experience pregnancy in reverse. It required multiple medical visits and tests to ensure that the medication I received had worked and that I was no longer pregnant. It took months to count my HCG levels back down to zero, and predictably I fell into a deep depression. Rebecca stepped into the role of being my main physical and emotional support. She took over the multitude of daily household tasks, the cooking and financial management, as well as the care for our young daughter while I was physically and emotionally unable to. Her grief, her loss was almost never recognized. There was no time and no name for it in her efforts to keep our family afloat. And still, as I grapple with my infertility month after month, its injustices and stresses and redundant cycle of hope and inevitable despair, she struggles as well, only twice as imperceptibly, and with no one noticing.

*

So what do I see from my vantage point in the queer parenting movement? A lot of very good work, and roads cleared, but also a lot of shiny, happy pregnant people. Sometimes I despair that the queer parenting movement suffers from what I'll call "the suffragette syndrome." God love the suffragettes, but they were predominantly white middle/upper-class women who wanted things for themselves and had very little interest in the rights of poor women or women of colour. All LGBT people work hard to create their families, and certainly there are the shiny, happy poster children among us.

I would be the last to begrudge anyone a second of pleasure or their right to happiness. But while this picture certainly exists, *its singularity is a lie.* We are in the midst of a LGBT baby boom, and where there is a baby boom there is infertility and pregnancy loss. If we could all just take a big breath and get over trying to be normal and just like everyone else shopping at Ikea, I think we'd all feel better. One of the problems around infertility/

pregnancy loss is this great quietness for all women. No one really wants to talk too much about it — it's all so painfully icky and somehow viewed as self-indulgent to mourn one's fertility or failed pregnancies. So it's really quiet when it happens to you, except suddenly everyone has a story to tell you about someone suffering a miscarriage or hopeless fertility pursuit. It's so common, so why is it so quiet?

It's complex and there's a great deal of a *shut up about your mal-functioning girly bits* vibe around in the world in general. Now, if you bring in the queer thing, there's this strange double silence. Because you hear even less about pregnancy loss/infertility from queers busily trying to put their best parenting face forward. It's *Heather Has Two Mommies* not *Heather's Mommies Broke Up Because Their Relationship Could No Longer Withstand the Stress of Infertility*, or god forbid *Heather Has Three Mommies* or anything that deviates from the traditional family dyad. No one is too interested in messing up that rosy picture — it's harsh because positive-image traps exist for a reason. We still need to defend our human rights and our families, but our omissions deny us the luxury of complication and support we might get from each other. Playing it safe and remaining silent has a terrible price — we, of all people, should not forget this.

Then there is the problem of not wanting to be here. *The pregnancy loss and infertility lounge* is not a great place to be — I wonder if this is partly what accounts for the silence. Everyone just wants to get out of here. Let's call it a room that you are thrown into or finally find yourself entering. The room is dark and soundproof and it's filled with limitless space, and a terrible lack of sound. At first you think you are alone because of the silence and the dark but if you stay still (and eventually you will, because in this room it's all you can do to get up off the floor sometimes), you will hear weeping and then whispering. Voices from all over the place, people you never had any idea ever suffered in this way. There are ghosts, too. Dead relatives and ancestors whispering their stories. You'll remember your grandmother's four miscarriages and you'll know what it means to count to that number. Soon it feels as though everyone has a story or knows of one, and pretty soon the voices overlap into a kind of humming and you can't help but wonder why some one doesn't turn on the damn light and start shouting.

*

Here's what I want for those of us who are struggling: support and love. I know that's vague, but support and love anyway. The sound of our voices, and our stories counted in, as common and as much a part of the experience of childbearing as any, acknowledgement of our struggles, our courage and tenacity, research studies and access to information so we can make truly informed choices about reproductive technologies and their effects on women's health, guidance in our own communities, and a place at the queer parenting table.

When I was pregnant (before I knew it was going to be a disaster), I'd daydream about calling our second child Ruby. The colour red means everything to me — fire, passion, life itself. The first winter after my ectopic pregnancy, Rebecca gave me a ring set with a small red stone that she bought at a store aptly called Courage My Love. I have worn it every day since, and it gives me tremendous comfort. There is a Jewish folk custom where the *rebbetzin* (rabbi's wife) in a *Shtetl* (a small town with a large Jewish population in pre-Holocaust Central and Eastern Europe) would give an infertile woman a red stone. Should a healthy baby be born, the new mother returned the stone (with its heightened power) to her *rebbetzin*, who would pass it on to the next struggling woman in need (Cardin, 1999). Perhaps the red stones I've passed out are not imbued with any special powers, but, as we are masters of magical thinking, they could be. Keep the stones that I've given you as a reminder that you are not alone. Use them as something tangible that connects you to others who find themselves in our poorly lit and terrible room, but let them remind you also of your brilliance and resiliency whenever you hold them up to the light.

REFERENCE

Cardin, Rabbi Nina Beth. *Tears of Sorrow, Seeds of Hope: A Spiritual Companion for Infertility and Pregnancy Loss.* New York: Jewish Lights Publishing, 1999.

BOX B

Lesbian and Bisexual Women's Recommendations for Improving the Provision of AHR Services

Lori E. Ross, PhD, Social Equity & Health Research Section, Centre for Addiction and Mental Health, Toronto, ON

Leah S. Steele, MD, PhD, Department of Family and Community Medicine, St. Michael's Hospital, University of Toronto, Toronto, ON

Rachel Epstein, MA, Co-ordinator, LGBTQ Parenting Network, Sherbourne Health Centre, Toronto, ON

This qualitative study, conducted in 2003–2004 investigated the degree to which a sample of Canadian lesbian and bisexual women were satisfied with the services that they received during the process of trying to conceive.

Summary of Recommendations to AHR Service Providers:

• Staff that are trained to be culturally competent in relation to LGBT communities — to be aware of and sensitive to the needs, concerns and sensibilities of LGBT clients, including the specific needs of trans-identified clients.

• Intake and procedure forms that explicitly make room for family configurations that do not assume male/female relationships, or a 2-parent model — i.e., that recognize the sometimes complex family configurations that LGBT people, and others, are forming.

• Involvement of all parties desired by patients, including partners, known sperm donors and co-parents.

• Provide accessible fertility services for known sperm donors, including gay men.

• Minimize costs for services and communicate a consistent fee structure.

• Language and treatment that recognizes that LGBT people are often accessing fertility clinics and sperm banks as part of routine family planning, and not as infertility clients.

- Provide opportunities for clients to make informed choices about interventions that are consistent with their known or presumed fertility.

- Offer infertility support that is specific to LGBT people or is provided by individuals who are knowledgeable about LGBT issues.

- Cues that services are LGBT positive. These might include positive space imagery or posters and brochures depicting LGBT families. Individual service providers can provide cues that they are open to LGBT families through choice of gender-neutral language, and attention to the ways that questions are posed.

- Information available about local LGBT services, supports and resources. Where feasible offer LGBT-specific services or services in partnership with LGBTcommunities and/or service providers.

- Expand the selection of donor semen, particularly with respect to donors of diverse ethno-cultural origins and identity release donors.

- Strive for a unified standard of care across geographic regions, and facilitate access for people living outside of major urban centres.

Sources

Ross, L., L. Steele, and R. Epstein. "Service Use and Gaps in Services for Lesbian and Bisexual Women During Donor Insemination, Pregnancy, and the Postpartum Period." *Journal of Obstetrics and Gynaecology Canada* (June 2006): 505–511.

Ross, L., L. Steele, and R. Epstein. "Lesbian and Bisexual Women's Recommendations for Improving the Provision of Assisted Reproductive Technology Services." *Fertility and Sterility* 86, no. 3 (September 2006): 735–738.

AHRA/LGBTQ Working Group. *The Assisted Human Reproduction Act* and LGBTQ Communities. Toronto, 2008. For more info: parentingnetwork@sherbourne.on.ca.

SHERBOURNE
Health Centre

Centre for Addiction and Mental Health
Centre de toxicomanie et de santé mentale

THE MAKING AND UNMAKING OF BIOLOGICAL TIES IN LESBIAN-LED FAMILIES

Suzanne Pelka

SINCE THE EARLY DAYS OF GAY LIBERATION, WE HAVE BEEN FIGHTING to have our relationships and our families validated in the public domain. With marriage and blood ties to children not always available to us as gays and lesbians, we have embraced the refrain that *love [not blood] makes a family* (Hayden, 1995: 43). Many gay, lesbian, or queer parents, if asked how biological connections to their children influence family dynamics, might respond: *Having a biological connection to my child makes no difference to me at all. Love makes a family* (cf. Clunis and Green, 2003: 45). While the saying "love makes a family" has profound meaning, many gay and lesbians who desire a family with children will go to great lengths and expense to conceive children to whom they are biologically connected. This is true even in cities where adoptions are easily facilitated for gay and lesbian parents. So what is behind the discrepancy between what we *say* about the lack of importance of biological relatedness and the seemingly contradictory actions that we take to ensure bio-genetic continuity?

Certainly many of us have chosen family and given/biological family whom we cherish in equal measure. Identifying as gay, lesbian, or queer does not uniquely determine our desires and motivations. We are also products of broader North American cultures, which are increasingly bio- and geno-centric in their cultural and scientific foci. In the process of family creation, many gay and lesbian individuals and couples make decisions that illustrate the significance given to biological connection. For example,

lesbians attempting to conceive using donor insemination (DI) will often go into debt to buy and store dozens of vials of a particular donor's sperm to ensure that future siblings will also be genetic siblings. The donor is often chosen for characteristics that the lesbian couple believes will capture the ethnic and genetic heritage of the non-biological mother. For example, if the non-biological mother is blond Italian and Jewish, only sperm from a blond, Italian Jewish donor will do! Some lesbian couples attempting to conceive through DI, consider it an ideal to use the non-birth mother's brother's sperm, so that the child looks like and is genetically related to both mothers. Similarly, some gay couples who become fathers through gestational surrogacy and egg donation have their semen mixed prior to the clinical fertilization of their chosen donor eggs. This is done to intentionally confuse genetic paternity and theoretically gives each partner equal chance at fertilization and thus biological paternity. Others are parenting twins in which each twin is genetically related to a different father, resulting from the transfer of several embryos fertilized by each partner to the gestational surrogate. Such practices illustrate the desire that each partner have the opportunity to biologically parent.

In the following essay, I offer up some snapshots from my research on lesbian families in order to explore some of the complexities and contradictions in the ways that LGBTQ parents and prospective parents manipulate biological tropes and make meaning of biological ties to biological and adopted children. Before I continue, however, I would be remiss not to acknowledge that biological ties often confer significant custody protections to parents, protections that are important to our politically and legally vulnerable communities. There are, sadly, numerous cases of gay and lesbian parents who have lost shared custody of their children because they lack a biological relationship, particularly when a second-parent adoption has not been pursued or is not legally possible (see Lewin, 2009, for a fuller discussion). Although custody protections are enormously important, I do not believe that they entirely account for the emotional import or meanings we make of sharing genetic or biological continuity with our children.

As an anthropologist and a marriage and family therapist, I have interviewed and worked with dozens of gay and lesbian parents. Some of these parents adopted as their first choice to become parents. However, as a result of my research focus, the majority of the couples I have interviewed conceived using reproductive technologies such as egg and sperm donation,

in vitro fertilization (external fertilization of the egg and sperm — IVF) and gestational surrogacy (through IVF, a surrogate carries a child to whom she is not genetically related). Through these interviews it has become clear to me that, whether we publicly discuss it or not, biology can play a significant role in gay and lesbian family dynamics. For example, when there are asymmetric biological ties between co-parents and children, there can be feelings of jealousy between parents (see Pelka, 2009). It can be challenging to be a same-sex parenting couple in a world that commonly assumes that children can have only one "real" (biological) mother and only one "real" (biological) father. Such hetero-centric perceptions are often internalized by members of our community, as we ourselves are, in part, products of hetero-centric and bio/geno-centric North American cultures. It is little wonder then, when we are financially able, that we often appropriate reproductive technologies to create families such that our children are biologically representative of both parents or in some way biologically related to their siblings.

Lesbian IVF

I have interviewed twelve lesbian couples who conceived children using what I call "lesbian IVF." This process involves an embryo transfer such that one mother is the genetic/egg mother and the other the birth/womb mother. Eggs are harvested from one partner and then fertilized externally in a Petri dish by the chosen donor sperm. A resulting embryo is then transferred to the genetic mother's partner for a hopeful full-term pregnancy. As I note in my essay "Sharing Motherhood" (Pelka, 2009), for the vast majority of couples I interviewed that used IVF to conceive in this way, only one partner truly desired to carry a pregnancy. The other partner was happy to be a parent but was very glad not to carry the pregnancy. Many of these couples were motivated to conceive using IVF by their overwhelming romantic desire to physically create children together as a couple. Many also believed that using IVF to biologically co-mother would confer an advantage with regard to obtaining equitable custody protections. They quite rightly imagined that it would be difficult for a court of law in North America to acknowledge only one biological mother when the women intended to parent together and one contributed the egg/s and the other carried the pregnancy/ies. Several of my informants went to court prior to the birth of their children to obtain what are known as "pre-birth orders" enabling both mothers to be listed as

"parent" on their newborn's birth certificate (cf. Thompson, 2005: 147–155).

When I asked one couple why they elected to conceive using IVF with embryo transfer rather than via DI, one woman explained: "The biggest benefit [of using IVF], as I said before, is that it is truly a child that we both make and grow. It's a child of the pair of us. It's the only way really that two women can do that" (Pelka, 2005: 212; Pelka, "'Truly Our Child,'" under review). This reply encapsulates the opinions of many of my IVF informants. Despite the invasive technological pro-cedures involved in IVF, not to mention the enormous expense of pursuing elective IVF, conceiving such that one partner is the birth mother while the other the genetic mother causes the IVF lesbian couple to feel that they have conceived in a way that is "truly together." While it is certainly novel to reappropriate IVF for the psychological outcome of both feeling like biological mothers to children thusly conceived, this practice nevertheless underscores the hegemonic, heteronormative cultural presumption that only mutual biological con-tributions result in a "real" co-creation.

Adoption

The majority of lesbian mothers I interviewed who chose to adopt had never desired to be pregnant. Yet a significant number of adop-tive informants expressed the desire to have birthed the children they adopted. As one said about her son, "I wish I could have had *him*. I would have loved to have given birth to him" (Pelka, 2005: 252; original emphasis). Desiring to have birthed one's adopted children might be viewed as an extension of the close, physical nature of the mother-child relationship that good postpartum parenting necessi-tates. Perhaps, too, like the lesbian IVF informants discussed above, the desire to have birthed their adopted children might stem from the belief that the biological processes of gestation and birth facilitate closer, more tangible bonds to their children. Several adoptive informants expressed feeling "a deep psychic" or "visceral physical connection" with their children while simultaneously narrating that their children feel like independent, unique individuals that the universe has "entrusted" to their care.

Adoptive informants Kristin[1] and Gail met in China while they were both studying abroad as college students. More than a decade later, adopting a baby from China was the only way that they wanted to create a family.

Their daughter, Summer, was six years old when I interviewed them. I asked the same open-ended interview questions of all the informants, regardless of their particular conception process (DI, IVF, or adoption); which is why I asked Kristin and Gail if they felt biologically related to their daughter:

SP: Do both of you or either one of you in any way feel biologically related to Summer?

K: That's a weird question. Well, you know, when she screams "Mama!" there's like a hormonal reaction in my body. Or if you're in a room full of people and you hear someone yell mama, to me, it just sends shivers up and down my spine. Now, probably you hear about biological mothers who when they hear their child cry they start to weep, their breasts start to weep.

SP: The milk lets down.

K: Yeah. Sometimes I had that sort of feeling with Summer when I hear her cry. It almost feels chemical that *"I need to get to my child now"* and that kind of thing. So, yeah, I do feel that [physically] because she's my kid.

G: That's a very interesting question. I see Summer almost as … I don't know, I mean I feel like she's entrusted to us, you know, we have no right to her. Sometimes I look at her and it's like she doesn't look Chinese to me, she doesn't look white, she just looks like Summer, you know? And sometimes I look at her and she looks so much like Kristin [my Caucasian partner], like, her expressions. I had one of those moments this weekend where I was just staring at her and she just looked like Kristin to me. (Pelka, 2005: 253; original emphasis)

Here biological relatedness is not merely related to conception, but is associated with certain maternal "hormonal" and "visceral" responses. Although Kristin and Gail recognize that they are not Summer's birth/genetic mothers, they nevertheless experience motherhood in traditionally physical ways. Kristin describes feeling the same types of chemical or hormonal responses to her child's cries that she expects are commonly felt by birth mothers. Likewise, Gail periodically sees phenotypic traits of her partner in Summer. Gail implies that "like biological parents, I too see my partner in my child."

Illustrated Kinship

In order to further explore my informants' conceptualizations of their families, I asked each of them to draw their child's kinship chart or family tree. As I note in "'Truly My Child'" (Pelka, under review), in every case of IVF, and in all but the three cases of DI with a known donor, the sperm donor was entirely left out or included very peripherally in my informants' drawings of their children's kinship charts.

The sperm donor becomes largely unrecognized kin once the child is conceived, minimizing biology and privileging chosen family. In fact, the informants that used anonymous donor sperm made a point of emphasizing that they used "donor *sperm*" rather than a "sperm donor." In "'Truly My Child,'" (Pelka, under review), I discuss how this semantic distinction objectifies the sperm as substance and depersonalizes and de-kins the sperm donor. Requiring donor sperm rather than the services of a sperm donor helps the lesbian-led family claim their independence from paternal models of family and keeps the two-parent model of the North American family intact.

Informants who used DI to conceive drew charts that excluded the sperm donors to an even greater extent than did the IVF informants.[2] The following chart was drawn by DI couple April and Kathleen. April had desperately wanted to experience pregnancy and give birth to one of their children but discovered she was infertile. For this reason, Kathleen gave birth to both of their children. It was challenging for April to grieve her infertility in the face of her partner's blossoming pregnancy (see Pelka, 2009, for a fuller discussion of this situation). Kathleen was nine months pregnant with "baby" when she and April drew this chart for me. The nuclear simplicity of their chart is highly representative of those drawn by other DI and IVF couples:

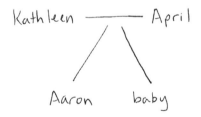

Figure 1: AI COUPLE (ANONYMOUS DONOR) KATHLEEN AND APRIL

Ironically, while the sperm donor was often omitted in the kinship chart or family tree, none of my informant families elected to use a different donor when conceiving subsequent children. It was very important to the mothers that their children share the same donor. The donor sperm was personalized once again in the context of talking about having been able to use "the sperm donor" for both children. Only one informant couple who wanted two children could not locate enough sperm samples from their original donor to successfully conceive their second child. Conceiving their second child using a different available donor was upsetting as they wanted their children to be "full genetic siblings." The donor, while previously unimportant, became central to enabling their children to share what they believed to be a very meaningful kin status.

The three lesbian DI couples that I interviewed who had used a *known* donor – those couples who chose a friend to father their child – drew remarkably *different* kinship charts and talked about their child's family very differently than did the DI and IVF couples that used anonymous donor sperm. The couples who chose to use a known donor drew and understood their children's family tree as more of a "bramble bush" (Clunis and Green, 2000: 10) than as a nice, neat, nuclear tree. They featured their children's fathers very centrally in their kinship illustrations. For example, DI informants Dawn and Sheila asked a dear friend to father their child. Their son, "Tucker," considers both his biological father and his father's gay partner his "Dads." Tucker recognizes two mothers, two fathers, and four sets of devoted grandparents, as illustrated in his mothers' representation of his family tree:

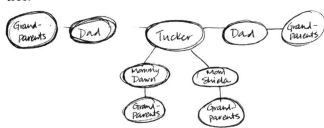

Figure 2: AI couple (known donor) Dawn and Sheila

Incidentally, when Tucker first learned to talk, his parental lexicon only included the title of Mommy. He called all four of his parents Mommy: Mommy Dawn, Mommy Sheila, Mommy Paul, and Mommy Eric!

None of the informants that adopted internationally had met their child's birth parents and none included any reference to their child's (unknown) birth family in their children's kinship chart. Gail and Kristin, mentioned earlier, who adopted their daughter Summer from China, drew Summer's kinship chart/family tree similarly to the IVF and DI (anonymous donor) informants. It is clear from this illustration that Gail and Kristen feel that they alone lay claim to the title "parent":

Figure 3: ADOPTION COUPLE (INTERNATIONAL) GAIL AND KRISTIN

By sharp contrast, many informants who had adopted domestically (in the U.S.) had either met or had a fair amount of knowledge about their child's birth mother. Some had acquired information about or even met the biological father, although this was less common. Consequently, those who had adopted domestically often included their child's birth mother (and sometimes the birth father) in their child's kinship chart. Like the three DI informant couples who had conceived using known donors (male friends), informants that adopted children in the U.S. drew family trees that often included biological parents:

Figure 4: ADOPTION COUPLE (DOMESTIC) YVETTE AND ERIN

Yvette and Erin domestically adopted their sons Danny and Kevin. Yvette and Erin are in contact with both their sons' birth mothers and feature the known birth parents prominently in their children's kinship chart. They even include their sons' other known biological brothers and sisters. Interestingly, Yvette and Erin's kinship chart locates their sons' birth parents closer to their children than they do to themselves. Such placement indexes the common North American assumption that kinship is synonymous with shared genetics/biology.

CONTRADICTIONS AND COMPLEXITIES IN THE MAKING AND UNMAKING OF BIOLOGICAL TIES

To say that biology doesn't matter in the creation of our families does not fully capture our reproductive desires and motivations, nor does it reflect what we actually *do* reproductively. Like our heterosexual counterparts, many of us want to pass on our unique individual and cultural heritages to our children. We, too, long to see our family's unique characteristics in our children (or at least some of them!). Many of us yearn to simply experience the mystery of pregnancy. Some of us will use every available avenue of reproductive technology (including IVF and gestational surrogacy) to feel as though we have come as close as we can to creating biological children with our partners. And, failing to conceive, some of us deeply grieve our infertility. Should we choose to adopt our children, we may feel a fierce physical connection to our children, as though we bore them ourselves. So, while love makes a family, biological connections can nevertheless feature large in our family planning.

I originally came to this research thinking that the lesbian couples using IVF to biologically co-mother were the ones creating truly "alternative" families. It is now my sense that it is actually couples like Yvette and Erin and Dawn and Sheila who have more radically broken out of a strictly nuclear matrix. They recognize other parents to their children while feeling secure and confident in their roles as sole and primary custodians of their children. This research has made me aware of the many ways we choose to emphasize and simultaneously de-emphasize the significance of biological connections in our families and how we often also manipulate biological tropes to more closely replicate traditional nuclear family models. As noted above, women using DI and IVF to conceive will often minimize the role of the "donor sperm" in their conception stories. This helps preserve their

independent and romantic co-creation. Yet the "sperm donor" often gets repersonalized when the couple conceives biologically related siblings by virtue of using sperm from the same donor.

It is my hope that by more consciously acknowledging the significance we give to biological ties, and by recognizing the contradictory ways in which we engage with biological tropes, we can both heighten our sensitivity and generosity towards one another, and, at the same time, bring a deeper awareness to our critical reflections on the meanings we make of biological and genetic connections, and the implications of these meanings for our reproductive choices.

NOTES

1 All informants' names have been changed to protect their anonymity.

2 Other social scientists have also found that lesbian mothers tend to minimize the contribution of the donor sperm or genetic father (see Drucker, 1998, and Sullivan, 2004).

REFERENCES

Clunis, D.M., and G.D. Green. *The Lesbian Parenting Book: A Guide to Creating Families and Raising Children.* 2nd ed. Emeryville: Seal Press, 2003.

Drucker, J.L. *Lesbian and Gay Families Speak Out: Understanding the Joys and Challenges of Diverse Family Life.* Cambridge, MA: Perseus Publishing, 1998.

Hayden, C.P. "Gender, Genetics and Generation: Reformulating Biology in Lesbian Kinship." *Cultural Anthropology* 10 (1995): 41–63.

Lewin, E. *Dreaming the Family: Gay Men and Fatherhood in America.* Chicago: University of Chicago Press, 2009.

Pelka, S. "Observing Multiple Mothering: A Case Study of Childrearing in a Lesbian-Led Family." *Ethos.* Under review.

—. "Truly Our Child': How Lesbian Couples Use IVF to Biologically Co-Mother." *Medical Anthropology Quarterly.* Under review.

—. "Sharing Motherhood: Maternal Jealousy Amongst Lesbian Co-Mothers." *Journal of Homosexuality* 56 (2009): 195–217.

—. "Lesbian Couples Creating Families Using In-Vitro Fertilization to Co-Mother: A Cultural Study of Biological Ties." PhD dissertation, University of Chicago, 2005.

Sullivan, M. *The Family of Woman: Lesbian Mothers, Their Children, and the Undoing of Gender.* Berkeley: University of California Press, 2004.

Thompson, C. *Making Parents: The Ontological Choreography of Reproductive Technologies.* Cambridge, MA: The MIT Press, 2005.

Extra Love:
An Open Adoption Story

An interview with Ann-Marie MacDonald

Toronto-based writer and actor Ann-Marie MacDonald, with her partner Alisa Palmer, has adopted two children through an open adoption process in the United States. Below Rachel Epstein chats with her about the adoption process, about becoming a parent, and about how parenthood affects her writing.

R: Start by telling me *about your particular journey to parenthood.*

A: Well, when I knew that I officially wanted to parent was when I fell in love with Alisa. Before that I wasn't interested in being a parent. Then I very much wanted to have children and raise them with her …

R: *What changed, what was it about that experience?*

A: I'm not sure. We worked together a lot. I was just absolutely crazy about her, and when I imagined having a child with her it made me very happy. It was really that corny thing that my parents told me, which was: "Well, we fell in love, and there was just too much love for two of us, so we needed to have children, because there was always extra love." And that's actually what I tell my girls, because it's true.

R: *And then how did you approach it? How did you go about thinking about having kids?*

A: Right from the outset we thought, wouldn't it be great to have more than one? And we wanted to have kind of a blended family. We imagined ourselves having an adopted child and a biological child. And we were

told that adoption would be the thing that would take the longest so we should start right away. In fact it was the thing that worked first. So we went with it, and then it happened again, we got two children who were placed with us at birth. We were chosen by their birth mother.

R: And was that international? Did you go out of the country?

A: It was in the States. As a same-sex couple we were not permitted to adopt from other countries. Apparently at that time China was starting to sniff out the supposed single mothers with the same-sex partner hiding in the background. We hated all those policies, and thought where can we go? And then we looked at the States.

R: Why did you think about international adoption to begin with?

A: Well, one of the first things we investigated was open adoption. We were spurred in that direction by a book that was given to us by a dear friend of ours who is an adoptee himself. He gave us Dan Savage's book, "The Kid," which is a fantastic memoir of him and his partner in their quest to adopt a baby. They went through an agency in Oregon called Open Adopt. It's a not-for-profit organization, a child-centered, birth-mother-centred organization. They pioneered open adoption. So we got ourselves down to Portland and we did a three-day seminar on open adoption and we thought, if we're going to be adopting, this is the way to go. We should know the birth mother, she should be choosing to place the baby ... this all bodes very well for happy kids, right?

So we went there and it was really kind of a bitter-sweet experience, we were told that as lesbians we'd be on the bottom of the heap. Not only after the straight couples but also after the same-sex male couples. And we said, but why? And they said a lot of birth moms are young teenagers and maybe they want to feel like they're going to be the only mother figure. So that was rather disheartening, finding out that we would really be on the bottom of the heap. But it was also fascinating to become educated to what the whole process of open adoption is like. It was terribly moving and very eye-opening and extremely inspiring, and we thought, we can't do this any other way.

We came back to Canada feeling downcast and enlightened all at the same time, and we did a home study with a social worker who was brilliant and wonderful. At one point we were told that the open adoption movement, if that's what you want to call it, owed a debt to the lesbian and

gay Pride movement — the idea of being out of the closet and dispelling shame and being open about everything. And I thought, that's really great to make that connection.

Meantime, on the recommendation of our Canadian lawyer, we registered with an American agency called Adopt Today — you can tell from their name that we were getting a different message from the one we got in Oregon *(laughter)*. So we talked to these lawyers in LA, these two gay guys in three-piece suits, and they were saying, "Your heart's in the right place. We're gonna get you a baby!" Well, we talked with these guys and they were saying, at a certain point you should just jump in. So we wrote them a retainer, but didn't mail it. Phone rings. The lawyers say: "We've been talking to a birth mother and we've shown her your package, and she's very interested in you." We were flabbergasted. Suddenly, we were on the fast track, after thinking this was going to take forever.

So we had a phone conversation with the woman who is the birth mother of both our children, who we now know quite well and whom we see a couple of times a year. Someone gave us a really good piece of advice at one point along the line, and it was "Be yourself when you present yourselves. Don't try to think about what a woman's going to want to hear. Tell her exactly who you are." So that's what we tried to do. And so we asked her "Why did we appeal to you?" And she said, "Well, I read a lot," and I'm an author, "And I work with horses," and Alisa had talked about how that was a passion for her, she loves to ride. So that was her starting point, and she liked our tone. It was interesting, she's over thirty, she's not a kid, and we were at the top of her heap. So we flew down to LA to spend the last few weeks of her pregnancy with her. It's the most astonishing blind date you can imagine. We flew down with all kinds of baby equipment knowing we'd have to stay there while all the paperwork was done, because the immigration hoops are unbelievable — you see, if you go out of the country and have a baby, that baby's Canadian because you are. If you go out of the country and adopt a baby that baby's not Canadian — although I think the law has changed now. It's just unbelievable the paperwork and the lawyers and the social workers and so on and so on. The baby has to have a blood test and fingerprints and a passport photo. Like, have you ever tried to get a newborn to open their eyes for a picture?

R: So were you sponsoring them?

A: Yes. We sponsored them. Filled out forms which were like "What's your present job?" No job! I'm a baby! *(laughter)* "Any criminal record?" I'm a baby! *(laughter)*

So we drive from the airport, miles and miles south of LA, forty-five minutes later we're in a bedroom community and we pull over to a kind of a chain mall outlet and that's where we're going to meet the mother of our child, as well as the facilitator with whom she's staying. I just kind of walked in like: hi, here's who we are, that's who you are, and we started to get to know each other. And three weeks later she had the baby and we were there. And it was astonishing. And twenty months later she had the second one, and we went down again.

Recently there was a snide reference in a *Toronto Life* article about a well-known Toronto lesbian author who'd paid $50,000 for a baby … a lot of people think that's what happens, so if you can dispel any of those myths it would be good. It's illegal to buy a baby. There actually aren't places in the U.S. where you can do that. California has laws that are almost identical to Ontario's, you're not even allowed to buy the birth mother a cup of coffee. What you do is through the lawyer, you pay for her room and board, beginning at the point where she can no longer work due to her pregnancy, and up until she can go back to work. Basically she stays in a motel, you pay her an allowance, you pay for those basics. You hire a lawyer for her, and you hire a social worker for her, so everything's at arm's-length. And she's got a month of business days in which to change her mind. It's the same as it is here.

R: *Was that stressful for you?*

A: No. That was the least stressful, because she picked us. And there was never any doubt that the children were going to be available to her, she's always welcome to visit, we visit, send pictures and whatnot. She said, "I'm pro-choice. This is my choice. I can do something good. I'm good at this." Interestingly enough, she has a real pride, too; she knows she makes really beautiful, smart children. And we are the beneficiaries of this. And she's so brave; she has a lot of dignity. I mean, there's still shame around women's reproduction — things that we heard from people who we thought were friends, things they'd say about her, and her motives. "Well gee, she better have her tubes tied." "Wasn't she on the pill?" "Hasn't she heard about this or that?" And it's really interesting because women can quietly choose to

have an abortion, and nobody's going to say anything about it, because they're not going to know. But if you go out and get big and you didn't have to, and you're not gonna raise that child, and then you place that child, there's a lot of women who still call themselves feminists who rise up against you and say, what kind of woman are you? What kind of woman can do that? I say, well, a really smart one, a really brave one, a really loving one. And one whose past is actually none of my business.

R: How old are the girls now?

A: They're four and five.

R: And what's their connection with her now, with the birth mother?

A: You know, she's a member of our family, we love her. We have her picture in our kitchen, the kids see it every day. It's dispelled, it's demystified. And, in the case of our younger daughter, we see her birth father regularly, and we met his mom, too. So now, you know, I have so many pictures I've got to send to people. I was never this nice before.

R: How has being a parent changed your life?

A: Oh, I'm happier, and I'm really much healthier than I was. When I was finishing my last book I got really pretty unhealthy. A constellation of complaints and things just deteriorating, hubcaps falling off, you know what I mean? I was just a wreck. And now I'm way healthier, way fitter and happier. And extremely busy.

R: What made you more healthy?

A: I've got to be fit for them. I've got to be able to keep up with them. I also have to look in my own closet for lingering demons and wrestle with them because I'm very aware that, even if I did away with every last demon, my kids are still going to pick up on whatever shadows are there. I've become a more patient person, that is what has changed. I've had to really learn to take a beat before I react.

I'm on time for things, I'm organized, I can multi-task better than I could. I'm friendlier, I'm more accessible to people. I feel like I have a real panoply of people in my neighbourhood and in my life now who have nothing to do with my work. I'm still rich in what I do, and in my colleagues and the artists and the people that I know, it's fantastic, but I also have the parents of the kids that my kids go to school with. I play hockey now, I

wouldn't have done that if I didn't have children. I thought I should know how to do something with them, apart from, you know, talk and read. So I started in and I absolutely went crazy for it. I'm in a women's house league at the arena near my home. It's a mom's league, and actually, as a lesbian I'm in the minority. There's actually just a few of us, but, it's a nice ... it's Olivia Chow's riding, all the moms are playing hockey.

R: *And what about writing?*

A: I haven't taken on any big intense projects since they were born. I didn't want to go there and become that preoccupied. I didn't want to go to those places when they were still little ... I know how completely absorbed I have been, and maybe I wouldn't have to be that way again, but based on experience I'd rather not take that much from them, you know? They're going to be little for a very, very, very short time ... So, am I going to go down to the inferno every day and then come home and kiss them goodnight? No! I'm not going to go there for a little while. They're just too tender, they're too young. I don't want to bring those kinds of shadows into the house.

R: *Do you think it will change your writing, being a parent?*

A: Probably, but I don't know how because I haven't created from nothing yet, since they were born. I hope it is different. I'm very curious. I just feel like they've saved me, I mean I have a whole new life. And you know, being an older parent I feel extremely privileged. They're not in my way. They're not preventing me from coming into my own as an artist. They're actually a really great excuse not to have to write, not to have to work that hard.

R: *Do you feel any pressure from an agent or a publisher?*

A: If they're pressuring me I don't notice it. I just think, isn't that nice that they want me to be writing something, how lovely is that. Isn't it wonderful that I'm not? And that I don't have to. I'm sure that my children are going to get a little more independent and I'm going to feel like there's a space — maybe that's the space where I might start writing again.

R: *So what does day-to-day life look like in your house?*

A: Very routinized. You know, we've got two close in age, and they

both go to the same school so they're on the same schedule. And they've got lessons, they are not over-scheduled kids but their dance card is full. So the mornings go the same way every day: we all sit down, we sit down together for all the meals, and bedtime is the same, all the routines are the same. We created steps actually, I felt like Captain Von Trapp with the whistle when we created this morning routine. I said step one, step two, and there were like ten steps before we were out the door. Now we don't talk about steps anymore, we don't have to. I heard a parenting guy speak, and he was great. He said routine got a bad name in the sixties and seventies, but in fact routine is how you get through your day. If you had to decide: should I get dressed now or not? If you had to make a decision about the minutiae every day, you'd go mad. And that's what we're doing to our children when we give them false choices. It's like no, this is the time you wake up, you do this, you do that, of course they resist and of course they go slow, and there's room on either side of that, but they love it when things are the same and it allows their imagination to run free. It allows them to have their inner space; it's not cluttered up with "what's happening now?" It actually empowers them because they get to go, "I'm in charge, I know what's happening next. This is my life. I get it."

R: And how do you and Alisa manage to work, for instance, right now you're involved in a production?

A: Yes, life changes for us a lot, so everything we have that's routine is especially important because our work is not nine-to-five, and you know, these kids can sleep anywhere, and they travel with us. If you have the same routine it feels like home no matter where you are, so our kids can sleep in strange places, and they can eat other food because we eat together, and we're sitting together in the same way and we have the same manners, that type of thing. Alisa has worked more than I have, so we've traded off. Now we're in a rare situation of working at the same time, but we've managed because the girls are in school during the day, and rehearsals are during the day, and when I'm in the show at night Alisa will be home. So it's minimally disruptive.

R: If you were picking up a book on queer parenting, what would you want to be reading about?

A: I'd like to know how people's families of origins react and respond,

and how they support or do not support, and how they find their way towards embracing queer families. I know my own parents had a huge journey with me as a lesbian, it was ten years of nuclear war, and now you'd never know it. My mother sends me cards with prayers on them saying what great mothers we are and how much God loves us. My mother made her peace with my sexuality in a phenomenal way, and she's totally embraced us, and her grandchildren. I consider it to be a miracle, truly a miracle.

And because I was forty-four when I became a mother, I had already been through a lot of that stuff. I was lucky because my children didn't have to go through the maelstrom of it, and they didn't have to see me get dragged through it and drag them through it.

R: So how do you think having two moms has influenced your kids?

A: I'm Mama and Alisa is Mummy. At their school I think we're the only same-sex parents, but there's a lot of divorced families. I hear them explaining their home lives to one another, "Well, I have two moms, but so does so-and-so," and "he's got a new sister because his mom got married …" "Well I have two dads!" So they're comparing notes, and the difference is that we're not separated, and that's a happy thing, but the kids explain their families to each other.

They get questions, but kids are very frank. Kids can go over to the kitchen table and see their birth mom's photograph, and they'll ask, "Who's that?" "It's my birth mother." "What? Whose belly were you in?" "Well, neither of them." "Well, then how? What? Where? In California? Oh, okay." They're quite blunt with each other all the time. I remember when my parents were quite worried about the whole open adoption thing, "Oh my god, is it right? The children will be confused …" No, the children are going to be confused if we lie to them, if there's some big patch of silence. And now my parents have actually met the birth mother and the birth father of my younger child, so all of those things have happened quite naturally, and I think everyone's been surprised by how undramatic and unmysterious it all is.

R: How do you imagine preparing your kids for stuff that they might have to deal with?

A: Punch 'em in the nose, man ... tell them to fuck off. *(laughter)* You've got to stand your ground. 'Cause it's gonna happen, and adults who are supposed to be nice are going to say nasty things ... You know, we all have to be strong in different ways because we're different in different ways. And, so yeah, your feelings are hurt, but you're not going to take that, you're going to say "that's your opinion" and walk away. But also the school teaches them to be kind and to share and to also be assertive and to say no to each other. I didn't even start to learn that until I was forty, so they might actually have an advantage there.

II FROM QUEER TO PATERNITY:

Queering the Family Tree

THE GIFT OF LIFE:
Sperm Donors/Donor Dads — Then and Now

Below Rachel Epstein talks with Suhail, John, and Matthew, three men who have acted as sperm donors or donor dads to women in their lives — Suhail in the 2000s, John in the 1990s, and Matthew in the 1980s. They talk about their decisions to become sperm donors and the negotiation process involved, about their relationships to the children they helped conceive and to the mothers of these children, about the responses of their families of origin, and finally, they offer advice to other men who are considering acting as sperm donors/donor dads and to women approaching potential male donors.

R: *LET'S START BY EACH OF YOU introducing yourselves, how you came to be sperm donors — though I don't even know if that is what you would call yourselves — so you could talk about the language you use, what your role is, how that came to be.*

S: I'm Suhail and actually sperm donor is a term I don't use very often. I think that term describes someone who goes to a sperm bank to donate sperm. I don't know what to use ... It all started almost six years ago when a colleague mentioned to me that a friend of hers was looking for a donor, and would I consider it? I thought I might be interested and it might be a good kind of solution to my dilemma of not having the desire to have children of my own and at the same time this kind of instinctive pressure to see your ... offspring *(laughter)*. So that was the first time I was asked, and three and a half years ago I was approached by a friend who said she had friends who were interested. So I met the mothers for that specific purpose, I didn't know them before.

I was the first one they talked to and we just clicked immediately. They went home, talked about it and called. "We want to hang out with you more, we feel like there is a connection." The energy was just flowing really well, and we started the process.

My being non-white was an important factor, because of who they are it was something they preferred. I think it meant something for me in a way that I can't really understand. I can't really put my finger on it, why that was important for me as a person of colour.

And now the girl is a year and a half.

J: For me it started in the early nineties, a whole bunch of friends were dying of AIDS, and also my mother was dying. A friend, Abigail, in Boston had been asking me to be a donor, and I'd been hemming and hawing and thinking about it. After a particularly bad bout of illness for my mother, I got on the phone and said, "I'm ready." This is something a lot of people have commented on — out of the AIDS crisis has come a baby boom, and it's not surprising. Of course many social factors contributed, but one of them was this factor of loss that we as a community were experiencing.

So Abigail and I were trying the long-distance thing. She was in Boston, I was in Toronto, and we learned way more than anyone ever needed to know about shipping sperm and dry ice *(laughter)*.

R: Were you and Abigail planning to co-parent?

J: It wasn't co-parenting. But I wanted to be a known donor, and involved in whatever way would emerge from there. We had a pretty good, clear understanding. She'd be the single mom, I'd be the known donor and involved. Then we tried, we tried, we tried. Frequent flying evidently doesn't aid procreation. So this was frustrating. Then one day I get a phone call saying, "I've met somebody." And I go, you know, "Oh fantastic, who is she?" And she goes, "Actually it's a guy." *(laughter)* So the short version is, they're very happy together raising their fourteen-year-old girl.

But when my friends Pam and Marg heard that we'd stopped trying, the next month they said, "Please sit down, we have something to ask you." And at that point it was actually quite easy, I just said, "Sure," because Pam and Marg had been very close friends of mine, in Marg's case since the early eighties. And because I'd been through all the issues already with Abigail, I had a pretty clear idea of what I wanted, and it turned out it was the same as what they wanted — again, a known donor who wasn't a co-parent. In

terms of insemination, Marg and I were living in the same building. A lot easier than cross-border flights! It took about six months to get pregnant — and in fact, it happened in Montreal, not Toronto. I was staying in an open concept studio for the summer, so they came down for the weekend, went for a walk around the block, and then we passed off the syringe, and then I went for a walk around the block *(laughter)* and that was our conception. And then Alice was conceived on the first try. So Maggie and Alice are now twelve and ten.

M: I guess I'm the oldest at the table, and the child, who is a boy, is almost nineteen. One day I ran into a friend who said, "Oh, person A and person B are looking for a father for their baby." So I gave them a call and we arranged a meeting, and they were very keen, and they had a book. This was the most exciting thing. There was a book about how lesbians can get pregnant and there was a sample agreement … the women said, "Take this, read it, see what you think." And so I did. And I thought well, this sounds fine. So we made the agreement that we would start the monthly process of trying to get pregnant.

I got this call at seven-thirty in the morning on a Sunday, "She's ovulating! She's ovulating!" I'm like, oh my god, it's January, they're on the other side of town, I say, "Fine, fine, I'll be over." So I bundle myself up, I get in a cab, I get over there. They're wild with excitement and I'm like barely alive. They hand me an artichoke-heart jar and a syringe, and they hide in the bedroom. And I'm sitting on the couch in the living room going … this is great. This is very erotic. So I do what I can and then, because I have no idea what their experience with sperm is, I suck it all up into the syringe, and I knock on the door and I hand it over, and I sit in the kitchen and I read the *Moosewood Cookbook (laughter)*. What is there to do? I wait and wait and wait and wait and wait, about half an hour later they come out, and the birth mother says, "You know, I think it worked." And we're like, ha ha ha. And she was right — pregnant the very first time.

The agreement was that I would donate my sperm, and I would have a connection with the child at whatever time the child exhibited an interest. And if any questions came up or there were any problems then obviously my whole family health history and everything else was right there.

Then at the age of six months our son's parent's broke up and it became a whole other story because the agreement was no longer really what it had been, their relationship was no longer what it had been. The birth mother

ended up with a man, they ended up having a child of their own ... then they broke up, there was a lot of turmoil.

R: When you were asked to be a sperm donor, or whatever language you might use, what are some of the things that you had to think about?

S: Well ... one of the things for me is my whole relationship with my family and community and the issue of sexuality. I'm from the Middle East, and just the fact that my parents are not after me because I'm gay is fantastic, you know. They don't talk about it, but they know. So the idea of doing something like this is completely out of the question. It's something I will never tell them. And my mother, she feels bad for me because I'm not having children. So part of me wants to tell her, "Well, you know, I do." But I can't.

There's also the issue that everybody tells you that you're going to be so attached and how can you do this and not be involved in your child's life? And I wondered, when I see her will I be so attached and will it be traumatic and emotional? And that didn't happen, I mean she's adorable and I'll hold her and play with her for an hour or two but then you take her ...

R: John, what kind of things went through your head as you were making this decision?

J: I thought about the first gay dad I'd ever known. He was a co-parent, raising a son with a lesbian couple. The couple broke up, so then it was he and the one mom. And it just went from bad to worse, to the point where when his son turned six he was cut out of the picture completely. It had made me very nervous about definitions and expectations and about trying as much as possible to define all the possible parameters of what might happen. Get it all written down on paper. So we had this contract and we sent it back and forth very responsibly for six months, and in the end, after thirteen years, we still haven't signed it. And so every time someone asks I say, "You *must* have a contract," and they say, "Oh, can we see yours?" And I go ... *(laughter)*.

The other thing is that the three of us are surrounded by a whole community of friends in common who would just beat us up if we acted badly with each other. But I think also that if we don't have trust in each other, that piece of paper is actually not going to help. One of the things that did help was that I had to give up all parental rights in order for Marg to adopt. So because I had signed all my rights away, all we had left was trust. And weirdly, I felt more comfortable about that because then I have no recourse to the courts, I have no recourse to the state, I only have recourse to

our friendship, our history ... We have to make this work on our own.

R: Did you have fears that you would become more attached?

J: Well, I got to play a crucial role at Maggie's birth. I got the phone call and it's like "Maggie's born, you can come over — oh, and can you pick up a couple of burgers, we're starved!" And so while they were having their burgers I got to hold Maggie, the same hour she was born. I was very, *very* moved about her, but I wasn't struck by lightning. I wasn't overwhelmed by paternity, and that was good to find out. Because you don't know. Society tells you, you will be.

R: And Matthew, what about you? What kinds of things went through your mind?

M: Well it was interesting that up until our friend said to me, "So and so are looking for a father for their kid," it had never occurred to me. I mean it was the late eighties, this was just never ever going to be a possibility in my life.

But the moment he said that, something about it clicked. It just felt right ... Probably for about a minute I thought to myself, there's that possibility that I'll get more involved than I think. Which later of course turned out to be true ... in the end the piece of paper was more symbolic than anything, it was an attempt for us to create rules where there were none. Relationships totally changed, dynamics totally changed and then we basically had to pick up the pieces and improvise, sometimes day by day, from about six months after our son was born basically right up until the present day.

R: What about health issues and sexual practices and trust? How did that get talked about and dealt with in each of your scenarios?

S: We started with the whole freezing thing, it was easier in terms of HIV testing. Then a whole year went by and we decided this was taking too long, let's forget the freezing. We trust you. Even before that, even while we were using the frozen stuff, something changed in me. Even though I'm always careful in terms of my own safety — now there were other people involved. It just switched my whole attitude towards how I have sex. It made me realize how something unpredictable can happen that can affect other people and I need to be more responsible. So it did change my sexual life and behaviour, forever, I think.

J: It was a big issue from the start because my partner's HIV positive, so we did all the testing, just sort of double-, triple-checked that part. The only frustration was the amount of time involved. But then in fact the waiting process became time to actually talk more, we went back and forth with our drafts of the contract (which never got signed!). And there was other stuff that was important to talk about, like family history. My family has a history of depression, so we were talking about that. Everybody comes with baggage so it was about making sure the bag-gage was on the table.

M: Well, I was already being tested every six months so … That was actually one of the selling points of my being a donor — was that I came prepackaged as somebody who had been tested, was going to be tested again very shortly.

R: So, after the baby was born, how did things go?

S: We had a very clear understanding and what transpired was quite similar to what we were thinking: that I'm going to be a friend of the family — Uncle Suhail who shows up every now and then, hanging out with them until the child is old enough to ask questions … we're just going to take it as it comes. We've ended up seeing each other much less than we thought we would, because I travel a lot and they travel a lot and they're very busy and I'm busy … If she ends up wanting to spend more time with me I'm really open to that, but at the same time I don't have any interest in becoming more involved. But I'm growing older so I'm changing. I've become more open to having some responsibility. So really, everything's open.

J: We had done a lot of talking through. For both Marg and Pam and myself it was very clear I'd be involved. Maggie would always know that I was the donor and she would use whatever terms she wanted. So she could call me John, she could call me Dad, the terms would be chosen by her. We had talked about some sort of regular involvement, something like once a week when I'm not swamped with work. And it's pretty well worked out to that. As they've gotten older now, we also do Camp John in the summer, for a week.

We tend to go week by week, month by month with the involvement. The girls are surrounded by a lot of other people in very close family roles too. There's a grandmother and grandfather that are very involved, and siblings with their own kids, including Pam's sister Gillian who's also a dyke, raising

her son with her partner Bo. There's close friends of the mothers who are very involved honorary aunts. So they've always been surrounded by a larger group than just the two parents.

Right from the start Maggie called me "Dad." I was touched, of course I melted! With Alice, there was this funny moment — she was around three, in preschool, it was the first time I was going to pick her up. I go to the door and I say hi to the teacher, and the teacher looks around and there's Alice playing fairly close by. She looks up, sees me, runs away to the *other* side of the room. And I'm going, "Oh no!" *(laughter)*. But it was all so she could turn around and yell, "Daddy!" and run back across ... so that the whole class would watch, so she could prove to her little three-year-old buddies, yes I have a daddy, too. So that was one of the moments where we could see it mattering in their lives, that investment in identity and categories. And then other times they're utterly indifferent to the societal definitions of "parents." They're lucky to go to a school where there's other queer parents, there's tons of kids being raised by single parents, and there's teachers and a principal who are very queer-friendly.

M: This kid came into a place where there weren't just two parents. There was an extended family, there were people everywhere. He became very skilled and very sophisticated at figuring out what the hierarchy was, who the primary parents were, who the less primary parents were.

At one point, because there were a lot of people involved and it was complicated, I decided I had to completely step away, painful as it was. And since then, it's all been dust settling. But the times that we were closest were marvelous times and things went really well. And it didn't really matter in the end what the roles were or what the name was, it was really all about what the contribution was.

R: What did you have to deal with in relation to your own families of origin when you were doing this?

S: I have to always remember that this is not my child, right? The fact that it's my sperm really means very little, it's the relationship that you build with the person. I know that if my mother knew she'd be like, oh my god, that's my granddaughter ... If it's just me I don't think that I need to tell anyone. It's not my child, but I have to consider how these kids might end up feeling ... The thing that comes to my mind is that my brother has children and my sister probably will at one point in her life. They live in different countries,

really far away from each other and the chance that these kids will ever meet each other or have any connection is very slim. But at the same time if this daughter is in my life, and I am her uncle, and my family comes to visit and they end up meeting, there's this blood barrier that needs to always be respected.

J: I told my dad right away — and his coldness communicated itself very clearly. He was very tense. He has a good relationship with my boyfriend, but this idea of a kid was too freaky for him, he couldn't cope. And so when he was visiting (he lives in Vancouver), I said, "Come for dinner and we'll have the mothers and the girls come over and you can meet them." And as the afternoon wore on he got tenser and tenser, just in anticipation. Finally, the best thing happened — he had a nap on the couch, like dads do, and didn't wake up until the moms and girls arrived, and he had to meet them before he was fully awake and had all his prejudices back in full running gear. Of course, in the end, he liked both the moms and the kids, because they're great. He could not cope with the idea, but he can actually cope with these real, living people. And he also knew that all four of my siblings had been involved from the start, are very supportive, and are close to both the moms and the girls.

I've been very lucky, this amount of involvement, this level of support. And I think it's about this moment we're living in, ten years earlier I don't know if this would have worked out. Twenty years earlier I know it wouldn't have. There would have been distances and tensions and separations.

R: *What's different now?*

J: Fundamental societal change. Queer babies and queer families are visible and familiar and a fundamental part of the culture now. My siblings all have queer friends, independent of me. In this decade, it's a completely different set of questions than it was in the eighties.

R: *And how have the moms been with that level of involvement from your family of origin?*

J: They're the reason this has worked, I think. I was very careful about definitions. I didn't want to get into claiming cousins or aunts and uncles. But it was Pam and Marg who went out of their way to get to know my siblings and their kids, and made them part of Maggie and Alice's world.

In terms of process, it's been step-by-step, finding out what things

make us insecure, what things we feel confident and comfortable about, responding to each relationship as it comes up and needs definition. Almost all of it was driven by the girls themselves. For instance, in terms of my dad, there was never an issue there, because the girls already had more than enough grandparents. On the other hand, they were keen about cousins their own age, or my brother's three-year-old twins, so those have been relationships that have developed over the years.

R: Matthew, what about your family of origin?

M: Well, again, I guess I'm the pioneer at this table. When we decided to conceive I had a huge fight in the workplace where my boss — who's Catholic — was livid that we would be so shamelessly experimenting with human lives. And then I lost a friend who was very invested in her gay friends as gay people who would never have children.

So already I felt unable to predict other people's reactions to my happy news. And because we were already in a complicated situation and it was only getting more complicated, the thought of telling my mother, or my father, remained out of the question for quite a long time. There were times where it was on the tip of my tongue. And not because my mother particularly ached for grandchildren, but I really felt that I was keeping an important secret.

At one point I decided I had to call my mother and tell her. Our son was at this point nine years old. When you get to that age it's not like, "Oh, I forgot!" *(laughter)*.

So it became like a story. "A long time ago there were these women who I knew ... and so we have a child ..." And this was simultaneously a wonderful thing and a completely horrific thing. Because we were talking about the child my mother was never going to meet. And I have to say she handled this with as much grace as anyone possibly could, until I found out from an aunt of mine that apparently I've had a relationship with this woman, and that my mother didn't know whether I was straight or not, but apparently we've conceived and then there's been this child and because of the sensitivity of the situation no one in the family could ever meet him. And I was, "Well, it's not quite like that, but okay."

R: And how would your mother think about it now?

M: I don't know what stories she tells herself or other people, but I think in some way it has normalized her abnormal son, and has given

her some sort of reconciliation within herself about how her gay son might not be quite that gay.

R: And the decision that he would never meet her?

M: That was sort of a collective decision. I think that in particular the birth mother and I recognized that our situation was complicated enough. This is a child who is not lacking for grandparents. My mother, I think she's actually kind of grateful to just have the knowledge with-out the complication, because there could have been no way that this situation would have been easy for her to sort out. It would have just been a mammoth puzzle.

R: What advice would you give to somebody who is thinking about becoming a sperm donor — or whatever language you might choose — and what advice would you give to women who are approaching men to be sperm donors?

M: I would say, for the donor, even if you don't actually have an agreement that everyone signs, it does actually help to go through the exercise of negotiating your best guess for what the relationship will be ... Don't overanalyze it, because you can't capture every possibility, but it's good that you all at least agree on the general definitions, responsibilities, rights, all of those things. I would say, know everyone in the situation as well as possible before you go in. Just open yourself to learning about these people and about yourself through the experience.

And for the mothers, I think it's important to find a person who you feel you'll connect with enough to have an ongoing dialogue, however the relationship is defined, because who you are when the child is conceived is not who you will be when the child is ten or when the child is in high school, or going to university. A lot of it is trusting your gut and just going with it. Despite all of this, I don't know anyone who has a child who has been conceived this way, who has regretted it.

S: I know what I felt when I was asked to do this and I know how men have a relationship with their ego when it's related to reproduction. The donor really needs to know why he's doing this, and to be very honest with himself, because people do it for different reasons ... I think people can fool themselves around why they're doing certain things, there's their own ego issues, and then there's the practical issues of how they feel about having a child and how they will emotionally work with people. And I think you don't know, it's not something you have any experience with. If it means therapy,

or counselling, or talking to many people, it needs to be done.

And when mothers are looking for somebody, it's important to understand what you need from this relationship, this third person. Sometimes people say, "Oh my god, they're great with children, they're loving, they're beautiful," so this is the right person, but the reality is if you don't want a third parent, if you just want someone to give the sperm, is that really the criteria for judging that this is the right donor for you?

J: How to add to such great advice? *(laughter)*. I was reminded of a situation of a friend of mine. He reached a certain age and deeply wanted to parent. He met a woman, they had tons of things in common, they went through a year of trying to get pregnant, and they also constructed a whole set of negotiations and contract and they made it extra ambitious by buying a property together with the perfect set-up: two apartments, a staircase, everything. And thank god the kid wasn't born, because it didn't work out at all. They realized in the end that despite this extraordinary compatibility on paper, on a day-to-day level it wasn't working out. And they were pursuing something that was a bit of a fantasy. It was a noble, wonderful kind of fantasy — I think all parenting has to involve some sort of fantasy — but they were pursuing it with the wrong person and thank god they ended up where they did, without a child involved.

I remember with Abigail, there were things in our negotiations that I was thinking but not saying. Because we were both single I worried about falling into patterns of dependency or falling into a nuclear family model, despite the long distance. So when Marg and Pam were asking, I immediately felt more comfortable, because they were in a long-term relationship. But as we all know, there's no guarantees. You know, nobody necessarily stays together forever and it has nothing to do with their gender or their orientation.

As we become more familiar with all the varieties of queer families, hierarchies will develop — this is a better model, this is a lesser model. But I think we should be smart enough not to do this to ourselves. If you're a donor, don't beat up on yourself if you don't want to be that involved — if you want to show up at the birthday and that's it. I think, by the same token, women who want to parent shouldn't feel that an involved donor is superior to a non-involved donor. Each of those situations is going to have its own dynamics. The contract is the vehicle to talking, figuring out the nitty-gritty — all the involvement questions, the grandparent question, the cousin

question, the who tells who what, decision-making — that is the sort of stuff that *must* be talked about in advance.

I think because we queers have so many choices open to us in this situation, it's important to feel that you can express your feelings — name your fears, blurt them out. What's working, what doesn't work for you, what you're worried about, what you're not worried about. You're making the conscious choice, with a lot of work, to bring a child into the world. Why not make sure that it's the most positive thing it can be?

R: Any other advice for women who are approaching donors?

J: Be very honest with yourself about what you want and what you need. There aren't formulas for success. The search for the perfect man — believe me, he doesn't exist! *(laughter)*. So instead let the work start with that first conversation. And maybe you'll approach six guys, and choose one, and then maybe you'll have to be harsh and say, six months down the road of talking, "I'm not feeling good about it," and then look elsewhere. Way better to do that and hurt somebody — yes, they're going to be mad at you probably, but definitely the much better solution.

M: Along with being open about your fears, if you don't feel that you can say your secret wishes or hopes, then you're obviously in the wrong situation. If you're pretending that you're going to be more removed or distant than you want to be, that's a problem. If you're not comfortable in the situation, then you have to put the brakes on and question what's really going on here. I think that's true probably of just about any parent, but I think it's especially true for sperm donors, because, even if you have a really strong, positive gut feeling, you have to have some sense of why you're doing this. If it's fulfilling some sort of psychological need, that really needs to be looked at. If it's because you really want to give something to somebody else, that's good, but that needs to be looked at, too.

S: I just realized that in Arabic we have a word for mother and a word for father, but we don't have a word for parent. The same word that we use for parent is the word that you would use for your extended family. It just struck me how relevant that is. You don't have to be the father and the mother or the two mothers to be a parent. Any relations you have can be part of being a parent. It's very generally, who it is that can add something to the child. If

everybody let go of some of their stubbornness about how we define family, things might be a lot more relaxed.

R: What's the word?

S: *Ahel*. It could even be your neighbours or friends. Like in old villages and tribes everyone is your *ahel*. My *ahel* is everyone who can support me.

R: Like your community ...

S: Yeah ...

M: And a very active sort of participatory one ... the people who care for you.

My Co-World and Welcome To It:
Adventures in Non-Conjugal Parenting

Aviva Rubin

I HAVE NOT NOW, NOR WILL I EVER, SLEEP WITH THE MAN WHO IS THE father of my kids.

The Decision

It's 1998 and I'm sitting at the Inside Out Gay and Lesbian Film Festival in Toronto, watching a film about a camp for kids of queers in California, and I'm bawling. I've just come from meeting Rob and Norbert for the first time, the men with whom I'll have and raise two kids. We'd sat and had coffee and muffins on their perfect gay-boy deck and chatted about children and the crazy far-fetched idea of having some kids together. Essentially, it's Rob who wants to do this. Norbert, his partner of nine years, is willing (generously and perhaps naively) to come along for the ride. Rob and I are strangers who have a few things in common: We both want kids, neither of us want to do it on our own, we're both thirty-eight, and our parents — two short, cute, grey-haired, upper-middle-class Jewish couples — look quite alike. Who are Rob and Norbert? I have no clue.

The match between Rob and me came about rather serendipitously when Rob ran into a friend of a friend at a party. They talked about having kids, a topic they'd discussed some years before when last they'd met. He told her he might still be looking for a suitable match. She told him she now had a son with her girlfriend but knew a woman who might be interested. Supposedly, she asked him what kind of involvement he saw himself having in a kid's life and she'd laughed at his naïveté when he said "things like helping pick the

school they'd attend." He was a bit clueless in the baby department; there are a few things that come before school.

So I received a call from my friend offering me the number of a nice Jewish guy looking to have a kid. I called and left perhaps the oddest voicemail I'd ever leave, suggesting that if he was interested in procreating he might give me a call. And so the story begins. Rob, Norbert, and I started to date. After the first coffee on the deck, we stopped talking about kids and started to just hang out to see if we liked each other. They met my friends; I met some of theirs; we had fun. While I wouldn't change the choice I've made, I do have to say that raising kids is slightly more challenging than hanging out and going for dinner together. Despite our efforts to get to know each other, we really took a leap of faith. Even once the decision was made and the deed was done (surprisingly, it took on the first go), we knew a grand total of almost nothing about one another. Perhaps that's a wee exaggeration, but truly, the realm in which we would soon find ourselves was effectively foreign territory.

The Negotiations Begin

It was suggested that prior to the birth we write a contract to cover some of the critical elements involved in raising our child. These included things like custody arrangements, religion, an agreement to remain in the same city for a number of years, the roles our partners would play in the event of our deaths. We saw a lawyer, discussed things like shared decision-making, finances, and mechanisms for mediation in the event of an irresolvable dispute. We wrote up a contract, and then the baby came and we just never got around to signing it. Over the years our commitment to trying our best at this parenting thing, with all our flaws and idiosyncrasies, tripping up here and there, has become our contract.

We now have two sons, Noah is nine and Ari is five. They spend five (sometimes four) nights a week with me and two (or three) nights a week with their dads. Parenting and decision-making is shared, some of it between Rob and me, much of it among the three of us. And then, of course, there is the role of my partner, my ex-partner, my future partner …

You see, when we started out on our project I was on my own. Single. This was not the way I'd envisioned having children, but this was what presented itself. When the opportunity arose, I knew it was my moment. I had no desire to wait for the right person to come along, the person for whom the circumstances and timing were just right. She hadn't shown up

yet and there was no reason to expect that she would any time soon. But then I met Kathy. We started dating when I was six-and-a-half months pregnant with my first son. We took things slowly. By the time he was born, we still hadn't had a sleep over. She came to visit me in the hospital when the beautiful pregnancy glow had given way to a bloated post-partum haze and I was just lucid enough to ensure that my bum wasn't hanging out of the hospital robe. She started spending more and more time with us and got really involved in all aspects of caring for the baby. She moved in when Noah was ten months old. Now there was a fourth parent figure in the picture — sort of. More on that later.

So contract or no, the reality is you've got no clue what's coming, what will go smoothly, where the moguls, potholes, and cliffs lie, what will blow a gasket and what will move you with care and support through a crisis. You've got no idea how to deal with the situation when your kid brings home a lovely little Mother's Day plant for you and, oblivious, the dads unwrap it and put it out on their table. No contract and no amount of pre-planning can anticipate the myriad little events and decisions that come your way constantly. No amount of getting to know each other will prepare you for the weekly or sometimes daily calls home from the principal's office to the dads' house because they've forgotten yet again that *you* wanted to be called, the differences in discipline styles, the inconsistencies in approach to repeated requests to "buy me this and get me that," and the overwhelming emotion and negotiation involved in deciding whether to put your kid on Ritalin.

These things are gut-wrenching enough to deal with when you have a husband, spouse, or life partner. When you have none of these things, when the first person your co-parent talks to about these issues is his husband and not you, when you feel as though they are a united front, a hermetically sealed unit that you repeatedly try to crack, parenting life has an additional layer of challenges.

But then, of course, the fact of being free of all the bullshit that accompanies intimate relationships is, well, liberating. And the fact that the children will never be used as weapons in hostility laden revenge tactics when the love breaks down is one less cause for concern. Life is full of trade-offs, really. As I watch my friends and acquaintances, gay and straight, come together, have kids, split up, one of the things I'm grateful for is that Rob and I will never split up. Our relationship is all about our children. But that is not

to say that I won't split up with anyone and that it won't have its own set of complications. I have and it did.

Getting Pregnant

But back to the heady and exciting moments that started us on this journey ... getting pregnant, which is so much more of an orchestrated event for us queers. For the first go at conception, we had a little gathering at my friend Brenda's house, hors d'oeuvres and a bit of wine, followed by the extraction of the required substance. Don't want to think too hard on that. I mean, it is kind of weird when you think about it, though it did put me somewhat closer to the source of production than frozen sperm in a vial. I was presented with the syringe, and spent the next half hour with my legs up against the wall. God knows enough women have gotten pregnant having stand-up sex but, hey, somehow this gives you the illusion of control. Then it's off to an Indian restaurant. Two weeks later the pee stick reveals that the future Noah is on his way.

I think the fact that it happened on the first try took us all by surprise. Except for my father, of course, who said he knew it would happen quickly. When the tiny bun was beginning to cook, my parents decided it was time for a brunch. My dad badly wanted to post a large sign outside the door that said Welcome to the Sperm, but my mom wouldn't let him. The boys were a big hit. I suppose the fact that they looked "normal," not too gay, not too radical, not too downtown hipster artsy-fartsy, but presentable, solid and neat made my dad comfortable. My mom was thrilled that they were planning the baby's room, getting ready for full-on involvement. They were *in*, big time.

The Babies Arrive

So Rob, with whom I've shared none of the intimacies of full partnership, was a full-on participant in the spread-eagle event of our child's birth. Forget lounging-around-in-sexy-lingerie intimacy, this was way past fourth base — more like zero to sixty in four hours! But pain is a quick cure for modesty. (As it turns out, there was no spread eagle, just an emergency surgical removal, but the lead up to this event, an attempt at a home birth, was rather revelatory.)

Once the baby was ex vitro, like, here for real, the work of figuring it all out truly began. Turns out, Rob's comment about wanting to be involved in decisions about things like schooling was more telling than it was naive.

Norbert, on the other hand, the one "willing to go along for the ride," took to the first, then the second, baby like he'd always done babies. Soothing them, playing with them, caring for them came easily. Rob, while totally in love with the boys, somehow seemed to be waiting for them to do something a little more interesting than gurgling, pooping, and crying. I sometimes describe Rob as the gay, new millennium version of the 1950s dad. He sits reading the newspaper over a cup of coffee while chaos is brewing around him and practical needs demand attention. Norbert often says, "Ah, Rob … you have children." This observation always gets a laugh at parties, but Norbert doesn't always feel the fun.

I have the advantage and the disadvantage of not having to deal with that particular set of frustrations. I live a curious, complicated mix of single and multiple parenting. This requires non-stop negotiation, which can be tiring. I'm often alone with the kids when they're with me, while at their dads' place there are always two parents to share the work. I don't always feel that Rob and Norbert understand how different my experience is from theirs except in the obvious ways — my house is far messier and not nearly as nicely decorated. But this is my choice and I would not organize things differently with regard to the division of time. While having the odd weekend to myself is a lovely break, I would not want the kids to spend any less time with me. I think the set up suits us all. And since the kids have become a bit older, Rob has been hugely engaged, and no longer requires the poking and prodding he once did. It's nice to think that the beauty of multiple parents is that we bring a range of expertise to bear on the tasks at hand. I, for instance, do not do math homework and science projects.

So, once we had forged this complex arrangement, we thought that we might as well do it all again. At least Rob and I subscribed to that logic. Sadly, neither of our partners did. While the decision to go for a second kid may have been the beginning of the end of my relationship with Kathy, I can say with certainty that everyone fell in love again the minute Ari arrived. Mr. Happy Happy had landed.

Will the "Real" Parents Please Stand Up?

It is astounding to witness the resistance to the breaking down of traditional notions of relationships. On the face of it, we can create new models of family and community and break down traditional models by actually building alternatives, but the reality is that our insecurities at the deepest

level are still profoundly triggered by not having a clear role to play as defined by traditional, heterosexual, normative models. Who's your mommy? Who's your daddy? Who's got title? Who's got claim? And, more importantly, who feels they don't? Where do I fit into this picture? What gives me legitimacy? While the societal and legal boundaries are being stretched and redefined, in the best of ways (so that the gay couple and their kids that live next door are not really something to get all riled up about anymore, either positively or negatively), when it comes to parenting what ultimately carries the most societal weight is biology.

I guess we'd like to believe, particularly as politically and socially conscious queers and feminists, that our convictions and our actions will always move in tandem, that we will uphold our principles regardless of whether the outcome of these choices falls in our favour. That we will build and honour chosen family and not let it be trumped by biology and blood. But, in fact, sometimes the opposite holds true, at least it does for me, and I suspect it does for others, when our feelings and interests collide with our convictions and beliefs. I'll try to explain.

The year after Kathy and I split was horribly difficult. Noah was five and Ari was two. In true lesbian fashion and arguably in the interest of some kind of practicality, we stayed living together for a number of months. Not, I'd argue, the most healthy of situations. Living with anger, frustration, and sadness and trying to keep it all under wraps so the kids don't get engulfed in it was exhausting and, at times, short of successful. Add to that the fact that my five-year-old was having a hard time at school. One day, when Rob was over, he shared his opinion that Noah was having problems because of us. (I felt compelled to point out that his relationship with Norbert was not exactly always happy, either.) The damage was done. Kathy felt personally attacked and tremendously resentful of the comment (a reaction I believe was grounded in her insecurity about the legitimacy of her relationship with the kids) and what little good feeling was left between her and Rob, was shattered. I was caught in the middle — understanding her reaction, dealing with my own, needing to ensure that my parenting relationship with Rob and Norbert was overall smooth and decent. Goodness knows that in the context of relationships non-useful comments are made all the time. At a certain point, not being able to move past or through them becomes self-destructive. Now everyone was pissed. And then we faced the question of where Kathy fit in the post-breakup world.

While we were not the first queers to give this a whirl, this set up of ours was breaking new ground. There were few rules to follow, few models to emulate, and virtually nothing to read. While there are comparisons to be drawn with divorced and blended families, our breakup was something different with its own very particular pressures and concerns.

Regardless of how the adults were feeling, the kids were clear. Kathy was their "Titi" — their pet name for her — and they loved, trusted, and depended on her. They were surprisingly easy-going about the transition. We tried to make the idea of Titi's new space fun and exciting. Not long after Kathy moved out, she confronted me with her request for an overnight with the kids that she was willing to go to court for. She loved the children; she still loves them dearly. She had every right to spend time with them. However, I sincerely felt that the interests of the kids would not be served by adding a third home to their roster, and it certainly made me wonder where this would all end. Would my next partner want access as well? Between how many people would my kids ultimately be divided? While I'd like to argue that rational concern was driving my position, in great part I was driven by emotion. There was no more time with my kids for me to give up. I already felt that I didn't have enough time with them.

My hope is that if we are able to keep our eyes on the prize — the prize being happy, well-adjusted, hugely loved kids — things will work themselves out. Kathy and I now have a great friendship and she sees the kids regularly. She picks them up from school twice a week and has an evening with them every two weeks — it's an informal and flexible set up.

To queer co-parent is to embark on a hairy journey with no map and no guidebook. It's kinda like bushwhacking, and I'm not much of an outdoor girl. But we've made it this far relatively intact and on track (whatever track that might be). The kids are great; they seem pretty well-adjusted and they go with the flow. Their demands and disappointments are still relatively simple and straightforward, and are based on the age-appropriate stuff they want and sometimes don't get. They are surrounded by adults — friends, family, partners, and exes – whom they embrace with an openness and trust that sometimes almost hurts to watch. They know that we're kind of different, but they have yet to confront that difference in any painful or profound way. Ultimately, we hope and expect that our kids won't need any more therapy than the rest of us. This is our family.

To Bi or Not to Bi:
Bisexuality and Disclosure in the Adoption System

Allison Eady, Lori E. Ross,

Rachel Epstein, & Scott Anderson

Narratives shape the process of adoption. Through applications, courses, home study processes, and the creation of the parent profile, potential adoptive parents tell a story about themselves that influences their experiences with adoption workers, which children are placed with them, and even whether children are placed with them at all. In recent years, adoptions by non-heteronormative families, including single parents and LGBT parents, have increased in number, and practices pertaining to LGBT adoptive parents have become significantly more positive (Brodzinsky, 2003). However, the dominant narrative of adoption still gives priority to a particular type of family story and structure at the expense of others. Potential adoptive parents who present themselves as resembling the heterosexual nuclear family, consisting of a married, monogamous mother and father, seem more likely to have children placed with them (Riggs, 2007). Those who do not present heteronormatively sometimes have their stories reshaped for them, or face difficulties in the adoption process. This prioritization of the heterosexual, married couple as the ideal family model is rooted in assumptions about what is right or best for children, based on their parents' sexual identity and relationship structure, and does not acknowledge the existence and appropriateness of other family structures (Tobias, 2005).

When gay or lesbian people set out to adopt, it is often immediately evident that they do not fit the traditional image of the family that is favoured in the adoption system, particularly if they are adopting as a same-sex couple. The beliefs and expectations of agencies and individual workers can mean that gay and lesbian people are asked additional specific questions about their sexuality and relationships and how these might affect their children, about how children will be exposed to other-gendered role models, and how they themselves will fit traditional parenting roles (Riggs, 2007). By promoting the idea that LGBT parents are "just like" heterosexual parents, and expecting potential adoptive parents to demonstrate this through home studies and case presentations, the adoption process makes invisible those experiences that are undeniably different for LGBT parents and puts additional stress on LGBT adoptive parents by expecting them to conceal the identities and experiences that make them different. It also ignores the unique features of LGBT adoptive families that may, in fact, be an advantage for the children of LGBT parents (Riggs, 2007).

Research and policy related to LGBT adoption have tended to focus on lesbian and gay adoptive parents, ignoring the sometimes very different experience of people with other LGBT identities. A literature search turns up no research on the experiences of bisexual parents, although there is reason to believe that the experiences of a bisexual parent may differ in unique ways from those of a lesbian or gay parent. For instance, bisexual people might present in the adoption process as single people, as same-sex couples, or as couples who appear heterosexual, and adoption workers may assume them to be gay, lesbian, or straight. Bisexual people are shaped by unique social experiences and by social beliefs about bisexuality, which not only affect their mental health and well-being but also affect how adoption workers perceive their ability to parent (Ross et al., 2008). The decision as to whether or not to disclose their bisexual identity thus becomes an important one in the adoption process. If they choose not to disclose and are perceived as heterosexual, they may have to hide aspects of themselves, such as previous personal relationships or involvement in LGBT communities. If they choose not to disclose and are perceived as gay or lesbian, they may face heterosexism and have to deal with the negative perceptions of workers and foster parents, while still concealing a part of their identity.

If bisexual people choose to go through the adoption process with open-

ness about their identity, they can face the negative impact of common social beliefs about bisexuality. These include that bisexuals must have a fifty-fifty split in their attraction to people of the same or opposite sex, that they cannot be monogamous, that they are dishonest and cheat on their partners, that bisexuality is a phase or a transition, that bisexuals are wild and promiscuous, that they spread STDs/AIDS, that they can't make up their minds, and that bisexuality does not really exist as a legitimate sexual identity (Dobinson et al., 2003). These beliefs may also influence adoption workers' opinions about their lifestyles, personalities, and abilities to parent. Bisexual people's choice to disclose their sexuality during the process of adoption can have significant ramifications on their experience of adoption and can add significant stress to an already very emotional process.

The following stories of bisexual adoption are gathered from a qualitative study on LGBT adoption conducted in Ontario from 2006 to 2008. Using a narrative research model, we interviewed over forty single and partnered gay, lesbian, bisexual, and trans parents or prospective parents, asking about their experiences with the adoption process and the effects it had on their physical and mental health. Participants were at different stages in the adoption process, and included people doing international, public, and private adoptions, as well as open and closed adoptions. This essay focuses on the experiences of the five participants who identified as bisexual. Their stories illustrate how perceptions of bisexuality can affect adoption experiences, including decisions about whether or not to disclose sexual identity. These stories also explore the mental health consequences of the ways bisexual people are presented, and how they present themselves, during and after the adoption process. Pseudonyms have been assigned to protect the participants' privacy.

Amina's Story

For bisexual people, the issue of disclosure is central to the adoption process. Amina, a single, bisexual woman, was waiting for a placement through a public adoption agency at the time she was interviewed. She decided not to correct her worker when she was assumed to be a lesbian after discussing a previous relationship with a woman:

> I just felt like I would have had to explain more [if she came out to her worker] because then I would come across as more promiscuous. Of course this is me assuming, but I do believe there would have been more

questions … I just felt like I didn't want to go there with her.

Amina chose not to disclose her bisexual identity because she feared the impact of her worker's preconceptions about bisexuality. As a result, she was presented throughout the process as a lesbian prospective parent, and she could not openly discuss her relationships with men:

> It was weird because I couldn't really tell her about certain things. You know, when they ask you personal questions about who you dated last and why was that not working or whatever, and it was a man so I just didn't mention it. So I withheld information because I was uncomfortable about it, because I felt it wouldn't impact the adoption or how I would be with a child … I felt like it was irrelevant.

Similar to Amina, the two participants who identified themselves as bisexual and who were in same-sex relationships were defined as lesbians in the adoption process. Although they identified on our screening form as bisexual, neither of these people spoke about their bisexuality in the interview.

Bisexual couples in opposite-sex relationships face different issues as they can more closely resemble the idealized heterosexual couple. This can be both a benefit and a source of discomfort. The two bisexual couples in heterosexual relationships that we interviewed chose to disclose their bisexual identities, and this decision affected them in very different ways. Their decisions to disclose may be related to the invisibility that bisexual people in heterosexual partnerships often experience. People in same-sex relationships are recognized as queer, while a bisexual person partnered with someone of the opposite sex must consciously make her/himself visible in order to have her/his queer identity recognized.

Miriam and Josh's Story

Miriam and Josh are a bisexual couple who were perceived as heterosexual by their private adoption worker through most of the process of adopting their daughter. Their adoption had been completed at the time of the interview. When asked about past relationships, they tried to disclose their sexual identities to their worker but felt the worker indicated to them in subtle ways that he did not want to hear about past same-sex relationships, even though these relationships were part of their history as a couple and as individuals. Josh said, "He had made it clear that he did not want to hear about us being involved with same-sex partners … you got the message that it was best not to discuss that."

This perception that they should not talk about same-sex relationships that had taken place during a separation, along with other assumptions the worker made, for instance, that they were married, made the couple uncomfortable. They decided to not discuss their sexuality any further with their worker, because after comments he made about same-sex marriage, they were concerned that he might be homophobic. However, their involvement in LGBT communities came up again when a police background check revealed that the man had marched in the Pride Parade with a group of nude men. Their worker then had many questions about their sexuality and relationships. Miriam told us:

> He started to question us about whether we were monogamous. He started to question what kind of same-sex relationships we had … it was clear that he thought that us being bisexual and Josh being at Pride meant that we obviously had relationships going on with same-sex partners … which would not be a good thing … So that was very clear, that being a same-sex couple is one thing, but not being monogamous, forget it … I guess it goes together with his assumption that we weren't monogamous if we're bi …

After this, the worker mentioned that he thought the government agency that regulates adoption would not accept the couple if it was known that they were bisexual and wrote the incident up in their file as if nudism was a hobby for Josh, in effect erasing the political meaning it had for him. This experience left both Josh and Miriam, during the rest of their adoption and probation period, reluctant to be involved with any leftist or LGBT public events where there was any chance of police showing up, for fear of how it might impact their adoption. Josh recalled his feelings about this:

> That sort of stuff like being bi … that barrier around it turned into another thing I could do wrong, not being bi itself, but going to Pride Day and getting another [record] and then their reaction … it could really be a disaster … that was like a whole other layer on us… Going to Pride is a happy thing for me … it was a fun group [Totally Naked Men], it's a positive group, and it's part of the culture in a certain way … I feel almost that there's a bit of community that I haven't gone to as much, we're very careful not to go, we haven't gone to demonstrations as much … being under that judgement is a real burden on me.

After their adoption was finalized, Miriam and Josh felt more comfortable attending public events and demonstrations, as they were no longer worried about jeopardizing the process through their involvement in political demonstrations.

Matthew and Brenda's Story

Matthew and Brenda are another bisexual couple who had a very different experience.

While overall theirs was a positive experience, they went into the process having heard negative stories about their agency's capacity to work with bisexual people from another couple who were fostering. This couple included a bisexual woman (Lynn) who was married to a man, and who chose to not disclose her bisexuality while fostering because she was concerned that she would be discriminated against by the agency. She and her husband left the fostering system, despite having taken in foster children for years, because of workers' reactions when they found out about her sexuality, and that she was in a relationship with a woman, as well as the man she lived with. As Lynn remembers:

> They made this whole thing [out of it, saying], "Well, you didn't tell us you were bisexual, and who's looking after the kids when you're out?" …
> Well, it's my husband, it's no different than if I was going out with some friends to a movie. I just happen to have one person in particular and, yes, I happen to sleep with her. I'm not neglecting the children! But it was made into a very big deal.

The adoption worker was uncomfortable with her sexuality and her relationships, and made assumptions about how her sexuality would influence her parenting. The reaction of this worker to her disclosure illustrates the potential harm common social beliefs about bisexuality can have and makes the reluctance to disclose on the part of some bisexual people quite understandable.

Brenda and Matthew chose to tell their workers from the start that they were bisexual, and volunteered to foster older children who were LGBT themselves. Their adoption worker did not react negatively to their coming out. They were never placed with LGBT-identified children, but this could have been because there were none in the system requiring homes at the time or because the couple had expressed more interest in younger children. Brenda and Matthew felt that they had an advantage in adopting because they looked like a traditional straight family, despite their involvement in LGBT communities. Brenda explains:

> I think the key was because we look like a heterosexual couple. We're both bisexual but we happen to be married to someone of the opposite

gender. And we're in a monogamous relationship ... we actually did the whole marriage thing ... our relationship doesn't look different, even though I'm very involved in the bi community ... we take our kids to Pride every year ... we have lesbian friends who have adopted children that we hang out with ... Even though we may look like a straight family, that's not how we live.

Brenda and Matthew found their resemblance to a straight couple to be an advantage. They had an overall very positive experience with their adoption agency, eventually adopting three children, and their identities as bisexual people were not an issue during the process. They did not disclose their bisexuality to any workers other than the one doing their home study, and did not mention it in their profile, so it was also likely that no one else working with them was aware of their sexual identities. However, the fact that, after their initial disclosure, their bisexuality was not mentioned again, could also be due to the worker's discomfort, unwillingness, or lack of understanding. Matthew felt that the workers did not understand the unique experiences and issues faced by bisexual people: "When we came out in the home study, they went, Okay, well whatever ... and just moved on, because they wouldn't understand all the complex issues that the bisexual community faces." While Brenda and Matthew had a positive experience in the adoption process, their resemblance to a heterosexual couple meant that they were treated as one, and they felt their sexuality was made invisible by the process.

To Bi or Not To Bi: That Is the Question

Based on the accounts above, it appears that knowledge about bisexuality is lacking in the adoption system. Adoption workers need to become familiar with the identities and experiences of bisexual people, as well as with the common beliefs about bisexuality and how they can impact negatively on mental health and well-being. As well, just as the adoption system is beginning to recognize the resiliencies developed by lesbian/gay people as an asset in prospective parents, a similar argument can be made for the strengths and understandings that emerge from bisexual experiences.

The issue of disclosure is crucial to bisexual people, as their identities are often not visible. Negative social beliefs about bisexuality lead to apprehension about disclosure and fears about the impact on the adoption process. These fears would be reduced by adoption policies that recognize the

existence, experiences, strengths, and rights of bisexual people (as well as lesbian, gay, and trans people). Adoption workers will require learning opportunities to increase their familiarity and cultural competency in this area.

People who are out as bisexual in the adoption process may face biphobia or monosexism, and individuals or couples who choose to not disclose their bisexuality often feel invisible and face the stress of hiding their identity and fear of being found out. Decisions about disclosure are not easy and can seriously influence the adoption experience. However, it is important for bisexual people who are considering adoption to recognize that, despite the difficulties they may encounter, it is very possible for them to successfully adopt, and that the system is gradually making improvements in its dealings with LGBT people. The adoption process, for all prospective adoptive parents, regardless of sexual orientation, can be challenging and sometimes stressful.

Prospective parents, especially bisexual ones, require support during the adoption process, from adoption workers, friends, family, and community. In particular, it is helpful to talk to other LGBT people who have been through the process. We asked the parents we interviewed what advice they would offer other bisexual people thinking about adoption. Here are some of their suggestions: explore your options in terms of agencies you can work with; if you're not comfortable with the one you're in, see if there is another option. There is a lot of pressure to disclose everything during the home study, and adoption workers can often tell if you are withholding information. It's best to be honest about your orientation, but be cautious in your choices about whether to talk about polyamory or non-serial relationships, and be careful in how you present them. It seems that adoption workers' assumptions have more to do with monogamy than with sexual orientation. When you disclose your bisexuality, it's helpful to talk about how your coming out process, experiences of discrimination, or involvement in LGBT communities have affected you as a person, and how they will be an advantage to you as a parent. Finally, don't give up! Despite the difficulties that some of them faced, four out of five participants have successfully completed an adoption, and while one is enduring a long wait for a child, she remains hopeful that a child will be placed with her.

Postscript: The fifth participant mentioned above has now successfully adopted a baby boy.

REFERENCES

Brodzinsky, D. *Adoption by Lesbians and Gays: A National Survey of Adoption Agency Policies, Practices, and Attitudes.* New York: Evan B. Donaldson Adoption Institute, 2003.

Dobinson, C., J. Macdonnell, E. Hampson, J. Clipsham, and K. Chow. *Improving the Access and Quality of Public Health Services for Bisexuals.* Toronto, ON: Ontario Public Health Association, 2003.

Riggs, D. "Reassessing the Foster-care System: Examining the Impact of Heterosexism on Lesbian and Gay Applicants." *Hypatia* 22, no. 1 (2007): 132–148.

Ross, L.E., R. Epstein, C. Goldfinger, L.S. Steele, S. Anderson, and C. Strike. "Lesbian and Queer Mothers Navigating the Adoption System: The Impacts on Mental Health." *Health Sociology Review* 17, no. 3 (2008): 254–266.

Tobias, S. "Several Steps Behind: Gay and Lesbian Adoption." In S. Haslanger and C. Witt, eds., *Adoption Matters: Philosophical and Feminist Essays.* Ithaca, NY: Cornell University Press, 2005.

The Revolutionary Artist Mom and Baby League:

Putting Young Queer Parents on the Map

Rebecca Trotzky-Sirr

The first time I went to an LGBT parenting meet-up in 2003, I had sought it out because I wanted to connect with other parents who were like me: who didn't fit the images staring at me from magazines in the checkout lane, who weren't hetero-married-suburban, and whose main worry wasn't choosing colours to paint the baby's room. Sadly, even in the LGBT parenting community, I was surprised by how few common experiences I shared with the other moms. I was closer in age to the children in question than to the parents to whom the meeting was geared. Sure, we shared common banal motherhood frustrations, like the ones headlined on parenting magazines at pediatricians' offices ("Baffling Kid Behaviour — Explained!!"). Still, pregnant at nineteen, I was decades younger and earned tens of thousands less than most. Working two part-time jobs meant no family vacations to stress over; no health insurance conundrums, either — neither job offered benefits. No, we didn't go to the cool mom-and-me yoga classes in the queer-friendly neighborhood. We lived in the bad side of town, so play dates weren't happening at our house. In the end, the traditional LGBT parenting groups alienated me as much as the traditional straight parenting groups. I felt like the odd-mom-out.

As my child grew through preschool, I became close to a number of other young queer, and otherwise non-traditional, mothers. At first we met over the Internet, slowly meeting face to face in coffee shops. We came to form a political parenting collective we called the Revolutionary Artist Mom and Baby League (RAMBL). The support we gave each other was crucial, the political work we did was meaningful, and our reasons for coming together spoke to broader social issues relevant to any queer parent or anyone working with young parents. Short-lived though it was, I want our collective to claim a place in queer parenting history. So here goes.

*

"Whenever I bring my kid, everyone assumes I'm straight," explains Sarah. She sighs, "If you know I'm a teen mom, it's like I can't be queer. If you know I'm queer, then I can't be a mom." Sarah's identity crosses many boundaries — queer, young, single, and a mother. There are not many playgroups she feels welcomed at or many queer community scenes that open their arms to her kid. But why should that be? The link between teen motherhood and sexual orientation is not new. Researchers reported in 1999, after analyzing the results of a survey of high school students, that "bisexual or lesbian respondents were about as likely as heterosexual women ever to have had intercourse, but they had a significantly higher prevalence of pregnancy" (Saewyc, Bearinger, Blum, and Resnick, 1999). Although there is no way to determine why queer teens report higher rates of pregnancy in this survey, we know that queer youth suffer higher rates of homelessness, abuse, and inability to access appropriate reproductive healthcare and preventative services. Unfortunately, few community organizations or health professionals recognize the distinctive needs of young, queer parents and the reproductive healthcare needs of LGBT youth often go under-addressed and unmet.

Young parents are also faced with the commonly held presumption that their experience will always be completely negative. Fiercely pro-choice, and rooted in radical gender theory, the now-defunct girlmom network (www. girl-mom.com) was unique in the teen-parenting scene. Allison Crews, a queer mom at sixteen who edited the girlmom peer-support and education website, explains: "As young mothers, we all know what it is like for our reproductive choices to be questioned and judged as 'deviant,' or wrong, by the rest of society." She continues,

We believe that in order for teen parents to succeed, they must be encouraged to do so and assured that they are capable. Degrading, vilifying, marginalizing, and rejecting teen mothers (as is customary in our society) is counterproductive and illogical ... When a teenage girl finds herself pregnant, it is one of the few times during her life course where she will not only be expected to fail, but socially encouraged to fail. (Crews, 2004)

United over the web, a handful of girlmom members started to meet at a coffee shop in Minneapolis. These meetings evolved into the formation of a peer-advocacy group, to discuss and support mothering in face-to-face conversations. In the cold Minnesota winter of 2003, a dozen young mothers founded the Revolutionary Artist Mom and Baby League to fuse progressive politics with the personal realities of parenting. A description of our organization reads: "RAMBL women include young, poor, queer, in recovery, on welfare, sex workers, going to school, working outside of the home, working at home, dropouts, pro-choice, trying-to-conceive, and in-your-face women." Members included Susan, a twenty-two-year-old queer punk trying to conceive; Katrina, who was ending an abusive relationship with her baby's dad and was engaged to a female-to-male trans partner; and Nori, who was heading back to college as a feminist-partnered sex worker, pregnant at nineteen.

The collective spirit of RAMBL was built more on sharing the political forces that marginalized moms bump up against than on a homogenous cultural identity. Many of the mothers first tried traditional parenting groups, focusing on attachment parenting, early family community education classes, or playgroups at libraries. All too frequently, our young moms were deeply uncomfortable in these situations. Comments such as "Oh, you are *such* a good nanny!" or an incredulous *"You're* her *mom?"* met our ears more than once.

The majority of RAMBL moms identified somewhere on the queer spectrum. This made the use of traditional "young parenting" services somewhat awkward. Some teen-mothering programs focused on building relationships with your boyfriend, with an implicit goal of marriage being idealized in the majority of curricula.

Turning to LGBT parenting groups for support, RAMBL moms found the age, income, and culture gap to be challenging. Without health insurance, two cars, home ownership, or college education, the realities of

daily life were substantially different than the upper-middle-class — dare I say Yuppies — present at these meetings. Omnipresent lavish baby gear — thousands of dollars for luxury strollers, car seats, slings — were visual reminders of income and status inequalities. Formal LGBT parenting conferences discussed issues that were not pertinent to younger, poorer families. Younger queer women who wanted to parent could not access official channels of sperm banks and adoption agencies. Legal intricacies of second-parent adoptions were beyond the financial means of our households.

Moms in RAMBL worked to blend practical support for everyday living with an eye towards social justice. Our mission stated, "We're a POLITICAL group fighting for peace, reproductive rights, and autonomy and respect for all mamas. But we're also a SUPPORTIVE group having toy and clothes exchanges, playgroups, homework and tutoring nights, and we're trying to develop an affordable housing co-operative for moms and kids." For the three years that RAMBL organized, we had various successes in articulating our precariously balanced lives.

In addition to working with existing youth-parenting organizations to make them more queer friendly, RAMBL moms organized our own autonomous events. Biking in the fall rain, with kids bundled up in burleys, we held a party to celebrate teen mothers at District 202, the local queer youth centre. Teenagers and tykes rocked out to DJ trance music, while members passed out community resources and zines. In addition to creating successful community events, we had regular meetings that became a much needed "check-in" time for our members. The child-care provided at these meetings was, for some of our single moms, the only kid-free time in the week.

Later, we presented at a national LGBT parenting conference in Minneapolis about the issues specifically facing younger queer moms. Like the way our trying-to-conceive young mom was denied access to sperm banks not because she was queer but because she was young. The most difficult stories included one teen mom's experience of being pressured to put her unplanned (but wanted) baby up for adoption, the implied message being that she was too young and too poor to parent successfully. She felt uncomfortable attending a conference with some of the same adoption agencies present. But she did it in the hopes that things could change for young women who followed.

Besides social supports, healthcare was an issue for many RAMBL moms.

As a young mother, prenatal care was alienating. Some thought disclosing issues related to sexuality would jeopardize their ability to access quality healthcare. Real or not, there is a perception by many teen moms that healthcare providers will report young parents to child-protective services for small infractions, so they did not disclose potentially "controversial" factors, such as sexual orientation. Engaging with social service agencies to receive food stamps or welfare meant our lives were under the microscope. For example, after my child was born, a social worker stopped by my apartment to ask me if I ever put alcohol in my baby's bottle or if I fed my baby junk food like soda and chips. I'm not sure if these types of questions are asked of older parents, but I doubt it.

Sadly, the pulls of our lives inevitably meant that RAMBL was put on the back burner while we struggled with the realities of making rent, finishing school, and taking care of our kids. We all went on to new challenges. I began medical school. My child started kindergarten. We moved forward.

Now that I am finishing medical school, I can attest to the health-care provider side of things. Unfortunately, many healthcare providers do not understand the social and economic issues of young parents or of queer parents. I know that most providers struggle to simply provide dignified prenatal care, so expecting healthcare workers to understand the complexities of a youth's sexual identity is a lot to ask. However, the concept that some teen moms are not straight is important to acknowledge as it allows for open lines of communication between provider and patient.

Reviewing the medical literature for the various iterations of homo-sexual (queer, lesbian, blah blah) *and* young parenting (teen, adolescent, blah blah) reveals fewer than ten articles among hundreds of thousands of articles about pregnancy and parenting. An extensive Google search for community organizations results in a similar lack of information. Clearly, it is difficult for academics and society at large to acknowledge that not all adolescent parents are straight. One academic article accur-ately reflects my community's experiences: "Health Concerns of Sexual Minority Adolescent Girls." It appears in a 2006 issue of *Current Opinion in Pediatrics*, and the authors encourage healthcare workers to remem-ber that "sexual minority youth are not solely dealing with their sexual orien-tations during adolescence. Each of these adolescents has a multifaceted identity, including race, ethnicity, religion, socio-economic background, and family structure" (Brown, 2006: 359). Issues of teen pregnancy and

sexual orientation should not be seen as disparate categories but rather as part of the multiple, intersecting identities of young people. I am glad to bring one more article to the table.

For its brief existence, RAMBL exemplified the strengths of young mothers working together to build a community responsive to the needs of all kinds of families. Though the organization no longer exists, the informal network of young queer moms remains in Minneapolis. Susan's boy just turned four. Katrina and Jason are getting married. Nori is on her way to law school. Imagine what young parents could do if they received that kind of support and welcoming from teen-parenting programs and from the queer community.

REFERENCES

Brown, J.D., and M.W. Melchiono. "Health Concerns of Sexual Minority Adolescent Girls." *Current Opinion in Pediatrics* 18, no. 4 (August 2006): 359–364.

Crews, Allison. "Girlmom Mission Statement and User Agreement," 3 October 2004. Available online at www.girl-mom.com/node/3126.

Saewyc, E.M., L.H. Bearinger, R.W. Blum, and M.D. Resnick. "Sexual Intercourse, Abuse and Pregnancy among Adolescent Women: Does Sexual Orientation Make a Difference?" *Family Planning Perspective* 31, no. 3 (May–June 1999): 127–131.

Beyond Thomas Beatie:

Trans Men and the New Parenthood

Maura Ryan

In November 2008, Thomas Beatie announced his second pregnancy. This second announcement, like the first, ignited a media frenzy: his pregnancy has landed him interviews with Oprah, Larry King, and Barbara Walters, as well as coverage in *The Advocate* and *People Magazine*; his photo has been splashed across TVs and newspapers — a partial profile of a very pregnant man. The first pregnant man in history, many headlines claimed. The tone of the coverage has been a mixture of media sensationalism, a somewhat genuine societal reflection on the fluidity of gender, and tabloid-style exploitation. To say the least, he and his pregnancy have caused a stir. Not everyone has applauded him for his efforts. Even some trans men are critical of his decision to make his story public because they know that visibility does not always mean acceptance. Ryan, an online reader of an article about Beatie, left this comment: "I wish this jerk hadn't gone public. Now other trans men are facing hate because of it. Like if this guy does a female thing we must all be women, too. What a selfish ass!" ("Even Oprah Can't Spark Trans Love," 2008).

Regardless of individual responses to Thomas Beatie, by putting his life and pregnant male body in the spotlight, he has created space for a new social category that, for many, had not previously existed: a pregnant man. Beyond inspiring people to rethink the fixed "naturalness" of maleness and femaleness, he has encouraged us to rethink the legal and social definitions of what it means to be a father. Many people wanted to know, *if he births a child, won't he be the child's legal mother and therefore **not** a father?* The answer: in

Oregon state law, he will be listed as the birth mother immediately following the birth, but he and his wife can then petition to list him as the father and her as the mother, as usually occurs with surrogacy births (Heller, 2008). As well as setting legal precedents, he has demonstrated the complexity of a fathering identity. A father is more than someone who contributes sperm to the formation of a fetus. As Beatie contends, he "used [his] female reproductive organs to become a father" (Goldberg and Thomson, 2008). And further, "It's not a male or female desire to have a child. It's a human desire" (Conlon, 2008).

Of course, Thomas Beatie was not the first trans man to become pregnant and he was certainly not the first trans man to be a father. Although medical advancements that allow for physical transition are relatively new, trans-identified people have always raised children. In so doing, they have bravely created space for themselves as part of an institution that was not designed to include them. Contrary to media conversations about Beatie, I would like to suggest that what trans men juggle is not the supposed baffling conundrum of how someone born female could be a father, but the rigid rules of gendered family life set up by other people. In maintaining their right to be parents, trans men have been active agents in challenging what it means to *father* a child.

This chapter is based on in-depth interviews with ten female-to-male (FTM) trans people at various stages of physical transition and family life. Some of the men I interviewed began identifying as trans after becoming parents, some of them had identified as trans for some time before they became parents, and some are trans-identified and currently planning families. Four participants are parents who were already raising children — either by birth or non-birth parenting — before they transitioned: two are fathers who planned their families after they transitioned to male; and four are trans men planning families: three are planning to become pregnant and one is planning for his partner to get pregnant. The details of the three trans men who plan to become pregnant are as follows: one of them is in pre-testosterone therapy; one is "no-ho" in that he does not plan to take male hormones; and one has stopped taking testosterone in order to become pregnant. All of the participants live in major U.S. cities.

This essay explores the unique experience of trans parenthood, including the ways in which parenting identities are situated within experiences of transphobia and in queer communities. The complexities of trans parenthood

offer a particular lens for viewing the world, parenthood, fatherhood, gender equality, and children's gender choices.

Transphobia, Trans Oppression, and Parenting

When trans people want to become parents (or when parents begin to identify as trans), they face a potent cocktail of gendered assumptions and gender oppression, specific to being a parent. In other words, parenting is a gendered enterprise. It is tied up with assumptions of natural maternal instincts to nurture and paternal instincts to provide. Families are laden with the cultural imperative that there are two and only two gender categories (male and female) and that children should be raised by one of each. Not only do trans people face an unfriendly legal system in creating their families, they have to deal with the personal reflection on their gender identity brought on by parenting.

Much like gay and lesbian parents, the trans parents I interviewed told me they had experienced structural and ideological barriers to building their families. They had to navigate the social terrain of transphobia — the extreme fear and dislike of people who defy cultural assumptions of maleness and femaleness. Many identified as queer and two, as gay men. These men are juggling the intersections of transphobia and homophobia.

Transphobia and homophobia function differently. When a trans man is in a relationship with a woman, it may seem that he reaps all the societal benefits of heterosexual male privilege. When Jackson (all names used in this chapter are pseudonyms created by the author; only Jayden chose his own pseudonym), a parent raising two children with his female partner, told his parents that he planned to transition to male they said, "Oh, well — now at least your kids will have a father and a mother." Although they did not celebrate his transition, his parents' heterosexist belief that children should be raised by a different-sex couple made it bearable for them. Similarly, Dallas, who is separated from his daughter's mother, told his child that even though she was not used to it, it might be easier for her to refer to him as "dad" when she tells her friends she is going to visit him. As he explained, "It would bring the questions down to zero because other kids have divorced parents." Because of decisions like this, Dallas says that his transition "normalized [his daughter's] life in a way she didn't expect." Although statements like these may make it appear that transitioned trans men in heterosexual relationships shift into a more privileged family sphere,

transphobia continues to heavily contribute to their family experiences.

The difference between homophobia and transphobia is not just a matter of a central focus on sexuality or gender. The public, in general, is much more familiar with gay and lesbian issues than they are with trans issues. Justin, a young father of twin boys, told me, "Gay men and queer women — it's like it's normal for them to have families. It's expected now. It's not expected that a trans person and their partner or trans people in general will have kids." The consequences of this invisibility lie in a lack of social scripts for dealing with trans parents and in trans people having fewer support networks than gays and lesbians. All of the folks I interviewed told me they knew trans men who did not want to be "outed" as trans to their children. It is, therefore, significant that the fathers I interviewed — people who agreed to be interviewed as trans parents — were all out trans people. However, these out trans participants had FTM friends who either chose not to tell their children about their trans identity or who chose not to have children because they are trans.

Justin, commenting on the relative normalcy of gay parenthood and the resistance some trans men have to trans people parenting, told me:

> Somehow [trans people] shouldn't be parents for some reason. Somehow ... being trans and being a parent shouldn't mix. Like, it's just too out there. Even just from other trans guys, you know [they say], "It's cool that we transition and it's fine and we function as men in the world," but then they liken [my parenting] to lying to my children. Like being this father to them is a lie because I'm not their real father or whatever. Even though to me, I am their father.

In addition, gay and lesbian parents have more social supports than do trans people. Austin, a young gay man planning a family with his partner, said:

> A lack of community is part of [the challenge of being a trans parent] because even lesbian parents have their groups and so do gay parents. There are gay dads associations and stuff, and I don't know if I would join one, but there's a community. There are so few trans people having children and they're so spread apart.

Austin is not alone in his experience of a lack of community. All the participants expressed a lack of support for trans parents in queer communities. Beyond the social community support many people find vital to the maintenance of their families, we can imagine that institutional

support for trans parents is also minimal.

Trans parents are so invisible in cultural imagination that often gay/ lesbian people — who are vilified but at least acknowledged in the public sphere — fair better than trans people in maintaining their families. For example, when Dallas told his lesbian ex-partner, Sheila, that he would be transitioning to male, she told him, "You do this and you'll never see your daughter again." Moving quickly, Sheila legally ensured that for the early part of their trial, Dallas could only see his daughter during supervised visitations. Their daughter, who was five years old when they separated, lived with Sheila and had no contact with Dallas during their custody trial. During the custody hearings, Sheila claimed that Dallas would be an inappropriate figure in their daughter's life, focusing attention on his history in the leather community and his being trans. Dallas was only able to request visitation of his daughter because he was legally recognized as his daughter's parent under Washington State's second-parent adoption program for same-sex couples; if they had not gone through this process or if they lived in a state where this was not possible, he would have had no legal rights to his child. Still, Sheila's ability to sue for sole custody and to keep Dallas from seeing his child during a lengthy trial was possible because of her privilege as the biological parent of their child and her identity as non-trans. After years of dispute, the courts agreed that Dallas could visit with his daughter every other weekend and on some holidays. This only occurred after he spent time, energy, and a considerable amount of money proving to the court that having a trans parent does not violate the best interests of the child.

In many ways, child custody for trans parents is uncharted territory. With very few legal precedents, it is hard to know what to expect. However, there are some positive developments in the legal area. A well-known 2002 American case granted Michael Kantaras, a trans man, custody of his children. His ex-wife claimed that he had no right to custody because Florida State law does not recognize children from same-sex marriages or same-sex adoption, but the court found him to be the legal *father* of his two children and granted him custody ("Transsexual Dad Wins Landmark Custody Case," 2003). Canada also saw a landmark case for trans parents when, in 2001, an Ontario court declared that a trans woman, Leslie Forrester, could retain custody of her biological child, setting a family law precedent that transsexual status alone should not be used as a factor in

whether or not someone is a good parent (Owens, 2001).

Dominant family ideology demands that all members of a family be biologically related in order for them to be considered an authentic family unit (Smith, 1993) — a criteria that affects anyone in a queer family. While many trans men reject the traditional privileging of biology in family relationships, some of the participants did express feelings about not being able to produce children the way other men do, by contributing sperm to the formation of a child. As Dallas says, there is a "grief around not procreating that way." For these participants, not being able to procreate like other men can lead to fears that other people may read them as less authentically male. For instance, Clay, who is planning a family with his female partner, told a story about talking to his fiancé's father about another infertile man. Her father kept referring to the man as someone who "shoots blanks" and Clay wondered to himself, "What does he think of me?" Highlighting the complex situation of someone existing as a non-biological father and a trans man, Jayden said that he fears that one day his child might say to him, "You're not my father. You're not even a man!" For some, their inability to procreate as male people means that their masculinity is subjected to an unanticipated scrutiny. Justin explains his feelings on the topic:

> We obviously need to be "real men" to have children and like I don't know ... I'm just a man in my everyday life ...whatever that means to people. It's how the world perceives me. It's who I am in my home, it's who I am with my friends, and I don't think about it. I didn't think about being trans and being a man until we were at the point where we were ready to have kids. I didn't have to question who I was, it was just out there. And then it was hard to know that this was something as a man that I couldn't do.

Justin and his female partner chose an anonymous donor from a sperm bank to impregnate her. He says that this left him "feeling alienated" from the process of procreation and like his "masculinity had been kicked around on the floor." Some participants experienced the negotiations around their biological connection to their children as an assault on their gender identities as men.

For other interviewees, the notion of having a biological connection to children that was physiologically female was also problematic. With surrogacy prices out of range and the perception that adoption agencies would not view trans parents positively, pregnancy became a viable option

for some. Lance, who is planning to have children with his non-trans boyfriend, told me that even though he knows pregnancy is their most effective option to have children, it would "bring up a lot of gender shit" for him. Specifically, "the fact that pregnancy is associated with all things feminine would definitely trigger me." The trans men I interviewed who had been or planned to be pregnant conceptualized themselves as men who had the unique opportunity to be pregnant. In short, they were pregnant men. However, they feared that most of society would not understand how to treat a pregnant man.

Austin, who at the time of the interview was trying to get pregnant, told me that when he is pregnant, he plans to leave his home only for visits to the doctor's office. Many of the couple's gay male friends do not know that Austin is trans and they plan to tell their friends that they employed a surrogate to become parents. His plan to stay in his home and to hide the pregnancy from their friends highlights Austin's understanding that pregnant men are culturally unrecognizable. Although the practice of trans men getting pregnant is becoming more common and many trans men are out and proud about their pregnant status, Austin was uncomfortable because he is aware of the cruelty that can ensue when assumptions of maleness and femaleness are challenged.

Trans men respondents who had children — whether through pregnancy or non-biological parenting — before they transitioned to male, often experienced a disconnect between the way they saw themselves (as parents or fathers) and the way other people saw them (as mothers). For instance, Samuel said that before his transition his son would explain to people that he "had two mommies." When asked if he ever felt like his son's mother, Samuel responded, "No. Never." Likewise, Dallas said that people — especially other mothers at parks and shopping centres — would assume that he was a mother like them, but that he never felt (or looked like) other mothers. When I asked him when he started to feel like his daughter's father, he said, "Always. There was no shift except that I was being seen that way. So I was finally being seen [as her father] once I transitioned." It is through physical transition — which can be cost-prohibitive for some men — that the social world will deem them the fathers they see themselves to be. Realizing this, many of the younger trans men I spoke to — who had more knowledge about the possibility of being trans and more access to transitioning — told me that they wanted to transition before they had

children or when their children were very young so that their kids would always see them as a father.

Fighting for the "T" in LGBT Parents

I am not trans. I am, however, a queer person who understands that homophobia and the cultural fear of gender transgression are intimately tied to one another. I am a queer person who believes strongly that no LGB movement can flourish if it forgets that the modern gay and lesbian movement was sparked by so many brave T people (Rivera, 2002: 82–85). As an ally to trans communities, as someone who has had friends, partners, and chosen family members who are trans, and as a researcher who spent time talking to trans parents, I believe that queer people have a particular responsibility to ensure that trans families get the same kind of social and institutional support offered to mainstream families. Although LGB communities are certainly not the only people to ostracize and oppress trans people, we have a unique way of doing it. We also have a unique responsibility to include trans people in our efforts for rights-based social change.

The exclusion of trans people from mainstream gay and lesbian concerns has presented a divisive problem in LGBT communities for a number of years (Broad, 2002; Califia, 2003: 86–90; Feinberg, 1999: 98–99). Furthermore, Terry Boggis (2001) has suggested that gay and lesbian parenting communities are often more politically conservative than other gay and lesbian spaces. Don't get me wrong — there are plenty of gay and lesbian individuals who have beautifully radical ideas about raising children, and radical queer parenting communities certainly exist. However, in the interest of securing rights for families headed by gays and lesbians, some leaders of the gay and lesbian parenting movement have presented a conservative, gender rigid, and "normative" portrayal of what it means to be a gay or lesbian family.

Because the LGB community has historically had difficulty agitating for trans rights and because gay/lesbian parenting communities often have an interest in presenting a conservative community persona to people in power, trans parents are most often ignored when queer communities think about issues of gender and sexual marginalization in parenting. There is also virtually no academic scholarship about the experiences of trans parents (Hines, 2006).

Participants in this study expressed frustration that queer communities

pay very little attention to the specific concerns of trans parents. Think about your own communities. Are there information sessions at the local LGBT community centre about how to plan families if one or both partners are trans? Are there support groups for trans parents? Are there play groups for children of trans parents? Most major cities have these things for gay/lesbian parents and/or children of gay/lesbian parents; most major cities do not have these same resources for trans people and their children. An easy response says, "Well, there aren't enough active trans people in our community to create these resources." Perhaps there aren't enough active trans people in our communities because we do not actively create resources for them. I believe it is time that we begin building a queer community that serves all its members. In queer parenting communities, it is time we include the parenting experiences of people who are oppressed for any transgression of hetero-normativity — whether by sexual (LGB) or gender (T) difference. In hopes of illuminating some of the unique benefits of trans fatherhood, the next section looks at how participants in the study view their parenting as a challenge to society-wide gender inequalities.

Challenging Patriarchal Fatherhood

The trans men I interviewed raised a common theme of resistance to patriarchal fatherhood based in biological connectedness, assumptions of binary gender and separate rules for girl and boy children. Admittedly, this group of participants is a small sample and they expressed contradictory feelings about loving children not biologically related to them and experiencing some "sadness" about not being able to procreate in the same way as other men. Still, there is a feminist engagement with gender politics embedded in the ways that the interviewees view parenting and in how they describe interactions with their children. It is certainly not only trans men who can challenge patriarchal fatherhood and not all trans men choose to, but the men I interviewed told me that they do fathering differently *because* they are men of trans experience. For example, Jackson talked about the lack of social scripts for trans people and the necessity, therefore, to decide what kind of parent one wants to be. For him, "growing up in a culture as if I were a girl, but with a spirit as if I were male, really does shape how I look at parenting." Jackson has decided that he does not want to be a parent who treats boy and girl children differently because in his own childhood he was treated like a girl child when he longed for the freedom of being a boy child.

Historically, an integral aspect of patriarchy has been maintaining the legal right to ensure biological paternity of a man's children and his right to control that offspring (Katz Rothman, 1989). Unsurprisingly, the men in my study were not focused on having a biological connection to their children. As Samuel puts it, "[I'm not upset about not having a biological connection with my son because] my feelings on reproduction and breeding and things are just sort of outside the norm anyways." As previously noted, some participants felt a sadness around not being able to reproduce children in the same way that many male-bodied people do. However, the participants who did not have a biological connection with their children did not express concern about their ability to love children they socially fathered. The focus instead was on the ability to choose to parent — biologically or non-biologically — and to choose the kind of parenting role that suits them. In other words, because they are men with a vastly different experience from other men, the men I interviewed were not constrained by conventional definitions of what it means to be a father. They were able to choose their own ways of parenting without relying on pre-scripted rules.

Because these trans men led the early part of their lives restrained by the enforcement of gender norms based on birth sex, they hope to offer their children more choices around gender than were offered to them. For example, Jackson explains that his son once liked wearing dresses and stopped because of the possible consequences:

> I was sad at the point when he told me "I don't want to wear a dress because I'm afraid the other kids will laugh at me." And it wasn't because I thought "Oh, shit, now he's going to be a normal boy and I don't want that." It was because he wanted to wear the dress and he felt like he couldn't. But now he's saying I'm not really into that anymore, I'm done with that. That's fine with me too. I don't need him to be one way or the other.

Jackson does not have an investment in how his children identify their gender; he has an investment in his children feeling that they can express their gender identities as they wish. Even for Richard, a lawyer who described the division of paid and domestic labour between him and his wife as "very traditional," told me that his daughter has a variety of unconventional gender role models. These role models include single mothers, feminists, queers, and out trans people who are active in her life. Above all, Richard says of his daughter, "she has choices." Similarly, Samuel tries to create space

for his child to counter traditional cultural gender norms:

> [I] try to counter the originally defined gender stereotypes that our culture has as well as the originally defined ideas about what is and isn't acceptable for sexual orientation. We tell him someday you'll have a "lovey" — we never say you'll have a wife or [refer to a future partner as] he or she. [We tell him] some women have long hair, some women have short hair, and you can't tell [how someone defines themselves] just by looking at the way they dress. It's just trying to counteract the bombardment of [gender and sexuality norms in] our culture.

Explaining why some trans men might have a unique reason for attempting to counteract mainstream gender teachings, Jayden said:

> Because I know what it's like on the other end of being whistled at like a sex object and just being overlooked because I was a female. I know that transitioning from female to male will give me privilege — you know, however much privilege a guy of colour has — but there's a certain amount of privilege men have. It's about understanding that that privilege is completely unfair, knowing that, and using it to make more of an equal playing field. That's a responsibility that every trans guy takes on or should take on.

If he has a son, Jayden says, "I just want one more good guy in the world. I'm trying my hardest to be a good guy and the fact that I lived most of my life as a woman puts even more responsibility on me to be a good guy and have a good-guy son." Mirroring the feelings of many participants, Jayden hopes to raise children who are unconventional in their gender assumptions and who believe in gender equality.

Parents and parenting activists should be working towards a more trans-inclusive parenting future for many reasons. On the one hand, all people have the right to parent, and it is about basic fairness. On the other, because of their own experiences in a gender-rigid society, trans people have unique insights into child rearing. As Justin puts it: "Because I'm trans, maybe I get the little secret about gender and parenting" — that parents need to be models of gender equality and to allow their children options in expressing themselves without constraint from oppressive gender rules. Many trans men, like others, have figured out how to be good parents. What they now need is the social and institutional support offered to more mainstream families.

REFERENCES

Boggis, Terry. "Affording Our Families: Class Issues in Family Formation." In Mary Bernstein and Renate Reimann, eds., *Queer Families, Queer Politics: Challenging Culture and the State*. New York: Columbia University Press, 2001.

Broad, K.L. "Is It Really GLB + T? Gender/Sexuality Movements and Transgender Collective Identity (De)Constructions." *International Journal of Sexuality and Gender Studies* 7 (2002): 241–264.

Califia, Patrick. *Sex Changes: The Politics of Transgenderism*. San Francisco: Cleis Press, 2003.

Conlon, Michael. "Pregnant Man Thomas Beatie's Baby Healthy, Oprah Told." *News.Com: News From All Angles,* 4 April 2008. Retrieved 12 January 2009 from www.news.com.au/story/0,23599,23482682-401,00.htm.

"Even Oprah Can't Spark Trans Love." *Queerty,* 4 April 2008. Retrieved 12 January 2009 from www.queerty.com/even-oprah-cant-spark-trans-love-20080404/.

Feinberg, Leslie. *Trans Liberation: Beyond Pink or Blue*. Boston, MA: Beacon Press, 1999.

Goldberg, Alan B., and Katie N. Thomson. "Barbara Walters Exclusive: Pregnant Man Expecting Second Child." *ABC News,* 13 November 2008. Retrieved 12 January 2009 from http://abcnews.go.com/Health/Story?id=6244878&page=1.

Heller, Nathan. "Will the Transgender Dad Be a Father? What Goes on the Birth Certificate?" *Slate: News and Politics,* 13 June 2008. Retrieved 12 January 2009 from www.slate.com/id/2193475/.

Hines, Sally. "Intimate Transitions: Transgender Practices of Partnering and Parenting." *Sociology* 40 (2006): 353–371.

Katz Rothman, Barbara. *Recreating Motherhood: Ideology and Technology in a Patriarchal Society*. New York: Norton Press, 1989.

Owens, Anne Marie. "Father's Sex Change Does Not Alter Custody, Court Says: Girl, 6, Calls Mommy and Daddy; Cautious in Public." *The National Post,* 2 February 2001. Retrieved 15 January 2009 from http://fact.on.ca/news/news0102/np010202.htm.

Rivera, Sylvia. "Queens in Exile: The Forgotten Ones." In Joan Nestle, Riki Wilchins, and Clare Howell, eds., *Genderqueer: Voices from Beyond the Sexual Binary*. New York: Alyson Books, 2002.

Smith, Dorothy. "The Standard North American Family: SNAF as an Ideological Code." *Journal of Family Issues* 14 (1993): 51–63.

"Transsexual Dad Wins Landmark Custody Case: Florida Court Says Transsexual Dad is Not Legally a Woman." *ABC News,* 24 February 2003. Retrieved 15 January 2009 from http://abcnews.go.com/GMA/Story?id=125332&page=1.

BOX C

TransFathers 2B

A COURSE FOR TRANS-MASCULINE INDIVIDUALS AND TRANS MEN CONSIDERING PARENTHOOD

TransFathers 2B was a community development initiative by a group of trans men in Toronto, Ontario. With support from Queer Parenting Programs at The 519 Community Centre and the LGBTQ Parenting Network at the Sherbourne Health Centre, the group developed and ran a twelve-week course for trans-masculine people and trans men considering parenthood. It identified the unique needs of trans men becoming parents through pregnancy and other means, surveyed relevant resources, and provided information and access to resource people. TransFathers 2B ran in the spring of 2007 with nine participants. It ran in conjunction with two other "considering parenthood" courses: Daddies & Papas 2B (DP2B) and Dykes Planning Tykes (DPT).

COURSE OUTLINE

WEEK 1: Uncharted Territory: Myths, Research and Self-Advocacy Strategies

WEEK 2: Getting Pregnant and Staying Pregnant — Pregnancy 101

WEEK 3: Adoption Options (joint session with DP2B/DPT)

WEEK 4: How Pregnancy Can Impact Trans Bodies & Identities

WEEK 5: Giving Birth — What Are the Options?

WEEK 6: Getting Pregnant — Fertility Services (joint session with DP2B/DPT)

WEEK 7: Strategies for Accessing Health Care

WEEK 8: Why Racism Awareness Is Important in Family Creation (joint session with DP2B/DPT)

WEEK 9: Legal Affairs (joint session with DPT)

WEEK 10: Trans Parenting 101

WEEK 11: Familiarizing Ourselves with the Hospital Environment; Labour and Delivery

WEEK 12: Putting It All Together Potluck

THE TRANSFATHERS 2B WORKING GROUP

COMMUNITY MEMBERS:
 Syrus Marcus Ware, Nik Redman, Andy Inkster

PROJECT CO-ORDINATOR:
 Chris Veldhoven, Co-ordinator, Queer Parenting Programs, The 519 Community Centre

ORGANIZATIONAL MEMBERS:
 Kyle Scanlon, Co-ordinator, Trans Programs, The 519 Community Centre,
 Rachel Epstein, Co-ordinator, LGBTQ Parenting Network, Sherbourne Health Centre

COURSE DESIGN / FACILITATOR: *Robin Fern*

Funding generously provided by the Community One Foundation (formerly the Lesbian and Gay Community Appeal), Toronto, Ontario.

SHERBOURNE
Health Centre

FROM QUEER TO PATERNITY:

A Gay Man's Uncharted Voyage into Co-Parenting

Derek P. Scott

WHEN HER BLUISH, SQUISHED CONE-HEAD LAY ON HER MOTHER'S thigh awaiting the final contraction, I felt a rush of air leave my body on a wail of change. From this moment, it would all be different. What had I done? I'd said yes to my young friend as we walked our dogs when she asked, "Will you knock me up?" I had always wanted to be a dad. We'd sort it out as we went along. How hard could it be? I was soon to find out.

As a gay man co-parenting a fantastic three-year-old girl with a bisexual woman fifteen years my junior, I've learned a few unexpected things and that's what I want to share here.

I want to tell you about how my understanding of women experienced a quantum shift as I witnessed with awe (and more than a little fear) the initial sacrifices of motherhood — body, sleep, identity, time, space, self — all under enormous pressure, all at once. But then what would she expect of me? How could I possibly match what this woman was doing? I want to leave you with this noble impression of myself, that I considered these questions and rose to the challenge. I don't want to let you know about the real challenge of identifying my misogyny as I failed to adequately support my child's mother. About how I heard the words, "Well, you're her mother, that's what you're *meant* to do …" coming out of my self-proclaimed pro-feminist mouth as, in her bewildered exhaustion, she spoke about feeling unable to meet the baby's needs.

153·

Nothing seems to throw one's personal weaknesses into relief quite like raising a child. My reactions surprised me. There is so much I'd rather not tell. Like, say, that I demonized my friend for demanding too much from me. She wanted me to support her with adult company and prepare meals so that she could eat well herself while a baby — my baby — was attached to her body 24/7, nursing every two hours for ninety minutes. But I was not willing to sacrifice my single time to babysit a grown woman. How had that become the deal? I asked myself in gay high dudgeon.

Should I admit to you the concerns I had about being the fag dad of a boy child and how different those concerns are with a daughter? I wanted to know the gender of my child in order to prepare myself. My fear informed me that a boy meant the inevitability of a time when my son would be ashamed to not have a "real man" as his father — when he would gently shun me, or worse, try to make me feel better about my lack of sporting knowledge. When I knew my daughter was on her way, my fantasies shifted to sharing musical theatre and dance. How unconsciously gender-typed were my expectations? Who knew?

I cannot truly tell you about her birth — about the energy that shifts on the planet when a soul re-enters, or about how my entire being knew in that moment that she had found her way back to me. That's too large to be trapped in ink on paper.

*

Until parenthood, the queer community — my community — meant many things to me. It was a place where we shared common interests and understanding, where we came together to fight social injustice as we supported each other in our diversity. Where we helped each other live, and helped each other die. I never really noticed the absence of children, but now I do. I cannot take my baby into the bar to show her off, and my former comrades won't leave their beers. The few gay dads I have met are coupled and more conservative than the tighty-righty heteros I know.

From other gay men I experience the polite disinterest in parenting that single straight men evidence. Describe the joy of your new puppy to a cat person, you'll get the vibe. Does the queer community support my kid and me? Not much. When I carry my thirsty three-year-old over to the long line-up for drink tickets at the Queer Pride celebrations under the relentless sun

and ask some fag near the front if we can cut in so I can get my daughter some water and I'm told, "It's a long line-up for everyone!" I am angry and saddened. This does not happen at non-queer celebrations in my town.

So my sense of "community" has shifted to mean the place in which I make my home, wherein my child and I are supported. The folks who inhabit the village in which I live seem to believe that kids (a) exist, (b) are welcomed, if not then at least tolerated, and (c) are looked out for. The (straight) staff at the local coffee shop excel in remembering (much to her delight) that my little girl likes her hot chocolate with coloured sprinkles *and* marshmallows. The (hetero) librarians recommend books she might particularly enjoy. The (mainstream) checkout staff at the Valu-Mart take time to reassure her that the scary goblins are not allowed to shop there. Straight people, formerly my oppressors, are now taking care of her, me, us.

In return, I offer my newly embraced geographic community my portable activism. The provision of only two highchairs at the local coffee shop is simply unacceptable, as my indignant email campaign pointed out. Are we supposed to risk our children's safety as we pass hot coffee over their tiny heads? We won. Six chairs now.

*

It was difficult getting support from the local "Dykes and Tykes" group — who bestow upon me honourary membership — as the women laughingly dismiss the donors. And they seem not to want to hear about how thrilled I am that my daughter looks so much like me. I understand that lesbian-parenting dynamics are complex. I get that non-biological mums can feel threatened in various ways. So unlike families where Heather has a mommy and a daddy, and both parents enjoy identifying possible genetic markers, I recognize that implicit in the statement, "She gets that from me," is the corollary "There is nothing we can identify of yours." Nonetheless, I am left with a desire to celebrate the similarities I share with my girl.

Are you curious about the struggle I see written on the faces of those who aren't sure if they can ask about my daughter's conception? What are the boundaries? Where are the lines? For those too shy to ask, the answer is: cheesy porn and a veterinary syringe.

Can I tell you about my heightened awareness of gender oppression as

my daughter is invariably assumed to be my son (why else would a father show so much interest)? About how men will be aggressive with my "son" by lifting her onto the train without asking me if it is okay? About how well-intentioned women with no gender analysis tell her how "pretty" she is and that she is a "princess," and about how difficult it is to fight such insidious forms of oppression? About how the best defence is to remind her she is "strong like bull" and ask her to haul wood in for the fireplace with me, then ask if she wants us to wear our sarongs and be Wonder Woman together.

I want to share with you my outrage (and oh-so-secret delight) as I am awarded approving smiles, nods, and support from women for simply being with my child — and the contrasting critical response experienced by her mother of whom is demanded on a sunny day, "Where's her hat?"

<p style="text-align:center">*</p>

Are you interested in the inability of men (or is it mere reluctance) to talk about parenting with each other? As I glance across the street to acknowledge another male parent I learn that straight men avoid eye contact with each other when they are walking stroller-bound kids to the park. They are engaged in the "too-cool-for-this-activity" one-handed stroller push. (If you haven't noticed this, check it out next time you're walking down the sidewalk. Women use two hands on the stroller handle, manly men position themselves off to the side as though the stroller isn't theirs and push with one casual hand. God only knows how they manage to steer.) These same gender-bound dads refuse to shout "Whee!" when pushing their infants on the swings, despite heartfelt pleas. I am saddened that their macho programming doesn't allow for the joy of engaging whole-heartedly with their babies and sharing that pleasure with other men. Can these really be the folks that are *privileged* by the patriarchy?

With whom, then, can I share my delight in opening to the inherent joy my kid accesses, and demands of me! With whom can I share my fears as I continue my personal therapeutic work, memories evoked unbidden as my first response to her "No!" is to seek to dominate her will by force of my own. At whose knee was that learned? What is required of me to truly nurture her, providing the safe container for her cosmological exploration? So far it seems to involve revisiting and acknowledging those long-buried places of pain, and repaginating my narrative as new chapters are inserted.

I had not anticipated that my shift in identity from out-loud-and-proud queer activist to queer parent would temper my willingness to expose myself to hatred that now implicates my daughter. Will I appear on the local CBC Radio show to talk about "The Issue" of queer parenting? No. My daughter is not an "Issue" in the way my lived experience of sexual oppression has been. Am I available for local TV programming to feature diverse families? No. I will not risk my child being identified as "that kid with the fag dad." Am I ambivalent about these decisions? Do I have parts of me screaming about selling out, the importance of activism, and working for change? Oh yes.

And now my closest friend, the only other person in the world who delights in my child as I do, is her mother. Together we share our observations and challenges, frustrations and delights as we break a trail through the complexities of heteronormative expectations. Just as being queer in the world invites the journey from self-criticism to social critique, so, too, does queer parenting invite social evolution in the simple, unapologetic joy of the endeavour.

I have come to realize that there was a place in my heart that was waiting for my daughter. My evolving love for her requires that I see her for the Divine Gift that she manifests. As I do so, it becomes necessary for me to find the courage to claim my own spiritual truth so as not to disallow hers. Karma chameleon.

For she sees me, you see. She invests me with a love and a trust I have never known. And I am learning to trust and love her visionary investment.

What does it mean to be the person whose arms *will* be there when she jumps unannounced?

It means I'm her dad.

HIP QUEER SINGLE MAMAS:
A Community

THIS GROUP OF SINGLE QUEER MOTHERS (SELF-DEFINED) FIRST CAME together in 2004 at a Queer Parenting Exchange meeting organized by the LGBTQ Parenting Network (Sherbourne Health Centre) and Queer Parenting Programs at The 519 Community Centre in Toronto. The initial meeting was a one-off discussion that affirmed the existence of single queer mothers and offered us the opportunity to share our realities. Some of us had one or more very young children, and some of us were awaiting the arrival of our first, or even second, child.

The fabulous surprise that evening was the immediate synergy and energy we felt: a recognition of something shared and something needed. Truly grassroots, the group's initial evolution consisted of get-togethers at each others' houses where we aspired to talk, but often only managed to be in each other's and our collective children's company. While limited, it was very satisfying.

Since 2007, the group has been more formalized. We have enjoyed very generous support (financial and more) from the LGBTQ Parenting Network. There are regularly scheduled meetings and child care; it is even possible to talk together! Membership has grown and evolved, as have we and our families. Importantly, membership in the group continues to be through self-definition. Last summer seven members of the group — Sarah, Lola, Jess, Carlyle, Lucy, Brenda, and Lorraine — chatted (on tape) with Rachel Epstein at one of our monthly gatherings.

RACHEL: *Let's start by having you introduce yourselves, talk about how you came to be a single parent and anything else you want to say about your current parenting situation.*

JESS: My name is Jess and I have a daughter, Yael, who's three. I had been in a relationship with somebody and when that relationship ended I realized that my parenting clock was ticking. Ideally I would have liked to do it with somebody else but I knew that if I met somebody it would take time to see about the possibility of parenting with them. So I just decided to go ahead and do it by myself. I got pregnant really quickly and I had Yael. It's been amazing and there are a lot of things about being a single parent that I find really challenging. They're not necessarily the things I thought would be challenging. There's a lot of surprises in it all.

SARAH: I started out with the intention of being a parent in a couple and in fact I think that desire ended up breaking up the relationship. We started out with me trying to get pregnant and using donor sperm, and then, not surprisingly, my age came up as a factor so then it was kind of a fork in the road. And my partner all of a sudden became really clear that she didn't want to have a kid at all. So then I considered adoption, and I thought, I won't survive this process ... the home study ... I'd be last on the list and a single parent and you're a lesbian and so then I decided I still wanted to go ahead and that's when somebody suggested an egg donor. So that's how my twins were conceived, egg donor and sperm donor. I think at the time I took it more lightly than I do now. I have an ever-increasing understanding of the ramifications of that decision, what my responsibilities are to them because that's how they were conceived. They're four now.

LOLA: My name is Lola and I have a twenty-one-month-old son, Michael, who is adopted. When I got him he was a year old. I was in a relationship and my partner wasn't really that keen on children. We started with my trying to get pregnant, and the relationship dissolved. I think that was probably one of the major reasons. In hindsight I'm happy that I chose the baby over the relationship. I tried a few times to get pregnant, but because of my age it didn't work out. And then I went the route of the Children's Aid Society. I didn't have any problems. I'm single, gay ... they were very accepting, they were wonderful. The process was very quick. I know people are afraid they're going to wait years but my process was very short, probably like six months.

LORRAINE: My name is Lorraine and I have a two-and-a-half-year-old. Maybe ten years ago I started thinking about becoming a parent. I got

closer and closer to a psychological cut-off date biologically *(laughs)* and I thought if I don't do it now then it's not going to happen. So then I thought, okay, where am I? I'm in this relationship that didn't quite fit for co-parenting, but then I realized that I actually wanted lots of space to become a parent because I knew that it would be a huge change in my life and I needed all my focus for that. I knew I didn't want to co-parent with her. We had really different approaches and I just really wanted to do it myself. So then I was inseminating and it kind of pushed us to break up. And then I became a single parent. It's been great so far. I feel like I have lots of room to explore whatever comes along and I realize I can make it what I want it to be, you know? Where somebody else might fit in, I haven't figured that out yet, but so far it's fine by myself.

BRENDA: I'm Brenda. I was in a long-term relationship that had its diffi-culties. Within that relationship I had known that I wanted to have a child and did do some insemination with a known donor and I didn't get pregnant. I finally managed to get out of that relationship and I was by that point thirty-nine and the clock was ticking. I had always wanted a known donor and so an ex-boyfriend from my early twenties who had remained a friend came into the province and offered his seed. It's been great, mostly. My daughter is four and a half, and I live by myself. I had a partner who I dated from the week I got pregnant, who still sees her every couple of weeks and then I have a lesbian couple, close friends, and they're pretty much co-parents. They have a room in their house for my daughter and she's there two nights a week. For me, it's been a very deeply important part of parenting. I have a lot of support and people who are like family for her. We don't actually have the right words for it all, but different people are family in different ways.

CARLYLE: I'm Carlyle. I knew I wanted to be a parent and was with a partner at the time and got pregnant, and then that didn't work out and so at eight months pregnant I was on my own. In some ways it was sort of liberating, partly because I'm not a good negotiator. I just didn't want to have to negotiate with another person about all the endless pieces that have to be decided — what kind of diapers, what kind of school, what kind of parenting style, all of those things. Because I was all of a sudden on my own I really discovered my community and lots of people became very important friends to me and my son and I thought okay, this is great,

this is fun, I want to have another one — partly because I thought it would be nice for them to have each other. So the second child was more consciously conceived in terms of being a single parent.

LUCY: My name is Lucy and I've got four kids. I was in a relationship and felt my clock was ticking, as seems to be common. I had no aspirations to co-parent with this individual, so I just said well, we'll see what happens and we conceived Violet and shortly thereafter I was a single parent. The father was gone for a while and then came back and I asked him, "How do you feel about conceiving another child?" And so we had three more *(laughter)*. The last child was conceived about fourteen months ago and we've been co-parenting since then. At the moment I am single parenting most of the week and a few days of the week their father comes for child care, but I do most of the primary decision-making.

RACHEL: *Jess, you talked about being surprised by things. What have you been surprised by? And what do you know now that you wish you knew before?*

BRENDA: One of the things I've been surprised by is how people come into my life and play significant roles with me and with my child, are very deeply involved with my child. The notion of the complexity and depth of family really works. I thought I'd be more single and I feel like I am part of a community for my child. So that was a big surprise for me, that there's the deep, long-term connected kind of people but there's also the other levels of people who have been very much a part of the whole parenting thing for me. It feels very nurturing. That was a surprise

CARLYLE: The one thing I wish I had known sooner was to start earlier. I would have had a whole bunch more kids if time hadn't run out.

BRENDA: I want to echo what you are saying: start earlier. It's not as hard as I thought it would be and I wish very much that I could have had more children.

JESS: I knew things would be hard, but one of the things that was hard for me was not sharing the experience with somebody else, not having a co-parent to share in the amazingness of love, because you know I think I was overwhelmed by the love that I felt. Also it's been intense for me because I don't have a relationship with my family of origin. I thought I'd worked through all that stuff, that separation from my family, but

then once I had a kid and I was creating my own family it really made me feel a whole new wave of grief and having to process the loss of my own family. Being a mom was so intense and at times it's still hard for me not to be sharing that with somebody else, not to be partnered in that intimate way. It's also hard for me to think that I can ask for support and recognize it when it's there, and so that's something that's been really challenging but really good for me to have to grapple with.

Another thing that was surprising for me was a new wave of recognizing all the misogyny and hatred of mothers, this whole new realm of life where I was made to feel like I couldn't measure up. There is so much criticism of mothers and of parents and I felt like I really needed to get a thicker skin, especially because I am a queer single mom. I'm already not fitting into the mould and I'd like to really be strong in that. There's such an eye, not just on women, but on parents — if you're too this or too that, is she too attached to me, is she attached enough? Or it could be anything, what I feed her — if I give her sugar, if I don't ... every little thing. I see it with so many women who are parenting, the ways we're made to feel that we're not enough. And I've always felt like, "Oh, my gosh, I couldn't be working any harder at this, I can't bear to feel that I'm not measuring up somehow."

Another surprise of this group for me is meeting other Jews. I went to a Purim party and all the queer single mamas were there. I've been looking for Jewish community in Toronto ... it was so amazing to go to this party that wasn't specifically a queer thing and there was suddenly all these Jewish dyke mamas.

RACHEL: *Are there things you wish you knew?*

LOLA: The first couple of months for me were really, really hard. I felt shell-shocked. I had this one-year-old dropped on my doorstep, this running, breathing, pooping little machine *(laughter)* and I had no idea about babies. I had no ideas about anything. The first time I put him in the brand new car seat, lock him up and start driving down the street. I drive no more than fifty metres, and I turn back and look at him and he's slumped over like this and I'm like, "Oh, my God, I've killed him ... *(laughter)* I've killed him!" And I pull the car over and I'm thinking "Oh, my God, I put it on too tight, he's not breathing!" And I get back there and he's ... he's asleep. So yeah, I had a very hard time, I'm calling up

my friends — What do you feed them? What do they eat? Do you have to heat it up? *(laughter)* I don't even know how to change a diaper! It was wonderful but very, very, very difficult, and one of the things that I wished I knew then that I know now is something very simple that one of my friends said: You don't have to be on all the time. You can let him play and you can lie on the couch for fifteen minutes and have a coffee, and relax, and I'm like, "Really? I can?"

I think right now I'm probably surprised that it's not that difficult, it's not as difficult as I thought it was going to be. I think that's why I waited for so many years to have a child because I thought it was going to be really difficult. But I've done it, it's been wonderful, he's the greatest thing that's ever happened to me and you know I've probably grown up more since January than since I was sixteen.

JESS: Looking back I wish that I had more support, certainly in the first year. Even though I have a great community around me and people who love me and love my kid, I think there's a lot of times where I felt isolated and things were just really hard. It was hard for me to ask for some of the help I needed and the physicality of it I found really challenging, being sleep-deprived and up in the night and not having any one else there.

SARAH: I wish I had figured out that I could have had kids any time in the past many decades. There's something particular about the generation of women I'm part of. Lots of us didn't have kids until late, it was something like — smart women don't have kids, you know, this real binary between domestic and intelligent. It wasn't what I wanted to be doing, I saw it as this incredibly difficult thing. I mean it is difficult, it is different, but it's like you said Jess, in being a parent and rising to the occasion, it's so amazing, it's worth all of the difficulty of it.

LORRAINE: I think I was surprised when I got pregnant, *(laughter)* I thought, What am I going to do? I'm pregnant, I can't believe it. I panicked, because before then it was a really intellectual exercise and then it happened, and I realized that I'd thought all this time that certain women have children but I'm not one of them, and then it was like, "Oh, my God!"

And then the other surprise is that I didn't realize that my parenting would keep changing, it keeps responding to my child as he changes. He's eight months — I think I've got a handle on this, and then he starts walking *(laughter)* and then everything changed again. So then I

thought, if I can learn to be this flexible then it would be good for me, it would be good for him, it would be good for the world, but that's also the hard part, right? To be able to be that flexible.

BRENDA: Related to that, I think I've learned that I wouldn't die if I didn't do absolutely everything that I thought was me. You know, I couldn't read books anymore, I couldn't go to movies anymore, I couldn't hang out with people in the same way, I couldn't do sex in the same way, I couldn't do relationships in the same way. I was forty when I had her and I knew who I thought I was. Everything about who I thought I was changed, and yet I was still me. And I didn't die with having absolutely no time to myself for a long time. It was very hard but I feel immensely stronger by virtue of the fact that I found out I can do that. That was good for my being.

CARLYLE: I'm listening to all this and all of a sudden it's hitting me that our issues are more about being single than about being queer. Our day-to-day life is — we're single. Queer is who we have sex with on a regular or occasional basis. It comes into who we are obviously but being single is the piece that I have to struggle with so much. I remember when I was starting my son at school. I don't necessarily look like someone who's queer, because I'm a single mom. I didn't feel like school was necessarily a daily battle. It's just more about getting through the day.

You know when Jess was talking about wanting to share the love and the experience with someone ... I never really thought about having missed that, and I suppose that would have been great. I feel like I shared that with a lot of different people, but I don't feel like there was a very intimate person. What I remember missing was, there's nobody to bring me chocolate ice cream! (laughter) Wanting to be pampered and nurtured and taken care of a little bit. That was the piece that I really missed and I'm so grateful for the friends that I have. We'd go away for a weekend and they'd say: "You sleep in, we'll watch the kids ... you go take a nap." Like, really? You know that whole sleep piece is so precious. That was a really big deal, having people who knew how to take care of me.

BRENDA: I also discovered how much better off I am than almost everybody I know who is parenting and who is in a relationship, like the thing about not having to negotiate ... I watch other couples and I see women who really are single parents but then they've got to deal with the partner

who is doing nothing, and the frustration of that, you know? I do it all and that's just the way it is. For me it's been good to separate out relationships and parenting, having the kid thing already taken care of, so I wasn't looking for that as an element in another relationship.

CARLYLE: Oh my gosh, not having to negotiate ... I feel like the parenting piece is so consuming, but then the other time that I have is my time. Since I have so much responsibility it's also nice to have so much freedom. I love that autonomy. There are a lot of things that I love about being single anyway, whether I have a kid or not, I mean singlehood is powerful. I feel really lucky actually, to be doing it the way that I am. There are things that are hard, but I think parenting is really hard any which way you go.

RACHEL: *Tell me about this group — what you've done in the group, what you've talked about, what are the burning issues?*

BRENDA: Sex and dating and sex and dating *(laughter)*. We talk a lot about that. At first we spent a lot of time just sort of hanging with the kids, and talking ... but there was still a sense of support, knowing that there were these other people. For me what's significant is that everyone who comes to this group is a very strong woman, uniquely on a journey, doing what is important to her. The people feel really strong, and this group has given me permission to embody that more for myself. This group makes me feel like I'm cool *(laughter)*, which has been an important self-esteem kind of thing. Not that I was poor in self-esteem before, but seeing yourself in others is a huge validation.

One of the things for me was around sex and dating and SM and you know, wow! We had a group that actually was very cool about these issues. I also remember talking about dads and donors and that was a very rich conversation, because we have a lot of diversity in terms of the construction of our families. The nuances of it all really helped inform me in some real decisions about how to present and deal with the father issue to my daughter and to the world in general. It's different when I'm talking to dykes who are in a partnership because their model is in many ways similar to a straight model of family, and so there's something very different when you are single and you've made these very different strides to try to get pregnant. It feels different than other dykes somehow, in radical ways.

CARLYLE: Once we got a space where we could chat without the kids around, I think sex and relationships was the first topic we wanted to talk about, because we couldn't do it around the kids, right? They were too old to be talking about that kind of stuff, and we couldn't talk about donor stuff, right? We needed the privacy to be able to discuss it, (a) for more than one sentence at a time because we were chasing after our kids and (b) with some kind of privacy because we didn't necessarily want the kids in on the conversation at that level.

LOLA: When I came to the group it was very shortly after I got Michael. It was very comforting for me to come here. I was probably very quiet, but it was very comforting. I felt like it was the first time I had been around other single women who had kids, and the things that they were talking about I could really relate to. We've also talked about the politics of race, and since my son is Black those things have been helpful for me.

LORRAINE: For me it's also important our whole connection to other people who are single parents, how racialized the whole issue is, how, for example, single moms are blamed for gun violence in Toronto. I feel a big connection to that, I feel like I'm always trying to come out as a single mom at daycare, and a queer mom at the same time, and I don't want to say, "Yes, I'm a single mom, but I am not one of *those* single moms." Right? A big part of the experience is about what resources you have and what resources you don't have. I really would like to have some other moms here who have different issues going on.

JESS: I also really love that this group provides a kind of little community for our kids. My daughter has gotten to know other kids who have queer single moms and that's so cool, and so when I do talk to her about family and that kind of stuff she has all these reference points.

SARAH: I have tried a lot of different support groups, and this is the one in the end that goes the distance. It's difficult to articulate why this works, but I think it's something about the way it's open-ended. I did go to another group, a lesbian mothers' group, but they were all couples, and I felt so incredibly marginalized in that group. Even the way it was run. One parent would hang around the campfire and help with the cooking and the other parent would go with the kids to the playground or the park, and I can't do both, you know. If I go with my kids then I'm not there to

help with the cooking, and I feel badly about that. So I've never gone back because I couldn't do it. So there's something similar enough about our experience but we also don't take for granted that it's all the same. There is something shared but there are also things that are incredibly different, and it's something about the combination of people listening and talking about things. And we make up the agenda every time and people can add things on.

LORRAINE: I don't know if anybody's had this experience going to any of the other queer parenting drop-ins, but when I meet people and mention that I'm a queer single parent, the lesbian couples will kind of gasp, like it's a real stigma to be single, I don't know what it is. They might say something like, "I don't know how you do it, that must be really difficult, I would never do that, I wouldn't be able to manage it." It's this whole kind of othering thing. I'm actually okay doing it, I chose to do it this way but it seems to be a big deal, people are shocked, and they're almost grossed out or scared.

SARAH: Yeah, that's been my experience, and maybe it's exacerbated in my case by the kind of circles I'm involved with, academia, visual arts and queer community. In each of those groups there are a whole lot of people who are not single and who are not parents, and I can't imagine being anything else. If you're an academic or a visual artist part of the identity is that you have no kids, it's just adults. In each of these circles there are people who I used to be friends with and I run into and it's kind of like I've crossed over. I have kids now and they just don't get it. The end result for me is that it's pretty isolating.

BRENDA: I've tried to get involved with other queer groups. It's like they say they're open but you could be the only single, you could be the only parent, it's not easy. Most queer forums don't have anything for you, you have to leave your kid behind. You just can't constantly get babysitters, and what's the problem with having kids going to some things, right? I think it's a problem with the queer community and I also think it's a problem with lots of other communities. They're just not geared to families.

CARLYLE: This group has been great for me as validation that it's okay for me to be whatever I am and realize that everybody else is going through their own stuff, and some weeks it's harder for some, and other weeks

it's harder for others, and at the end of the day we can call each other up or email if we're panicked. We don't always have a whole lot of energy to offer each other, but it feels like there's emotional support.

Beyond Normalization:

An Analysis of Heteronormativity in Children's Picture Books

Anika Stafford

OVER THE PAST TWENTY YEARS, ONE OF THE MOST FASCINATING SITES OF struggle with regard to queer families has been children's storybooks. Since the late 1980s, there has been a growing body of books that depict families with same-sex parents (or other relatives in same-sex relationships). From *Heather Has Two Mommies* by Leslea Newman (1989) to *Mom and Mum Are Getting Married* by Ken Setterington (2004), the emphasis has been on same-sex relationships as "normal" and "healthy." Despite their unthreatening tones, these books have been highly contested and often banned. The most notorious Canadian example took place in Surrey, B.C., when the Surrey School Board banned three such books. The case began in the late 1990s and dragged on for years, in local and supreme courts. Intensely polarized reviews of these books had some reviewers warning potential readers that the books in question dealt with *unnatural* relationships, while others praised the books for honouring *diversity*. Unaddressed in both these perspectives are the ways that power, privilege, and heteronormativity are reproduced or challenged in these books. The highly polarized debate also pays little attention to the ways that literary quality is often sacrificed in order to make a political point.

In this essay, I examine some of these children's books to show how they attempt to break down homophobia and heterosexism. Many of these picture

books focus on convincing a homophobic public that "homosexuality" and same-sex relationships are normal. It is important to examine the literary and political implications of this trend. Below, I analyze some of the nuances involved in creating anti-oppressive politics and how literary form can help or hinder a political message.

The framework from which I analyze these books has been shaped by current queer and anti-racist feminist theory as well as by children's literary criticism. Often, discussions of children's literary criticism and discussions of anti-oppressive politics take place in isolation from one another. The result is that children's literary criticism has a tendency to discuss literary quality while ignoring issues of systemic power and privilege; while books that actively engage with anti-oppressive politics can ignore the way didactic political messages can compromise not only literary quality but also the effectiveness of the message itself (more on this below). My framework takes into account the ways in which this isolation can be problematically reflected in children's books that challenge homophobic norms when illustrating meanings of family. Central to my analysis is the assertion that an intentional engagement with anti-oppressive politics does not have to be done at the expense of literary quality; rather, that a combination of theories is useful in assessing ways in which quality children's literature can challenge normative regulation of relationships/identity so that gay and lesbian relationships can be more fully developed and represented in this literature.

With the poverty of resources depicting queer families, queer communities have been quick to defend any children's books which include same-sex couples. Children's stories, so often repeated, can begin to shape values and expectations. It is important that we take a closer look at the messages in the still-growing literature that deals with queer families so that we can understand what they are saying and how they are saying it.

Questions for Analysis

The first step in my analysis was to compile a list of critical questions that I could use to analyze children's picture books with characters in same-sex relationships. To do so, I drew on political theory by authors such as Kevin Kumashiro, Shane Phelan, and Himani Bannerji. I also drew on the literary works of such critics as Hazel Rochman, Sheila Egoff, Deidre Baker, and Ken Setterington. The following political and literary questions guided my overview and critiques:

POLITICAL QUESTIONS

- Do the picture books recreate power hierarchies from the dominant culture such as gender expression, race, and class in order to normalize homosexuality (for privileged populations of LGBT/queer people)? How is this reflected in the illustrations?
- Is the LGBT/queer reader "othered"? Is the education structured in a way that assumes the reader is heterosexual and homophobic to the point where LGBT/queer readers are excluded as potential readers?
- Is homophobia dealt with in a way that shows homophobia as the problem to be challenged as opposed to families with same-sex relationships needing to justify that they are healthy and not damaging their children?
- Is the family validated for homophobic reasons; for example, are they framed as acceptable because their children are straight, or because the child has straight friends, or because they have positive role models of the other sex?

LITERARY QUESTIONS

- Are the pictures visually stimulating? Do they ignite the imagination? Do they draw the reader further into the story?
- Is the story told in an interesting way? Is the only event the fact that there are same-sex relationships, or is there something happening to these characters that the reader can come to care about?
- Is the use of language engaging for a picture book (that is generally meant to be read out loud)? Can the reader be drawn in through lyricism, rhythm, or patterns?
- Are the characters in the story distinct individuals or static symbols? Does the reader get to know them in ways that show their uniqueness, their humour, their quirks? Can the reader identify with them?
- Does the theme come through as an engaging story or is it merely an explicitly stated "moral message"?

How "Gay is Normal" in Children's Picture Books

When I began researching children's picture books with "gay" characters, I was glad to see that there were close to forty books that could be grouped

into this category. It was my hope that among this number there would be books that depicted a wide range of individuals with family structures departing from hetero-nuclear family norms. I was dismayed by the number of books that replicated normative conceptualizations of family and gender (more on this below). Many books focused on the assertion that "gay is normal" at the expense of enthralling story lines, multi-faceted characters, enticing language, and other elements of literary quality.

For example, in *Daddy's Roommate* by Michael Willhoite, the young boy narrator's parents got divorced the year before the story opens. His dad now has a "roommate," an obvious euphemism for partner/lover/spouse. The boy's dad and his roommate "live together, eat together, sleep together, shave together, and times even fight together. But they always make up."

The pictures are cartoonish and oversimplified, depicting conservatively gendered, white, middle-class norms. There is truly nothing else in the story besides a description of how gay people can eat, sleep, shave, and so on, just the way real (a.k.a straight) people do. If difference (from the mainstream) is depicted as okay because it is actually sameness, the underlying message becomes that difference is really not okay.

Similarly, in another book by Michael Willhoite, *Uncle What-Is-It Is Coming to Visit*, a brother and sister find out that their uncle is coming to visit. When they ask if he has a girlfriend, they find out that he is gay. Not knowing what that means, they ask homophobic people in their neighbourhood who tell them tales about gay people being leather people and drag queens. The children get so terrified by this that they don't know if they want their uncle to visit after all. In the end, he is just an "unthreatening," conservative man who doesn't like Brussels sprouts just like them. The cartoonish pictures depict 1950s-style gender roles with the parents and children. The uncle is unthreatening because he looks like a white, middle-class, gender-normative man. The homophobic bullies appear to be working class, probably mechanics. This book definitely falls into the category of those that do more to uphold the status quo than contesting it. Adding conservative, middle-class, white, gay men to the margins of what is acceptable does not necessarily do much to break down barriers and embrace difference.

In my research, I grouped the books into two categories: books explaining how a family can include people in a same-sex relationship (expository books), and books with the same-sex relationship as the background, but not the focal point, of the story (background books).

While expository books tend to focus didactically on messages that the family is "normal," background books tend to use storylines and illustrations to create an environment in which the background characters in same-sex relationships are as close to the heteronormative mainstream as possible. Both categories often position the reader as heterosexual and homophobic — thus denying the possibility of gay and lesbian readership. As a result, the same-sex relationship, as opposed to homophobia, is usually positioned as the aberration to be studied.

Within the expository category there is a trend towards explicitly stated moral messages. Unfortunately, the didactic nature of the message shifts the focus away from the characters as individuals as they become symbols of something to accept, as opposed to specific and interesting people with whom a reader can connect. For example, the daycare teacher at the end of Leslea Newman's *Heather Has Two Mommies* (1989) gathers her students around her and tells them, "It doesn't matter how many mommies or how many daddies your family has ... it doesn't matter if your family has sisters or brothers or cousins or grandmothers or grandfathers or uncles or aunts. Each family is special. The most important thing about a family is that all the people in it love each other." In *How My Family Came to Be: Daddy, Papa and Me* by Andrew Aldrich (2003), the main character describes how he and his family "play, talk, read, hug and sometimes fight, just like other families." The repetition that all families are the same does not leave room for families with cultural differences and for families with "gay" members to be part of non-mainstream countercultures. This detracts from the message of "diversity" and of valuing difference, because conforming to the mainstream is the trait that makes the family acceptable; the capacity for sameness rather than difference is what is honoured. The reader is also positioned as heterosexual and homophobic through the constant assurance that the family is okay, implicitly suggesting that the reader would have originally thought otherwise. The reader is not engaged in the overall storyline or drawn into an appreciation for the characters as individuals.

Background books often begin with long explanations of every-day things that gay families do together. In *Anna Day and the O-Ring* (Wickens, 1994), the main character, a young boy with two moms, tells the reader that he has sleepovers and eats cookies. *Gloria Goes to Gay Pride* begins with a rundown of how Gloria and her moms celebrate Valentine's Day, Halloween, Mother's Day, and Hanukkah (Newman, 1991). In both

books, the preambles do not further an overall plot nor are they worded in particularly engaging ways. The reader is again assumed to be both heterosexual and homophobic; children or adults who know individuals in same-sex relationships would already be aware that their families do everyday things together. When the audience is presumed to be homophobic and heterosexual by default, those whose identities fall outside of heterosexist norms are not positioned as a potential readership. Consequently, these readers are "othered" because they are situated not as subjects but as objects to be studied. In addition to perpetuating exclusion, this limits the potential of the books to challenge heterosexist assumptions of potentially homophobic readers as they replicate heterosexist frameworks in the way in which the reader is positioned.

The exclusion does not end with "othering" gays and lesbians. Another aspect of the relentless normalization of characters in same-sex relationships is that often families are exemplified for the ways in which they uphold the status quo in all ways expect for this one exception. The four books I have discussed thus far primarily feature white, middle-class characters. Books that include characters of colour generally do so in the context of "hypernormal," suburban, nuclear families. For example, in *Molly's Family* by Nancy Gordon, the story follows a plot similar to stories previously seen on this subject, such as *Asha's Moms* and *Heather Has Two Mommies*. When Molly draws a picture of her family for a kindergarten open house, some of her peers tell her that she can't have two moms. The teacher and her moms help validate Molly and her family. In the end, Molly puts her picture up on the wall for the open house. The illustrations depict conservatively gendered and mostly white characters, reinforcing dominant power structures. People of colour, poor, working-class individuals, and those whose familial structures do not replicate nuclear family norms are "othered" when whiteness, class privilege, and normative family structures are used as sites through which select families with people in gay and lesbian relationships are validated. Additionally, such familial depictions detract from the book's literary quality as characters become stereotypes and their cultures lack the specificity that makes for engaging setting and scenery.

The trend of defending families with same-sex relationships on the basis of their conformity to mainstream standards can result in the replication of homophobic norms. For example, in *Zack's Story* (Greenberg, 1996), Zack reassures the reader that he plans on marrying a woman when he grows up

(assuring the reader of his future heterosexuality) despite the fact that he has two moms. Would there be something wrong with him or his family if he, too, grew up to be gay? The overarching message of the story is that Zack has a good family; however, the attempt to normalize him results in Zack's potential heterosexuality becoming homophobic reinforcement of what validates his family — his family is okay because he is straight. Similarly in *How My Family Came to Be*, the reader is reassured that the (nameless) main character has female parental role models and friends from straight families. Again, this reiterates the notion that families with same-sex parents are inadequate in comparison to families with heterosexual parents. From a literary perspective, within this context of normalization, families with same-sex parents are generalized and lose the individualism that makes the members of a family amusing or interesting as characters in the story.

In both expository and background stories, there is a propensity for the same-sex relationship to cancel out any specific attributes the characters have. As a result, the same-sex relationship subsumes all other aspects of a person's identity in ways that a heterosexual relationship does not. The implications of such a trend counteract the explicit goal these books often have — to challenge homophobia.

However, not every picture book reflects the trends that I have critiqued. While the overall trends show a tendency towards problematic politics and literary shortcomings, there are examples of both background and expository books that do more to engage the reader and challenge oppression than those I have discussed.

One example in the category of background books is Bobbie Combs's *ABC: A Family Alphabet Book* (2001), which reflects a broader range of characters than the books previously discussed. In *ABC*, each letter of the alphabet is depicted in bright, original, and captivating illustrations. The letters are paired up to depict same-sex couples having fun with children. The different genders, ethnicities, and personalities expressed by the alphabet characters break up the emphasis on normalization that is commonly found in books depicting characters in same-sex relationships. The text that accompanies the illustrations describes what is going on in the picture: the couples and the kids are going to the zoo, the kids are waking up moms in the morning with big musical instruments, and so on. The images portray a wide enough range of activities that the depictions of the families move away from stock characters set up as normalizing role models.

Another example of a book in which the same-sex relationship is clear while not defaulting to a "moral message" is *And Tango Makes Three* by Justin Richardson and Peter Parnell (2005). *Tango* (for short) tells a true story about two male penguins who partner-up and make a nest together at the New York City Park Zoo. Whereas *ABC* shows a range of different familial networks in order to move away from heteronormative characters, *Tango* uses specificity in a way that alleviates the same-sex family from the responsibility of having to normalize all families outside the heterosexual mainstream. In the story, the two male penguins sit on rocks and other egg-shaped objects hoping that they will hatch. When a zookeeper eventually finds an egg in need of care, he gives it to them. Together, they take turns sitting on the egg until it hatches into a baby penguin, their little daughter, Tango. The illustrations bring the penguin characters to life, particularly little Tango, and successfully draw the reader into the story.

Within the expository category, Johnny Valentine's *One Dad, Two Dads, Brown Dads, Blue Dads* (1994) describes a family with two dads in a way that challenges homophobia. In *One Dad, Two Dads,* Lou, who "has two dads who both are blue" is asked questions by a friend who doesn't think anyone can have blue dads. After being asked "If they hug you too hard will the color come off?" and other allegorical questions, Lou shakes his head and wonders why his friend can ask such silly things. Lou replies, "They were blue when I got them and blue they are still." He declares that although "it is hard to see blue dads against a blue sky," his dads are "remarkable wonders" and their lives are just fine. It is a humorous Dr. Seuss-style explanation about how dads are dads in all their varieties.

The illustrations feature bold colours and combine images of the dads going about their activities and images of Lou's friend's silly questions about how the dads became blue. The story is amusing and there is a greater attention to language, cadence, and rhythm than in other books, which makes it entertaining to read out loud to audiences of younger children. Additionally, it is the questions Lou is asked and not Lou's family that are positioned as the problem. The focus is less heterosexist because the book does not assume the reader and the reader's family and friends are heterosexual and homophobic. However, despite these positive attributes, conflating issues of racism with "appreciating different colours" is problematic. It risks perpetuating the idea that anti-racism is about being "colour blind," which can subsequently erase considerations of white power and privilege. As well,

the emphasis on appreciating difference because "we are all the same" can negate the celebration of difference. While this book successfully avoids homophobic traps, it would be strengthened by a deeper questioning of the systemic power of racism.

*

The normalizing trends within children's picture books depicting characters in same-sex relationships often shortchange literary quality and the ability to effectively convey a political message. Analyzing the books from both a literary and political framework, I found the concept of difference is often used in a problematic way. While espousing a politic of valuing diversity, the message frequently asserted is, conversely, that those outside the heterosexual mainstream are "okay" because they are *normal* and *just like everyone else*. If difference is only celebrated because it matches the status quo, then it is assimilation rather than difference that is actually being celebrated.

The nature of privilege is often invisible to those who have it. It is what is taken for granted. One of the ways in which privilege manifests itself is that those who hold it rarely have to question their place as subjects of their own experience, as opposed to objects for others to study. Children's picture books with characters in same-sex relationships continue to ove-r whelmingly position relationships outside the heterosexual mainstream as objects to be studied. The emphasis on these populations as "normal" turns individuals into stereotypes. While this may be done as an attempt to end homophobia, when one is turned into a symbol, one is no longer in the position of being a fully complex person or of inhabiting a culturally specific space. Creating an anti-oppressive political framework is a multi-faceted task informed not only by ideologies but also by the pedagogical forms in which such ideologies are conveyed. Children's picture books that seek to end homophobia and heterosexism provide a rich landscape for examining how the form in which a politic is conveyed can be as crucial to challenging or reinforcing an ideology as the explicit politic itself. They are valuable examples of the multi-layered ways oppressive norms can be reiterated even as they are resisted. Such contradictions need to be addressed in order to understand how family structures outside the heteronormative mainstream are not yet being fully and effectively depicted in diverse and inclusive ways within children's picture books.

REFERENCES

Alden, Joan. Illustrated by Catherine Hopkins. *A Boy's Best Friend*. Boston: Alyson Wonderland, 1992.

Aldrich, Andrew. Illustrated by Mike Motz. *How My Family Came to Be: Daddy, Papa and Me*. Bel Air, CA: New Family Press, 2003.

Baker, Deidre, and Ken Setterington. *A Guide to Canadian Children's Books*. Toronto: McClelland and Stewart, 2003.

Bannerji, Himani. "But Who Speaks for US: Experience and Agency in Conventional Feminist Paradigms." In H. Bannerji et al., eds., *Unsettling Relations: The University as a Site of Feminist Struggles*. Toronto: Women's Press, 1991.

Combs, Bobbie. Illustrated by Danamarie Hosler. *ABC: A Family Alphabet Book*. Ridley Park: Two Lives Publishing, 2001.

Greenberg, Keith Elliot. Photographs by Carol Halebian. *Zack's Story*. Minneapolis: Lerner Publishing Group, 1996.

Kumashiro, Kevin K. "Against Repetition: Addressing Resistance to Anti-Oppressive Change in the Practices of Learning, Teaching, Supervising, and Researching." *Harvard Educational Review* 72 (Spring 2002): 67–92.

Newman, Leslea. Illustrated by Russell Crocker. *Gloria Goes to Gay Pride*. Boston: Alyson Wonderland, 1991.

—. Illustrated by Diana Souza. *Heather Has Two Mommies*. 1st ed. Boston: Alyson Wonderland, 1989.

Parnell, Peter. Illustrated by Justin Richardson. *And Tango Makes Three*. New York: Simon and Schuster Children's Publishing, 2005.

Phelan, Shane. "(Be)Coming Out: Lesbian Identity and Politics." In J. Dean, ed., *Feminism and the New Democracy*. Thousand Oaks, CA: Sage, 1997.

Rochman, Hazel. *Against Borders: Promoting Books for a Multicultural World*. Chicago: American Library Association, 1993.

Setterington, Ken. Illustrated by Alice Priestly. *Mum and Mum Are Getting Married*. Toronto: Second Story Press, 2004.

Valentine, Johnny. Illustrated by Lynette Schmidt. *One Dad, Two Dads, Brown Dad, Blue Dads*. Boston: Alyson Wonderland, 1994.

Wickens, Elaine. *Anna Day and the O-Ring*. Boston: Alyson Wonderland, 1994.

Willhoite, Michael. *Uncle What-Is-It Is Coming to Visit*. Boston: Alyson Wonderland, 1993.

—. *Daddy's Roommate*. Boston: Alyson Wonderland, 1990.

III HANDING OUT CIGARS:

History, Visibility, and Social Change

POLITICS OF THE HEART:

Recognition of Homoparental Families in Quebec

Nancy Nicol

IN JUNE 2002, PRIOR TO THE PASSAGE OF CIVIL MARRIAGE FOR SAME-SEX couples in Canada, the Quebec National Assembly passed Bill C-84, which created civil unions, a structure closely equivalent to marriage and open to both heterosexual and same-sex couples. With regard to parenting rights for same-sex couples, Bill C-84 revised the filiations provisions of the Civil Code of Quebec to extend equal parenting rights and recognition to same-sex couples. These changes to the Civil Code put Quebec in the forefront of extending recognition and rights to same-sex couples with regard to parenting rights and recognition. Bill C-84 built upon legislation passed in 1999 (Bill 32) in Quebec, which redefined the term "spouse" in thirty-nine provincial laws and regulations to include same-sex spouses in common law relationships, resulting in the extension of same-sex benefits to some 450,000 unionized workers in Quebec. In contrast to other jurisdictions in Canada where there had been strong dissent to the passage of such legislation, particularly over the question of same-sex parenting rights and adoption, the National Assembly of Quebec voted unanimously and without abstentions in favour of Bill C-84. Yet, prior to the mid-1990s, there was no recognition of lesbian and gay relationships and families in Quebec. How these changes came about is the subject of this essay.

In 2004 and 2005, I travelled across Canada conducting research for a documentary film series on same-sex relationship recognition, same-sex

marriage, and parenting rights and recognition throughout Canada (Nicol, 2005, 2006, 2009). I had the opportunity to interview many same-sex couples as well as lawyers and activists who have been at the forefront of these recent battles. This essay draws upon my research and focuses on the role of grassroots organizing and coalition building as instruments of social change in challenging the historical exclusion of same-sex relationships and families. While Canada is seen as a global leader in gay and lesbian rights, it is important to understand that these rights are a result of many years of struggle for change through social movement mobilizing as well as legal challenges to inequality. Every province has its own story, and Quebec's story is particularly fascinating because of the role played by organized labour, the women's movement, and lesbian mothers. The passage of Bill C-84 and the changes to the filiations provision of the Civil Code came as a result of a highly organized campaign for same-sex relationship recognition and parenting rights for same-sex couples.

The ways in which relationship recognition, parenting rights, and same-sex marriage have unfolded in Canada are multi-faceted, with unique histories in different parts of the country. This is particularly the case in Quebec, with its distinct linguistic, cultural, and political identity and legal traditions. Quebec has a very high level of trade union and feminist organization that is, in part, linked to its history of national self-determination. Membership in public and private sector unions is one of the highest per capita in North America. The Confédération des syndicats nationaux (CSN)/National Trade Union Confederation, a federation of all the Quebec unions, and the Fédération des femmes du Québec/Quebec Women's Federation, a province-wide organization of women, both play an important role in Quebec society and have had significant influence on the context and outcome of the struggle for LGBT rights (Lagacé, 2004; Demczuk, 2004). This essay examines two interconnecting aspects of this history: the grassroots organizing of lesbian mothers, including the first couple to launch a lesbian mothers' adoption case in Quebec (Greenbaum and Paquette, 2004), and the building of two coalitions that played key roles in the struggle for equal rights for same-sex parents and same-sex relationship recognition — La table de concertation des lesbiennes et gais du Québec/The Roundtable of Lesbians and Gays of Quebec, a coalition of lesbian and gay organizations in Quebec, and La coalition québécoise pour la reconnaissance des conjoints et conjointes de même sexe/The Quebec Coalition for the Recognition of Same-sex

Couples, a broad-based coalition that includes trade unions and women's organizations throughout Quebec.

As lesbian and gay parents have sought recognition and rights and become more visible throughout Canada, the ramifications of this struggle have become complex and multi-faceted, exposing prejudices and barriers from school-board fights over inclusion in the curriculum of children's books that depict lesbian- and gay-parented families, to heated political debates in provincial and federal legislatures. Before focusing on Quebec, I briefly describe below some key events that took place in Ontario and British Columbia.

Ontario and British Columbia

In Ontario in 1994, a bill to recognize same-sex relationships (Bill 167) was defeated in a storm of homophobic backlash. Bill 167 would have changed the definition of "spouse" to include same-sex couples in some sixty-seven statutes of Ontario law. One of the most controversial aspects of the legislation was the inclusion of adoption by same-sex couples, despite the fact that lesbians and gay men already had the right to adopt as individuals as a result of a 1986 Ontario Human Rights Code amendment. Members from all sides of the house, including some members of the governing party (the NDP), opposed the legislation, arguing that recognition of same-sex relationships and adoption by same-sex couples was an assault on the "traditional" family and that it would lead to the breakdown of society. Charles Harnick, then Conservative member of the legislature and critic for the Attorney General, framed his opposition to Bill 167 by decrying the "silencing" of those who sought to uphold "traditional family values" and recalling how U.S. "Senator Daniel Patrick Moynihan was condemned as a racist" for his 1963 War on Poverty study that focused on single Black mothers and argued that poverty and crime was rooted in the absence of a father figure. Harnick stated the following to the Ontario legislature during the debate on Bill 167:

> The changing nuclear family and the consequences of this change are today being documented and studied by sociologists as never before, to see if they lie at the root of the unprecedented social turmoil we see all around us in the 1990s. From poverty to illiteracy to criminality, social scientists are fast coming to the conclusion that many of our most pressing public policy challenges can be traced directly to society's declining support for the traditional family ... The case for this argument

was best surveyed in an essay in the May 1993 issue of the *Atlantic Monthly* ... It recalls how in the mid-1960s Senator Daniel Patrick Moynihan was condemned as a racist for drawing a link between the prevalence of black single-mother families and the lower socioeconomic standing of black children. Every time the issue of family structures has been raised, it notes the response has been at first controversy, then retreat and finally silence. The essay continues, and I commend it to everyone in this Legislature, through 21 dense pages of evidence drawn from dozens of studies, all of which point to the same conclusion, that with the decline of society's support for the traditional family and the emergence of so-called alternative family models follows the decline of the social, psychological and economic development of society as a whole. (1 June 1994, Hansard: 6582)

The fact that Moynihan's study was enlisted by the Conservative opposition to contest recognition of same-sex relationships and adoption by same-sex couples in 1994 is an indicator of the stubbornly persistent gender and racial assumptions underpinning the "traditional family values" position. In a last ditch effort to save the legislation, the governing NDP revised Bill 167 to remove adoption from the legislation. Nonetheless, the bill went down to defeat at second reading, sparking one of the largest demonstrations by gays and lesbians in Ontario's history. One year later lesbian mothers won an important victory over the Ontario legislature, when an Ontario court ruled that the *Child and Family Services Act* of Ontario violated the Charter of Rights and Freedoms by denying applications for co-parent adoption by lesbian mothers. The case was brought by four lesbian mothers and their partners seeking the partner's right to adopt their children (see *K.* (Re) (1995)).

In 1997, British Columbia became the first province in Canada to adopt legislation recognizing same-sex relationships. Yet at the same time, a major controversy broke out in a suburb of Vancouver, when the Surrey School Board banned three children's books that depicted same-sex parents. Kindergarten teacher James Chamberlain had introduced the books to his class as part of the curriculum on family. Religious fundamentalists organized a series of large community meetings and public demonstrations supporting the ban. The controversy continued for almost six years while the case wound its way up to the Supreme Court of Canada, ultimately costing Surrey taxpayers $1,200,000 in court costs (spent by the Surrey School Board in defending their ban of the three children's books). It should also be noted that despite

the opposition of the Surrey Board to the books, seventeen of twenty parents with children in James Chamberlain's kindergarten class supported the books and petitioned the Surrey School Board to "uphold inclusiveness in the classroom." The B.C. Teachers Federation which had, just weeks prior to the book ban, voted overwhelmingly to combat homophobia in the schools, supported Chamberlain throughout the controversy (Chamberlain, Chudovsky, and Henderson, 2004).

Key arguments presented by counsel for the Surrey Board revolved around questions of sexuality, procreation, age appropriateness, and "cognitive dissonance." According to Joe Arvay, the lawyer representing Chamberlain and the B.C. Teachers Federation: "In the Surrey School Board case, 'cognitive dissonance' meant pretty much the same thing as confusion" (Arvay, 2004). According to Lorraine Weir, who acted as an expert witness defending the books, the opposition was based on the idea that "if you introduce these books the children will be confused because these images do not conform to what they see at home" (Weir, 2004). In essence, legal arguments advanced by the Surrey School Board seemed to be based in a belief that same-sex parents simply do not exist or, if they do exist, they should remain hidden. Kim Forster, a lesbian mother with two sons in public school in Surrey at the time, remarked that the opponents of the books constantly referred to the "homosexual agenda" as an "outside influence" undermining "their" families, seemingly with no understanding that there were lesbian and gay-parented families in Surrey (Forster, 2004). The Surrey case is an eloquent example of the culture wars over same-sex-parented families and the deeply seated fears that same-sex parenting engenders for some. As Weir describes it:

> The topic of procreation is irrelevant to these books. But it was a pressing concern for parents and for some members of the Surrey School Board as a result of that lifetime of aversive programming that sees heterosexuality in terms of blissful and truly ethereal experiences that are somehow un-sexualized or desexualized, and same-sex partnership as somehow in terms of the most literalized and negative understanding of sexual experience ... Cognitive dissonance means what is beyond their imaginative range, what exceeds their cognitive grasp. It's a way of saying that same-sex relationships are unimaginable and should not be imagined. And, on the other hand, what is so familiar at the seat of this aversive response, as part of a deeply negative landscape that's associated with the opposite of their normative family values, is what

must be marked and recognized as negative. So there's a double message. On the one hand they are saying to the children, "You must not learn this." And on the other hand they are saying to the children, "You must learn this as negative." (Weir, 2004)

In 2002, the Supreme Court ordered the Surrey School Board to reconsider the books. In its decision, *Chamberlain v. Surrey School District No. 36*, it stated that the "the Board violated the principles of secularism and tolerance… without considering the interests of same-sex parented families and the children who belong to them in receiving equal recognition and respect" (4). Chief Justice Beverley McLachlin wrote: "Tolerance is always age appropriate" (46), and "learning about tolerance is therefore learning that other people's entitlement to respect from us does not depend on whether their views accord with our own. Children cannot learn this unless they are exposed to views that are different than what they are taught at home" (45).

The Struggle in Quebec

Despite the fact that Quebec was the first province in Canada to include non-discrimination on the basis of sexual orientation in provincial human rights legislation in 1977, the government continued to discriminate against gays and lesbians for the next twenty-five years under fifty-four different statutes related to family and relationships. But by the early 1990s a number of factors contributed to an emerging crisis. To begin with, Montreal was devastated by the AIDS epidemic; it was one of the hardest hit communities in North America. Gay couples faced tremendous hardships: the absence of the recognition as "next of kin"; denial of visitation rights in hospitals; the absence of bereavement leave, pension benefit, or health benefits for same-sex partners; denial even of the surviving partner's right to mourn as homophobic relatives of the deceased excluded same-sex partners from "family" funerals. All of these factors contributed to mounting bitterness and anger. Parallel to the AIDS crisis was a series of murders of gay men in Montreal between 1990 and 1993, which, according to reports in the local press, ranged between fifty and sixty individuals. The crimes went unsolved and created a perception that the police were doing nothing. At the time, lesbians and gay men tended to be organized separately. The crisis precipitated by violence and discrimination, however, led to the formation of joint organizations and work between gay men and lesbians.

A well-organized lesbian community had existed in Montreal for the past

thirty years with deep historical links to a strong feminist movement in Quebec. Lesbians had participated in the women's movement and were involved in the establishment of women's health care services, pro-choice organizations, and clinics during the 1970s and 1980s. Throughout that time, lesbian mothers' organizations remained small support groups, principally made up of mothers who had divorced a man and who lived in a reconstituted family with their children. The issues of that period were custody rights in divorce cases, invisibility, social stigma, and isolation (Caldwele, 2004; Chamberland, 2004; Demczuk, 2004). Lesbians and gay men began working together in 1990, following a violent raid by the police.

On July 15, 1990, police conducted a late-night raid on "Sex Garage," a fund-raising party for HIV-positive men. The following day, gay and lesbian communities protested in a large demonstration, and once again were violently attacked by the police, this time in broad daylight. The confrontation was filmed and televised widely. These events were the catalyst that led to the first coalition of lesbian and gay organizations in Quebec, La table de concertation des lesbiennes et gais du Montréal/The Roundtable of Lesbians and Gays of Montreal. One of the founders of La Table, Irène Demczuk, speaks to how the raid led to the need for organizing:

> [The raid on "Sex Garage"] was an event that raised our consciousness; that in spite of the fact that homosexuality was decriminalized, in spite of the fact that there was non-discrimination in the [Quebec] Charter we were not treated as equal citizens. And this prejudice was more the way we were seen by the police and by people in society than how we really were. So that was really an important event. And so, almost immediately, we started working on the question of rights, on the question of judicial equality. (Demczuk, 2004)

La Table put pressure on the Quebec Human Rights Commission for a public enquiry into discrimination and violence against gays and lesbians and launched an organizing drive throughout Quebec calling on organizations and individuals to testify before the Commission (Hendricks and Leboeuf, 2004; Demczuk, 2004). In June 1993, the Commission held ten days of public hearings in which seventy-five organizations and individuals gave testimonials about relationships with the police, violence, HIV and AIDS, and the consequences of not having family and relationship recognition. Among those testifying was Anne Robinson, a professor of law from Laval University, who spoke on same-sex families, custody, and adoption and

called for granting the right to marry to lesbians and gay men. On June 1, 1994, the Commission issued its report entitled *De L'Illégalité à l'égalité / From Illegality to Equality*, which made forty-one recommendations dealing with a range of issues from relations with police and violence to relationship recognition, parenting rights, and same-sex marriage. The report provided a base for the lesbian and gay movement to press for legislative and political change. Three years passed and there was no progress. Seeking to pressure the government into action, La Table set out to build a coalition with organizations outside the lesbian and gay groups focusing on the trade union movement and the women's movement. The alliance became La coalition québécoise pour la reconnaissance des conjoints et conjointes de même sexe / The Quebec Coalition for the Recognition of Same-sex Relationships (or La coalition québécoise for short). The coalition's strategy reflected deeply rooted nationalist, feminist, and labour organizing traditions in Quebec (Demczuk, 2004; Lagacé, 2004; McCutcheon, 2004).

BUILDING THE COALITION

La Fédération des femmes du Québec / The Québec Federation of Women is one of the oldest and largest feminist organizations in Quebec, with regional councils located throughout the province. In the 1990s there were approximately 1,800 women's groups and individual members in the organization. In August 1995, La Fédération des femmes organized the Bread and Roses March to demand an end to poverty for women. The march was an extraordinary event, organized throughout the province of Quebec with roughly 25,000 women participating, many travelling by foot to the National Assembly in Quebec City. The government agreed to meet with them and they succeeded in making some significant gains, notably, the raising of the minimum wage, indexation of benefits for people living on social assistance, and supports for immigrant women. It was in this context that Irene Demczuk and others formed a committee for recognition of lesbian rights within the Quebec Federation of Women (Caldwele, 2004; Demczuk, 2004).

For Demczuk, as an activist in the Federation during the time of the Bread and Roses March, there was, as she describes it, "an extraordinary paradox [since] four-fifths of the organizing committee of the Bread and Roses March were lesbians but we were not able to speak in a collective voice to say we would also like to add to the list of demands a demand for

equality for lesbian women." So, in September 1995, at the general meeting of the Federation following the march, Demczuk demanded the support of the president of the Federation, Françoise David, to launch a committee for the recognition of lesbians in the Quebec Federation of Women. This committee worked intensively between 1995 and 2000 to build support for lesbian rights within the women's movement in Quebec. Its work laid the groundwork for the support from the Federation of Women when they were asked to join La coalition québécoise in 1998.

Beginning in the mid-1980s, and fuelled in the 1990s by the AIDS crisis, work was being done in the trade union movement to combat discrimination and to integrate lesbian and gay rights into collective agreements as well as to develop support for LGBT human rights and equality in society. As a result, activists in the CSN were also instrumental in the formation of La coalition québécoise (Lagacé, 2004).

Another key player in the coalition was the Association des mères lesbiennes du Québec/Lesbian Mothers Association of Quebec (LMAQ), founded in October 1998 by Mona Greenbaum and Nicole Paquette. The first meeting was held in their living room, when their son Léo was two and a half months old. Some forty women showed up. Mona and Nicole founded the LMAQ in direct response to a series of obstacles they had faced in their attempt to have children. To begin with, clinics in Quebec refused to give an unmarried or lesbian couple access to donor insemination. Later, once Mona became pregnant, the couple sought to establish recognition of Nicole's parenting role and launched the first case for co-parent adoption by a lesbian couple in Quebec in the spring of 1998. When access to family planning and donor insemination continued to be a problem for lesbians, the LMAQ took matters into its own hands. Mona Greenbaum tells how it was done:

> We did our own insemination. My partner's a doctor, so we were able to do it. We started our own mini sperm bank. We had a big liquid nitrogen tank. Lesbians would order sperm and keep it in our tank and ring our door bell at five in the morning, [saying:] "It's time, we're going to do it before work." And they would come and pick up their little vials. It was complicated and none of us were fertility experts, so it was kind of hit and miss. It was actually the lesbian mothers' sperm bank. (Greenbaum, 2004)

The issues for these women were reproductive rights, access without

prejudice to fertility clinics, the ability to negotiate their relationships to known sperm donors or to live as three-parent families, and recognition and legal rights for both mothers (since only the birth mother was accorded any status in law in relation to the child). Initially, the LMAQ acted as a support group, seeking to overcome isolation and building community, doing educational work and sharing information about supportive doctors. But very quickly the LMAQ became a political organization, reflecting a higher level of confidence and sense of entitlement than what had been expressed by lesbian mothers' groups of the previous decade. Mary Lamey, a member of the Political Action Committee, explains:

> Once you decide that you're going to live as a lesbian, you've already thrown off what the world's expectations are, right! The world already says that you shouldn't be a lesbian. So once you've crossed that frontier, you've made a decision. Are you going to not have children because the world says you shouldn't have children, that this is some sort of social experiment? No, you know who you are, and you know what your motivations are. If the world ... is not always a kind place [and] you want your kids to be safe in the world, then the world's got to change, not your kids. (Lamey, 2004)

THE COALITION'S CAMPAIGN FOR HOMOPARENTAL RIGHTS

On November 8, 2001, the Quebec government released a "White Paper" on preliminary legislation that would introduce a limited form of civil union for same-sex couples (Mario, 2001: 1). The proposed legislation provided hospital visitation rights and some benefits for same-sex couples, but fell far short of equal rights and recognition of same-sex relationships and contained nothing with regard to same-sex parenting rights and adoption. La coalition québécoise — which for months had been asking for a meeting with the justice minister to advise the government on any proposed legislation — reacted with outrage to the "White Paper." It demanded and got a meeting with Justice Minister Paul Bégin. At that meeting, Bégin agreed to hold a public Parliamentary Commission on the legislation. The LGBT community and La coalition québécoise, including its allies in the trade union movement and the Quebec Federation of Women, responded by initiating an extensive public campaign and organizing drive, similar to what they had done in 1993 for the Quebec Human Rights Commission. In particular, members of the LMAQ launched a press campaign to raise awareness in Quebec about the

needs of same-sex parents to have their relationships and families recognized and to be given full rights as parents. Mona Greenbaum describes their campaign and the impact of the widespread media attention it captured:

> People realized that we existed. I don't think people knew that we existed before that. I mean, we, back in 1998, we didn't know that we existed! So, you know, all of a sudden it came into the public domain, about lesbian parents. So there were a lot of interviews and a lot of debating back and forth whether or not we should have rights as parents. I think Quebec society had evolved enough to that point where the majority of people were very clear that couples, gay and lesbian couples, should be recognized; but when it came to kids, it was very "iffy." People didn't know. The group had gone from being just a social and support group, an information group, to being a political group. And those women were very involved and they knew that we were fighting for something very important that was going to affect all of us on a very personal level. (Greenbaum, 2004)

The Parliamentary Commission heard from a wide range of labour and community-based organizations supporting same-sex relationship recognition and parenting rights, the fruition of years of organizing by the coalition. The president of the Federation of Women presented a paper to the Commission and appeared before the media to defend lesbian and gay parenting rights and relationship recognition (Caldwele, 2004; Demczuk, 2004). The Confédération des syndicats nationaux's presentation called for the recognition of same-sex adoption and parenting rights. As well, it successfully argued with the National Assembly members and Minister of Justice Bégin that civil unions should not be established as a separate category for homosexuals as was originally proposed in the legislation. A separate civil union provision only for lesbians and gay men, the CSN argued, would constitute a segregated status, violating the dignity of same-sex couples by maintaining the taint of discrimination against same-sex relationships. Rather, the CSN argued, civil unions should be open to anyone regardless of their sexual orientation (Lagacé, 2004).

In addition, quite spontaneously, Irene Demczuk, acting as the co-ordinator and the spokesperson for La coalition québécoise, decided that the National Assembly should also hear from the children of lesbian and gay parents. She asked three youths who had been raised by lesbian or gay parents to present their perspectives to the Parliamentary Commission.

Their testimony proved to be a turning point in the hearings. One of the youths, Annick Gariépy, told the National Assembly that her mother had always hidden her lesbianism and that even on the day of her testimony her mother did not know she would be testifying before the Commission. She went on to explain to the Assembly why they should vote to extend parenting rights and recognition to lesbians and gay men:

> My mother is a mother who is there for me, who has given the best of herself. She is encouraging, attentive, available, devoted: all the qualities that a mom should have. As I was saying earlier, it has only been four or five years since I started to reconcile myself with my mother's sexual orientation. I stopped feeling humiliation to have a parent often associated with pedophilia, abnormality — a parent seen as outside the norm. I often asked myself, and this is in my testimonial, how could a feeling as noble and as beautiful as love have inspired in me feelings as devastating as shame? As a child I was mortified by this situation. Continuing to play ostrich and denying them rights normally recognized for heterosexual parents constitutes more of a menace to the family than could ever be the inverse, contrary to what some may think. How could giving all of one's love and dedicating your life to a child be a menace to society or to the family? Why ask gays and lesbians to renounce a part of their humanity in the name of this difference? (Nicol, 2005)

The testimony of the three youths moved the members of the Quebec Assembly to tears and profoundly influenced the proceedings. Initially, Justice Minister Paul Bégin had faced considerable opposition to the proposed legislation from members of the Assembly. However, following the Parliamentary Commission, Paul Bégin rewrote the legislation to establish civil union for both heterosexual and homosexual couples in Quebec, extending to civilly united couples the same rights as married couples (since marriage is federal law, Quebec could not change the *Marriage Act*), and modifying fifty-four laws to revise the Civil Code of Quebec to establish new "assisted procreation" rules (donor insemination) and adoption and parenting rights for same-sex couples.

The legislation allowed *both* women in a lesbian couple to sign the birth certificate upon the birth of their child and eliminated the need for co-parent adoption to secure parenting recognition for both parents. Members of La coalition québécoise attended the vote in the legislature in Quebec City, as did mothers from the LMAQ who brought their children with them (it was the first time that children were allowed into the National Assembly during

a vote on legislation). Together they stood as witnesses in the National Assembly as members rose and voted unanimously and without abstentions to support the legislation.

In reflecting on this history in Quebec, a few observations are important to note. Prior to the Parliamentary Commission, polls indicated that only 35 percent of Quebec society supported parenting by lesbians and gay men. By the time the legislation was passed, the debate, the work of La coalition québécoise, and the LMAQ media campaign had significantly influenced public awareness. Throughout the televised debate in the National Assembly on civil union and same-sex parenting, there was little religious or conservative opposition to the bill. The Catholic Church did not intervene in the Parliamentary Commission hearings. The reasons for this can be understood against the background of the 1960s Quiet Revolution (Révolution tranquille) and the secular-ization of Quebec society, which has, over the past generation, significantly transformed the role of the Church in Quebec (a complex history which goes beyond the scope of this essay). In 1995, the Quebec government had initiated work to give all children the same rights with respect to questions of guardianship, care, responsibility, and inheritance whether in married or unmarried/"conjoints de fait" families ("conjoints de fait" is similar to "common law" but with different legal status). Paul Bégin, the justice minister who rewrote the Civil Code of Quebec to extend equal parenting rights and recognition to lesbian and gay parents, commented on this history in the following way:

> Mark André Bédard (the former minister of justice between 1976 and 1984) had said ... "all children will have the same rights (in Quebec)"... In 1994/95, that wasn't true, children did not all have the same rights ... children living with parents in "conjoints de fait" didn't have the same rights (as children living with married parents) ... And, there were also homosexuals who didn't have the same rights in regard to their children and their children in regards to their parents. (Bégin, 2004)

Anne Robinson also reflected on how the passage of civil union and parenting rights for lesbians and gays equal to that of heterosexual couples affected the debate on same-sex marriage in Quebec:

> I'll remind you that the vote on the civil union was unanimous in the National Assembly. That means that all the parties involved, the whole of representatives present in the National Assembly voted in favour of civil union and Paul Bégin got a standing ovation. There was a great

consensus in the Parliament … And there was no major opposition within the population, there were no protests, no demonstrations in the streets, not even the Catholic Church made public pronouncements or contested the question when the law on civil union was adopted. It must have had an effect at least psychologically on Quebec judges who read the papers like everyone else. So no doubt it had repercussions … for the judgment on marriage. When Michael [Hendricks] and René [LeBoeuf] won their case in the Superior Court and following from that in the Appeal Court, it made a lot less fireworks than in the other Canadian provinces where there's been many, many articles in the newspapers and on television [and] radio. In Quebec, it's stayed more a dead letter, because the debate had happened with civil union. (Robinson, 2004)

Moreover, during the debate on same-sex marriage between 2003 and 2005, national polls indicated that the highest support for same-sex marriage in Canada was in Quebec. (The first successful case for same-sex marriage was launched in Quebec by Michael Hendricks and René LeBoeuf, although arguably the success of their legal case rested on the outcome of cases mounted in Ontario and British Columbia.) At the same time, the lowest support for marriage as an institution was in Quebec. This, I would argue, is not a contradiction but rather reflects a higher level of support for different forms of families and relationships. Moreover, the struggle by lesbians and gays for the recognition of same-sex marriage, relationship, and parenting rights that resulted in the passage of the civil union bill has effectively broadened the choices of relationship recognition available to people in Quebec, whether heterosexual or homosexual.

While activists in Quebec used the courts to advance their goals, the campaign in Quebec was characterized by deep traditions of social movement activism arising out of Quebec nationalist, feminist, and labour roots and informed by a perspective that grassroots organizing across civil society has the capacity to transform society as a whole in a way that judicial activism alone is less likely to achieve. As Irene Demczuk comments:

It was important to sensitize the most important social movements in Quebec to begin with. Without them we would not have been able to obtain the formal equality in the laws, which we have now. And also I'd say that there's a certain tradition in Quebec because we are a minority people as francophone, and because we don't have the British tradition of using tribunals. So rather than supporting individuals to take cases to courts that will establish jurisprudence for the majority, these are private

individual actions. I think that in Quebec our traditions come from the community movement that has been so strong here for the past thirty years, the idea that by education, by consciousness-raising, you can change things in a way that's much more profound than in front of the courts. (Demczuk, 2004)

Similarly, Minister of Justice Bégin, who wrote the legislation, stated:

Courts impose on society how to live, and there are people who still have a lot of animosity, hostility with regards to it. Whereas here, it [the change to the Civil Code] has been the fruit of a process that was shared by society. Everyone had a chance to express their opinion ... The Parliamentary Commission revealed that by doing this we weren't changing people's mentalities, we were just rising to the level of what society already was. (Bégin, 2004)

In the wake of these advances in rights in Quebec, LGBT groups have grown in confidence and organization. From the forty women who responded to a call for the founding meeting in 1998, the Lesbian Mothers Association grew to represent 900 lesbian and trans-parented families throughout Quebec by 2005, becoming the largest lesbian organization in the province. Recently, it joined with the Papa-Daddy Group to form the LGBT Family Coalition and in 2006 launched the first Québécois book for young children that depicts families with same-sex parents. Today, the LGBT Family Coalition has received funding for a paid co-ordinator, and continues to do groundbreaking work in support of LGBT-led families in Quebec, including working with the Montreal School Board on curriculum inclusion of same-sex families.

The LGBT Family Coalition's current work in the schools in Quebec is a reflection of both the successes and the challenges the organization faces. Children of LGBT parents still encounter prejudice at school and there are insufficient resources to raise awareness and overcome marginalization. Groups like the Lesbian Mothers Association of Quebec have been at the forefront in challenging unjust laws, overcoming barriers, and seeking change. The gains they have achieved since the beginning of 1990s are a remarkable achievement, but the work of overcoming prejudice and building a new society where every child is treated equally and every family is accorded dignity and respect remains a work in progress.

REFERENCES

* This essay is a revised version of a paper presented at the conference "Heresy, Blasphemy, and the Freedom of Expression," January 18–20, 2007, University of Central Florida, Orlando, FL. It was funded in part by a Social Sciences Research Council of Canada (SSHRC) Creation/Research grant for the documentary *Politics of the Heart/ La politique du coeur*, held by Nancy Nicol. I would like to thank Pascal Hugo Plourde and Krys McGuire for their research assistance, Miriam Smith for her expertise and insightful comments on this work and the interview subjects for agreeing to participate in this research. This research was conducted in accordance with Canada's *Tricouncil Statement on Research Ethics*. All interviews were conducted by Nancy Nicol, except as noted. The essay draws on interviews that aimed to explore the political strategies, meanings, and goals of same-sex couples, their lawyers and allies and designed to understand the organizations and strategies used by the movement for same-sex relationship recognition and parenting rights in Quebec.

Arvay, Joe. Interview with author, Vancouver, BC, 16 July 2004.

Barratt, Amy, and Mary Lamey. Interview with author, Montreal, QC, 30 July 2004 and 20 August 2005.

Bégin, Paul. Interview with author and research assistant Pascal Hugo Plourde, Quebec City, 4 September 2004.

Caldwele, Evangeline. Interview with author and research assistant Pascal Hugo Plourde, Montreal, QC, 7 May and 29 July 2004.

Chamberlain, James, David Chudovsky, and Donelda Henderson. Interview with author, Vancouver, B.C., 19 July 2004.

Chamberland, Line. Interview with author and research assistant Pascal Hugo Plourde, Montreal, QC, 9 May 2004.

Cloutier, Mario. "Québec reconnaîtra l'union civile homosexuelle, Paul Bégin travaille à un avant-projet de loi consacrant les droits des couples de meme sexe." *Le Devoir,* 9 November 2001: 1.

Demczuk, Irene. Interview with author and research assistant Pascal Hugo Plourde, Montreal, QC, 7 May and 1 August 2004.

Forster, Kim. Interview with author, Vancouver, BC, 16 July 2004.

Greenbaum, Mona. Interview with author, Montreal, QC, 6 May and 2 August 2004, 5 September 2007.

Greenbaum, Mona, and Nicole Paquette. Interview with author, Montreal, QC, 2 August 2004.

Harnick, Charles. Ontario Legislative Assembly, Session 35:3, June 1, 1994. Debate on Bill 167, *Equality Rights Statute Law Amendment Act*. Hansard: 6582.

Hendricks, Michael, and René Leboeuf. Interview with author and research assistant Pascal Hugo Plourde, Montreal, QC, 8 May and 2 August 2004.

Lagacé, Francis. Interview with author and research assistant Pascal Hugo Plourde, Montreal, QC, 7 May and 29 July 2004.

McCutcheon, Laurent. Interview with author and research assistant Pascal Hugo Plourde, Montreal, QC, 6 May and 28 July 2004.

Nicol, Nancy. Director. *The Queer Nineties*. Film. Toronto: Intervention Video Inc., 2009.

—. Director. *The End of Second Class*. Film. Toronto: Intervention Video Inc., 2006.

—. Director. *Politics of the Heart*. Film. Toronto: Intervention Video Inc., 2005.

Quebec Human Rights Commission. *De L'Illégalité à l'égalité: Rapport de la consultation publique sur la violence et la discrimination envers les gais et lesbiennes*. Quebec City: Québec Commission des droits de la personne et des droîts de la jeunesse, May 1994.

Quebec National Assembly. 2nd Session, 36th Legislature, June 2002 Bill C 84, *Act instituting civil unions and establishing new rules of filiation*.

—. 2nd Session, 36th Legislature, Parliamentary Commission, 6 February 2002. *Testimony by M. Ludovic Maillé-Prévost, Mmes Julie Pétrin and Annick Gariépy*.

Robinson, Anne. Interview with author and research assistant Pascal Hugo Plourde, Quebec City, 4 September 2004.

Weir, Lorraine. Interview with author, Vancouver, BC, 16 July 2004.

LEGAL CASES CITED

Chamberlain v. Surrey School District No. 36, [2002] 4 S.C.R. 710, 2002 S.C.C 86.

K. (Re) (1995), 23 O.R. (3d) 679 (Ct. J. (Prov. Div.)).

Coalition des familles homoparentales

BOX D

LGBT Family Coalition (Quebec)

Founded in 1998, Quebec's LGBT Family Coalition (*Coalition des familles homoparentales*) is the result of the merger of two highly successful non-profit community organizations: the Lesbian Mothers Association of Quebec and the Papa-Daddy Group. We are a bilingual group of lesbian, gay, bisexual and trans-identified (LGBT) parents and future parents having fun together with our children, exchanging information, and sharing resources.

The LGBT Family Coalition also advocates for the legal and social recognition of LGBT families in collaboration with government bodies and the media. We work to increase the visibility of our families and to raise public awareness of the reality of LGBT families. Another mandate of the LGBT Family Coalition is to create new resources that can be used in primary and secondary schools, daycares, doctors' offices, community organizations, or social services to sensitize the public about our families and the diversity of our family structures. In 2008, the Coalition received a grant from Quebec's Ministry of Education to develop a workshop and resource kit to sensitize primary school professionals to the realities of LGBT families.

The Coalition was recently awarded the Quebec *Prix Arc-en-ciel* attributed to an organization that has contributed to the advancement of the LGBT community.

www.familleshomoparentales.org

Handing Out Cigars:
Outlaw Moms No More

Lois Fine

"I'll see you in court."

I hadn't expected to hear those words from my former partner of sixteen years. After all, our split was years behind us, not to mention the fact that we had done it in a big-hearted fashion. It wasn't a court that had helped us figure out who would get the house, or whether our then ten-year-old daughter, Sadie, would see me on Tuesdays and my ex, Rachel, on Sundays.

But there we were, at 393 University Avenue in Toronto, at Ontario's Superior Court's Family Division, where lawyers for both sides, garbed in long black robes, laid out our story before Mr. Justice Paul Rivard.

The thing was, we were sitting on the same side, Sadie between us. Together with three other lesbian couples and their kids, we were part of a historic joint Charter challenge, *Rutherford v. the Registrar General of Ontario*, seeking the right for birth mothers to be able to name another woman as a second parent at birth.

Our lawyers, Joanna Radbord and Martha McCarthy, presented a seventy-seven-page submission outlining why lesbian parents should have the right to register our kids' births in harmony with our actual familial relations — and why not being allowed to do so is a violation of Canada's international human rights commitments and Charter values under the guarantee of equality, liberty, and security.

If our case was successful, it would mean that both lesbian parents would be able to claim parentage at the time of the birth. We would no longer have

to pay $1,000 to $2,000 for a second-parent adoption after the fact, or for separated parents, $4,000 for a declaration of parentage before a judge.

When the case went before the court in 2005, I had been a mother for twenty-one years, but always as a parent outlaw. The fact is, I have never given birth but have parented two children — the result of two different loving relationships at different points in my life. My son and daughter are brother and sister. And there is no document to declare this. They go on my word.

When Sadie was born, my ex, Rachel Epstein (one and the same editor of this anthology) and I tried to put my name down as father on the Ontario birth certificate application. In her affidavit, she describes this:

> We wanted to both be registered legally as her parents and we wanted her surname to be a hyphenated version of both our names. I checked off the "cultural heritage" box as the reason for this digression from the norm. Our registration form was returned to us, with the information that they did not accept the hyphenated version of two women's names. When I received the long-form birth certificate and saw the blank space under father — the complete absence of any recognition of Lois — it felt like such a hurtfully inaccurate representation of the reality of Sadie's life.

In court, we listened to the government's argument: "The Ontario birth registry under the *Vital Statistics Act* records at first instance the particulars of a child's biological mother and father." That is its key function, lawyers for the Attorney General's office argued. "Non-biological parents may obtain an order of parentage under the *Children's Law Reform Act*."

But what happens, as in the instance of one of the couples in our case, when the gestational mother is implanted with the fertilized egg of her partner and their babies have a biological connection to each of them?

In fact, the Deputy Registrar General had recognized that each of the women had a genetic connection to their babies and had registered them, but not before the onerous requirement that they prove the DNA connection through medical certification. This is never asked of fathers.

When a sperm donor is used by different-sex parents, the mother fills out the form and lists her partner as father, and the Deputy Registrar General accepts the registration.

In the courtroom full of lesbian moms, children, and friends (the babies were banished from the room so the judge could hear clearly), Radbord read

part of my daughter's submission. Sadie described the discomfort of having to misrepresent her family in her passport signature, at the border, and even in listing her legal name on her affidavit in this proceeding.

"Most of my friends," she said, "have not had to think about things like this — they take it for granted that their parents are legally recognized as their parents. It would help if the government and the law recognized that I have two moms. I want my family to be accepted just like everybody else's family. It would feel like we would not have to lie anymore. I could just be who I am and sign my own signature, Sadie Rose Epstein-Fine."

The other side got up to argue its case. The other side? Wait a minute, this was Michael Bryant's ministry. I was a constituent in his riding, for goodness' sake. Wasn't he part of the same Liberal government that supported same-sex marriage?

And since my ex was the co-ordinator of the LGBTQ Parenting Network, I knew that Bryant's cabinet colleague George Smitherman had just approved permanent funding for the group. So what was he trying to say? That we could have kids but we couldn't register them legally?

Well, not exactly. We could have them, and we could register them legally, but just not right away, and not until a judge agreed that we were parents. As counsel for the government, Vanessa Yolles and Elaine Atkinson argued, "Your honour, this isn't a matter of whether these women are parents, but rather a matter of when."

When I heard the words "There is no question that they are parents," I wanted to hug them. They were the government, the powers that be, and they were saying I was a real mom. It was embarrassing to think I wanted to thank them. But only momentarily — their further arguments quickly threw a cold, wet blanket on my open heart.

I knew I wasn't supposed to get personal, but I really wondered how either of them would feel if they were told that, when their child was born, they would have to pay a huge fee no one else was required to pay to apply for parental status. And how would they have liked to face the possibility, in the case of separated couples, that a judge could decide the baby wasn't properly bonded with the other parent and deny the application?

Still, sometime on the afternoon of the second day, seemingly out of nowhere, Justice Rivard spoke straight into my non-biological mother's womb. "Will counsel draft a declaration of parentage for the families that I can sign today?" My uterus exploded at the sound; my ovaries stood at

attention. The government consented, everyone agreed.

Of course, I remembered then, it wasn't a matter of *whether*, it was a matter of *when*. The judge had simply decided that it was to be that day.

Rivard acted because he knew the larger constitutional decision would take months. But he decided, nonetheless, that the unrecognized mothers in his courtroom were not going to have to wait even one more day to be acknowledged in law as well as in love.

Today, the document declaring that I am Sadie's mother still sits by my bedside so that it's the first thing I see when I wake up each morning. I remember at the time feeling like I should be giving out cigars. And yet, in our house, nothing has changed. It has been nearly four years now since that victorious moment in court. Rivard ruled in our favour, which means that every time a child is born to a lesbian couple in Ontario, they can both be named on the birth certificate. This was a huge step towards recognition of queer families.

Of course, there are still complications. Sometimes the law changes brick by brick. The ruling only allows two women to put their names on the birth certificate if they have used an anonymous sperm donor, and it does not allow for more than two names on the birth certificate. This means that women using known sperm donors are still required to do a second parent adoption in order to secure the non-biological parent's legal rights and, if there is a known dad who is to be named, the non-biological mother may still remain invisible and unprotected. The 2007 case in London, Ontario, known as AA/BB/CC set a precedent for the recognition of three parents, but it remains a case-by-case decision.

As for Sadie, she is happy that the name she has used all of her life is finally recognized in law. When asked recently what it was like for her when we won the case, she responded:

It didn't change my life that much, truthfully. Life went on as usual. We haven't even gotten my birth certificate changed yet. But I think it's gonna do a lot more for lesbians who are having children now, because they won't have to go through the anxiety, and the worry, and the fear about what happens if their child gets hurt and her/his legal parent isn't there. Even though the odds are so slim, there's always that fear. It's sort of like gay marriage, it makes you feel like we've accomplished something and it makes you feel more accepted and that you have more rights, you know?

TWO PATHWAYS TO REVOLUTION:

The Difference that Context Makes in Canada and the United States

David Rayside

NATIONAL ELECTIONS WERE FOUGHT IN BOTH CANADA AND THE UNITED States in the fall of 2008, offering up confusing results. Americans chose Barack Obama, who made clear his support for a wide range of queer-positive measures and his rejection of the kind of anti-gay sentiment that had so permeated Republican administrations and the rhetoric of the religious right. At the same time, he and other leading Democrats signalled their opposition to gay marriage. Election night also saw victory in three states for conservative supporters of anti-same-sex marriage ballot measures and another (in Arkansas) directly attacking the parenting rights of lesbians and gay men. The campaigns favouring these referendum proposals were won, in part, by raising the spectre of the risks to children of extending legitimacy to homosexuality and gender "deviance."

Just weeks before, Canadians re-elected a Conservative government that included significant numbers of legislators and policy advisors opposed to gay marriage and to the extension of parenting rights to same-sex couples. But LGBT activists had already secured considerable gains in these areas and, though many Conservatives would have liked to undo previously won rights, the party leadership viewed any attempt to resurrect these issues as too risky (McDonald, 2006: 47–49; Rayside and Wilcox, forthcoming).

First impressions tell us (accurately) that queer parents across Canada had access to an expansive set of rights and obligations from the early 1990s

on, and that from the mid-1990s the pace of change had taken off. By the early 2000s, gains were rapidly spreading across a variety of parenting issues, at a time when same-sex parents in even the most progressive countries in Europe had only begun to make inroads on exclusionary policies. In the United States, the seemingly endless struggle over queer rights, pitting advocates for LGBT equality against the formidable religious right, produces as many setbacks as gains.

Complicating the Comparison

However, the tendency for observers to set up Canada and the United States in starkly contrasting light requires shades of grey. Significant victories have, in fact, been won by queer parents in the United States, especially since the mid-1990s. The American political and legal systems have created room for pioneering recognition of queer rights in particular locations, in some cases ahead of any other jurisdictions in the world. By the end of 2008, seven states plus D.C. had enacted measures that extended wide recognition to same-sex couples, including parenting rights. Two (Massachusetts and Connecticut) used formal marriage as the vehicle. These advances built on much earlier gains at the local level and through the courts.

Important victories have been won by lesbians and gay men making parenting claims — especially in second-parent adoption — in about half of the states (see Merin, 2002; also Pierceson, 2005). This is especially surprising when we realize that only about one-third of states have even the most basic of civil rights protections for sexual minorities. It is also impressive in light of how unresolved parenting claims remain even in those parts of Europe where lesbian and gay relationships are otherwise recognized as equal.

Here are a few striking examples. In 2003–2004, courts in New Jersey, California, and Virginia approved the inclusion of two same-sex parents on the birth certificates of their children, at about the same time that such rights were being secured in Canada. In 2007, a Pennsylvania court granted custody rights to three "parents" — the lesbian couple who planned for the child and the known sperm donor who assisted them — in the same year that an Ontario court delivered a similar ruling. These parenting gains in the United States have been made despite the continuous anti-gay mobilizing by religious conservatives and their constant preying on popular anxieties about vulnerable children.

How has this happened? One reason is the decentralization of family policy-making in American federalism (Smith, 2008).[1] Overall, Canadian provinces have greater power than American states. However, on issues related to sexuality, states have even more autonomous leverage than Canadian provinces. States also have their own constitutions, and the state court systems are more distinct from the federal system than provincial courts are in Canada. This has allowed for considerable variation from one state to another in the treatment of sexual diversity. Courts in those jurisdictions where basic rights protections have been extended to sexual minorities have the leeway to rule in distinctively progressive directions.

The absence of a clear direction on lesbian/gay rights from the U.S. Supreme Court creates further room for wide variation from state to state. Its rulings have included victories for LGBT advocates, most notably in the 1996 ruling that struck down an anti-gay ballot measure in Colorado (*Romer v. Evans*) and in the 2003 ruling that struck down the sodomy law in Texas (*Lawrence v. Texas*). But at no time has the court moved significantly towards including sexual orientation (let alone gender identity) in its interpretation of the Constitution's Fourteenth Amendment guarantee of "equal protection."

Another reason for surprising advances in the U.S. is the fragmentation of the healthcare system, and the capacity for institutional development beyond the reach of state regulation. This allowed for the opening up of assisted reproduction services to same-sex couples and to lesbian and gay individuals when such services in many other countries remained essentially closed to them. The U.S. medical system has many flaws, and weighs down the uninsured and the poorly insured with impossible risks. The substantial costs associated with assisted reproduction make it available only to those with money or comprehensive insurance. Still, clinics willing to offer services to lesbians and gay men, or that are specifically created to do so, have provided openings for large numbers of couples and individuals who are uneasy about more informal arrangements. This has expanded the population's ability to imagine queer people as parents.

An important impetus to legal change on parenting in the U.S. is the sheer number of queer families, multiplying the number of claims going to court. Judges across the country have been faced with requests to legalize the parenting roles of non-biological parents, mostly with the enthusiastic support of both partners, armed with evidence of well-functioning households. Family courts more typically faced with relationship breakdowns and cases

of parental irresponsibility often find these new claims persuasive. Since only a few states (now including Arkansas) explicitly prohibit individuals from adopting or fostering children, judges have had the leeway to rule favourably — sometimes in very conservative areas.

Explaining Canadian Progress

However remarkable the American gains have been, change in parental regulation has been more sweeping in Canada than in the United States. And because the parenting shifts in Canada have included federal jurisdiction, they are more substantial than in even the most progressive of U.S. states.

Public opinion does not help us much in explaining this. The Canadian public is just about evenly divided between support for and opposition to parenting rights for queer people, not much different from the American public, which is also evenly divided. Yes, there is a plausible argument that Canadians have become less adherent to "traditional" family values than Americans, a point made by pollster Michael Adams (Adams, 2002). And yes, there is an important difference in the proportion of Canadians and Americans who support same-sex marriage (55 to 60 percent in the former, 35 to 40 percent in the latter). But on a wide range of economic and social issues, including not only lesbian/gay adoption but also prohibitions on anti-gay discrimination in employment, Canadians are not much different from Americans. In recent years, too, Canadians have shown a willingness to elect governments at the federal and provincial level led by parties with visible currents of moral conservatism. Prime Minister Stephen Harper has, on many occasions throughout his political career, declared his opposition to the extension of rights to gays and lesbians, and to same-sex couples.

Nor can the contrast be attributed to smarter or better-organized advocates for change. Canadian activist groups have always been small — often a pale shadow of the large LGBT groups operating in Washington and at state and local levels. Individual advocates and court claimants in the U.S. have often been able to secure the support of these groups or such allies as the American Civil Liberties Union in going to court, particularly if their case has become politicized by religious conservatives. While there are regular complaints that the loss of such significant battles as Proposition 8 in California is a product of mishandled campaigning, there is no systematic evidence for such claims.

One factor that has made a difference is the constitutional rights frame-

work in Canada. Early in the 1990s, the courts in general, and the Supreme Court in particular, moved gradually towards the view that sexual orientation was covered by the equality rights guarantees in section 15 of the Charter of Rights and Freedoms. By the mid-1990s, the inclusion of *individual* rights for lesbians and gays was made clear, and in the 1999 ruling on *M. v. H.*, the Supreme Court unambiguously extended section 15 coverage to *relationship rights* and family law. A few years later, appeal courts across the province effectively extended their prohibitions on discrimination to marriage. This interpretative evolution required compliance at all levels of government, and drastically reduced the capacity for individual provinces to go their own way. Change was forced even in Alberta, the most recalcitrant of Canadian jurisdictions on sexuality issues. Quebec has followed a somewhat distinctive path, in part because of its civil code, but the overall timing of change on relationship and parenting issues has not been much out of line with provinces like Ontario and British Columbia.

Two vitally important victories on parenting rights (in Ontario and British Columbia) occurred in 1995 during a time when the Supreme Court of Canada was making clear that sexual orientation was covered by the Charter. (In B.C., a wide-ranging change in adoption legislation extended recognition to same-sex couples; in Ontario, a court ruling — *Re K. and B.* — effectively established second-parent and joint adoption rights for same-sex couples.) Sweeping change in parenting rights at the end of the decade and the early years of the 2000s followed the *M. v. H.* decision of 1999.

Another explanation for Canadian activist success was the radical broadening of rights and responsibilities accorded de facto couples. Changes in Canadian law and public policy from the 1970s on had gradually narrowed the gap between formally married and co-habiting straight couples. By the mid-1990s, there were few rights and responsibilities associated with marriage that were not automatically extended to "common law" couples. There have been important variations from one province to another. Alberta, for example, was slowest in extending relational rights to co-habiting couples, but court rulings opened space, even there, for the recognition of same-sex de facto couples. Quebec's civil code did not recognize "common law" relationships as extensively as did other provinces, but an extensive and skilful network of parenting activists ensured that the province's 2002 civil union regime broke new ground in creating equitable treatment for queer families.

In most of Canada, then, same-sex couples made significant gains in family recognition by claiming equivalence to heterosexual "common law" couples, without raising the hot button issue of marriage. American activists were often able to make gains on parenting issues, and more broadly on relationship claims, without raising the marriage issue, but for many of them marriage was the most obvious route to change. The growing local and state activist pressure to use marriage strategically produced a court victory in Hawaii at a very early stage. The 1993 *Baehr v. Lewin* ruling was in some ways ephemeral, since a state-wide referendum effectively reversed it, but it emboldened activists elsewhere. It also provoked a conservative firestorm for which LGBT advocates were ill-prepared, cementing the place of marriage on the movement's agenda (Rimmerman and Wilcox, 2007).[2]

Critical for Canadian success, too, was the relative weakness of the religious right. While religious conservatism is more of a force in Canadian politics than most observers acknowledge, the constituency forming the base of the religious right in the U.S. is at least twice as large (as a proportion of the population). Evangelical Protestantism is a particularly important core of the religiously based opposition to gay rights in the U.S., and it is a much more powerful voice in the U.S. than in Canada, not only in its demographic base but also in its capacity to amass politically useful resources. Although evangelical Christianity is a smaller force in Canada, the language it borrows from American counterparts gets routinely characterized as extreme.

Roman Catholics constitute a much higher proportion of the Canadian population than the American, and on some family-related issues the Catholic hierarchy has joined evangelical Protestant leaders in condemning the recognition of same-sex couples. But the Catholic Church's official position on questions related to homosexuality has not typically been reflected in Catholic public opinion (in either Canada or the U.S.), which is typically *not* more conservative than the rest of the population. In Quebec, the province with the highest proportion of nominal Catholics, support for lesbian/gay rights is relatively high. There and elsewhere across the continent, the Church's credibility has been damaged by scandals implicating clergy in child abuse and exploitation.

Canadian political institutions at federal and provincial levels provide fewer points of access to social and religious conservatives (and other intervenors), reducing their leverage over public policy. Individual legislators have fewer opportunities than their American counterparts to introduce

bills and otherwise make trouble for governments. Referenda are far scarcer in Canada, and opportunities for popular initiative in placing referenda on the ballot are almost non-existent. Federal and provincial governments therefore have much tighter control of the policy agenda than their U.S. counterparts. This can create impediments for equity-seeking activists of course, but once courts or legislators have taken steps to recognize LGBT rights, they are harder to reverse.

Conclusion

In the short period from the mid-1990s to the early 2000s, queer parenting activists across Canada, at times with only modest resources, made enormous gains. What distinguished them from their American counterparts was the opportunities created by earlier changes in family law, a constitutionally entrenched rights regime that was rapidly shifting to include them, and the comparative weakness of opponents. These factors do not necessarily mean that it will be easy or straightforward to eliminate those inequities that remain in formal policy, institutional practice, and social norms, but they will make it hard to take away the gains that have been achieved.

The important differences in political and religious contexts in which American queer activists struggle might well have predicted complete paralysis on parenting rights, particularly because opponents have so systematically positioned children at the heart of their campaigns. The surprising gains that have been made to this point are testaments to the tenacity of equity advocates, and to their capacity to marshal resources for legislative and courtroom battles.

Queer American parents, of course, now face a new challenge in the wave of broadly worded state constitutional amendments prohibiting lesbian/gay marriage. By the end of 2008, twenty-nine states had state-level constitutional prohibitions on such marriage, most of them using expansive language aiming to bar any extension of marriage-like rights to same-sex couples. The California amendment approved by voters in November 2008 was not one of those, and would appear not to threaten the parenting rights extended earlier to the state's same-sex couples through a domestic partnership regime. But for those states with more expansively worded measures, it is not yet clear how effective this language will be in either preventing further gains in parenting and relationship rights, or in rolling back gains already made.

Nothing in past experience predicts an easy path ahead in the United States. However, the parenting "facts on the ground" — created by lesbian

and gay couples eager and able to include children in their families — will likely make any setbacks temporary. Gains on the specific question of marriage will be hard, but the very focus on marriage may well ease the path for change on other fronts related to queer families. Fragments of evidence on public attitudes, and the continuing slow spread of positive outcomes on parenting claims, suggests that the marriage fight may become separated out from other issues. Even if courts decide that the expansive language of constitutional amendments on marriage prevent one or another right being extended to lesbian and gay parents, the sheer impossibility of retaining such limitations will become more apparent as the claims and challenges multiply. The pace of change will continue to be laboriously slow, but it will not relent.

NOTES

* I have written extensively about parenting in Canada and the United States in *Queer Inclusions, Continental Divisions: Public Recognition of Sexual Diversity in Canada and the United States* (Toronto: University of Toronto Press, 2008).

1. Miriam Smith (2008) explains Canadian–American differences primarily through this and other institutional factors. I agree that these are important factors, but also attach significance to religious and other socio-cultural factors.

2. There is a substantial literature on same-sex marriage in the United States. Several important contributors to that work have articles in Rimmerman and Wilcox (2007).

REFERENCES

Adams, M. *Fire and Ice: The United States, Canada, and the Myth of Converging Values*. Toronto: Penguin, 2002.

McDonald, M. "Stephen Harper and the Theo-Cons: The Religious Rights' Mission in Ottawa." *Walrus* (October 2006): 47–49.

Merin, Y. *Equality for Same-Sex Couples*. Chicago: University of Chicago Press, 2002.

Pierceson, J. *Courts, Liberalism, and Rights: Gay Law and Politics in the United States and Canada*. Philadelphia: Temple University Press, 2005.

Rayside, D., and C. Wilcox, eds., *Religion, Sexuality, and Politics in Canada and the United States*. Forthcoming.

Rimmerman, C., and C. Wilcox, eds. *The Politics of Same-Sex Marriage*. Chicago: University of Chicago Press, 2007.

Smith, M. *Political Institutions and Lesbian and Gay Rights in the United States and Canada*. New York: Routledge, 2008.

Mommies in Critical Care

Diane Flacks

THE WORDS "LESBIAN MOM" MAY SOUND INSIDE-THE-BOX IN THE ERA OF Ellen and Rosie, but we queer mamas are revolutionary. We are changing the world, one five-year-old at a time.

Recently, my son was talking to a newly divorced, straight friend of ours who has one son. He asked her why she couldn't have another child. She explained patiently that she was now separated from her husband. My five-year-old looked at her and said, "Well, you could use a donor."

My partner and I have two sons: one that I bore and one that she did (a neat trick I'm sure straight moms wish they could pull out of their purses — "your turn for labour, honey.") We also have two sperm donors/dads, both of whom are involved with the children. But they are not co-parents, and are not legally or financially responsible for them.

Some of the most complex struggles that queer parents go through are with systems, not individuals. Like many queer parents, we worried about negotiating institutions like schools, travel, and healthcare. We heard stories of children being bullied, families being rejected at customs, and non-bio moms being denied decision-making in ERs.

In terms of schooling, we've been fortunate. We live in Toronto where our eldest son attends a progressive Jewish school. Two other kids in his class have lesbian moms. We've reached critical mass. One of his best friends, a child of hetero parents, recently insisted that he, too, had two moms. Peer pressure to fit in, I guess.

Travel has been more of a reality check. A few years ago, an American customs agent warned us that his country did not accept our family as a unit, and that in his opinion my partner should go through customs in a separate

line. We held our tongues, although both of us were burning with rage. And we all went through the line together.

Our most significant institutional experience in our children's short lives was at one of the country's most famous children's hospitals, the Hospital for Sick Children in Toronto. We discovered that this institution is made up of individuals for whom what mattered most was not our sexuality but our ability to parent in a state of crisis.

Our second son, Jonathan, was born in November 2006 with two life-threatening medical conditions: an abdominal defect called a giant ompha-locele, where his abdominal organs, including his liver, stomach, and much of his bowel were outside of his body in a fragile sac. He also had an associated heart defect, Tetralogy of Fallot, that required open-heart surgery in his first six months.

He spent the first nine months of his life in Sick Kids — six months in the Neonatal Intensive Care Unit (NICU) and three months on the cardiac ward. He has had three surgeries. Many times in his first year, he "circled the drain" (in the words of our core nurse). Friends, family, and strangers often ask, "How did you get through?"

Somehow, you do. As a friend who lost his teenage son defined coping, "Well, you have two choices. Give up, or find a way to go on."

Jonathan wouldn't give up, and neither could we.

He smiled amid the most excruciating interventions, from surgeries, to immobilization, to multiple life-sustaining tubes and IVs, to daily, painful dressing changes. Our other son was an innocent bystander in all this, and he deserved every ounce of joy his moms could scrape up for him.

To keep going, I was held aloft by three pillars: the love and support of family and community, an inappropriate sense of humour, and those fabulous bitter blue sleeping pills.

We bore no special burden as lesbians in this context. We were just like all the other parents: trying to advocate for our child, suffering with him — riding a roller coaster of hope that he would pull through and come home, and then crashing to the ground when he had another complication or a painful reaction. As did many other parents, we needed to take care of our other child and manage somehow to stay afloat emotionally and financially. We also felt fortunate compared with some of the immigrant parents — the communication and cultural barriers that they have sometimes faced could compound an already devastating time.

Occasionally, however, there were moments that reminded us that we were different. But we rolled with them. We had no energy to do otherwise. In the NICU, you have to call in from a security phone to enter and see your own child. After six months, it became beyond annoying. A special annoyance for us was when the front desk would page us at our son's bedside like this, "Could Jonathan's mom or dad take a call?" I'd often reply that the doctors better start referring to me as "Mister" or just "Daddy."

Still, the nurses, nurse practitioners, and doctors, the ones who have to interact intensely with parents on a daily basis and who actually believe that parents have a right and obligation to be involved intimately in their child's medical care, quickly began to see the advantage of a sick child having two moms. They had two devoted Mama Bears to collaborate with.

During our long stay in the NICU, we noticed that it was rare to see fathers sitting by the baby's bedsides all day. We assumed it was because the dads worked. In our case, we had advance warning that our son's stay in hospital would undoubtedly be long, so we managed to put some money aside so that we could both be there as much as possible — to engage with our baby, give him love, strength, and stimulation. A lot goes on each day. There's a lot to remember and to learn, and we were the only consistent force in his care. We quickly became the authorities in the complex thirteen-part dressing change to cover his omphalocele, we knew how much food he could tolerate, and that he was fully and cognitively present and needed to be talked to, told stories, sung to, and rocked. We were his advocates. Maybe as women we've been socialized to subvert our needs to our children's, and maybe that can be negative, but in this case, it was essential. We were also both full of maternal fury and determination. Neither of us moms could keep away.

In our entire stay at Sick Kids, we only had one run-in with a doctor who we suspected had an issue with us as lesbian moms. We've never forgotten it, primarily because it illustrated how much of a non-issue it was in general, and how terrifying it can be when someone who has power over your child's life may harbour intolerance. Our son had been on the cardiac ward for two months and he'd lost weight. He was eight months old at the time and weighed only ten pounds. We were frantic. A senior gastro-intestinal specialist was called in. He immediately thought it pertinent to ask, "Who's the biological mother?" I joked that we both were and it was a miracle of science. He chastised me saying it was important medical knowledge.

However, we quickly realized that he didn't know what medical condition our son had, what his caloric intake was, what he was being fed, and how long he'd been there. So familiarizing himself with our son's medical needs, or even reading his chart, was not important, but "who's the *real* mom" was?

His advice to us about weight gain was that maybe we should put a hat on our son. Eventually, our baby's calories were upped; Jonathan began to gain weight.

The roller coaster of euphoria and despair at Sick Kids, the fragility of the art of medicine, and the absolutely random suffering of children can make you lose your noodle. The thing that often saved my partner and I was laughter. Not "polly-polly bright side" — that annoying state of optimistic denial, ignoring that our child was in pain and in critical condition — but discovering the absurd in the midst of the crisis.

For example: At one of our worst points, after we almost lost our son, we had a big medical-team meeting. The neonatal doctor, who just started rotation with us, repeatedly referred to my partner and I as Janis and Denise.

Finally, I turned to Janis and said, "Who the hell is Denise?! Now is not the time to have an affair!" That story whipped through the NICU until everyone was calling me Denise.

There have been times when no laughter could be mustered. One night, a baby who had been our roommate in the NICU for two months died unexpectedly. The next morning, his parents asked us to come into the bereavement room with their family. We realized we knew their baby better than most of their relatives, because visiting is not encouraged in the NICU. This deeply Christian family had invited the "two mommies" to share this most intimate moment.

We held their sweet baby boy — finally free from pain, tubes, and wires. He was still warm. He was beautiful. His parents left the NICU with nothing but his blanket.

We know how lucky we are. Jonathan is home now, with his brother, where he belongs. He's got sleek auburn hair and a ready, quirky smile. He reveals delight in every gesture.

My membership in the "sick kids club" is a bit like Woody Allen's in the country club — once you're in, you're not sure it's a club you wanted to join. But it has given me insight about how to keep going forward. It's put me in awe of my son, and of people's sheer determination to live.

As well, this experience has revealed to me, again and again, the power

and the necessity of being out, claiming our space, feeling second to no one, with no need to justify our choices to be parents. Once we did so, as open and caring parents, with a touch of dark humour, mostly everyone was happy to respect and honour us as mothers and co-warriors with them for our sick child, despite whatever prior limited contact they'd had with queer parents.

One of our core nurse practitioners told us a story that has quickly become a favourite. Her nine-year-old daughter came home from their suburban-area school one day and was complaining about a new math teacher who she said was mean. "And mom, she's a lesbian." Our NP asked what difference that made. Her daughter answered, "Well, Diane and Janis are lesbians, and *they* are so nice."

Change is happening, one child at a time.

READING, WRITING, AND RESILIENCE:
Queer Spawn Speak Out about School

Rachel Epstein, Becky Idems, & Adinne Schwartz

ANTI-HOMOPHOBIA INITIATIVES IN SCHOOLS USUALLY FOCUS ON QUEER YOUTH, often excluding "culturally queer" children of LGBTQ parents, or "queer spawn," terms coined by Stefan Lynch of COLAGE (Children of Lesbians and Gays Everywhere). These youth have a unique experience at school. The homophobic/heterosexist teasing or harassment of which they may be targets are not necessarily due to their own sexual orientation but most often stem from their parents' sexual or gender identities and their family structures. They may be straight-identified themselves, but find themselves identifying with and defending queer people and cultures. Abigail Garner, in her book *Families Like Mine*, refers to the "bicultural identity of heterosexual children who are linked to queerness through their heritage." While not all children of LGBTQ parents identify as straight, those that do sometimes find that it is not always clear where they fit in relation to queer or straight culture. Sometimes, even in anti-homophobia initiatives and committees such as Gay/Straight Alliances (GSAs), queer spawn have to explain their presence:

> There was one instance where I was at the lesbian/gay orientation week activity. And people were like "Why are you here?" They were kind of confused and so I had to explain my history to them. (girl/16/lesbian moms)

In 2001, the LGBTQ Parenting Network held a series of focus groups to ask LGBTQ parents about the kinds of programs they would find helpful. Across the board, the issue of biggest concern was schools: How will our children experience homophobia/heterosexism/transphobia at school and

how do we prepare them to respond? When and how do we intervene individually and/or collectively with other parents and community members? In 2004, the LGBTQ Parenting Network, with funding from the Wellesley Central Health Corporation, launched a research project, designed to explore the impact of the same-sex marriage debate on children and youth with LGBTQ parents. We spoke to thirty-one young people with LGBTQ parents, seventeen LGBTQ parents of teenagers, and fifteen teachers interested in anti-homophobia work in the classroom. The interviews quickly became focused on school experience.

In this essay we have tried to capture, in their own voices, some of the distinct and under-recognized school experiences of queer spawn (QS), and to draw out some of the strategies they use to deal with the homophobia and heterosexism they encounter. Our interviewees range in age from eight to eighteen. Eighteen are girls and thirteen are boys. More than a third speak another language in addition to English, and they identify with a variety of cultures and ethnicities, including Canadian, WASP (White Anglo-Saxon Protestant), Jewish, Sri Lankan, First Nations, Caucasian, Portuguese, Italian, Polish, African Canadian, British, Chinese, and Armenian. They describe an array of family arrangements. About one-quarter have at least one heterosexual parent. Others describe a gay, lesbian, or trans two-parent "nu-clear family," or a "blended family," created when their birth parents separated and formed new families. Several are co-parented by lesbians and gay men.

The main commonality among the QS interviewed here is that almost 90% have at least one lesbian parent. Another common feature is their urban location: 87% were living in a large Canadian city at the time of the interviews; 13% describe living in a mid-size community.

Interspersed with our reflections are the voices of these thirty-one queer spawn who poignantly respond to the questions: How do homophobia and heterosexism manifest themselves at school? What helps? What doesn't help?

What Helps: "These Are Things that Should Be Discussed Every Day in School"

It is important to state at the outset that, although the queer spawn we talked to described profoundly heterosexist and homophobic school cultures, it does not mean that they have had only negative experiences at school. Some have experienced very little homophobic harassment at school, and others describe supportive actions and attitudes from teachers and peers. Many of

their comments in regards to teachers, administrators, and school practices are not surprising. For example, what they find helpful include the presence of "out" teachers and students; GSAs and/or equity committees working on anti-homophobia; curriculum inclusion of LGBTQ issues, including books, films, and discussions; and anti-homophobia workshops like those offered by TEACH (Teens Educating and Challenging Homo-phobia — Planned Parenthood of Toronto).

Queer spawn particularly appreciate when LGBTQ issues are integrated into school curriculum in an everyday way and not as a one-time workshop or discussion or in the context of a controversial issue like same-sex marriage:

> I think the biggest problem is that the only time that LGBT issues are discussed is when something like same-sex marriage comes up, when it's a huge, big controversial thing ... It creates a huge gap in the two views and people feel they have to take one or the other side, it separates people, whereas it should be an issue that gets discussed in everyday life, the more basic things, like growing up with gay parents or being gay, what is homophobia ... these are things that should be discussed every day in school and in our community, and they're not. (girl/16/lesbian moms)

What they appreciate from their teachers is a willingness to confront and challenge homophobia; gender non-conforming attitudes and expressions; the display of LGBTQ-positive symbols; and a simple attitude of openness, respect, and support. These can go a long way:

> [The teacher] had a meeting with all the kids in our class [after an incident of homophobic name-calling] ... You know, we talked about what happened and how everyone felt, and we worked it out ... In fact, I don't think I heard an anti-gay or lesbian comment for a year. (boy/10/ trans lesbian mom and bi mom)

> My [straight] teacher comes to school in like dresses and skirts and he's really cool and really supportive ... He wears pink triangle shirts and he didn't want to support Canada so much because Canada doesn't really support everyone, so he hung up a rainbow flag in his classroom. (girl/13/lesbian moms)

> High school's been the best, people don't care and our school is really good about that, you can say whatever you want and be really open. And people are really accepting, the teachers especially. (girl/16/lesbian mom)

Everyday Heterosexism: "Straight Until Proven Otherwise"

However, despite these positive experiences, the culture in most schools continues to be deeply homophobic and heterosexist. Queer spawn describe a range of ways this plays out in daily school life, from every-day put-downs, to direct teasing, to harassment and bullying from peers and their peers' parents as well as from their teachers. They are aware of heterosexism in administrative practices (such as school forms that presume a heterosexual, nuclear family) and in the curriculum. These result in QS feeling invisible and as though they don't quite belong:

> It's also about forms, when it says "father" and "mother" (*a lot of agreement from others in the background*) and we have to cross it out and write "mother." I hate that. I should be like parent or guardian one and parent or guardian two. It's really oppressive, every time having to cross it out ... even at my school which was very progressive, a very awesome school, but even they had forms that said "mother" and "father." It's just annoying ... it's like straight until proven otherwise. (girl/18/lesbian mom)

> Last year I was taking an introduction to sociology, anthropology, and psychology and you had to make this chart and I couldn't do it — it didn't work with my family, so I went up to my teacher and she says, "Oh well, you can just do it on some other famous family." And I'm like, "No, I don't want to. I want to do it on my family, just like everyone else is doing." She was like, "No you can't." It's this scientific stupid thing. So I made one up and said, "You can fail me if you want because it's not real, but I don't care. I'm not doing it." She said, "Do the Eaton's." I was like, "No, I want to do my family." She knew my parents were lesbians and didn't even think when she gave us the assignment that it might be an issue, and it was just ridiculous. (girl/16/lesbian moms)

Harassment: "That's So Gay! Who's Your Real Mom?"

A sense of invisibility and not belonging is heightened when QS become the target of teasing or harassment. Queer spawn describe harassment from their peers as ranging from yelling "ewwww" at them in the playground, to taunting them for supposedly "gay" behaviours, to shutting them out of social circles. They recount many variations on the ubiquitous "that's so gay," describing how many of their peers commonly use words like "Gaylord" and "Lesbo" and sing homophobic rhymes and songs:

> The time I felt most awful ... I was talking to one of my best friends and

I told him my parents were gay ... He kind of sat there and looked at me and he's like, "Are they Gaylord?"
(boy/10/trans lesbian mom and bi mom)

Some interviewees distinguish between these more generic insults, which are often applied as random put-downs, devoid of understanding, and more deliberate teasing, name-calling, and harassment:

They were just always teasing me ... I'd be minding my own business in the playground or doing whatever at lunchtime and they'd just come up and start calling me names ... I don't think they knew the word lesbian, they weren't smart enough, they were just like, "You're gay" or "You're a fag" ... always asking me questions about my mother, "Do you have two mothers ... that's so weird, that's so stupid." (girl/16/lesbian mom)

Name-calling, calling me stupid, and saying that it was my fault that my mother was a lesbian and that it was a problem that she has a partner that was a woman ... and that it was against every religion known to mankind and that it was the wrong way to be ... He wasn't a Christian, but he used that as an excuse to pick on me. (girl/14/lesbian mom)

Queer spawn describe intrusive questioning from both peers and adults, based on stereotypes and misinformation:

"So who's your real mom?" "Where or who's your dad?" "Do you know your dad?" "How were you born?" ... The worst I got that from was actually adults ... a close family friend [of a friend] was there and she found out I had four moms and she just didn't get it, and I spent the whole TTC ride trying to explain. (girl/16/lesbian moms)

They describe the emotional and social impact of this constant barrage of negative messages and homophobic attitudes:

I kind of built a wall against myself, like to shield myself from certain people. (girl/14/lesbian mom)

They would suddenly accuse that boy of being gay and say, "Oh, you're so nasty. Oh that's wrong." It's kind of like movement-sensor dynamite — you flick, you take one little move, the dynamite goes off.
(boy/10/trans lesbian mom and bi mom)

I especially wanted to beat the crap out of one guy ... but I knew that I'd be the one who'd be hurt, 'cause it was all of them who were saying it ... I was like really sad and angry at the same time, but I didn't do anything. I didn't say anything, I just, I just stood there, and then I felt like, why

am I gonna stand here with six bastards around me, so what I did was go back inside the school ... Nobody knows, nobody except people I can actually trust. (boy/9/lesbian mom)

The Target of Teasing: "They Go for Your Weak Spot"

Some kids note the constant presence of teasing in their lives, "every day, every week." Many come to understand that homophobic teasing, like most teasing, is designed to hit your "weak spot." One young woman describes how information about her parents was used against her:

> ... once they found out about my parents, they used it against me. I was harassed on MSN ... they accused me of looking down girls' shirts, and because my parents were gay they suspected that I was gay. And everyone knew it and no one defended me and, honestly, it was terrible, and I'm thinking to myself, "You know that I'm not, and you're just making this up so you can get to me." And then it really did. (girl/16/lesbian moms)

What helps? Queer spawn who describe the most positive school experiences seem to have a fundamental sense of confidence in themselves and a lack of shame about their parents' sexual orientation and/or gender identity and about their family configuration:

> All my life I've gone to an alternative school and I've never been bullied. It's also like how confident you are. It's part of my opening introduction now, it's like, "Hi, I'm ... and I have two moms." Just because I want to get it out in the open, I don't like to leave it there 'cause then someone figures it out ... so I feel confident about it. If you're not, then people might see that weakness and start bullying you. It's about being confident and not trying to hide it. 'Cause you try to hide it and I think that's how people see your weakness. (girl/13/lesbian moms)

For LGBTQ parents this signals a profound need to reflect on ways to encourage and build confidence in our children. This begins with a willingness to identify and confront the internalized shame we may still be carrying. If we convey to our children, in deep ways, that there is absolutely nothing wrong with their families, and that no shame is necessary, they will carry this confidence with them to school and their family structure will not be their "weak point," the place they can be gotten.

Strategies: "Confront, Deflect, Diffuse, Poke Back"

Many QS do carry a deep sense of confidence in themselves and in their families, and choose to directly confront homophobia as a problem that is

external to them and not as a reflection of their worth. Sometimes they find themselves defending themselves, their LGBTQ friends, other kids with LGBTQ parents, and LGBTQ people generally:

> ... my friend whose dad is gay, they wouldn't stop bugging him and teasing him and all that, so I just went looking for the guys. I said, "You make my best friend cry one more time, you will have to deal with me, and trust me, I am shorter than you but I can beat your ass up." And then they like just stopped bugging him after that 'cause I think they kind of got scared. (girl/15/gay dad)

Many expressed incredulity at the ridiculousness, ignorance, and stupidity of some of the remarks and attitudes they encounter. One response strategy involves toying with this ignorance by reversing what are perceived to be silly questions, agreeing with or not responding to provocative statements, and generally using humour to diffuse and to poke back. Some develop sophisticated assertiveness techniques to deflect and diffuse homophobia:

> She walked up to me with four girls behind her and they kind of pushed her forward and she looked back and she's like, "Can I ask you a question?" And she stood there for twenty seconds and I'm like, "What do you want to know?" "Are your parents lesbians?" After twenty more seconds I say, "Yeah," and she says, "Oh." So then I said, "Okay Nancy, let me just back up here. Just stand there for a second." And I walked down to the other end of the hall and I walked back up to her and I looked behind me sort of to the side and stuff and then I say, "Nancy, could I ask you a question?" She was totally confused. And I say, "Are, are your parents straight?" *(laughter)* She was so taken aback. It was hilarious. And then she asked, "Why did you do that?" And I'm like "'Cause you ask the stupidest questions in the world. You know, you just asked me, 'Are your parents lesbians?'" ... You know, she had to make a big deal about it, be all creeped out by it. So that was fun. (girl/14/lesbian mom)

> A guy in my class was like, "Oh, that's a fruit school." And we were like, "hmm, yeah, okay." But then when I figured out what he meant, the next time he said that we were like, "Yes, we are going to a fruit school," and then he goes, "Huh?" He just kind of got taken aback. He didn't expect us to challenge him. (girl/13/lesbian moms)

> We were talking and I said, "Yeah, no, I come from a sperm bank," and she said, "What's that?" I was like, "It's this place where you go

if you don't have a male [partner]." And she goes, "Oh, really?" So she asked me all these questions, like "How does the sperm get into your body?" I was like, "You breathe it, it like goes through your mouth," and she's like "Really?" *(laughter)* ... It took twenty minutes to describe what a sperm bank is. And then she says, "Which mom do you like better?" She actually asked me that, which one. Like uh, "Both," and she's like, "No, but which one do you like more?" And I asked her, "Do you like your mom or your dad more?" and she says, "Neither." And I'm like, "There you go." It was just really funny ... I really enjoyed it. (girl/13/lesbian moms)

Teachers and Parents: To Tell or Not to Tell

While direct confrontation and other forms of assertiveness can help, young people are often compelled to make complicated decisions about if and when to tell teachers or parents about painful incidents. These are not easy decisions when the consequences of teacher/parent interventions are not always straightforward, predictable, or helpful. Sometimes, despite good intentions, teacher and parent interventions backfire:

One day I couldn't handle it [harassment from other kids] and I went to talk to the teacher about it. She seemed pretty okay and stuff, so the next day she tells me to go next door and so I leave the class, I hear her slam the door and yelling ... When I came back the girl next to me told me she had screamed at them because they were treating me different and if she heard anything they would be suspended.

When the teacher yelled at the class when you left, how was that for you? What did you think of that?

Worse. She made it worse. Because I couldn't even go outside, I had to stay inside to help the teacher with something, because I couldn't handle it out there. You know, it was ten minutes, but ten minutes of hell. "Oh, you need a teacher to defend you. Oh, you and your gay parents, why don't you just move out, go to the country man, no one wants you here. We're straight." Like, oh my god, it was terrible.

I was working in the office and the girls come in and said, "Oh look, that's the girl with the gay parents, neh, neh neh." So my mom, for Easter, she sent me flowers to school to make me feel better. And then people found out, "Oh my god, see, see, she is gay, her mom had to send her this, neh neh." The thing is, I know my mom had good intentions but, oh my god, it was terrible. I had such a bad experience, like honestly half

the time I can't even talk about this stuff because it really hurts. (*crying*) (girl/17/lesbian moms)

*

In Grades 4, 5, and 6 I had a lot of problems, the students were making fun of me, calling me a fag, and I never told my mom. Then one day I just got so upset and I called her and I just started bawling, and she went and told my principal and then the principal suspended the two people who were doing the most. But then one of my best friends at the time was friends with them and she stopped talking to me because she said I got them suspended. (girl/16/lesbian moms)

*

Do you guys generally tell your parents when stuff happens at school?

You better believe this, never!

You never tell your parents?

Hell no!

How come?

Because once I told them and they told the principal and it made me really embarrassed in front of my friends. (boy/10/lesbian moms)

From these and other accounts, it seems that zero-tolerance approaches can have unforeseen negative effects on the students who are targets of harassment. These accounts point to the need for sensitive, thoughtful, and non-formulaic interventions from teachers and parents. In the instances above, the adult responses, while well-intentioned, are made without consultation with the students involved. This, in the end, disempowers them. We would advocate for approaches that are consultative and that help those students who are the targets retain some sense of control.

Lack of Intervention: "There's So Much Homophobia and They Never Do Anything!"

While teacher and parent interventions are complex, as discussed above, QS usually appreciate the attempts they make. Indeed, youth are very clear about their desire to have everyday homophobia interrupted. In the face of ongoing and pervasive use of homophobic language as insult, the young people we talked to were sometimes astonished at the lack of intervention

on the part of teachers and administrators. Over and over, they relate how, even within equity-mandated boards, homophobia goes ignored and un-challenged:

> It's weird at my school 'cause there's so much homophobia and I know there are a few gay teachers, and they never do anything. They just see the kids doing it and they just sort of pretend like it didn't happen, like when kids say stuff they'll just look the other way, when it comes to the gay stuff they just brush it off. (boy/15/lesbian mom)

One participant explains that while certain types of teasing are off limits, homophobic teasing still seems to be acceptable:

> There's hardly any kids who tease kids about fatness or anything else ... 'cause they get in trouble more about the fatness and other things ... This boy in my class came up to my friend and said, "Oh you're gay, you're stupid," and everything like that, and the teacher didn't do anything. (girl/9/lesbian moms and gay dad)

Violence: "The Buildup Just Made Me Snap"

In the face of inaction from school staff, and the complexities involved in turning to parents or teachers for support, some young people respond to homophobic harassment from their peers with violence. Interesting, and potentially troubling, is the number of young people who respond with anger and with violence when they are harassed — and who describe it as the most effective strategy. Kids who do not perceive themselves generally as violent or angry people talk about how, when incidents and anger accumulate, they sometimes snap:

> It was hard because it was my first school switch and I was very shy and I wasn't used to talking to people and I felt weird because now I had two moms ... I ended up having a close group of friends in Grade 6, and I told them around the end of the year and everyone was fine except for one kid. As soon as I told him, he completely changed. Nothing happened until Grade 7 when he got a whole bunch of kids and they started laughing and pointing at me ... I wasn't the type of kid who would yell and get aggravated, but I guess the buildup of him and these other kids just constantly tormenting me ... it was winter and I think they were throwing snow at me, and so the buildup just made me snap and I threw him in a tree ... It was really an odd action for me to take 'cause I'm not usually that physical with anybody, but I don't know what

happened. I just got really aggravated. But he never did anything like that ever again. (boy/16/lesbian moms)

*

I've known six kids that have had lesbian and gay parents, or bi or trans. And basically we would just hunt out the homophobic people and nail them down ... Someone actually came up to me and said that they didn't like the fact that my parents were gay. Next thing they had a fist in their face. So yeah, that like went by pretty fast ... I beat up a kid in Grade 3 when I was in Grade 1.

Did you tell the teacher why you had punched the lights out of him?

Yeah. They said violence wasn't the answer. (boy/13/lesbian moms)

Another unidentified interviewee echoed this response:

They always say that. They always say that, it's always the same story ... think of a better excuse to like you know, put you in detention.

When queer spawn respond with violence, they sometimes end up being punished, while the person perpetrating the original homophobic attack gets ignored. This can increase frustration and reinforce the idea that the only way to achieve justice is to take matters into one's own hands. One young man explains how his teachers' lack of interventions led him to react violently, which meant he often ends up being the one punished:

I usually got in a lot of trouble 'cause I got mad at them [kids who initiated homophobic bullying] and started punching them.

Did you ever tell the teachers?

They didn't do anything.

At which school?

At every school. (boy/10/lesbian moms)

*

I got all pissed off at a kid 'cause he insulted me. He made fun of me 'cause I was adopted, so I got all mad at him. I sent him home with a black eye and a bloody mouth ... I was sent to the principal's office. I was starting to be suspended.

And did you tell them what it was about?

Yeah, and then he didn't get in any trouble at all. So the next day he was still insulting me, so he still went home with bruises. And then the next

day he came to school with like a hidden stick ... So when he insulted me, I wasn't going to do anything that day because I had gotten in enough trouble, he started smacking me with the stick. (boy/10/lesbian moms)

While we would not advocate that QS react with violence, the above accounts illustrate how it seems to sometimes be the only viable option. When harassment is incessant, when teachers ignore everyday homophobia, and when teachers or parent interventions can lead to negative reactions from peers, why not resort to violence — especially when it works? This troubling finding points to the need for sensitive and nuanced responses from school staff — responses that recognize the complexities of student cultures, that avoid making quick assumptions about what has happened and who is at fault, and that take the time to explore the specifics of a situation.

Teachers' Attitudes: "A Child Should Be Raised by a Man and a Woman"

Complicating matters is the reality that not all teachers are on side. Many lack the cultural competency necessary to fully support the QS in their classrooms, while still others inadvertently or intentionally perpetuate homophobia and heterosexism. This lack of knowledge, awareness, and sensitivity to the realities of LGBTQ families can lead to serious exclusions in curriculum and classroom activities:

When I handed [the family tree assignment] in to the substitute, he was just utterly confused about how I could not have a father and how could I not have filled it out properly. So I just didn't fill it out and I sat at my desk the whole day, the whole day, because he said that until I finished my work I wasn't allowed to do anything. (girl/11/lesbian moms)

My teacher was really great except my mom told me that when I was in senior kindergarten, we were making pots for Mother's Day, and they didn't buy me two, but just because they forgot ... like, the teacher was really supportive and it wasn't because she didn't want me to have two pots ... I guess they just weren't aware [of having to] buy the second one. It wasn't anything against me; it was just like they weren't thinking about it. (girl/17/lesbian moms)

Some young people report blatantly homophobic attitudes from their teachers, to which they feel more or less able to respond:

This teacher was completely and entirely horrible and when he said that

a child should be raised by a man and a woman I completely ripped his head off. I'm like, "You know what? You're completely, totally wrong 'cause I've grown up all my life with a woman and a woman raising me and I've had no problems." And he goes, "Well, wouldn't you have liked a male role model in your life?" And I'm like, "You're raised by who you need to be raised by." (girl/14/lesbian moms)

My Grade 5 teacher openly confronted me one day, he held me back from recess and he's like, "Your parents are lesbian, and that's really wrong. You're like really screwed up."... I was really depressed for the next couple of days 'cause I didn't know anyone else with gay or lesbian parents, so I thought that I was the only person in the world who was royally screwed up like this. (girl/12/lesbian mom/FTM parent)

This young woman chose not to tell her parents about this incident, because:

I didn't want them to get all mad or something and get him in trouble or fired or anything like that. (girl/12/lesbian mom/FTM parent)

This participant's comments demonstrate the powerful effect teachers' attitudes and the attitudes of other authority figures can have on QS.

Peer Support: Queer and Straight

In the face of the uncertainty of support from school staff, and because so much of young people's school experience is centred around their peers, QS often give prime importance to peer interactions. Decisions about whether, when, and how to disclose their family configurations can be big issues for QS, and their disclosure and coping strategies vary widely. Some embrace a strategy of coming out early and always, as a way of heading off homophobic reactions and establishing their family structures as "not their weak point." Others are more careful and selective about where and to whom they disclose. What is always involved, though, is a process of assessing their safety. QS are sensitive to clues about safety and picky about who they choose as friends. Sometimes it is hard to put into words what the clues are, but there is just "something about them" that inspires caution:

I don't really know, it's just sort of like you have a reluctance bringing it up with certain people, there's just something about them.
(boy/13/lesbian mom and gay dad)

I went to a day camp and there would be two boys playing together and then kids would go, like "Ewww, that's nasty," and then later they were

making rude jokes about gay people ... Oh no! I never told them, the first time I heard those comments I zipped my lips, I did not want to get tormented. (boy/10/trans lesbian mom and bi mom)

Youth describe the significance of a single bully in creating situations where QS are not safe to come out to their peers, for fear of being targeted:

He pretty much changed everyone's mindset to "you have to pick on her because she has two moms." (girl/14/lesbian moms)

The bully kid who had the anger management problem ... if he saw two women walking down the street near my school he would be like, "Oh my god, they're lesbians, oh my god everyone!" And then he would get everyone to point and laugh ... there was no direct bullying but ... it had an effect because ... I knew that if I was ... out that ... people would do that to me also. So now this person isn't in my class anymore, but I still don't want to say anything. (girl/11/lesbian moms)

Knowing other queer spawn can be an important, sometimes crucial, source of support and comfort:

At my new school there is a girl and her dads invited me over and we really bonded and I found that having someone to talk to about these kinds of things, it kind of helped, because you know I didn't feel like I was the only person in living history to have parents like I do. (girl/17/lesbian moms)

...at the beginning of Grade 7, we were in equity studies class, and I said, "My dad and his partner are gay, so please don't use gay as a general insult around me 'cause I could get very mad at you."... And then a number of other people stood up and said, 'Yeah, my parents are gay or lesbian, too ... so we'll all get mad at you."... I'm not sure if they would have said it if someone else hadn't said it already because there are other people in the school who have gay or lesbian parents, you can see it on the phone chart, but they don't say it ... It's nice to have help, instead of being the only one. (girl/13/gay dads)

[Knowing other kids with LGBT parents] ... I don't feel like E.T. or something. And they back me up in lots of situations. (boy/10/trans lesbian mom and bi mom)

Support from straight peers — friends who will recognize and confront the homophobia of other kids and who will put themselves on the line — is equally, if not more, significant:

Then one of the guys made a joke, I knew they were talking about me but they weren't saying my name, and then a girl goes, "Oh my god, gay people are so egghhh." And one of the other guys says, "Shut up and sit down, no one wants to hear you talk." Everyone was just quiet then. (girl/17/lesbian moms)

... and then she's like "You're dad's gay. Oh my god, that is like so weird!" At first I kind of started crying a bit, and then my other friend, she was like, "What's wrong?" And I said, "[She] is talking trash about my dad ..." So then my friend, she's known my dad the whole entire time, for like seven years almost, we say she's like his adopted daughter, she just rolled up her sleeves, and she's a year younger than me, and she's like, "That's it, where's that ... (she called her the "b" word) and then she went looking for her. (girl/15/gay dad)

Sometimes, given the expectations young people come to have, they describe a sense of surprise and relief when they are supported:

One time this eleventh-grade girl came up to me and says, "Is it true that your dad is gay?" And I was like, "What makes you think that?" And she says, "I don't know, we saw him come and pick you up." So I say, "Well, maybe he is, maybe he isn't, right? So [it's] kind of like not your business, right?" And then she's all, "No, no, no it's just I wanted to ask you cause like a lot of kids when they're your age and they come here they're all worried about it," and she's like, "Don't worry, here it's a good school, everybody's open about it. Like if your dad's gay, good for him ..." I was almost crying cause I was so happy. (girl/15/gay dad)

Education: The Key to Change

As an overall strategy, the young people we interviewed stressed the need for education, on many levels, as the most effective challenge to homophobia and heterosexism in schools:

The clichéd answer — education. For every social issue everybody is always like "education," it's all about education, but it's true. The thing is you can't start when you're in high school ... if the first time you're hearing about it is when you're sixteen and you're struggling to be cool, it's difficult to break a bad habit. So you have to start when they're really young and that's where it becomes complicated because when you're young you don't have the ability to stand back from your parents and form your own opinions and say, "I don't agree with my parents' opinions." That's when it becomes really hard — you're going to have

parents who don't want their kids to know about this. But it really is important that you have that in school, you have those books, you have discussions, especially when you do stuff like family trees because for a kid to not see their family represented or talked about and then they have to go and make this family tree, what do they put? They know they have two moms but if the teacher didn't say anything about it [and you ask], "Is it okay if I put that I have two moms?" and then other kids are like, "How do they have two moms? That doesn't make sense." It's really up to the education system to kind of get on it. (girl/16/lesbian moms)

Queer spawn call for the education system to represent queer families in the early grades. Practically all the young people we interviewed described the level of homophobia as much higher in elementary school than in high school. Many of the most painful incidents they described happened in Grades 1 to 6. For many, life got easier in high school. While this suggests an avenue for future research, we can conjecture that it may be due to maturity of their peers, an increase in confidence on the part of queer spawn or the development of a stable, supportive peer group. Whatever the combination of reasons, it is clear that anti-homophobia education cannot begin too early.

Attitudes from Home: "Bad as Poo"

While education of teachers, school administrators, and students is critical, these accounts from young people call for education on a much broader front. Many QS recount incidents of their friends sticking up for them and acting as peer educators, challenging homophobia through their words and actions; but they are also aware that many of their peers learn homophobic attitudes at home, from parents, and other family members.

There are the kids who are exposed to homophobic views from their parents or wherever … When I first started school they weren't knowledgeable enough to even verbalize what they thought, like they wouldn't even know what a lesbian was, because if your parents hadn't literally talked to you about the issues, you wouldn't be able to even approach it at all. (girl/18/lesbian moms)

With the kids you kind of have to say, "Look, this is what it is," and then after they've learned a bit about it then often they're fairly supportive, but often they don't even really know about it at all … and then they'll say something that they've learned at home or that they've heard somewhere and it will be something bad about gays or lesbians. Like once somebody

actually said he heard it at home that gay and lesbian people were as bad as poo. (girl/13/gay dads)

Their experiences can be translated into a plea to straight parents to educate themselves and their children about the existence of a diversity of sexual orientations, gender identities, and family configurations:

> There's this girl across the street and she teased our other friend because she's fat and me 'cause I have gay parents ... but then she realized what she was doing 'cause her parents talked to her ... She had a friend who had told her gay people are bad, which is why she kept teasing me. Her parents told her it wasn't right and then she stopped ... If everyone had parents [who] would talk to their children ... (girl/9/lesbian moms and gay dad)

Little attention has been given to this kind of community anti-homophobia education; that is, education that could touch and potentially change the beliefs and attitudes of QS's peers and their parents — who are often the source of the attitudes that get carried to school and that become the basis of harassment. Our interviews suggest that young people who are educated in their families about the diversity of sexual orientations, gender identities, and family configurations may be less likely to ask intrusive, uninformed questions, and less likely to harass. This shift in individual attitudes could eventually transform school climates.

Homophobia and heterosexism are deeply embedded in the culture of most schools. Transforming school culture requires more than a desire to oppose homophobia. It requires an ongoing commitment to understand the day-to-day experiences of queer spawn (and queer youth), the thoughtful implementation of education programs for teachers, administrators, students, and community members, and the interventions and approaches that seriously prioritize the perspectives and recommendations of young people.

In closing, we'd like to thank the queer spawn who so enthusiastically participated in this project. We also acknowledge the generous support of Family Service Toronto, the Sherbourne Health Centre, and the Wellesley Central Health Corporation.

Summary of suggestions from queer spawn about what helps at school:

• Facilitate ways of queer spawn connecting with other queer spawn to share experiences and strategies.

• Discourage shame in queer spawn.

• Develop strategies for community anti-homophobia education that recognizes that homophobic attitudes are often learned in heterosexual families and communities.

• Establish anti-homophobia education for students from JK to high school, with special emphasis on elementary grades.

• Implement compulsory pre- and in-service teacher education on anti-homophobia and other equity issues, with explicit inclusion of queer spawn experience.

• Include LGBTQ-led families and recognition of the particular experiences of queer spawn in school curriculum, beginning in elementary school.

• Solicit commitment from school staff to intervene in the everyday use of homophobic language and insults in school environments.

• Consult and empower students who are the targets of homophobic harassment when intervening in youth peer-to-peer conflicts.

• Encourage the formation and work of gay–straight alliances and equity committees.

• Display LGBTQ-positive symbols in classrooms and schools.

• Create or modify school forms to recognize diverse family configurations.

• Promote a school environment which encourages teachers, administrators, and students to be "out."

• Create a school environment of openness, respect, and support.

The W.I.S.E. Up!® Model

Developed by The Center for Adoption Support and Education, W.I.S.E. Up! is a simple tool designed to help foster and adopted children manage their feelings and answer the questions, comments, and curiosities of others about being adopted.

W.I.S.E. Up! empowers children (and their parents) to understand that their personal information belongs to them and that there are choices when it comes to responding to questions.

You can:

Walk away, or choose not to pay attention.

You can say:

It's Private. You can choose to tell anyone that you do not want to share information about your adoption story.

You can:

Share something! You can choose to share some information about adoption or your adoption story.

You can:

Educate them! You can choose to educate others about adoption, by telling them correct information and helping them to understand it. You can make them WISER.

Many children of LGBTQ parents are adopted, and the model is easily adapted for all children with LGBTQ parents, who also get asked questions that they sometimes don't know how or don't want to answer.

W.I.S.E. Up! is a registered trademark of The Center for Adoption Support and Education (C.A.S.E.). No portion of the W.I.S.E. Up! Powerbook or program may be reprinted or reproduced, in whole or in part, without ex-pressed written permission. For more information about W.I.S.E. Up! or to purchase a copy of the Powerbook please visit: www.adoptionsupport.org.

A Queer Spawn Manifesto:
Empowerment and Recognition

Jamie K. Evans

WITH NEW REPRODUCTIVE TECHNOLOGIES AND THE SOMEWHAT FRIEND-lier attitude towards LGBTQ people, it is increasingly possible for LGBTQ couples and single people to form families. These families are queer families, and children with lesbian, gay, bisexual, transgender, or queer parents are queer spawn or gaybies. Queer spawn hold a very particular, peculiar, and special place in the queer community and in the straight world's conception of what family is. Rampant heterosexism and homophobia, as well as ageism, have led queer spawn to be ignored, to be made invisible, and to feel alienated from their own existence. I, as a white female-identified daughter of queer mothers, am ready to push for representation and validation. I am ready to stand for a voice that has been lost, suppressed, and ignored on many different levels.

Representation in the Media

We live in a culture that is constantly bombarded by the media. Be it in the form of TV shows, movies, advertisements, or the radio, our culture is deeply embedded with media messages. Where is my family represented in the media? Where am I validated and acknowledged as existing and being legitimate? Recently, on its *True Life* series, MTV featured a show on teens who have gay parents. The show followed a teenage daughter of a lesbian couple who was competing to be her high school drum major, a college-aged son of a lesbian couple who was attempting to make contact with his sperm donor father, and a daughter of a gay couple who was going to an

overnight event for students accepted at Wesleyan College in Middletown, Connecticut. The first two queer spawn featured more prominently in the program because, like any good story, they were experiencing a conflict. For the teen daughter competing to be a drum major in her conservative town, becoming the drum major (or the leader of the marching band) was a sought-after and highly regarded position. She was afraid that her advocacy for gay people would affect her possibility of winning the title. The college-aged son was shown finding his donor dad and finally having the chance to speak to the man who contributed to his being; it was tense and emotional. And the third queer spawn? Well, she wasn't featured that much because she didn't have a major conflict. She was boring because her story was so normal. She had no struggles to overcome to prove that her gay dads were good fathers or that she turned out okay. The show didn't delve into her experience as the biracial daughter of two gay dads or show her transition from living with her parents to going to college.

When queer families are represented in the media, they are represented as having a problem or an issue to overcome. They fear they won't be accepted by their peers because of their family, they wonder who their sperm donor is, and so on. The first two queer spawn featured in the show were successfully portrayed as seeming like any other family. The girl proved that her moms were loving and supportive just like "normal" parents when she was going through her anxiety and feeling nervous over the drum major competition. When the boy searched out and made contact with his sperm donor, his moms were emotional and supportive like "normal" parents. And the third queer spawn had no real conflict, no dilemma to overcome to prove that she was "normal," so she wasn't represented as much as the other two. Throughout the show, I wondered how families like mine would be represented. They would never pick my family for that show ... my family of five moms and a straight dad, where do we fit in? Queer families are not neat cookie-cutter gay versions of heterosexual families.

The framework in which queer families are expected to exist is one that shows how normal they are despite their obvious differences. Because so much attention is given to these families to see whether the children will somehow turn out "normal," gay, or straight, there is no room for the children to air grievances they may have with their parents. Being queer does not mean being super human. Queer families experience abuse and pain just like any other family. Queer spawn need to be able to speak about

the not-so-fabulous aspects of their upbringing, if there are any. Queer spawn cannot carry the burden of heterosexual society's desire for model children. I say this with caution because as soon it is aired that a child with two moms has been abused, the abuse will be blamed on the mothers' "lesbianism" and their being unfit parents. When queer spawn can openly claim the abuse and pain in their families and when such grievances are seen as a product of parenting and not of the parents' sexual orientation, then we will know that queer spawn and queer families are free from stigma. Even with other challenges, such as struggling with academics or being bullied, children of LGBTQ parents often confront the issue that all of their problems are somehow linked to their family even though they are simply the regular challenges of adolescence.

Identity

SELF-IDENTITY

Who can claim a queer spawn identity, and why is it important to do that? The ability to self-identify as queer spawn fosters empowerment and has the potential to build communities. I do not care if your parents were married for ten years before your dad came out as being trans, you have the right and the option to claim the title of queer spawn and to be a member of the queer community. It does not matter if you were born through donor insemination to your lesbian moms, or your mom just came out, you can call yourself queer spawn regardless of the years, months, days, or moments of "experience" you've had with queer families and parents. The realities of queer families cannot be painted as a neat and tidy picture. Queer people have been oppressed, and thus their ability to be safe, content, and supported in themselves may take some time. Our stories of how we came to be are what make us so powerful — we need to share them.

RACE

Our families are formed in a myriad of ways outside the white husband and wife paradigm. For this reason, there are many interracial queer families with white parents and children of colour. What does this mean for queer spawn? Well, in a society where their basic family structure is already not represented, it means it is doubly confusing and frustrating to be the kid of colour in a family of white people.

If parents adopt a kid internationally or interracially, it is the parents'

responsibility to educate themselves so they can offer to their child the gifts that her/his culture has to offer (be it language, food, religion, etc.) as well as help their kid prepare to be a youth and an adult of colour in a racist society. Race can be a tricky subject to talk about because it brings up issues of power, privilege, and oppression. It also may bring up issues of not fitting in or not belonging in the family or in the community. Queer spawn of colour may feel angry that they have white parents; they may feel angry that they didn't get to grow up in a family that looks like them. This anger, frustration, and confusion are important. If a white parent adopts a child of colour they need to understand the consequences this may have. They need to be prepared to deal with their child's anger, frustration, and hurt if that comes up for them. Parents should be ready to talk to their child about these issues, to create safe spaces for him/her, and to acknowledge the identity confusion the child may experience. Ultimately, most queer families are formed out of love instead of blood, and that is a beautiful thing to be celebrated and acknowledged!

Sexual Orientation

Queer spawn fit into a unique and sometimes very confusing role in the queer community. We can fit in two distinct ways: as erotically queer or as culturally queer. For example, consider Little Johnny who was brought up by his dyke moms and most likely was exposed to a lot of queer culture. However, say Johnny grows up (and now wants to be called John) and realizes that he is straight. This makes John erotically straight but culturally queer. Where is he accepted and valued in the queer community? The fact that he has seventeen Pride Parades under his belt and grew up with drag queens for aunties is ignored in the face of the fact that he dates heterosexually. He is an ally because queer is his cultural reference. This is a delicate subject, one that I often find myself struggling with. It took me a long time to understand that I could identify as queer without failing the expectation I felt was put on me by the heterosexist world, that is, that I needed to be straight in order for my parents to be good parents. I felt deeply protective of my parents, that somehow for them to succeed at being queer parents they also needed to only have straight kids. Over time I have learned that this isn't true. What gets tricky is when someone who is straight and takes up a lot of space with their straight or male privilege asks to be included in queer communities. While they are a part of the queer community because

of their family, when one has those kinds of privileges they must be hyper self-aware and be accountable for the kind of space they take up in a queer space. Identities are complex and layered, there is never a simple answer, but there needs to be space for queer spawn in the queer community. *Queer spawn are living proof that queer people exist — we must be included in queer studies and the queer movement!* Queer spawn need to be represented and validated in psychology books, case studies, health classes, sex education classes, and so on. Dr. Freud, what is my Oedipal complex?

CLASS

Where are the queer spawn from working-class and poor families? Class comes with many other privileges besides the obvious one of easy access to money. Working-class LGBTQ families experience a range of economic challenges that are complicated by their inability, in many places, to use traditional means such as marriage to recognize their families and access healthcare, benefits, and other economic privileges. For example, my biological mom had to move to a town in Central California in order to find affordable housing. However, this town was also extremely heterosexist and overtly anti-gay. This meant that due to her economic situation she was forced to live in a place where she could not be open about herself. As a butch lesbian, she had to be aware of where she was safe and where she was not. She could not be open about her life or her family unless she knew she could trust the person; in fear of her safety, she had to be closeted. A struggle is not a struggle unless all are included. There must be some sort of outreach and connection made to those queer families who need to remain closeted for economic or safety reasons. It is not cowardly or a disservice to other queer people to remain closeted. Not all of us live in communities that are supportive. We need to respect and understand why some people cannot come out. However, for those of us who can be out and open about our families, we need to let families who may be living in fear know that they do not stand alone and that other queer families exist.

Community and Voice

The summer after my first year in college I took an internship with an organization called COLAGE (Children of Lesbians and Gays Everywhere). COLAGE is the only organization by and for people with queer families. We

had an event that summer where we showed a documentary a few queer spawn had made about their experiences. I brought three of my moms and my three younger siblings to the event. One of my moms was utterly shocked when she saw how moved I was to finally find, after twenty years of being a queer spawn, other people my age that were also queer spawn. I was annoyed and I was surprised! My mom had always sought out a community of lesbians and queers. In them she finds comfort, support, and the best thing of all — not having to explain or justify her existence or who she loves. Just as queers need to seek out other queer friends and communities, so do queer spawn. I did not realize how many of us there are until I was at this event. I was sitting in a room of 200 of us in the Mission District of San Francisco, and I couldn't stop crying, which was odd because I never had any struggles with my queer parents and I was never teased or ridiculed. The thing I realized at that moment was that I had never been represented, I had never been validated, and my family had never been validated. I remember my mom telling me that she watched the look on my twelve-year-old brother's face that day. She said he couldn't stop smiling because he seemed in awe to be around his people, to be around kids like him. That night I felt like I had found a home. I had found something that I didn't know I so desperately needed: community and voice.

I cannot stress how important this sense of having and belonging to a queer spawn community is to queer spawn. It was not until that day in San Francisco that I realized my place and my validity in the queer world. Queer spawn need to have their own community and to be the authority of their experiences. Sure, their parents are the queer parents, but the children are the ones who are of and from those queer parents. That is why the queer struggle is intimately connected to queer spawn's empowerment and representation. Queer spawn hold a unique identity, it is one that is complex, multi-layered, and ever-changing. I call for queer spawn to have the power to identify themselves as queer spawn, to build a community of queer spawn, and to explore the fluid nature of the identity as they grow and learn. Queer spawn can do great things as they are often at the cusp of many identities. I hope in the future we will be celebrated as we find our communities and voice.

IV ALL OUR ROOTS NEED RAIN:

Parenting Dilemmas
in the Day to Day

LITTLE WHITE CHILDREN:
Notes from a Chicana Dyke Dad

Karleen Pendleton Jiménez

"I am almost one hundred years old, and I have seen everything change, even the position of the stars in the universe, but I have not seen anything change yet in this country," he would say. "Here they make new constitutions, new laws, new wars every three months, but we are still in colonial times."

> — Uncle Leo XII, *Love in the Time of Cholera*,
> Gabriel García Márquez

TORONTO, 2003

"I always worry with little white children," she confesses, focusing into her glass of iced-tea. "Sometimes they're afraid of me." My brown-skinned tía[1] sits across from me at the kitchen table on the first floor of a tall Victorian house. She has made the trek up to Canada from California to find out what life I've made for myself so far away from Aztlán.[2] "They get frightened by my colour." Her voice shakes at the end.

My girlfriend, Claudia, and her two children are some of the whitest people I know. When I first met them, they seemed foreign to me as someone who grew up in a predominantly Mexican neighbourhood. However, after five years of loving and living with them, they have become my family. I reassure my tía that there are many brown people in Maya's and Joshua's lives, and that I've never seen such behaviour, but I admit that you never can tell what children will do. There was the time at the store window when

dark-haired, olive-skinned Maya declared that she looked like the lady in the magazine with the blond hair and blue eyes. It's a popular test of racism in North America today: find any little girl of any colour and ask her what she looks like, and nine times out of ten she'll draw a picture of herself as having blond hair and blue eyes. At six, Maya is alert to beauty, and notices that white — in dolls, in magazines, in movies — represents all that is pretty in the world. Joshua, though, who is eight, doesn't seem to notice colour even when it is pointed out to him. I become uneasy sitting there with my tía. I am aware that Joshua's inability to recognize difference, and Maya's embrace of popular beauty, could end up hurting her.

Juarez, Mexico/El Paso, USA, 1915

A mother and her young daughter (my abeulita³) walk across the border to leave behind a drunk father and the ruins of a revolution.

San Diego, USA/Toronto, Canada, 1999

I followed Claudia to Canada a couple of years after my mother died; California seemed to remind me only of sadness and anger. I needed a mother, and Claudia was one. She had two young children and a soon-to-be-former husband. I felt safe and loved against her body, the same body she used to care for her kids. She held baby Maya in her arms when we'd meet up, while Joshua went to daycare. She knew about literature and movies, she had a thoroughly lefty Canadian political agenda and that dry sense of humour like my Iowa relatives, the kind that could make you laugh deeply and unexpectedly. She had the hourglass shape you see in museum portraits — blond-silver curls, blue eyes; she also loved me. She answered any hesitation on my part to our romance with the force of the Pacific Ocean: at one moment flinging me out to crash ashore broken and alone, at the next tugging me deeply into her. I gave in.

I gave in despite a commitment I had made to myself nearly a decade before that I would marry a Mexicana and we would make Mexican children together, end of story. I would put an end to two generations of my family's American racist dream. Instead, I fell in love with Claudia and embraced her children as my own. Even if I had been ready (financially or emotionally) to give birth myself, that was no longer my path; I was joining a white middle-class Canadian family.

San Francisco, 1930s

The U.S. government terrorizes Mexican–American residents of California through mass deportations to Mexico. My abuelita is a young woman married to the love of her life. Her husband has lost his job, he drinks, he gets caught breaking into a store, he is in jail, he is too "dark-skinned" for my abuelita, so her family tells her. She is urged by her mother to leave him and search for an Anglo man who could offer prosperity, a future for the next generation. She weds the truck driver from Missouri who paid her the dime for a dance in an Oakland dancehall.

Los Angeles, 1950s

My mother is informed that she is not to date any Mexican boys. They are "braceros,"[4] while she is a "different kind of Mexican." She has already failed her beauty-school-credentialed mother because she is a "fat" child with one eye that strays. She is doomed. Never mind that she is the intellectual of the family; it's marriage that will save her. She must find an Anglo man to make family. She does.

Toronto, 2000

Scientists neither hold the monopoly on genetic engineering nor invented the practice. It is a strategy of colonization, and an aspiration of family. When the Europeans colonized the Americas, the soldiers took the land with their weaponry, their diseases, and their sperm. The symbolic father and mother of the Mexican nation are the conqueror Cortez and Malintzin, a betrayed daughter of the Aztec aristocracy. And when my Mexican family moved quietly into California, they found security and privilege in the marrying of Anglo men. I would like to think that some of it has been about love, but without question it has also been about power and material wealth.

On the third generation of life in the USA, my family obtained enough privilege to get me into a good university, where I finally had access to the Chicano history and literature necessary for understanding my family's path and silence. I proclaimed that I would be the generation that stopped whitening the family, which is why you should never proclaim such things. Was it my ancestral conditioning to fall in love with a blond-haired, blue-eyed woman and her white middle-class family, despite my conscious opposition to following in my mother's and grandmother's footsteps, and 500 years of Mexican colonization? Was it just love?

Los Angeles, 1970s

A small boy (my brother) with soft hair and dark eyes builds a mountain in a sandbox. Two other boys shape the walls of a castle behind him. Both structures depend on a great deal of sand. When the castle-builders pull too much sand away and the mountain begins to sink, the small boy shouts at them, "You go away you dirty Mexicans! You get out of my sandbox!"

My mother didn't know how to deal with her children's racism against her own people. In my abuelita's eyes, my mother succeeded; she married a white man, she made middle-class (or at least lower middle-class) children, she found a job, and later she would go to school, but she lost her children in a way. We passed as white, refused to speak Spanish, laughed at the idea of our mother being Mexican, thought of the Mexicans who sat beside us in school as if they were "a different kind of people." There was no conscious acknowledgement of our ancestry. There were occasional blips: my brother's skin would get dark brown during the summer, my grandmother spoke Spanish, cooked Mexican food, and brought us Mexican toys. Our complicated brains allowed for the contradictions; Southern California racism insisted upon them.

Toronto, 2002

I bring Maya Mexican dolls. I open a plastic bag, unwrap the tissue paper, and reveal bright reds, greens, yellows, sashes, skirts. Long black braids of hair woven with pink ribbons. Dark diamond eyes, coffee-brown sewn skin.

Twenty-five years ago I took a similar gift hesitantly from my abuelita. I wanted to explain to her how I was really a boy kind of girl and didn't know what to do with dolls, let alone Mexican ones. But when you're a mixed-race girl like me who thinks she's a Southern California white boy in T-shirts and surf shorts, the sixty-year gap between that girl and her grandmother, between Reagan America and Revolutionary Mexico, between tomboy and princess was seemingly too big to overcome. How long does it take to learn to love? How many stitched dolls did she need to lay in my hands year after year — a ritual between us — before I understood that these beautiful babies had something to do with me? I used to place them in the far reaches of my bedroom, but as I grew older, they found their way out of the bottom of bags, chose closer shelves, until I was less uncomfortable, until I cherished them and the mystery of what I'm supposed to do with

them. I still don't know how to play with dolls but they make me feel less lonely when they are nearby. And I offer them to my little high-femme stepdaughter and hope she might show me.

She hesitates when the package is open.

"What? What's wrong?" I sense an echo of my abuelita's confusion with me.

She sucks her lips, disappointed, "That's not a doll."

"Sure it is," I try to reassure her. "It's from Mexico."

"Well," she shakes her head, "it's not a real doll."

"If you don't want it, it's okay. I'll keep it for myself." And I did. There's no point in trying to sell a gift to a five-year-old if she doesn't like it, no matter what the reason. Five-year-olds are too honest, and unless you want them to feel guilty, not the intention of the doll at all, you should let it drop. Besides it's unclear whether a Mexican daughter would have reacted any differently; they all watch the same television. Either way the rejection hurts.

It's odd being mixed-raced, mixed-cultured. When I was in relationships with Latinas, I felt like the white one, stumbling along like a child, with a heavy "lengua,"[5] broken "palabras,"[6] missing rolling r's, uncertain how to build an altar, and being the one to console my girlfriends when some fucked-up racist thing happened to them on the street, in school, at work. With this white girlfriend and family, I feel more Mexican than I ever have. They don't really understand my Guadalupe, my chile, the bright colours of my office, they look at me blankly when I tell them to take their swimsuits off and put their *chones* back on after a swim. "What's that mean?" Joshua wants to know.

I don't want to repeat it. I say, "Look I've used the same word with you since you were two, don't you know what it means? Won't you remember any Mexican thing I've said or done around you by the time you grow up?"

"My underwear?"

"Yep."

I remember, at eighteen, my first Chicana teacher asking me a question, followed by "Entiendes?" And I knew in my bones that she was asking whether or not I understood, and I said that I did, but I did not know why and I did not know for sure, and I felt so ashamed. I was one of the mixed-breed children who had refused my Spanish and now I was ashamed. I was ashamed that I begged for a pair of white leather Reeboks

when we didn't have the money, that I took German over Spanish because I thought Europe was cooler than Mexico (not even realizing Spain was in Europe, because Spanish has nothing to do with Spain when you live in the American Southwest), that I wanted to get out of working-class Mexican Rosemead and over to the middle-class white high school, that I didn't raise my hand in school when they asked who had Mexican heritage, that I kept my abuelita far away from the rest of my life.

There's nothing fair about this. I was only a kid who wanted to be liked in the world. I wanted to do well in school. I was already plagued with jokes about my boyishness, the part of me that I could not hide. And then at the usual time, I was a selfish teenager who rebelled against my mother to establish my independence. What's unfortunate is that when you're mixed-race, part ruling class and part oppressed, these basic childhood desires get wrapped into poison. My brothers and I hurt our mother when we only were trying to get ahead in the world as she had done, and as her mother had done. With my kids I have gone one step further; they are now entirely white, no drop of Mexican blood running through them. And I have no idea what our cultural relationship should look like. What should I and should I not pass down to them? What choice do I have?

"What is a Latina?" Joshua asks, out of nowhere, over dinner. (He pronounces it in the Anglo way: *Luhteenah*.) I am hesitant to answer. I give the children my sweet chile sauces, my toasted tortillas, my rice and beans, my "La Bamba" to dance to in the living room, my childhood adventure stories of Los Angeles, and they devour them with such joy it makes me smile. I would give the children the world, but I don't want them to have this word. It is all of a sudden my private sphere, like my colourful office on the third floor. But I am caught. I grudgingly mumble a dictionary definition, but avoid telling him what it means to me.

I feel sad when I think they don't care about who I am and where I come from. I don't know whether it is being a queer parent, a step-parent, or simply a parent, but sometimes I feel like my children have no interest in my history or background. It's just how children often are with parents, so I need to get over it. It's how I was. What makes it a distinctly queer and step-parenting experience is that I start second-guessing myself: worrying if I count in their minds less than their biological mother and father, worrying about the way their classmates eye me when I drop them off at school, worrying if blood is, after all, what ties people together. Perhaps the dream

of "making familia from scratch" (Moraga, 1986: 58), a queer aptitude for creating family with friends and lovers because our own blood families often reject us, wasn't true after all.

And a second later I am the one hiding my history from their questions. It's none of their business, they are white children entitled to the world, they don't need to have this piece of me as well. Did my mother and grandmother feel the same way when they saw their own children excelling in their white skin? Maybe they thought they were giving us more privilege by hiding themselves, maybe they were protecting something brown, rich, and old from further exploitation. What do my mixed-racial messages tell my children?

*

A couple of years ago I was asked to help facilitate a mixed-race queer parenting workshop. I was thrilled to be asked, and thought about the stories that haunted me, or at least provoked questions; questions that I had not been able to sort through on my own. I wanted to be a stronger parent, to love my children as fundamentally as possible, and so I was worried about these recurring mixed-race issues. I wanted to explore the insecurities I carried about the strength of the love between me and the children, as well as my tendency to disengage if the topic of my Chicana cultural identity arose. I did not want my insecurities to harm our family.

I was shocked by what I encountered at the workshop. I found a room of predominantly white parents with children of colour and mixed-race children, both biological and adopted, who were proclaiming that they had not encountered problems with racism, nor did they expect to in the future. They explained that the love of family superceded racism, that the daily interactions over many years and the relationships forged would somehow be much more powerful than this pesky social issue of racism. And, well, if there were unspoken problems, it wouldn't be clear until the next generation. (They imagined, I guess, that mixed-race families were invented by the contemporary queer baby boom.)

My skin froze and I wanted to yell at them all. Let's get it straight. There's no need to wait a generation to find out whether or not racism will hurt us in mixed-race families. It will. Five hundred years of Latin American mixed-race families, and three generations of my own, have proven that the notion

of family does not save us from racism.

I wanted to tell them that I'm a romantic. I believe passionately in the love of a queer family, and I understand how incredibly devalued our families are already, without bringing up the painful issues of racism; but my mother and I loved each other fiercely, and that did not save me from hurting her. And it did not protect me from feeling the shame of having hurt her. And it does not save my children from hurting me, nor my family, nor friends. And it won't save the many children of colour now parented by white queers, though how this racism will be experienced, I do not know.

I wanted to tell them that family love does not supersede racism. And hiding racism does not stop the hurt. However, the fear of speaking through such difficult issues should not hinder us from loving anyway. What love does not involve fear, or submission, giving over so thoroughly you would sacrifice your own life to save your child's life, or your lover's? What love does not rely upon the difference between two bodies as a source of hunger? What do we imagine that we lose in acknowledging the racism between parents and children, and between siblings of different colours?

*

When my stepdaughter came home and found me and my tía sitting at the kitchen table sipping our iced-teas, she immediately stormed out of the room. Joshua had followed her into the kitchen and out again. He returned shortly. "I like you," he tells my tía, "but Maya said that she hates you." It was something that eight-year-olds say. He was trying, in one line, to earn points for himself and lose points for his sister. If a brown woman had not been at my table, it wouldn't have meant anything. (On any given day, Maya mentioned how she either loved us or hated us, depending on her mood.) My tía rose abruptly from the table and spent the last week of her trip in my office, hiding her tears and protecting herself from what may or may not have been a racist response from my white children. Maya had her own tears, trying desperately to apologize. Joshua wasn't sure what happened. It could've been a case of Maya's frequent shyness with new people, but I won't ever really know. My girlfriend and I tried not to let the stress lead to our own fighting. I drank every night for the week to survive the pain.

It's not a big deal for kids to talk like that. It wasn't their fault. It was

too much hurtful history. It was too much silence. It was one bloody queer family explosion on colonized land.

Toronto, 2006

Maya's friends at school create a game on the playground. The girls are not content with a simple game of tag. They add racial slurs to punctuate the moment of capture. Nine-year-old Maya does not like this game and tells her friends that it's wrong. They tease her for being so serious.

Joshua, Claudia, and I hear about Maya's day at the dinner table. She expresses her hurt and outrage. We soothe her. I am amazed by how articulate both she and Joshua have become on the topic of discrimination. Their insights and openness far exceed that of many adults. We have all come a long way. Certainly, we have not prevented racial disasters like that one fateful afternoon with my tía, and any one of us can still, at times, blurt out words tinged with racism that lead to heated arguments. However, we have often managed to talk through it as a family. Talking about racism does not make our queer families less worthy; it does make them more honest, more loving, more enduring.

NOTES

1 Aunt.

2 The symbolic homeland of the Chicana/o people and geographically the southwest of the United States.

3 Grandma.

4 A Mexican labourer working in the United States.

5 Tongue.

6 Words.

REFERENCES

Márquez, Gabriel García. *Love in the Time of Cholera*. New York: Penguin, 1988.

Moraga, Cherríe. *Giving Up the Ghost*. Los Angeles: West End Press, 1986.

The Move

Cindy Holmes & Anne Fleming

On 4/15/07 8:38 pm, "Cindy Holmes" <cindyhomes@interchange.ca> wrote:

Anne,

When I saw the call for the queer parenting anthology, I immediately thought of the conversations we have had over the past two years about our experiences as the queer parents of a young child in Kelowna. Together we've struggled to articulate to ourselves (and even more to others) how hard it has been living and parenting as a queer couple with a young child in this conservative community. It is a specific mix of things in this place that makes it hard and, in fact, like no other place I (or we) have lived.

We knew the move would be challenging. We were leaving a large urban centre — Vancouver — where we had fourteen years' worth of community, including a close-knit network of friends (who babysat!), wider social and political networks in the feminist and queer communities, a queer parents' group, work contacts, a writing community for you, and so on. In short, we had a lot of connection to the city.

We were going to a small urban centre, known for its fundamentalist churches, its Conservative MPs, its racism, its miles of malls. I'd just had firsthand experience of all this: right when you were offered the tenure-track faculty position in creative writing at the new campus of the University of British Columbia in Kelowna (an opportunity that doesn't come up very often in Canada), I was co-facilitating a training and roundtable in Kelowna as part of a provincial LGBT anti-violence project. The stories my colleagues and I heard of fear and violence, of homophobia and transphobia in the Okanagan, horrified us. Things in Kelowna seemed much worse than in Nanaimo and Nelson, our other project sites: children of lesbian parents

taking knives to school as a response to homophobic threats; teachers terrified to be out in their communities and schools, fearing homophobic retaliation and possible firing; gay men facing homophobia in court when negotiating custody and access visits with their children; a heterosexual man threatening to kill his lesbian neighbour; a trans woman being refused medical care upon disclosure of her trans identity. We heard of people's resistance, too, and their courage and determination in the face of this hostility.

Cindy

(p.s. When are we going to make the decision about moving back? We've been talking about it for at least six months. At some point, we're just going to have to decide. Kindergarten orientation is right around the corner.)

*

On 4/20/07 10:45 AM, "Anne Fleming" <annefleming@interchange.ca> wrote:

Cindy,

In a way, it would be easier to articulate our experience if, like the people in your roundtable, we had had some overt homophobic incident directed clearly at us. (Oh, that sounds callous and idiotic — of course I don't wish bad things on ourselves or anyone. I mean, it would be easier to demonstrate our well-founded assertions to others, our reasons for leaving, if or when we do.) Instead, it's a feeling, or rather, it's the accumulation of many small things. For me, it's the way that I'm read as male probably 80 or 90 percent of the time in Kelowna, versus, say, 30 or 40 percent in Vancouver or Toronto or Guelph or Kitchener or London. It's the way in two years I've seen maybe two masculine women around town. In two years, I've seen only two other people who look like me, whereas after sitting for five minutes in Continental Coffee in Vancouver, I see half a dozen gender-queer souls with female biology. What the dearth in Kelowna says to me is that it's not okay to be a masculine woman here, and I think that's borne out when you look at the kind of femininity that predominates: it's blond, it's white (well, actually, tanned), it's long-haired, it's coiffed. I had a student — a very femmy, blond, slender white student — write a poem railing against exactly this. It was called "Kelowna." She identified the standard with the place.

What I started to notice after about six months was that passing this much affected my sense of self. I had become — de facto — a trans person. And I started to feel it. I started to feel more trans.

For a long time, I've located myself very comfortably on the border of a trans identity: not quite trans, not quite not-trans. Happy with that. Then the need to come up with a parental name for myself occasioned something of a crisis. You wanted Mom or Mommy, not just Cindy. And you didn't want you to have a parental name and me not to have one because that would imply I was not as full a parent. We were not entering into this as Mom and Partner of Mom but as two parents. The name I would choose for myself as a parent was Dad. Or Pop. We had a lot of discussions about this. I would say, "I don't feel like a Mom. I don't relate to 'Mom.' I really don't." You would ask, "Why can't you change the category of Mom to include yourself?" A perfectly reasonable question because it's what I do with the category "woman." But all I could answer was, "Because it doesn't feel right. Because 'Dad' feels so much *more* right."

We never resolved this. And you thought you wouldn't be able to call me "Mumpa" without laughing. We never came up with anything else. I thought a full-on paternal name like Dad or Pop would be socially more difficult to explain than I was comfortable with, especially to my conservative, already-uncomfortable-with-lesbian-parents family. It might cause similar discomfort for our child, too, down the road. So I chickened out. I'm Mum. I'm still a little jealous of the lesbian dads I meet who do have daddy-ish names, like Seana who's Ma-pa, and Monica who's Appa, and Jill who's Daddymama. What's funny to me is that we had all these discussions in Vancouver, and that we chose what felt like the more conservative (less queer) option, never suspecting we'd move to Kelowna, where if I had been called Dad, I would have turned no heads at all, and where Kate calling me Mum totally outs us, turning "Mum" into the more daring, more queer option.

Anne

(p.s. How about the end of April?)

*

On 4/30/07 9:29 PM, "Cindy Holmes" <cindyholmes@interchange.ca> wrote:

Anne,

It is exactly this — the pervasive white heteronormative gender expression — not just the expression of it but the regulatory effects of these

norms that we have felt in and on our bodies. What we feel is that it's not okay to be who we are in Kelowna. We have felt the effects on us individually — as you describe as a butch/masculine/gender-queer woman — and on us as a couple and as parents. The feeling of not belonging, not seeing oneself anywhere, feeling out of place, isolated, stifled, and under surveillance. We are continually shocked by the severity of it as well as how many people don't understand what we have experienced.

For me, I've never felt so invisible as a queer femme as I do in Kelowna. In Vancouver, I'm often read as queer on my own and when we are together with Kate we are almost always seen as a lesbian family. As you say, there is the 30 to 40 percent of the time when you are read as male in Vancouver or when we are read as a straight couple/family. But in Kelowna we are almost exclusively read as a straight couple. No one assumes that I might be a lesbian because it does not occur to most people that it would be a possibility or an option. Most people here don't think that gays and lesbians exist in Kelowna, let alone gay and lesbian families. They see it as a rarity or oddity.

Now there is another thing that we've identified as problematic — while we have experienced extreme heteronormativity in Kelowna, we have also experienced an uncomfortable mainstream acceptance in our suburban, white middle-class neighbourhood: call it homonormativity. I remember at Kate's fourth birthday party, I felt this strong sense that if we just assimilated and downplayed our sexuality (don't touch in public, don't show our attraction, or love and affection for one another) and just tried to show all of the other white heterosexual families how we are "just like them" (but not sexual!), we would be accepted and safe. I always felt that our privilege as white middle-class women shielded us from more overt forms of hate-motivated violence (although that also felt precarious and unstable: often I didn't feel safe in public spaces, parks, sometimes downtown at night, and I worried when you were out alone in the city that you might be attacked because you transgress the boundaries of what a woman should be).

Cindy

(p.s. Have you worked out a budget to see if we can manage the expense of having you commute for work?)

*

On 5/03/07 5:45 PM, "Anne Fleming" <annefleming@interchange.ca> wrote:

Cindy,

Yes. It's like being white and having middle-class jobs trumps the slight glitch of being lesbians. I had the feeling when we moved in that as long as we cut our lawn, we'd be good in the neighbours' eyes. They might not know how to say hello, which you took care of by going over and introducing yourself — "Hi, I'm Cindy. My partner, *Anne*, and I just moved in next door with our daughter, Kate" — but we wouldn't be bringing down the neighbourhood. I think there's a kind of unconscious class/race loyalty that operates. If someone can demonstrate "like-us-ness" in either category, then disapproval of other categories remains suppressed or unspoken. Our seventy-five-year-old-across-the-street neighbour Joe, who endeared himself to me by calling me "dear" and "buddy" in the same conversation, assumed we would bond through our shared whiteness, and quite happily announced that the reason he'd left Toronto was that there were too many Black people there. It was way more difficult for him that we challenged his racism than that we were lesbians.

Anne

(p.s. Re: budget. Yes, I've worked it out, and, boy, is it ever a squeaker. I'll show you tonight.)

*

On 5/03/07 9:29 PM, "Cindy Holmes" <cindyholmes@interchange.ca> wrote:

Anne,

Homonormativity is not what I want for myself and for our family. Not what I want for Kate. I'm an activist, but in Kelowna I felt like my safety is predicated on silence and white middle-class homonormativity. I think of that Audre Lorde quote I used to have up when we lived on East 3rd: "Your silence will not protect you."

Also, on heteronormativity — Suzanne talked about how hard it is to be a single mom in Kelowna because the white, middle-class, two-parent, male-headed heterosexual family is the defined norm in Kelowna and anything and anyone who transgresses this is shunned or defined as odd or abnormal.

I'm wondering how to address the unexpected kindness of Dottie and

other neighbours — while still not really feeling like we belonged?

Cindy

*

On 5/04/07 4:15 AM, "Anne Fleming" <annefleming@interchange.ca> wrote:

Cindy,

Nancy said exactly the same thing. As a single mom, she was consistently treated as morally suspect and an outsider.

I think Dottie's a lesson. You can be lay minister of one of the most conservative evangelical churches there is, you can end every sentence with "Bless you," and still be effusive and voluble and genuine in your neighbourly warmth.

I found that article Luis mentioned, the one he did with Patti and Ricardo that looks at how Kelowna is being constructed as a specific kind of space for a specific kind of people: the city reimagined and re-designed as an "all-year playground — a resort town," an ideal retirement location, a site for the high-tech industry and as a place of whiteness (Aguiar, Tomic, and Trumper, 2005).

Anne

(p.s. I think what your tears said the other night is that we have to move, whether we can afford it or not. We can't afford to feel trapped. We can't afford to feel as though we've made a choice for Kate to be isolated and alone as one of a tiny minority, as the child of same-sex parents when she could be one of dozens at her East Van school. Let's do it.)

*

On 5/04/07 9:29 PM, "Cindy Holmes" <cindyholmes@interchange. ca>wrote:

Anne,

Are we overstating things? Are we being fair? I'm sure we were the first queer family to enroll their child in our daycare, but the staff responded positively to us and did not treat us differently. They accepted the queer-positive children's books that we gave them and, although we don't know how much they read them to the kids, we do know that they were supportive of our daughter when other children asked why she did not have a dad. However,

their reinforcement of those heteronormative gender roles/expressions was strong and unquestioned. They sure didn't offer any feminist versions of what it means to be a girl or boy, as seen in their removal of the play kitchen when there were mostly boys in the daycare, and its reappearance when there were more girls enrolling. But even as I type this, I know that this is really a huge problem everywhere. There are so many people (straight or queer) who are unthinkingly teaching kids sexist (and racist and heterosexist) assumptions about what it means to be a girl/boy.

And this brings us full circle again. Those white heteronormative gender norms. I've been so worried about the impact of all of this on Kate. When she was two, I was worried but managed to tell myself, "She's young, there is a lot of time. She won't be going to school here." I know that kids of LGBT parents experience homo/bi/transphobia in schools in large cities like Vancouver as well as in smaller, more conservative communities. But I've always felt that she would have more support in Vancouver to cope with this and that in Vancouver she would experience a wider range of alternative beliefs and values. She would have a larger queer community in Vancouver to buffer the discrimination and oppression she would experience and would know that she is not alone.

Cindy

(p.s. All right. The move is on. We have so much to do!)

*

On 7/14/07 4:15 AM, "Anne Fleming" <annefleming@interchange.ca> wrote:

Cindy,

We talked on the weekend about the question of safety. What, specifically, are we talking about when we say we feel unsafe? I think one of the things that factors into the struggle to articulate is that what we are talking about are almost always non-verbal cues. They are looks — the double-takes as people try to gauge gender, the hostile gaze as people sense gender transgression, the long stares. These have been with me all my life, but in Kelowna, their frequency is greater. They are posture, the way people hold their shoulders, their heads; they are stiffness in bodies, crossed arms. They are in people's own gender conformity and their insistence on their children's gender conformity — the pink-arrayed, long-haired girls; the

Spiderman-shod, short-haired boys. Some of what we perceived as hostility, I'm sure we can assume, is not hostility as much as confoundment, and would not hold up under prolonged contact. Some of it, as you alluded to earlier, is a simple sense — reminiscent of the early 1980s, actually — that people just have little experience with queers who are out; their blank or reserved looks are because they don't know what to say or how to act. And sometimes, we may suspect a totally neutral or even supportive stranger of homophobia just because we've seen so much of it around. Remember the waitress at the restaurant we went to on Mother's Day who surprised us when she brought two carnations with the bill for the two mothers at the table, just as she'd been bringing to every mother? Still, unscientific as it is, I remain convinced that the times we felt unsafe were times that, more likely than not, we were unsafe. The tongue-lashing I got for using the women's washroom in the restaurant in Hope is two towns and a heartbeat away from the looks in Kelowna.

We also talked about how being parents takes us into different spaces than it takes childless queer adults. Without a child, we wouldn't be going to swim classes at the Y or gymnastics classes at the Gym Club. We wouldn't be at the soccer field (where boys outnumber girls five to one). And we might go to the occasional LGBT community dance or to the potlucks in Winfield or the few other queer events in town. We might organize more queer events ourselves.

Anne

(p.s. We're not nuts, are we?)

*

On 8/25/07 9:29 PM, "Cindy Holmes" <cindyholmes@interchange.ca> wrote:

Anne,

No, we're not nuts at all. That *Queer Spawn* movie we saw at Out on Screen is proof. Christopher and his gay dads in Manhattan *are* us in Vancouver. Kyle and her lesbian moms in an Austin suburb,are us in Kelowna.

The film brought up so many emotions for me. I felt validation hearing similar experiences, and grief about the hostility that queer families have to navigate in so many conservative communities in the world. Kelowna may not have the anti-gay marriage lawn signs that the Austin suburb had ("Marriage = 1 man + 1 woman"), but it *was* the headquarters of the anti-gay marriage force in Canada. And we've never interviewed people coming out

of the giant, well-attended evangelical churches that permeate Kelowna, but, Dottie aside, we can be relatively certain they're going to spout the same hostility that came out of the mouths of the churchgoers in the documentary.

Then there is the history of the social conservative politicians in town, not just Stockwell Day and Ron Cannan, but the former Kelowna mayor Walter Gray, and the fact that in the late 1990s, a woman who testified at the human rights tribunal against Mayor Gray for his refusal to proclaim Lesbian and Gay Pride Day (Gray believed that the use of the word "pride" would be seen as an endorsement of "homosexuality" by the City of Kelowna) felt so fearful for her safety that she had to wear a bag over her head at the hearings.

Add to that the violent threats against the University of British Columbia Okanagan student throughout the winter and spring of 2006 (including a note attached to a rock listing the things the perpetrator would do to the victim with the rock), the hate letter sent to the student newspaper at the same time, the proliferation of anti-gay graffiti on campus, and the homophobic incident in my shared office space this year, and we actually do have our own catalogue of hatred. So although we never experienced any direct violence or threat of violence, this history and all of these recent events shape our consciousness and feeling of safety. And this social, religious, and political context sounded very similar to that of Kyle's community in Texas. All of which makes me so, so glad that we made the decision to move.

After a year of living in Kelowna, one day out of the blue, while playing with her dollhouse, which had always included a mum and mommy, Kate sadly announced to me, "I guess this family is like Rae's and not like ours." She now read the mum doll as male instead of simply short-haired. She had also forgotten that she had friends with lesbian moms who didn't have dads (in Vancouver, Toronto, and Minneapolis). There it was: we were beginning to see the impact of the monolithic heteronormative white community on our daughter. We became exhausted from our weekly dialogue about how bad it was and when and how were we going to get out.

It was our queer-identified babysitter (not originally from Kelowna and also struggling to be herself in this conservative city) who said, "What are you going to do when she starts school? You're going to have to leave or put her in the Waldorf school." Others said, "High school's one thing, but maybe it won't be so bad in primary school." But in my heart I didn't feel

this. We thought that if she started school in Kelowna, it would only get harder for us to leave as she would have friends and established connections at her school.

I want Kate to grow up seeing lots of gender, ethno-cultural, and sexual diversity. I want her to see more possibilities about what it means to be a girl/boy than Kelowna offers her. Geez, it's hard enough in Vancouver to shake up the gender binaries and the conformity to traditional white middle-class femininity, but in Kelowna it just felt like a huge up-hill battle — and virtually alone. I know that in Vancouver she is going to be around gender-queer folks. Already in three weeks in Vancouver, between the folk festival, the Pride festival and hanging out on Commercial Drive, she has been around more gender-queer people than in the two years we spent in Kelowna. And regardless of what she decides to do with this knowledge and experience, I want her to have access to it. I want to open up more possibilities rather than have them shut down. In Kelowna, it felt like the possibilities were so limited and tight for all of us. I want more. I want more.

One last question: what do we do with all those folks who are NOT conforming to conservative, white middle-class heteronormativity? To not address them seems to be telling an incomplete story. I think of Marlo, Jake, David, Urban Harvest Lisa/David, the environmentalists, the peace activists, the critical thinkers and intellectuals, the labour activists, the artists, the Okanagan indigenous communities, the immigrants of colour who have lived and worked in the Okanagan for over one hundred years, the gay/lesbian/trans people who are activists and those who are not but who are living their lives and transforming attitudes in the community in small and big ways, the academics, social workers, youth workers and anti-poverty activists, and the feminists at the anti-violence orgs and the women's orgs. They are not a monolithic group — they are not all anti-heteronormative, they are not all anti-racist, and they are not all progressive ... but many are, and we need to talk about their presence. I hated when Vancouver folks recent ly negated the very existence and strength and presence of these activists and named Vancouver as the place where everything "good and alternative" begins and ends. There are problems in Vancouver, too — heteronormativity, homo-normativity, and racism are alive in East Vancouver. Also I don't want to forget the Positive Space campaign and building allies, the Pride Centre, and the history of student activism in Kelowna.

Cindy

*

On 8/26/07 6:45 AM, "Anne Fleming" <annefleming@interchange.ca> wrote:

Cindy,

I agree, but we're way over our word count.

Anne

*

On 8/26/07 1:33 PM, "Cindy Holmes" <cindyholmes@interchange.ca> wrote:

Okay, we can't cover everything here. There's still so much to think through ... Have you seen the website "White Anti-Racist Parent"? I'd like to think more about how we can keep working against whiteness in our parenting and how it is tied to homonormativity and middle-class privilege. It would be great to do more linking of the kind of analysis there with the stuff that is coming out of the lesbian dad blog (LesbianDad.net) ... I guess that's for next time.

Cindy

*

On 8/27/07 9:33 AM, "Anne Fleming" <annefleming@interchange.ca> wrote:

I keep thinking about Steve Earle — Texas-born Steve Earle, "Copperhead Road" Steve Earle — talking in *The New Yorker* about living in Greenwich Village: "I need to be able to walk out of my door and see a bi-racial same-sex couple walking down the street holding hands. That makes me feel safe."

Yeah.

Anne

REFERENCE

Aguiar, Luis, Patti Tomic, and Ricardo Trumper. "Work Hard, Play Hard: Selling Kelowna, BC, as Year-Round Playground." *The Canadian Geographer* 49, no 2 (2005): 123–139.

ALL OUR ROOTS NEED RAIN:
Queer Parenting from the
Sri Lankan Diaspora

N. Gitanjali Lena

AS A PARENT, I SEEK TO CHANGE THE WORLD FOR AND WITH MY CHILD. As a Sri Lankan Canadian, that "world" includes a teardrop island in chaos that many of us have abandoned. Our roots lie there and I must tend to them for my son so that he takes pride in his origins. I want him to know that Sri Lankans are more than suicide bombers, corrupt politicians, and humanitarian crises; to critique the mainstream narrative of the war and state Buddhism; to feel the dignity of its working people and their arts; to sing out his two tongues; and to know how to make a proper kottu roti.

I don't want my child to be just another ignorant Canadian settler. When he comes home from school waving Canadian flags and singing "O Canada," I quake inside, reminded that he learns nothing critical at school. I am responsible for his cultural learning. I'm thirty-five and I don't speak either Tamil or Sinhalese fluently. I often feel I am a cultural orphan. Still, I've vowed not to let my son down.

However, as a queer unwed mother of mixed Tamil and Sinhalese ancestry, there are no simple recipes for "cultural" authenticity. The mixing doesn't even stop there — my son also has a Bangladeshi father who has disappeared. And we're not done yet ... his other mother, Stacia, is a Black adoptee into a white family. These are the tangled nests of roots we are sifting through daily with our son.

Sri Lankans have survived three decades of war. This is still a time of

war. Three generations of children have only known our island in crisis. My son has only known the island from a distance like many other children of immigrants and refugees. The cultural distance increases exponentially since his mother is queer and unmarried. The sexism and homophobia of my various communities act like border officials keeping us out.

Several aunties and uncles flatly ignore my co-parent, my son, and me. We don't get invitations and their children are kept away from us. One of my aunties was shocked to see that my son was respectful and articulate despite being raised by queers. Another aunty on seeing me at an event without a husband said, "Well at least you have a son, you have *someone*." Some roots get overwatered, rot, and need to be pruned. That said, I am incredibly lucky to have a loving and supportive mother, father, sister, cousins, aunties, and uncles to provide me and my son with a sense of community.

Over the years I have learned to understand the choices my parents made in assimilating. Who am I to judge them? As part of the pre-war, late 1960s brain drain, they charted the immigrant journey from Sri Lanka to France to England to Canada. They eloped when my Sinhalese grandpa prohibited their marriage. Twenty years later that same grandpa hid Tamil friends and neighbours in his home as Sinhalese mobs hunted them down on the streets of Colombo.

In Ottawa in the 1980s, they were young middle-class professionals who wanted their daughters to fit in. You see, multiculturalism, that celebrated liberal phenomenon, was in its infancy, and we still got plenty of knocks at school for being "Pakis," even though we pointed out that we were actually Sri Lankan. As a result, we didn't want to be Sri Lankan and they stopped trying to teach us. But the presence of all my grandparents in our home at different times in my childhood was like an umbilical cord to Sri Lanka.

The way my grandparents died is typical of the divided and tormented experiences of our families. My Sinhalese grandparents died dappled in the fierce gold Colombo sun, while the Tamil ones died wrapped in the grey chill of Ontario. The Sinhalese half died at home in their Kotahena neighbourhood where they belonged. The Tamil half died diasporic deaths, lost in Scarborough and Markham, but left clear instructions: *bury us back home.*

I loved my grandparents so deeply but often reluctantly, misunderstanding them until it was almost too late. To me, the death of each grandparent was more than the loss of a loved one. With each I lost a library, a teacher, a

storyteller, and a historian. That's what relatives hold for you when dominant European cultures reflect no part of your ancestry or culture. For example, when the Sri Lankan army burned down the Jaffna library in 1981, my grandpa became my Tamil library. This is critical for a people surviving genocide. Now that he's gone, I rely on my uncles and scholarly friends to teach me about our political history and our social movements. Neither of my grandmothers lived to meet my son but they would have nurtured him well, while tenderly anointing his temples with 4711 eau de cologne.

When I told my Tamil grandpa I was pregnant, he told me I was courageous. He knew full well that I would be scorned as a queer mother. Truth be told, he was relieved that I didn't want to have an abortion. He accepted my son as his "kunju" and adored my co-parent who is a Black working-class queer woman. Clearly my grandfather understood me. Traditionally, he chose each grandchild's Tamil name. He had originally suggested names with meanings like "Prince of the world" and "King of the universe," but when I requested something less macho, he came up with "Amuthan" meaning "sweet like ambrosia."

A few weeks before my grandpa died he asked for my son to be baptized. I wanted the family to celebrate his existence. The family priest agreed to recognize both my co-parent and me as mothers in front of the family. We never got a baptism certificate but our same-sex family was witnessed by a huge extended family and that must have been a first for Tamil Catholics.

And what of the women? How do they teach us culture and politics? The older women don't make speeches and debate in the living room. They stir rasam and parrippu and cuddle babies, sing and tell stories. They sniff your cheeks and rub Tiger Balm onto your chest, clasp rosaries, and share secrets. They are not incessantly scouring the Internet for news and analysis of the conflict. The way they interact with politics and culture is through small acts of resistance springing from daily life. Their politics are in their stories: how one aunty rescued the children from school on a motorbike when the school was bombed; how my Tamil grandmother stood up to the Indian "peacekeepers" as they threw gasoline on her when she defended her daughter who was being sexually harassed by them; how a Sinhalese aunty opened her home to terrorized Tamils during the riots of July 1983 in Colombo.

My mother teaches Sinhalese traditional dance and drumming to teenaged girls in our basement. She even came and performed at queer events. She and my aunties wake up at six a.m. and marvel at the slothfulness of my

generation. They have taught me how to cook everything from appam to curries to sambals to rotis to kiribath and the list goes on. I teach my son those dishes and let him smell and grind all the spices. And he drinks black tea sweetened with condensed milk, just like we did growing up.

We go to as many family and community events as we can, to feed our thirst. There are times I feel comfortable in my skin and there are times I stomach the anxiety about how my son will be perceived and treated. Sometimes I am so nervous I cannot eat, which is tragic since I am cheating myself out of home-cooked crisp vadais with pol sambol, tangy meen curry, fiery prawns, and iddiappam. Instead, I just smoke outside with my uncles and male cousins.

My relatives can afford to travel so my son has a great deal of contact with family, but I doubt that is enough. I know myself through family, especially when surrounded by a sea of white. But I also know I am more than just our maze of relatives and family friends. My family is primarily Tamil and Sinhalese, middle-class and Catholic. I want my son to know all kinds of Sri Lankans: queer ones, wild ones, Hindu and Muslim, Burgher ones, working-class ones, socialist ones, musical ones, mixed-race ones. We have to dig for our roots. We have to dig deeper past the surface of colonial manipulation and patriarchy. All sides in the conflict have rewritten ancient and modern history, overemphasizing ethnic divisions and other war-promoting propaganda. We Sri Lankans need to crack open taboos and speak to others.

That must be why I yanked my boy from mild-mannered Ottawa and plunked him down in the GTA (Greater Toronto Area). Now we are a short ride away from the Scar, home to all things Tamil and diasporic. We call it Little Jaffna, and even though we are from Mattakalaippu, it feels so familiar. Hanging out in Scarborough is cheaper than the several thousand I'd have to save up to take him home, and safer too. The GTA is home to the biggest Tamil diaspora in the world, but no out queer Sri Lankan or Tamil group exists. Thankfully, with a handful of queer Sri Lankan friends in Toronto, on both the Tamil and Sinhalese sides, I get to feel whole now and then.

Part of the difficulty of teaching my son about his roots is the hypermilitarism of Sri Lankan society and the simultaneous trivialization of war as a game in the West. Everywhere we go there is a camouflage motif, a soldier movie, a toy gun, a military Halloween costume. Our wars are real.

They happen somewhere we have been. The business of war takes our loved ones from us in so many ways. Tamil communities are full of refugees and people traumatized by war. The sounds of fireworks trigger terror memories of cluster-bomb showers. War is not a theme party.

Being Sri Lankan in a time of war makes the diaspora self-conscious. Ethnic divisions have grown deeper in some ways and generations are damaged and scarred by torture and rape. That is the dejected backdrop for teaching my son about my homeland that was once a paradise. Seventy thousand people have died, millions are displaced, unique ecosystems are ruined, economies have collapsed, libraries have burned. Forgetting our home is not for us. We are needed in the struggle to rebuild and re-vision.

As a queer people we have been told that our struggles are frivolous in a time of war. But there are wars within wars as women and children know; there are social dynamics like homophobia that intensify wars; there are power structures like patriarchy and imperialism that laid the foundations for the war and that continue to undermine peace.

These details are not peripheral. Claiming the fullness of our experiences can allow our roots to spread out wherever they need to go.

RACE RELATIONS IN THE FAMILY:

On Being a Transracial Spawn of White Queer Parents

Tobi Hill-Meyer

As I GREW UP, HAVING LESBIAN PARENTS WAS THE MOST NOTICED AND MOST discussed identity issue I faced. That I was a person of colour was the least noticed and least discussed identity issue I faced. I had white parents, a white brother, a white extended family, lived in a white neighbourhood, and went to a white school. Everybody assumed I was white, too, including me.

It wasn't until I was in my early teens that I started being interested in information about the role of race in my life. When I was sixteen, I actively started seeking that information after an experience in a Women's Studies 101 class discussion on white privilege where everyone tried to convince me that my not feeling white was just a part of that privilege. Having not had the opportunity to discuss my race in much depth before, I quietly gave up the argument. It wasn't until later that afternoon that I remembered that I *actually* wasn't just white. Everyone in my family was white, but my donor was Chicano and Yaqui. Stumbling upon my learned ignorance of race, it was at that moment that I realized that I needed to do a lot more work on the issue.

In recent years, race has been gaining more attention as a queer parenting issue. After going to my first large queer family conference in 2006, I can see why. The number of white parents with children of colour in attendance astonished me. Very frequently I get asked about having queer parents and about specifically being a trans woman with queer parents, but I almost

never get asked about being a person of colour with white queer parents. (I keep a space between trans and woman here. Politically, I prefer that representation because it's clear that trans is an adjective describing women, instead of creating a new category of identity that is often placed in contrast with women.) I've had plenty of opportunities to discuss how I came out as trans at age twenty and struggled with my parents for a few years before they came to be fully supportive, but I really haven't been encouraged to discuss issues of race. The more I think about it, though, the more I realize that I have a lot to say on the subject.

As a product of transracial donor insemination, I don't have personal experience with adoption. However, because a significant portion of children of colour who are raised by white queers end up in their families through adoption, I find the race dynamics in adoptions systems are important to address. Discussions of transracial adoption are just about the only place to find information about people of colour raised by white parents. It is also important to pay attention to the larger political and racial issues around adoption. While some people might want to debate whether or not white queer couples *should* adopt across race or continental lines, that's not what I want to do here. I'm suggesting that by facing with eyes wide open the issues of race that are embedded in transracial adoption, both historically and in the present day, we can begin to look for solutions — regardless of individual choices to adopt transracially or not.

Transracial Adoptions

To help understand how the West treats transracial adoption, I find it useful to analyze media coverage of transracial queer parenting, which often shows the ways racism and homophobia intertwine in these complicated situations. One such example was a National Public Radio story in San Francisco about gay and lesbian parents adopting Black children, which I happened to hear back in 2006. The story began by mentioning that the National Association of Black Social Workers (NABSW) had concerns that transracial adoption was a form of cultural genocide. This was not about sexual orientation but about the race of adoptive parents and the impact on the Black community because so many Black children are raised apart from Black culture. Instead of calling the NABSW for further explanation, the reporter went to the local barbershop to find out what the Black community thought. The one person of colour she quoted said, "I'm a thousand percent against it. Whether it's a

Black gay couple or a white gay couple raising children, it doesn't matter, I'm against it," making it clear that his opinion was not only about racial dynamics but also about homophobia ("Gay Adoption of Black Children Raises Concerns," 2006).

The two positions — a concern about the cultural erasure when large numbers of children are removed from a minority community and a homophobic rejection of all queer parents — were quickly conflated. As if to prove this point, the rest of the program focused on a white gay couple and their adopted Black children and created the appearance that the concerns about racism and cultural erasure from activists of colour were just another form of homophobia that white queer adoptive parents must face. This unfairly places the blame for homophobia directly on communities of colour.

Blaming communities of colour and birth parents for problems that same-sex couples face in the adoption process, along with the common representation of white parents as "rescuing" children of colour, is a way to avoid discussing the ways that institutional racism is involved in the adoption process. An honest approach demands a discussion of institutional racism.

We can see how racism works by analyzing a story that is often used to explain the need for transracial adoption. This story is about the disproportionate number of children of colour who are in foster care systems or up for adoption worldwide and how much these children need loving parents. The story emphasizes that finding loving parents is more important than addressing the race and culture issues implicit in large-scale adoptions of children of colour by white families. This makes some sense when looking at individuals in need, but it is important to look at the macro-scale context in order to understand how this story has historically been used to hurt communities of colour and to understand why children of colour are disproportionately represented in adoption systems.

Throughout the history of the United States and Canada, there has been a regular practice of cultural genocide. Both countries have a bloody history of slaughtering indigenous peoples, but once mass killings were no longer considered reasonable, it became important to find other ways to eliminate their cultures. There are several example of this. Let's take a moment to look at three of them.

At Native American boarding schools in both the U.S. and Canada,

children were forcibly taken from their families. At the boarding schools they were forbidden to speak indigenous languages and required to convert to Christianity. The people who ran these schools (under the auspices of their respective governments) were attempting to eliminate cultural traditions as a way of dealing with the "inadequacies" of the Native tribes. They saw it as necessary for "civilized" white people to save the poor children.

During the Korean War, Operation Babylift was an integral part of politically selling the war to the American people. Images of poor children of colour in need being taken in by loving white families drew upon public sympathy. The American public took it for granted that Koreans would be deficient parents and the poor children needed white parents to save them. To supply this emotional rationale, significant pressure was applied to Korean parents to give up their children, regardless of how much need they were in. In one documented example, an American worker explicitly solicited a parent by saying, "I can take your children and bring them to America. It's better for everyone" (Choy and Choy, 2006: 224).

There has been a long history of forced sterilization in the United States and Canada, and it is still practised today. In the U.S., social panic about (implicitly Black) "crack babies," defamation of "welfare mothers" (as excuses for making cuts in welfare) and the attempts to require less-than-permanent sterilization in order to receive welfare are all examples of this (Roberts, 1997). Some rather brutal policies to "end welfare as we know it" have been passed with the implicit assumption that Black and working-class communities cannot be trusted with their own children.

These examples are in some way motivated by a narrative that depicts children of colour as being in need, regardless of whether or not that is the case. The narrative triggers an almost missionary-esque white compulsion to help. Of course, that help often conveniently has the effect of destabilizing communities of colour by disrupting generational ties, traumatizing individuals, and punishing cultural practices. While white families have proven that they can be capable of providing loving homes to children of colour, we must not unquestioningly accept the modern use of this narrative or ignore the systemic effects it has.

In addition, the large and disproportionate numbers of children of colour available for adoption is often left completely unquestioned or unexplained. The explanations that are given are often rife with racist assumptions that communities of colour are somehow inherently deficient. However, there

are strong critical voices that point out some of the issues involved, not the least of which is the fact that often a lack of financial resources, not parenting skills, is at the root of the issue. It's also important to remember that a good portion of these children are not orphans. If they have parents and/or extended family, we must ask why such children are in adoption systems in the first place, as opposed to being with their birth families. In fact, prejudiced assumptions about parental deficiency is something that queer families know well.

Being raised by lesbians, I couldn't help but develop the fear of being taken away from my family. In 1992, when I was eleven, Oregon faced an anti-LGBTQ ballot measure. This referendum was up for a vote at the same time as the presidential election. At the time, I saw the anti-LGBTQ television ads attacking gay and lesbian parents' ability to raise children and I became convinced that I was at risk of being forcefully taken away from my parents. It was quite terrifying and, had the ballot passed, that measure would have prevented new same-sex parent adoptions. Even though my parents' relationship wasn't legally recognized, I was never at any real risk of being taken away by the state. For children in working-class and immigrant families of colour, however, that risk is very real. Ellen Barry, founding director of Legal Services for Prisoners with Children in the U.S., shared this excerpt from its legal archives in a recently published article:

Ms. C was a new immigrant from Nicaragua. After the birth of her second child, she had a postpartum breakdown. The oldest two children were removed from her care and placed in foster care with a middle-class white family that wished to adopt the two girls. Ms. C, whose English was quite limited, was given eight hours a month of visitation with her daughter and little other support or encouragement concerning reunification with her daughters. When her third daughter was born, she was removed from Ms. C's custody based solely on the fact that the previous two children had been removed from her. She was arrested and convicted of child stealing after she took her newborn daughter from the social services office during a regularly scheduled visit. After a long and complicated legal battle, she lost permanent custody of both older girls, although she was found fit to retain custody of her youngest daughter. (Barry, 2006: 61)

Parents can lose their children in the legal system for a myriad of reasons. Previous incarcerations, often regardless of the circumstances, will endanger parental rights. The institutional racism that infests our legal system is just

as present in cases such as Ms. C's and has taken a significant toll. "After several decades of a massive escalation in the incarceration of people of color and in the removal of thousands of children of color from their parents and extended family, the cumulative damage to these communities of color is palpable" (Barry, 2006: 68).

As people who know the fear of having our families forcefully torn apart, queer people are natural allies to immigrant, working-class, and people of colour families in the position of losing their children. Unfortunately, in the midst of desire for children of their own, queer people have often been placed in direct opposition to these families. Kim So Yung is a writer for Transracial Abductees, an activist website expressing the voice of transracial adoptees. They strongly criticize transracial adoption and see it as a form of abduction. So Yung wrote a response to an article titled "Gay Adoptions: Defining Triumph against Adversity," which profiles white same-sex couples who have adopted children of colour and the difficulties they face. She draws attention to the fact that "the article vilifies birth mothers who AWOL before giving up their babies, absurdly portraying them as a form of 'adversity' faced by queer couples that is equal to, if not more powerful than, institutionalized homophobia" (So Yung, 2005).

If the concern for providing a loving home is paramount, then you might imagine that the opportunity for a child to stay with her/his birth parents would be seen as a triumph, as opposed to a part of the "adversity" that same-sex couples face. In many cases, the only thing preventing a child from having a loving home with their birth parents is that the parents lack the finances to support a child. So when "the cost [for transcontinental adoption] is rarely less than $10,000 and can be as high as $30,000" (Lev, 2007), it's pretty clear that the child's interests might be at least equally served by making a five figure donation to their birth parents. It's not hard to imagine what a destitute family living in a depressed economy could do if they were given the money directly. At the very least they might no longer need to give up their children out of financial necessity and, more likely, that much money would make a positive contribution to the whole community.

It is clear that becoming parents is often a much more significant motivation for people than the desire to altruistically help the needy. This is part of what leads some transracial adoptees to refer to the process as "buying children of colour" or "transracial abduction" (TransracialAbductees.com, 2004). Personally, I believe the drive to become parents is a worthy goal in

itself, but to best understand the race politics such children deal with we need to stop pretending that adoption is only done out of altruism and examine the way in which racism influences both the adoption process and the dynamics that arise when a family includes a transracially adopted child.

As I pointed out earlier, when looking at all these issues, it is tempting to make a judgement call as to whether or not white queer couples *should* adopt across race or continental lines. Indeed, this is where a lot of discussion focuses, yet it's not a particularly productive discussion to have because it distracts from the structures that create inequities as well as the individual choices that people face when dealing with discriminatory systems. The choice of whether or not to adopt transracially is not the only issue of racism that needs addressing. I would argue that one's overall approach to these systems is more important. A person who chooses not to adopt transracially because it is the politically correct thing to do, yet who refuses to examine the racist dynamics in adoption systems or other systems in their life, is still perpetuating institutional racism. And a person who adopts transracially and takes the time to investigate the ways racism influences every aspect of their life is in a good position to provide their child with the anti-racist tools that they will need.

Instead of brow-beating white queer parents who raise children of colour, I believe it is much more effective for parents to learn about how they and their children are affected by these oppressive systems and suggest ways to confront them.

Growing Up White, When You're Not

I was born as a multiracial baby into a white family. My experience overlaps with transracial adoptees in the experience of being a person of colour raised by white parents. I happened to be lucky enough to have a relationship with my donor and saw him somewhat regularly when I was under the age of ten. My moms both worked at a feminist newspaper when they were looking for a donor, and found my donor after he submitted an article to the paper. He's Chicano and Yaqui, yet throughout the process my parents never considered the issue of race. After I was born, however, my parents, like most progressives would, recognized that race would be an issue for me. They wanted to make me aware of my racial heritage and be available for me in that process. They didn't have much information to share with me, and I really can't recall the details of any discussions we may have had. Despite my

parents' best intentions, something was obviously missing for me; I lacked a racial consciousness. This is something my parents could not give me.

Parents who want to address race in their child's life often look to education about their child's heritage. While an awareness of one's heritage is obviously a positive thing, it is easy to focus on examining the past while neglecting to discuss the role of race in contemporary society. This can be especially damaging if heritage is explored as a series of facts instead of as a cultural narrative that addresses the experience of being a person of colour in a racist society.

History is always a driving force of the future, yet knowing the past without knowing the present does little to prepare a child for dealing with the varied and often veiled ways in which racism operates. Tools for dealing with racism are often passed down from person to person within a community or family of colour. Clearly, this could not have been my experience, as hard as my parents tried to pass on my heritage to me.

I have often heard queer folks complain about not having an inter-generational connection with other queers — having to find or create community and family instead of having it to begin with the ways communities of colour often do. I had that queer family and community and had plenty of queer role models growing up. They showed me how to deal with homophobia, how to build community, and how to survive in a society that constantly denigrates queer people, but I never had the opportunity to learn the same things around race and racism, at least not until I sought out people of colour on my own.

When I was sixteen, I realized that I needed communities of colour to help shape my racial identity, and for a while I thought that my knowledge of my heritage would play a significant role in my racial awareness. So I sought out elders who might be able to help me. I longed for a Yaqui elder who might tell me more about Yaqui culture, but there are very few in the northwest United States. Finally, when I went to college a couple of years later, I got the chance to meet someone else who was Yaqui. It was incredibly anti-climatic. We talked briefly, but there was no mythical spark or connection. She had no answers for me that solved the racial identity crisis I was dealing with. However, my ethnic studies professor, whose heritage came from the other side of the globe from mine, opened my eyes immensely. Cultural history and traditions are important, but what I needed most at that moment was

an understanding of how to deal with racism in contemporary white-dominated Western society. Being Asian American and an ethnic studies professor, she was more than capable of helping me with that. I also worked alongside activists fighting for racial justice on campus and gained a sense of community that way. This is how I found the tools I needed to develop my racial consciousness.

It's awkward to talk about what I lacked in my family growing up. I always felt my family was under a lens and I needed to prove queer parents could be good parents. I fell into the need to hide any imperfection my parents had, which is a common experience among queer spawn (Garner, 2004). Even now, and especially knowing that my parents are likely to read this, it's hard to point out their flaws, yet on the issue of race they really haven't been perfect.

As I was growing up, my parents made an effort to provide me with a male role model (which, as a young trans woman, I promptly rejected), but they never found me a person of colour role model. Nonetheless, they tried to expose me to my heritage when they could. When I was in middle school they took me to a powwow held at a local community park. Unfortunately, they didn't know anyone there to introduce me to, so I quietly kept to myself. At one point my parents asked me if I wanted to go dance with the others in the powwow. I didn't know anything about how to do that and, between my adolescent angst and my fear that my ignorance and outsider status would readily be visible, I chose to stay on the outside and didn't talk to anyone. This is not an uncommon response; according to one study of transracial adoptees, 29 percent perceived that people of the same racial background as them viewed them negatively (Simon and Alstein, 2000).

In closing I'd like to offer a piece of advice to white queer parents who are raising children of colour: it is important to be humble and to find help. Anyone who is white should assume that they will occasionally make racist statements. My parents have, even those prefaced by "I don't want to sound racist, but ..." Instead of trying to maintain an unblemished appearance as an anti-racist activist, be responsive to criticism and use such incidents as learning opportunities. In finding help, surround your family with a community of anti-racist activists. Participate in responses to and demonstrations against racism in your community. Have white allies in your life from whom you can ask support. Have people of colour in your life; if you're responsive, they will help you be accountable.

Children are often a lot smarter than they are given credit for. With resources, people to talk to, and support structures, they will come to their own conclusions about the role of racism in their lives. As a growing number of children of colour are being raised by white parents, it will become increasingly important that queer organizations talk about the complex dynamics involved. I know I'm not the only one thinking about these issues. And it feels like I'm just touching the tip of an iceberg.

REFERENCES

Barry, Ellen. "Parents in Prison, Children in Crisis." In Jane Jeong Trenka, Julia Chinyere Oparah, and Sun Yung Shin, eds., *Outsiders Within: Writing on Transracial Adoption.* Cambridge: South End Press, 2006.

Choy, Gregory Paul, and Catherine Ceniza Choy. "What Lies Beneath: Reframing Daughter From Danang." In Jane Jeong Trenka, Julia Chinyere Oparah, and Sun Yung Shin, eds., *Outsiders Within: Writing on Transracial Adoption.* Cambridge: South End Press, 2006.

Garner, Abigail. *Families Like Mine: Children of Gay Parents Tell it Like It Is.* New York: HarperCollins Publishers, 2004.

"Gay Adoption of Black Children Raises Concerns." *News & Notes* (National Public Radio). October 31, 2006.

Lev, Arlene Istar. "Gay and Lesbian Adoptions." *Planet Out.* Retrieved 20 August 2007 from www.planetout.com/families/article.html?sernum=384.

Roberts, Dorothy. *Killing the Black Body.* New York: Randomhouse, 1997.

Simon, R., and H. Alstein. *Adoption across Borders: Serving the Children in Transracial and Intercountry Adoptions.* Lanham, MD: Rowman and Littlefield, 2000.

So Yung, Kim. "White Queers Address Homophobia, Ignore Racism (Shocking!)." *Transracial Abductees: Abduction Update.* 2005. Retrieved 20 August 2007 from www.transracialabductees.org/update.

Lost:

The Unthinkable Cost of Love

Serena Patterson

I think that I have lost my daughter. Oh, she's out there; I follow her blog surreptitiously and I show up at her place of work now and then. There is brief acknowledgement, without eye contact.

I long to tell her that she is doing great things, that I am proud of her as an artist, that I admire her tenacity in surviving Vancouver on minimum wage, that all roads — followed in good faith — lead to wisdom. I long, also, to tell her that I miss her, to embrace her, touch her skin, smell her hair. Mothers often imprint on the smell of their children; I cannot forget that she was mine.

As a baby, Ella — not her real name — greeted me every weekday afternoon by enthusiastically motoring across the daycare, lifting her arms to be held, and filling her diaper. When I surprised her with a preschool visit, she exclaimed proudly, "This is my mom!" There were long bedtimes when I would sing until she stopped saying "More!" or when we would read together and she would twirl my hair in comforting quiet. Throughout her childhood, I remained dear to her, and even in her early teens she was slow to stop holding my hand in public. She would call to me, "Mom, come and watch TV with me," and I would, just to sit next to her.

There is a sweet sensuousness to mothering that I always wanted to have my arms full of. I wanted to hold her safe, to create and maintain a small world where she would unfold without trauma, without shame.

Do I have to explain these things? There is still something that makes me want to defend myself as a "normal" mother, a "good" mother, because of

all that happened. I am in need of forgiveness, for the brokenness of a failed bond. For not being enough.

Ella was welcomed into the world by two parents who were better at adoring her than at adoring one another. There was nothing on either of us to mark the coming disaster; no faint lavender-coloured "L" graced my forehead, and nothing in her dad's eager face showed that mature fatherhood was anywhere except around the corner. We were poor, but that would change. I was working on a dissertation. I thought that motherhood, as the more universal task in front of me, would be the easy one.

The marriage was rocky, but its end still took me by surprise. Ella was nine, and I was angry that her father did not rise to the task of becoming the father and husband that I expected. His abdication shamed and terrified me. He demanded visitation rights and used them sporadically, whispering to our daughter his new conviction that I was a betrayer, an adulteress, a lesbian witch.

I had suspected that I was a lesbian, and I had not trusted my husband to keep this other passion a secret should divorce arise. After one breathless kiss from the neighbour woman, I had locked that door behind me. I knew what happened to lesbian mothers in divorce: they lost the children. So I had committed firmly to holding the marriage together. I had looked grimly ahead to the day when Ella was grown, and I would have choices again.

Those choices came sooner than expected. Three years later, when the dust settled and the litigation cleared, I did an inventory of my assets. I had:

1. Negative financial equity.
2. A fifteen-year-old Honda Civic with 200,000 kilometres on it.
3. A ten-year-old daughter.
4. My mothering self; a fountain of fierce, unknown strength and vulnerability.
5. A pretty good job.
6. The creative ability to put almost anything into words.
7. A woman, Monika, who would love and cherish me, ready or not.

It was complicated. It was so simple. I grieved my previous life mightily, but I fell deeply and joyously in love. I felt that I had entered an entirely new country, and also that I had come home.

Meanwhile, Ella said, "If this gets out at school, Mom, I'm dead meat." My spiritual and social geography had changed, but Ella's world had not. She still had to negotiate the end of elementary school, the loss of her father, and

the faint beginnings of puberty and womanhood. Partaking innocently in a universal ritual of girls' friendships, she told a classmate the delicious secret of her mother's new love. When the secret was broken, she plummeted in her social standing. She was, the girls said, a lesbian. Anyone who talked to her, played with her, sat by her, or defended her was a lesbian. Ella told the teacher and me that she was fine. She practised her wit and held firm. But she endured the remaining days of Grade 5 alone.

I should have taken her out of school. Or maybe I should have stayed in that school the next year. I should have done something different, I know. I talked to the teacher and the school counsellor (who was clueless but supportive), and the neighbours (who were neither). I sold my house and moved Ella to a new school.

By coincidence, a speaker came to town that spring decrying the gay agenda in public schools. Many good Christians claimed the "religious freedom" to shield their children from the news that gay people existed. The pope himself declared homosexuals to be child abusers who should be denied the right to raise children. There was a famous court battle to remove the children's book *Heather Has Two Mommies* (1989) from school libraries.[1] I wondered — if I tattooed my arms and buzz-cut my hair, would I be exposing their children to danger with my overt lesbian presence or protecting them by clearly identifying myself as the lesbian menace? If I brought Rice Krispie squares to the school fun fair, was I masquerading as "normal"? Should I be more or less visible? What would help my daughter?

At the new school, I presented myself as a single mother and felt the sting of the new teacher's hard, dismissive gaze. It said, "single mom, transient, low income address — end of story." But, I'm a psychologist, I thought to myself, I have a PhD. People respect me! I sat, my knees bumping against the bottom of the desk, my face burning in front of this portly, bigoted man. I prayed that it would be okay.

Sometimes, it was okay. More often, it was not. Monika and I weren't very good at staying hidden: within a year of moving, we were at school functions together and inviting Ella's friends, when she had friends, over to visit. But the friends kept bowing out for reasons that Ella did not, or could not, tell me. Mothers stood by, looking quietly relieved. Teachers were strangely silent when her locker and musical instrument were vandalized. She did group projects alone. She walked through her junior-high corridors with her head down. Monika and I were baffled.

Even in good times, when she had friends, the words "faggot," "gay," and "homo" rang through the school hallways as all-purpose putdowns. Girls who walked too close, spoke up too loudly, or didn't wear makeup were "dykes."

Ella stopped bringing friends home. Some, she reported, were uncomfortable meeting lesbians. "It's not that she thinks you are going to hell or anything," she explained about one girlfriend, "she just thinks that you are … a mistake."

Still, I thought that we were winning. When Ella started high school, I felt secure in our accomplishments. There had been no great rebellion. She liked us and liked our friends. She told a new acquaintance who declined to meet her lesbian parents, "That's okay. I won't come to your house either. I'd be uncomfortable meeting parents who teach that kind of fear." She did not experiment with drugs or sex, and, in hindsight, showed remarkably little interest in rock and roll. She preferred classic jazz and the CBC. She meandered to her own drum, seemingly impervious to her peers' judgement. She made beautiful music. She was quirky, but gaining self-assurance.

With high school, changes came fast. I went through a serious illness. Her father, newly remarried, came back into her life bearing gifts of a computer and summer orchestra camp. Her first boyfriend dropped her. My father died, and I went back to my big loving family without her, to grieve. Same-sex marriage became legal, and Monika and I got married. Ella balked, and moved out. When she returned, her arms had developed an "eczema" of straight little cuts; she was hurting herself with sewing needles. There were frustrating and mysterious disappearances of money and small objects around the house. She narrowed her circle of friends, spent more time alone in her room, or sat in front of the Internet until the wee hours of the morning. She portrayed herself at school as a child living independently, without parents. I could not bear this. I felt her tear away from me with the force of a person who suddenly cannot stand you. I tried every theory I could think of, and every technique I knew to try and help. But all Ella would say was, "It's about you."

There came an evening when I knew with certainty that she was lost to me. It was a warm, damp evening with the cloudy stillness of West Coast gloom. Earlier, we had fought over the theft of $20 and a pair of earrings. I had held my ground, delivering the consequences that I had promised for what I saw as a basic moral issue, and had arranged an interview with a police officer. But now I was walking alone around a football field, while Ella was

inside, starring in her school musical *Grease*. The principal had escorted me out. Ella, he said, was too upset by my presence to go on stage; the entire production was jeopardized. I asked if this was common, that a parent was denied seating at a school event? "Oh, occasionally," he replied. "When a parent is an alcoholic or drug addict, it happens."

When Ella was still living at home, I did a small academic study — interviews with lesbian grandmothers (Patterson, 2005). Nearly all of the participants had, like me, borne their children into heterosexual marriages. Most had denied their lesbian identity until the children were teenagers or grown. There had been times of estrangement and anger, when their lesbianism and their divorces had come between them and their children. Yet most had, by the time of the study, come to good terms. Their grandchildren cherished them. It was a happy story: they had gambled all that mattered to them on the chance that they could have both integrity and love, and they had won.

I think of these women when I need a reason to believe in redemption and reunion. But I'm a good enough scientist to know about selective sample bias — maybe the really wounded ones don't volunteer to be interviewed.

I still want to believe that mother-love and the faithfulness of mother-labour can overcome and outlast all that challenges them. I want to be the mother bear that I was when Ella turned her wondering infant face up at me and I knew, without a doubt, that I would simply pluck out the eyes of anyone who would do her harm. I want my love to be a talisman that protects my child from evil. I keep trying to travel back in time and try out all possible actions until I find one where the outcome is different. But how different could it be? However I play it in my mind, I'm still a lesbian mother.

Even in the most conventional of families, adolescents do not live in a world that tells them to turn around and love, honour, or be gentle with their mothers. A collective underlying disdain towards mothers is one of the cornerstones of patriarchy, after all. The support of men — of fathers, priests, school principals, and other authorities — gains some mothers a certain kind of respect. In return for staying within the boundaries of "good" motherhood, they are said to have superhuman powers: mother-love can, and should, be enough to lead children to the right, the good paths in life. "God cannot be everywhere," reads the Sunday-school plaque, "so He created Mothers." But we mother misfits — single mothers, lesbian mothers,

poor mothers, mothers without men to lend us authority — we know that the smug belief that mother-love overcomes all evil, heals all wounds, and outweighs all other experiences in life is a conceit of the privileged. We know that our love has limited power and *that* knowledge keeps us awake at night — praying to something beyond ourselves or going crazy with worry.

Beyond this, we know that our children's path to acceptability in conventional society is paved with betrayal. They must choose between loyalty to the mothers who raised them and belonging to the society of their peers, teachers, and civil and religious leaders who deny the legitimacy of their families. Their right path isn't clear at all.

I don't think that my daughter wanted to betray me. But when she did, she couldn't admit to either a failure of courage or the human need for acceptance and belonging outside of her own house. She had been so strong — how could something as humble as wanting to fit in bring her down? Turning away from me had to be about a higher, nobler goal. It had to be about breaking free from a villain: me. Or maybe the weight of all that homophobic pressure simply wore down our bond until there was nothing left for her to hold onto. On my bad days, I think maybe she was telling the truth when she said, "It's about you." Maybe I just failed, plain and simple.

It's been five years now since she left home to live with her father and then, when that fell through, on her own. She is young; there may yet be reunion, redemption, forgiveness, and healing. And then, there may not.

It is important and courageous to claim our full selves as lesbian mothers. But it is not without great personal risk. Sometimes, we lose.

NOTES

1 This picture book presented a lesbian family in matter-of-fact language to readers between the ages of two and eight years. It sparked a controversy across the United States and Canada over the inclusion of family diversity as a topic in school curricula. Still banned in some school libraries, it broke ground for a spate of children's books featuring "alternative" families.

REFERENCES

Newman, Lesléa. *Heather Has Two Mommies*. Boston: Alyson Books, 1989.

Patterson, Serena J. "'This Is So You Know You Have Options': Lesbian Grand-mothers and the Mixed Legacies of Nonconformity." *Journal of the Association for Research on Mothering* 7, no. 2 (Fall/Winter 2005): 38–48.

Radical Fairies & Lesbian Avengers:

Reflections from a Gay Dad and His Dyke Daughter

Julie Mooney-Somers & Eamon Somers

I remember telling a friend that my children and their mother were going to live on the other side of the world. And his "look-on-the- bright-side" response was, "Well at least no one can blame *you* if one of them turns out to be gay."

— Eamon Somers

THERE IS A GROWING BODY OF EMPIRICAL RESEARCH ON THE PSYCHOLOGICAL development of children of lesbian and gay parents (see, e.g., Tasker, 2005). The general finding of this research is that children raised by lesbian and gay parents are *just like* those who have been raised in heterosexual families. That means they are just as likely to grow up to identify as straight or as queer. Yet there seems to have been a silence around the specific experiences of these queer children. Children growing up to adopt a queer identity is a popular argument drawn on by those who oppose queer parenting (Clark, 2001; Clark and Kitzinger, 2004; Hicks 2003, 2005; Riggs, 2004), so the silence may be about denying these groups ammunition. There are some signs of change, though, with a few recent collections of writings from children of queer parents featuring queer young people (see, e.g., Garner, 2005; Howey and Samuels, 2000; Sonnie, 2000). Queer people with one or more queer parents are often called second generation or second gen-ners. They appear on on-line forums for children of queer parents such as www.COLAGE.org and www.FamiliesLikeMine.com. Participants on the

COLAGE second-gen on-line community (www.collage.org/programs/2ndgen) share their experience of a double coming out — their own and their parents', of having one queer and one straight parent, or of the difficulty of being out but having a closeted parent. These issues are unique to queer offspring of queer parents. There are few corresponding accounts of the experiences of the queer parents of these queer children, and nothing of their shared experiences of adopting a queer identity.

Our story is complicated, but we will start with this: In his early twenties, Eamon got married to a woman and had two children (Julie and her brother). When Julie was three years old and her brother not yet one, Eamon left the marriage and came out as a gay man. Now he lives in London, England, with his male partner of twenty-six years. In her late teens, Julie came out as a lesbian. Now she lives in Sydney, Australia, with her female partner of fifteen years. On the surface we share something that is central to our sense of self, but our identities were formed at different times in history, in different social and political contexts (especially in relation to the women's and gay liberation movements), and are marked differently by gender. Julie has written a little about her experiences (Mooney-Somers, 2006), but we'd like to write about *our* story. We want to explore what, if anything, we share in our experience of being gay, specifically in the context of Eamon being a queer parent and Julie being a queer daughter (queer spawn!). We want our story to be known and documented. But we also think it may help people with similar experiences, emerging queer parents, and their queer offspring.

We live at different ends of the world so our conversation has been by email. This is an edited version of our exchange.

J: The few narratives I've read, from queer kids of queer parents, are filled with angst around letting the side down, as if turning out gay confirms the accusations of homophobes that gay parents can't raise "normal" kids. Apparently, having a queer child is the terrible guilty fear of many queer parents. There is a second-generation activist who tells a story about a lesbian mother telling him, "You are my worst nightmare" (Kirby, 1998). I think our shared narrative is neither a painful one nor one full of angst.

E: Angst? Letting the side down? No way. The late 1970s and 1980s was a time of splits in the emerging lesbian/gay community as we tried to define ourselves. Brave people had put themselves on the line, and while I was inspired by them, I was neither that brave nor convinced that I wanted to

dedicate my entire life to the cause. Although I wanted to be a radical fairy — rejecting "hetero-imitation" and redefining gay identity by challenging the commercialization and patriarchal aspects of modern gay life — I became a woolly wannabe, nervously standing shoulder to shoulder with my more strident and visionary brothers and sisters. I would have wanted to breed queer children if I'd given the matter any thought. So when you turned out to be a dyke, there was a little fillip of pleasure, something radical had occurred. You should also remember the bizarre assertion that homophobes used to make about queers: that because we're not able to breed, we have to seduce and convert straights. A point reclaimed wonderfully by your Lesbian Avenger T-shirt slogan: We Recruit.

J: I forgot how confronting that slogan was, though obviously we Lesbian Avengers (a direct action group promoting lesbian perspectives and rights) try to provoke discomfort. The irony of the slogan, in terms of my own situation, was entirely lost on me at the time. I think for queer people who have had a negative reaction from parents — or feared it — the idea of having a parent who is also queer is perfect, like all the problems or challenges that people associate with being queer (being rejected by the people who should accept you) will disappear. Of course it was easier in some ways, as was coming out to a heterosexual mother who already had a good awareness of gay issues. But I still had to work out who I was (or wanted to be) in the same heterosexist world as everyone else. I've written about this before (Mooney-Somers, 2006), but you haven't told me if you feared our rejection — whether you thought your children would desert you when you came out?

E: I don't recall feeling that either you or your brother would reject me. I think I somehow believed that if I was open and honest from an early age, that you would be okay with my gayness. It also helped that you grew up in a supportive environment, even if I was not there. If I had a negative feeling at all, it was about why I was the last to know about your sexuality. I worried that my outness might have delayed yours, rather than helped; maybe my angry, hyper-sensitive relationship with a heterosexual world would make it difficult for you to be a "lipstick lesbian" (for instance) if you wanted to be. Why wasn't it like the movies, with you dropping hints, or telling me you wanted a serious chat, or even misbehaving in some teenage way, with me (and only me) having the understanding to see what was

actually happening? Of course we didn't have a movie-like family, and being on opposite sides of the world didn't help. But somehow I felt I should know before anybody else. And for "anybody" you can read "your mother." It was a feeling of being superfluous in the face of the demonstrably good parenting by your mother and stepfather, even in this specialist area, where I was the expert.

J: I'd never thought of my coming out in that way. I often feel that one of the losses for people who opt out of heterosexuality is around ritual — what are our rites of passage? What life markers are recognized and celebrated by everyone around us? In an alternative universe, coming out could be one of those rites. So, I suppose I did deny you a part in that. The geographical distance didn't help. And it was before email and Facebook; dropping hints by letter or having a serious conversation on the telephone (or happy families round the audio tape!) would not have been a fun prospect. But the bigger issue, I think, was that I didn't have any angst about it. In that way it was probably terribly normal — I was a teenager working out my romantic attachments. I did misbehave but discreetly; as the eldest child, I carry the burden of not wanting to trouble anyone. In other ways my coming out was not so normal, or usual. And that *is* down to you. You may not have been on-the-ground but you were there. You being gay meant it was an option that was available to me, as valid as the other option. I don't think I ever felt that my desire for women was anything to be concerned about. I know this is a world away from your experience of coming out.

E: When I became involved with the National Gay Federation in Dublin in 1979, you were nearly five, and I was emerging into a supportive, identity-affirming community after many years of confusion and deep unhappiness over my sexuality and identity. However, while I wanted some of what the community could offer, I was very clear that I needed to preserve the "essential" Eamon. I clearly recall saying to myself: "I don't want to be changed by this." I guess I was afraid of being overwhelmed by sensual experience — as seemed to happen in the few trashy novels I'd read — and then being revolted by the person I would become. At that time, many married (and likely secret) homosexuals stayed with their spouses for the sake of the children, and in some instances for their "cover," sneaking away once in a while to "indulge" their other life. Or they (mostly men) started a new life and lost touch with their children: which I did until I decided I wanted

an integrated life. Yes, to be gay, but also to be a parent. In reality, because I was a weekend parent (Julie and her brother lived with me every second weekend until they moved overseas), I didn't have to confront the straight world's attitudes very often. I wasn't bringing up two children in the suburbs with my same-sex lover. But I did carve out a place for myself and my family in the gay world. Regularly bringing you and your brother to events such as otherwise gay-only house parties and to the activities I organized to raise the profile (and self-regard) of Ireland's lesbian and gay community.

J: I love the idea that I had a gay childhood! My memories of your gay world (and so, my childhood) in Ireland are great — people were friendly and nice, probably treating us a little older than we were. I remember a party (New Year's Eve?) in someone's house when I must have been six or seven. They had a Culture Club calendar in the bathroom, and *The Rocky Horror Picture Show* was playing on the TV — it was great. Around the same time, I remember watching myself dancing in the mirrored wall of the Hirschfield Centre (gay community centre) disco — in the middle of the day. And I remember on weekends you waking us up by playing *Wham* (the first gayer album). I suspect you being gay has meant — still does — that you are more in touch with popular culture than other people's dads, which makes you seem younger. I think this contributes to the feeling I've always had that our father–daughter relationship is different than other people's. I don't know what having a straight dad is like, but we talk to each other in a different way than the way my friends talk to their dads. We also do gay stuff (plays, films, bars, nightclubs), and it isn't because you are trying to be supportive or understand me!

E: Halcyon days that ended in the mid-1980s when Ireland's economic and hegemony woes drove your side of our family to Australia, and mine to London. My first real job in London was working to implement Haringey's (local government district council in London) positive policies for lesbians and gays: Dealing with the hate campaign started when newspapers discovered *Jenny Lives with Eric and Martin,* a cartoon book about a little girl living with her dad and his boyfriend, in the local library. So gay parenting was at the heart of the vicious backlash that allowed Mrs. Thatcher's government to implement legislation to outlaw the promotion of "pretend family relationships," as the reactionary press and religious

right called queer families. However, I was perceived by some of my radical colleagues as not really gay or not gay enough. I had tasted forbidden flesh, had "wielded heterosexual power."

By the time you came to London a few years later, I had found a work and social world among people who generally were in the "caring" professions. My gayness, my parenthood, my lesbian daughter, and my immigrant status were markers that indicated which side of Mrs. Thatcher's divided Britain I belonged on. In braver moments I even felt I possessed a little "radical chic." But my "integrity" forced me to utter the words and come out, waiting for their response even while this same integrity was insisting that any mention of children be balanced by reference to "my partner," and then "my boyfriend." And visa versa. This sometimes provoked questions, but always left me exhausted, and with a sense that I was forcing too much information too quickly.

J: And as if telling people you had kids and then clarifying that you're gay isn't enough, did you tell them I'm a dyke?

E: To be honest, this is a very uncomfortable question. I am happy to tell other queers about you, to boast even. But that's about building up the "network," as much as anything. However, I am old-fashioned about outing other people to straights. My responsibility is to out myself only. I know there's an internalized homophobia component to this, but there are also issues of power, both good and bad. It is a reluctance to embrace my own actual power, but also a reluctance to use other people's sexuality (including yours) as a weapon to challenge or punish prejudice, especially when you are not there to charm them.

J: Yes, I've seen the enjoyment you get from introducing me to acquaintances and then watching as they realize I'm queer too. I don't have the same kind of reluctance. You being gay comes up when I'm telling a story about you and your behaviour seems odd for a heterosexual man and I out you to explain that your behaviour makes sense. Or I say something — forgetting everyone doesn't automatically know (or at least consider the possibility) that you're gay — and they look confused. And then I have to out you to clarify. But as an adult, I don't often get asked about my parents. I'm usually very proud to tell people about you being gay. But there are times when I don't want to tell people or wished I hadn't. I feel embarrassed, because most people avoid drawing attention to their parents' sexuality. Or like you,

I've felt exposed because I've given too much personal information. I feel like I live very publicly as a lesbian — it is rare that I feel I am allowing a silence around my own sexuality or my relationship. But, there are moments when I realize *your* heterosexuality is being assumed, when I find myself considering whether to gender your partner, when I begin to feel complicit in the silencing of *our* experiences. This I find challenging. I feel guilt and some shame if I fail to clarify, allow an assumption to stand, take the easy option, or even hesitate.

E: We also live in communities, darling! Where I lived in London (Streatham) was suburban and people couldn't miss the obvious, but the woman lodger we had at the time may have helped people draw the wrong conclusions. Our gay lives were largely lived out of sight. Then you arrived to live with us, and you, with your Doc Martens and shaved head, were unmistakable. I was scared of your radicalism. The Lesbian Avengers terrified me. I don't have the heart for direct action, although I'm happy enough to leaflet and picket, and even participate in gay pride in Dublin with not many more than a dozen people attending. I often wondered (I must admit) would you have been so radical if I had been straight or if I had not been involved in campaigning myself?

J: But you were out there living a gay life — the neighbours knew, you looked like a gay man so I assumed the people in the local shops knew, your work colleagues knew, and you were running a gay support service within a very conservative Irish immigrant community. Even before London, your involvement in the National Gay Federation was so public, and personal; I remember seeing you on the TV! And you thought me radical? This is a most surprising revelation! I don't think it ever occurred to me that the way I was living my lesbian life could have challenged you or exposed you. So, we had some of the same cross-generational tensions as the rest of the population!

*

Our exchange does not have a tidy ending. Our conversation has just begun, and over the past few months we've discovered that there is a lot we had not talked about. Our small part in challenging prejudice, and insisting that the world accommodate us as we are, has probably helped to make us an endangered species. We've both witnessed the so-called Pink Baby Boom

and we know that being the lesbian daughter of a formerly married gay man — or the formerly married gay father of a lesbian daughter — is likely to become quite rare, at least in those societies that reduce the barriers to people making choices about their sexuality and therefore facilitate coming out at a younger age. It is therefore all the more important that we record our experiences and support each other in our continuing efforts to make our ways in the world. We wonder how the next generation of queer parents and queer kids will make their way, and await the third, fourth, and fifth generations. This is our history.

REFERENCES

Clarke, Victoria. "What about the Children? Arguments against Lesbian and Gay Parenting." *Women's Studies International Forum* 24, no. 5 (2001): 555–570.

Clarke, Victoria, and Celia Kitzinger. "Lesbian and Gay Parents on Talk Shows: Resistance or Collusion in Heterosexism?" *Qualitative Research in Psychology* 1, no. 3 (2004): 195–217.

Garner, Abigail. *Families Like Mine: Children of Gay Parents Tell It Like It Is.* New York: HarperCollins, 2005.

Hicks, Stephen. "Is Gay Parenting Bad for Kids? Responding to the 'Very Idea of Difference' in Research on Lesbian and Gay Parents." *Sexualities* 8, no. 2 (2005): 153–168.

—. "The Christian Right and Homophobic Discourse: A Response to 'Evidence' that Lesbian and Gay Parenting Damages Children." *Sociological Research Online* 8, no. 4 (2003). Available online from www.socresonline.org.uk/8/4/hicks.html.

Howey, Noelle, and Ellen Jean Samuels, eds. *Out of the Ordinary: Essays on Growing Up with Gay, Lesbian, and Transgender Parents.* New York: St. Martin's Press, 2000.

Kirby, David. "The Second Generation." *The New York Times,* 7 June 1998.

Mooney-Somers, Julie. "What Might the Voices of the Second Generation Tell Us?" *Lesbian & Gay Psychology Review* 7, no. 1 (2006): 66–69.

Riggs, Damien. "On Whose Terms? Psychology and the Legitimisation of Lesbian and Gay Parents." *Gays and Lesbians in Psychology News* 3, no. 1 (2004): 3–9.

Sonnie, Amy, ed. *Revolutionary Voices: A Multicultural Queer Youth Anthology.* Los Angeles: Alyson Books, 2000.

Tasker, Fiona. "Lesbian Mothers, Gay Fathers, and Their Children: A Review." *Developmental and Behavioral Pediatrics* 26, no. 3 (2005): 224–240.

The Pop Luck Club

BOX F

The Pop Luck Club

In August of 1998, founder Paul Oberon and a small group of men in southern California began to gather on a regular basis, aiming to establish a meeting place for gay fathers and their children. Their mission was to create a sense of community, a place where children could meet and get to know other gay parents and their children, and where fathers and prospective fathers could have a forum to discuss their unique experiences, problems, and concerns. The hope was that building community would increase people's confidence in themselves as parents.

Today, The Pop Luck Club has blossomed into the largest known gay fathers organization in the world, with hundreds of families and continued strong growth. In addition to its regular monthly meetings, Pop Luck sponsors many special events, including resource fairs where people can learn how to become parents; participation in annual LGBT Pride Parades; joint events with lesbian moms; and lots of activities for the kids.

While it has retained the simple tradition of each member sharing food and stories, The Pop Luck Club has evolved into a substantial voice, helping to support our wonderfully diverse community.

www.popluckclub.org

GAYFATHERS **OF**TORONTO

Gay Fathers of Toronto

Throughout history gay men have created families. Some were open about their sexual orientation, others felt the need to hide. Many of those men would eventually come out of their closets, sometimes at great cost. Facing an unwelcoming world, a group of newly out gay fathers established Gay Fathers of Toronto in 1978. Our aim was to provide mutual support as each one found his way to reconciling his same-sex desires with his love for and obligations to his children. Dealing with one's emotions, conflicts, and fears in this journey, is a process of discovery, adjustment, and learning, and it is often stressful.

Today many new parenting options are open to gay/bi/queer men, yet many still become fathers through traditional relationships or marriages to women. Notwithstanding today's friendlier social and legal systems, during that period of transition, the emotions *feel* as they did to those men in 1978. Gay Fathers of Toronto meets twice monthly to reassure men going through this journey that they are not alone and to support them as each finds his own path.
www.gayfathers-toronto.com

This Hyphenated Mothering Thing

Makeda Silvera

All our children are outriders
For a queendom not yet assured.

— Audre Lorde, *Sister Outsider*

Part I

THESE DAYS I SPEND A LOT OF TIME REFLECTING ON THE PAST, YET REMAINING very conscious of the present. I'm sorting through a roomful of boxed-up mementos, and as I do so, I consider my life and my choices.

I am of African descent, a woman, a mother, a lesbian, a writer, an activist, a feminist, an educator, a survivor, and the daughter of Jamaican immigrants.

Most of my life I have lived in Canada. Over the centuries, many battles have been fought over this land and its meaning.

In more recent times here, as lesbians, we have fought for the right to control our reproduction, the right to retain custody of our children, the right to adopt, and the right to foster — struggles hard fought and hard won. The casualties were legion, their names mostly unknown: among them were the many lesbians who found themselves pressured to comply with the institution of heterosexuality, for fear of losing their children; many of them moved from place to place to escape that injustice. For those of us who are racialized, it often meant leaving family members and others who were the cornerstones of our lives, many of whom we had struggled alongside against racism, only to have to flee their wrath. Nonetheless, we refused to compartmentalize our lives for the benefit of acceptance.

Part II

I rummage through papers, photographs, newspaper clippings, stopping to toss out posters and flyers from years back. I would keep them, but I'm running out of room. Still, I hesitate to be responsible for the loss of even a part of a history that is already so marginalized. The discards remind me of how far we have come and of how far we still have to go. There is uncertainty, too, for many of our hard-won victories may be rolled back, the struggles left for our grown children and perhaps our grandchildren to take up.

I take out photos of some of us at Gay Pride celebrations in the 1980s. Our numbers were small, but we raised our banners high on Church Street. We were risking jobs, risking assault, risking all we had to be openly Black and gay, and, in the process, forming new families and communities. I thumb through minutes of the meetings of organizations founded in hope and defiance, organizations that brought us together in common purpose, helped us dream of better days, helped us refuse defeat.

I skim letters we wrote to the editors of Black community newspapers demanding to know why they refused to publicize our events. There's a stack of flyers announcing meetings with straight Black women's groups to discuss our commonalities. Despite the struggles within our communities, we never lost sight of the need to keep fighting against racism. More often than not, our children were present. Even the nine- or ten-year-olds had some understanding of what it meant to be of colour and lesbian or gay. Why have them present? Children are very observant. Ours had already begun to ask why some of our straight friends had stopped coming around, why the silence about our lives when they visited grandparents, why raw eggs were hurled against our front windows. We talked openly with our children. At a very early age, they understood who we were, that we cut against the grain, and that we were not ashamed. As they grew into their teens it became awkward for them, sometimes hard, to explain to teachers and friends why they had two mothers showing up at parents' meetings, or to invite friends over. In their early years it hadn't seemed to matter much, but as acceptance by friends became important, lesbian parents had to work harder to help their children understand.

I peer at photographs of my two daughters, then young, and of friends with their children — reminders of birthdays, Thanksgivings, Christmas feasts, school concerts — ahh, those school concerts. Most of us were young

and I am caught up in images of us with our children. Mothering is always a challenge, and lesbian mothering was all the more challenging during those tumultuous times. Here we are in our fierceness, righteous anger, pride, and love. Year after year, holiday after holiday, birthday after birthday, we came together. Photos show us dancing; relaxing or napping; deep in an embrace with a lover; in heated debate; cooking; reading to, or feeding, a child; watching our children act out a skit, decked out in costumes pulled together from foil paper, old clothes, and newspapers.

Another photo, taken from a window, shows the lovely face of one of the children and, behind the child, a wintry tree with frozen icicles hanging. We are at my house, our refuge, and where most of us lived. Just weeks ago, I packed up *MA-KA Diasporic Juks: Contemporary Writing by Queers of African Descent* to lend to a new friend. As I leafed through it, I came across a short piece by a member of that second family. She writes: "In that house, and around back in that yard, we whispered our secrets and shouted our fears. After heated political debates and arguments over strategy, we sang and danced many a night away, no longer strangers but a family, nine strong, many of us with children. Some came fleeing betrayal by blood family and community, others came seeking a place free of the bigotry that so often characterized gay and lesbian groups, bars, and clubs" (Douglas, 1997).

Part III

In part, I am thinking back on those days because I am now a foster parent and the child I'm currently caring for is a young Black teen of Caribbean descent, a child who, like so many in foster care, knows abandonment and loss. Inevitably, children with that experience are reluctant to trust, and as adolescents, come with their own necessary, yet at times maddening, brand of spirit. My first priority is to provide a safe and secure place for my foster child. All children who have to leave their family, no matter the circumstances, fear that they won't be safe, won't be accepted, and that even a small bit of trust will be betrayed. Foster mothers must be able to accept their foster children's feelings of grief, loss, anxiety, and isolation.

The child-welfare agency can be maddening. There is a general, albeit not always explicit, pressure to live up to the expectations that would be exacted of a heteronormative family. (The training that the agency offers to

foster parents does speak to being queer and being Black, but that training does not always make its way into the agency's own practice.) Many decisions around fostering are made by people in positions of power, often white, and often locked into beliefs and values that differ from those of Black and lesbian and gay foster parents. As a foster mother, I am very much aware of this and know that it will take some time for the agency to treat lesbian foster mothers as "normal." Until then, a tension will remain: we want to raise the children within a queer-positive household; the larger society finds this unacceptable or problematic — the widespread, though proven false, view that children can "catch" homosexuality if "exposed to" lesbians and gays still has currency.

As well, the agency's approach is often one of "colour doesn't matter." Perhaps not, but biases do surface among the agency's representatives. This is no condemnation of the agency's training or of its intent. We do, however, live in a society with racism and cultural biases, however subtly or unwittingly these may be expressed, and these biases, not surprisingly, often do shape how agency staff view foster parents.

Like many other mothers, I face another challenge that's rarely spoken of — ambivalence about mothering. This ambivalence has etched itself in the far corners of our minds: some of us look back on our own childhood and fear making the mistakes our parents made; others take up that challenge with deep optimism. Just as many straight women feel the pressure to give birth to prove their womanhood, so too do many lesbians. Then comes the pressure to be the Good Mother — the all-sacrificing one who keeps her ambitions and desires tucked away out of sight. The result can be devastating for both child and mother.

My own children were born when I was in my early twenties. While I was pregnant, all my hopes and dreams centred on the life growing within me. Once an actual child presented herself, however, the bliss turned into *What am I doing? What have I taken on?* At times, there was resentment and anger, especially when they were old enough to ask, "Where is my daddy?" or "Why did you leave him?" and all I could offer was a line about a love gone wrong. When they realized that he was never coming back, this imaginary father they'd never really known, they were quietly resentful for a long time.

Much later, during their teenage years, I would write in my journal that no lover could exact such strong emotions, both joyful and excruciating, as my children could. And yet I wouldn't trade those experiences for the world.

Part IV

Friends ask why I want to do "this" job again. I answer that I want to "give back," that young girls of African descent are appearing in increasing numbers on the rolls of child-welfare agencies, and that I see providing a safe and nurturing home as a social and political act. I listen to myself with a sigh, because I know that my words don't come close to reflecting this rocky terrain I'm crossing. Rocky because I mean to accompany her on her journey from loss and grief; and rocky perhaps because her journey recalls both universal experiences and my own grief at losing a daughter. My joy — and my surprise — are profound when a sudden breakthrough happens. A quick hug, a mention of a crush, a comment about her past — all are signs that she's taking a more confident path. As is always the case with foster parents, I don't know when our journey will end or how. We've come far enough, however, that I am sure that we will maintain a relationship.

Friends ask if my being lesbian complicates my fostering of a child brought up in a straight Christian household. Of course it does. I raised my own children from infancy. They grew up in an environment where to be lesbian or gay was not remarkable. My foster child, however, came to me with the values and beliefs of her home, one in which motherhood had meaning within a very narrowly fixed sexual identity. Audre Lorde's "mythical norm" (Lorde, 1984: 112) springs to mind. Above all, "hyphenated mothers" — Black and brown mothers, lesbian mothers, working-class mothers — do not fit. Lesbian parents are not "just the same" as heterosexual ones. And however much we at times may want to be "normal" or feel the push, compliance weakens our legitimate choice to be both parents and queer. And so, in the face of misunderstanding, judgement, and attack, we keep going. We strive to help our children grow up to be whole and with a strong sense of social responsibility — and that includes being our whole selves with our children.

Evidence of Black queer culture is not hidden away in my household; books are everywhere, along with paintings, posters, and photographs. Discussions with friends about political issues are still part of my everyday life. My foster daughter knows my friends, many of whom are lesbian, or gay, or transgendered, all of whom are opinionated and strong. They laugh and argue politics. They talk freely about homophobia and heterosexism. Hearing their views in no way makes her shy away from crushes on boys.

She has no reason to shy away. That is not what is taught in this house. What is taught is respect for choices.

I hope that she will come to question received wisdom, come to see how the state works both for her and against her.

Of course there are risks involved in all of this, and I am well aware of them. The child-welfare agency provides financial support, and as the representative of the state, makes all the major decisions in her life. These facts in themselves pose a challenge for hyphenated mothers, who, after all, remain primary caregivers and the transmitters of values.

I do believe that raising children requires specific awareness. How can I send a young Black girl out in the world without ever speaking of racism? How can I not encourage the questioning of authority? There is no room for silence. We need to teach all children to stand up for themselves and for others. Shielding them will only help perpetuate the very things we set out to fight.

Part V

History is so easily forgotten, even though the origin of the word itself reminds us of the importance of maintaining its narrative, I think, as I sift through the papers and photos. They remind me, too, of the importance of community and of the effort many of us put into building it. Although there is still a far way to go, we've kept the torch burning and passed it to younger hands.

Homophobia still exists within mainstream Black opinion, although no one can now deny we exist. Racism still divides queers. Yes, we had allies, even in the early years, but their numbers have not greatly increased. Even so, participation in Pride Parades, especially the Dyke March, has greatly increased over the years, and there are many more lesbian mothers celebrating with their little ones in the streets. I am struck, however, by the fact that few otherwise engage in activism.

This is bothersome, particularly at a time of economic crisis. I've overheard young lesbian mothers talking about their intense interest in blogs and blogging and wonder if that is taking the place of activism, and if, to paraphrase Max Frisch, technology has so arranged the world that we no longer experience it (Frisch, 1997: 39).

The blogs for and about lesbian mothers have the potential to create an open, supportive, activist community. I am concerned, however, that many

new lesbian mothers seem unaware that there were lesbian mothers before them, women who fought for themselves and for those who would come after, women who had very little time to think about brand-name strollers because they had to put their energy and time into fighting on many fronts. The proliferation of books and articles on lesbian parenting does not mean we can take our gains for granted and confine our attention to the delights of home-cooked baby foods, designer clothes, the breed of dog suitable for a walk in the park, mid-day coffee with other mothers, or how best to combine motherhood with career advancement.

We need to keep asking ourselves hard questions about raising a child in this society and about what we wish to impart. We should be talking with our foster children, our adopted children, and our birth children about, for example, the challenges facing other racialized children, about First Nations youth, about why there are children living in poverty, about Black youth shooting each other, and about the sexualization of young girls. How do we do this? Of course we should not saturate our children with these or other social problems. Of course they need ample time to be children, to think their own thoughts, imagine their own futures. But unless we begin to explore these problems with them, their futures may be limited indeed. I attend rallies with my foster child, which means not just celebrations like Pride. With or without Pride Week, young Black men continue to shoot each other, young girls continue to be made into sexual objects for grown men … elsewhere, child soldiers are as young as seven years old. Young girls, some barely in their teens, are forced into marriage. I am fully aware that the dominant view is that teenagers "should be enjoying their teen years." Of course they should. But my foster child must prepare herself for a world where for many reasons she may have to pick herself up and keep going, confident that she can. It's my responsibility to help her begin to do that. At some point, my being lesbian is bound to cut against the grain, if only because for young women her age, a marriage between a man and a woman is the ideal, as well as the norm.

She will, in time, move on. I hope that she will leave with respect for herself, unafraid to speak up, having silenced that little voice inside that says "I am not worth it," prepared to think about her choices and to live with the results, eager to learn and to be challenged. She has challenged me. And no doubt will continue to do so. What better gift?

Parenting is a social and political task as well as one of encouraging development, love, and connection on the most personal level. All gay and lesbian parents have a few things in common: we are all hyphenated, we are all in struggle, we all want to see a new dawn — but, please, let's not confuse it with "normalcy." Let us come together to further the collective work that brought us this far, let us renew and deepen our analyses of class and racism, both of which often get overlooked in this latest phase of capitalism. To neglect either in the search for "normal" is to abandon the opportunity for growth — growth not just for ourselves, but for our children.

REFERENCES

Douglas, Debbie. "Introduction." In Debbie Douglas, Courtnay McFarlane, Makeda Silvera, and Douglas Stewart, eds., *MA-KA Diasporic Juks: Contemporary Writing by Queers of African Descent.* Toronto: Sister Vision Press, 1997.

Frisch, Max. Quoted in Lewis Lapham, *Waiting for the Barbarians.* London: Verso, 1997.

Lorde, Audre. "The Master's Tools Will Never Dismantle the Master's House." In *Sister Outsider: Esssays & Speeches by Audre Lorde.* Trumansburg, NY: Crossing Press, 1984.

V HOUSES FULL OF LOVE:

What We Offer Our Children

Dear Who-Knows-Who:

An Expectant Mother's Parenting Intentions

Elizabeth Ruth

June 14, 2007

Dear Flutterbug, my Flutterbug, my Who-Knows-Who,

I am writing this letter on the bus, travelling between Kitchener and Toronto, Ontario. I've just given a class at the Kitchener Public Library on writing effective characters in fiction. This is what I do — I write, I teach, I talk to the public. I talk to anyone, actually. I like people. Well, that's not entirely true. Often I am shocked at how frustrating I find human beings, but just as often I am stupefied by our imaginations, our capacity to grow and change. I talk to people to *learn* them, and you learn someone through their story of themselves. What I'm writing now will form part of the beginning of your story.

Today, you are eleven weeks and one day on your way into being. We've been told to expect you on December 25th but know enough to be ready any time. I wonder if you'll come close to the new year, because you're my new beginning, everything I've waited so long to hold. The books tell me that you've fully formed your major organs, including sex organs, though your head makes up half your size and you weigh a mere 250 ounces. The books say your ears are not developed and so you cannot hear us yet, but I don't believe that. A writer knows we hear first with our hearts and minds — *the idea of a thing* ringing and squeezing out thought. So, I think of you

often, and talk to you through the belly of your other mother, knowing that somewhere in that watery world, you twist and turn and roll and grow, with the sentiment that we're out here, waiting for you.

Next week your blood will begin to course through your umbilical cord, bringing oxygen and nutrients, and taking away waste. We may even hear your heart beat on our midwife's Doppler. For now though, you're a fish-child, a tadpole, a floating amphibian, breathing liquid, preparing yourself to swim upstream and become fully mammal.

Since you were conceived I've been travelling back and forth between home in Toronto and the library in Kitchener, to fulfill my duties as Writer-in-Residence. Tonight my talk ended on faith, the need to have faith in oneself as a writer to achieve one's goals. I talked about the miracle and magic of the human imagination, how we can move from a desolate blank page to a fully formed universe. If we can do this, we can do much that feels undoable. Faith and imagination — the qualities that help me write are also what sustained me through the dark tunnel of years when we tried to imagine you into being. Are you now my best blank page?

Your other mother carries you in her body like a strong and gentle bear. She *bears* you. It's her blood that you will bleed later, when you fall off a tricycle or cut yourself shaving, her blood that now allows you to breathe. From her flesh you will form muscle with which to throw a Frisbee or mount a horse or climb a mountain or a tree or a ladder. I hope, above all, that you inherit her kindness and decency, if those qualities can be inherited. You will come to know, when you meet her face to face, that your other mother is a hard worker, she busies away at the things she wants, methodically, with perseverance, and eventually she achieves them. She's a long, tall figure who seeks to do the right thing, the respectful thing, always. She is patient, and as I said, she is very, very kind.

I'm not so patient. Compare the two of us, your other mother and me, you'll find that I'm all spit and fire. I want what I want when I want it. I settle for nothing. I don't believe in the word "impossible." But, because of you, I have had to learn patience. For five years I've waited for you, wished you into being, made lists of names, row after row, wondering which will be the best fit. I've prayed for you, even though I don't believe. I've wanted and craved and watched friends have babies, create their families. I've cried in your other mother's arms, month after month, as you passed us by. I want you to know that you were always wanted. You couldn't be more

wanted — what a lucky soul you are to be able to claim such a thing. There will be times in your life (may it be long and happy) when you'll need to remember this: we craved you before we met you, we loved you before there could be love, and now, we wait in wonder to discover who you are and who you'll become.

It is my great privilege to impart my values and insinuate myself into your heart and mind so that we're sewn together, stitched tightly together, in this queer family. The world is a wild, harsh place and from the moment you emerge into it, the lights and sounds and temperatures will assault you. From the moment you slide from within the protective circle of your other mother's womb to the violence of our airy world, you'll find yourself bewildered and amazed. From that moment, you'll also be on your way to the end. Life begins and life ends. Is it odd that I would write of death before you even take a first breath? I don't think so, for there can be no full life without death, no real love without acknowledging death. Your time on this planet will be but a brief shudder, so you must strive to live every day as though it may be your last. And, whenever you're offered a choice between having money or time, fame or time, I hope you will always choose time. Time is the most valuable gift there is. Too many people waste it.

So, scream loudly if you must, sleep soundly, eat greedily, dance every day. Study hard — in school and out. Read about other people and places. Think. Think hard. Don't assume or easily accept what you're told. Travel whenever you can, make time for people and for yourself. Love fiercely, recklessly, passionately, loyally, and it will be new each time. Let your heart be broken (it will be anyway), feel the ache of desires that never came to fruition, feel the sting of judgement by others who would have you fall in line rather than follow your own pleasure. Never, never fall in line, my child, unless it is a line you wrote yourself. Take lovers with care, but take many. Sex is one of life's few pleasures, one of the only one that fills all of your senses. Sex can be purely for procreation, or purely for pleasure, and rarely for both. Bad sex is worse than no sex at all, but good sex is the closest you will likely come to knowing, or believing, in God.

There is no God. Your other mother would agree. There is no heaven or hell, save those we construct for ourselves, but there is here and now, and that's enough. The way you conduct yourself with fellow human beings is a holy act. Choose actions with care. The only sins are to hurt someone else, hurt yourself, or to waste your life by living according to other people's

rules — including mine.

Many people want to know your sex — whether you're a boy or a girl — but we've opted not to know. We've opted for surprise; there are so few surprises anymore, and I dread the thought that once you're born you'll be held, judged, perceived, and valued by some according to your sex — there's no reason for the weight of such stereotypes to press down on you now. I hope, once you are here, that we're able to counter many of those stereotypes, and when we fail, I hope you'll be the one to remind us. But, because sex and gender do impact all of our lives, I've given some thought to how I'll respond.

If You Are A Girl:

I will hold you and squeeze you from the moment of your first breath, to imprint my scent on your skin, to smother you in affection. I will make you know that physical affection is a beautiful thing, a holy thing. I will also teach you to say "no." Your first word should be no. It's the most dangerous word in any language because it's only by saying no to people that you discover what they're really capable of. Then, I will teach you "yes" so you may embrace life fearlessly, to make adventures, to act. Too many girls are taught to be passive, to wait for excitement to come their way. If you're a girl, I will seek to rise above my own insecurities about safety so that you are free to explore the world around you and to take risks. You will learn not to wait, because you're entitled to share this world in full. If you're a girl, I will teach you to perceive your body as a temple for your own pleasure and enjoyment, and never allow someone else to devalue it. I will teach you to understand that touch is a gift, pleasure is a gift, and that you are entitled to receive such gifts without any obligation. From having lesbians as parents, you'll see that it is possible for women to respect men without revering them, that respect is earned, not a given. I will build your confidence to the sky because by the time you are a woman, the world will have stripped much of it away. You will be left with reserves. Yes, you will start high, high so that at least you may end up on even ground with others — and know that you're the equal of any man and of other women, that you may do anything you wish to do. You will know the long line of strong women we come from, and how you can claim these women as your own, because everything that has been before, I now pass down through me to you.

If You Are A Boy:

I will hold you and squeeze you from the moment of your first breath, to imprint my scent on your skin, to smother you in affection. I will make you know that physical affection is a beautiful thing, a holy thing. I will offer, by example, pure touch, untarnished by greed or violence, so that when you reach for another — male or female — it will always be with a sense of respect for the power of human contact, and your own good fortune to be permitted entry. You will learn from me that flesh is sacred, yours and others', and you will therefore not wish to cause it injury. Too many boys and men know touch only in the context of punishment or sex, but you will experience more. I will hope to make you a Mumma's boy — a man who loves his mothers, respects and admires those first women in his life, so that he may respect other women, and women generally, as he moves into the wider world. I'll teach you the difference between us — which is not the great divide most are led to believe, and I'll learn from you, what I haven't yet had the opportunity to learn about men. From having lesbians as parents, you'll see that it is possible for women to respect men without revering them, that respect is earned, not a given. I'll build your self-confidence, high, high and simultaneously teach you about entitlement — that the world is yours to explore, that you may take from it what you wish but that you must always give something back in return. Too many boys learn only about taking, and that contributes to violence. Your first word will be "yes," so that you'll be open to generosity and to accepting beauty, and only then will I teach you "no" — so that you may jump off into independence when the times comes. And when you do jump, you'll take with you everything that has come before, which I now pass down through me to you.

If You Are Both Or Neither:

If you are both — a boy and a girl — or neither, or another, as yet undetermined sex, I will hold you and squeeze you from the moment of your first breath, imprint my scent on your skin, smother you in affection. I'll make you know that physical affection is a beautiful thing, a holy thing, teach you to love your body with a religiosity so fundamental that you cannot believe anyone could find you disadvantaged. I will teach you to love and honour your physical, emotional, and intellectual self in the face of opposition, and

your other mother and I will fight for your right to remain as you came to us, we'll fight for your right to choose one or the other sex, or to reject sex and gender categories altogether, or to make up a new category that suits you best. I promise to ensure that no one — not stranger or friend — makes decisions about your gender/sex and body except for you. I will also make sure that you are not exclusively defined by your body, and have the opportunities to explore other aspects of yourself. From having lesbians as parents, you'll see that it is possible for men and women to be equals, to love each other without revering each other, so that neither men nor women seem superior or disappointing. From having a queer family, you'll find safety outside the thick walls of gender and sex that divide. If you are both or neither or a yet unnamed sex, I will teach you everything I would teach a boychild and a girlchild, but you will teach me more. Everything that has come before, I now pass down through me to you.

*

My child, your family won't look like every other family. You will have two mothers. You will have no father. Until you're a few years old, you won't understand that this is unusual, or wrong in some people's eyes. Some may view us as deviant and others will support us, but you must learn to look with your own eyes, look for love and honesty, and blind yourself to judgement. I am well-suited to teach you how to do such a thing because I was born into a family that many people thought — perhaps still think — was odd, and sometimes even deviant or damaging. I've never had a father, never been troubled by it the way society said I would be, or should be. I've been lucky to have a great and resourceful mother whom I would choose again if I could, one who parented consciously, and loved unconditionally. I have chosen to be your mother, and I hope one day you will feel you'd choose me, too. Because my biological father is sort of like the sperm donors of today, I will have answers if you have questions, and I'll know when you have questions before you ask them.

Being a lesbian is not the most significant aspect of my identity, and having lesbian parents will hopefully not be the most significant aspect of your identity — though other people may try and make it so, and for a time, you may struggle to make sense of it all. You may ask me and your other mother

about our relationship, about sexual orientation, and sex, and we'll discuss these things with you frankly. I also promise to listen, even when what you have to say is hard to hear. Difference is a wonderful liberation. Cherish difference, for without it the world, our species, and life itself would stagnate, pale, shrivel into a mass of sameness, nothingness, boringness. I promise to help you value difference so you may treasure it in your own life and in others' lives too, and may you never make another living being feel lesser-than because they're different from you or from what society expects. The pursuit of sameness is a powerful temptation and a lie that gets propagated by those who are miserable with their own choices and would like to have company, so I expect there will be moments when you are tempted to conform. It's not always easier being yourself, sometimes it will be painful, but I promise you that it's the only way to real happiness.

Your other mother and I are proud of who we are, and how we live, including your creation. We live a life that includes many kinds of people. You'll have friends, like you, who don't have fathers, never had fathers. You'll have friends who have a mother and a father, some divorced, some still married, some never married. You'll have friends who have one parent, or no parents, friends who've been adopted, and friends who have two mothers or two fathers. Perhaps you'll have a friend being raised by a grandmother, or a friend with three parents. And you may at times envy each of them for the uniqueness their situation brings to their lives. Through it all, however, I promise to teach you to stand up for yourself, for our family, and for those who are too weak to stand on their own behalf.

I will allow you the freedom to choose — from the mismatched clothing you may select for school, to the subjects you become interested in, to the lovers you bring home. Without choice you can gain no satisfaction. Without choice you cannot learn consequences and you must learn these things in order to become a positive force on this planet.

It matters to me that you cultivate passions. Arts or sciences, I don't care, but you'll be given exposure to many experiences so that you may form and choose your own interests. Though we're not wealthy people, we've made a commitment to you and we will use our resources to share as much of the world with you as we're able. I have aspirations for you, my soon-to-be-child: I want you to add light where there is none, bring hope where there's grief, make easier others' burdens, make peace where there is war and pain,

and love, love — especially when you can find no other way forward. How you go about doing these things will be entirely up to you.

There will come a day (though it's hard to imagine now) when you'll stop looking to me and your other mother for validation and direction, a time when you'll need us less, but will hopefully still seek us out for comfort and guidance. But before that time comes, when we're no longer the strongest voices in your head, I'll do my best to whisper and shout all that I hold true so that a part of me will remain with you despite your best efforts to be independent. No human can exist alone. You'll need others, by degrees, and you may not wish to admit it, but you will always need your mothers. If we have been good mothers, honest mothers. And, the truth is, we will always need you.

I will be almost forty when I hold you in my arms for the first time, and in those four decades I've moved homes forty-seven times, lived in many cities, different countries. I've learned that I prefer myself in another language, that I love your other mother in ways I've never loved anyone. In these forty years I've been selfish, loyal, foolish, and wise. I have loved men and women, known good friends, known grandparents I adored and who adored me, and been part of an extended family. I've loved and lost a great many people — to illness, to suicide, to addiction, to their own untruths and finally, to madness. I've heard my soul crack with the weight of too much anguish and loss, and I've been exhaled by the creation of literature at my hand, and now, mercifully, by your life. The universe, in all its chaotic reasoning has sparked your light, and I promise to keep it burning.

IN THE BEST INTERESTS OF THE CHILD:

The Awful Truth about
Queer-Raised Kids

christina starr

Children raised by same-sex couples exhibit poor outcomes not so dis-similar to those raised by divorced heterosexual parents.

> — Dr. Dean Byrd, Clinical Professor, University of Utah
> School of Medicine, and Vice-President, National
> Association for Research and Therapy of
> Homosexuality, January 2007

Allowing children to be adopted by persons living in [homosexual] unions would actually mean doing violence to these children, in the sense that ... [the] environment ... is not conducive to their full human development. This is gravely immoral and in open contradiction to the principle, recognized also in the *United Nations Convention on the Rights of the Child,* that the best interests of the child ... are to be the para-mount consideration in every case.

> — The Vatican, "Considerations Regarding Proposals to Give Legal
> Recognition to Unions Between Homosexual Persons," 2003

I DON'T KNOW WHAT I WAS THINKING. HAVING GIVEN BIRTH TO A HEALTHY, robust baby girl in the safe cocoon of a married heterosexual relationship, I threw all responsibility to the wind, separated from her father and came out as a lesbian when she was two years old. My daughter is thus doubly afflicted as the detritus of a divorce and the child of a gay parent, doomed never to reach her "full human development."

As could only be expected, my parenting went downhill. When my creative little toddler drew on the walls, I taped up paper for her to draw on. When she spoke to strangers on the subway, I expected them to answer. The first published photo of her was not a prim image of a little girl in a dress but one of her at a sit-in demonstration with a group called Mothers Against War. I made sure the first wedding ceremony she deliriously attended was that of two women, and by the time we got to the Santa Claus Parade, she'd been to so many protests and marches she didn't understand why we were weren't marching in this one. She's been forced to accept diversity in identity from a very young age (including the usual tired list of sexuality, gender, race, ability, class, religion, etc.) and, without better guidance, has been unable to understand why lots of other people don't.

Having had her progress in the world so selfishly thwarted, she nevertheless has picked up, who knows where, a remarkable ability to *appear* to be healthy and well-adjusted. Unaware of the impossible odds of her background, you might well think her an extremely mature, responsible, compassionate, engaged and engaging teenager. She consistently achieves an over-eighty average and made the honour roll every year in high school, even while participating in a language-exchange program that took her away from her regular studies for two months. She volunteers twice a month at a community agency and has reliably held down her first-ever paid job for more than a year (besides babysitting, which she's been able to fool parents into thinking she's exceptionally good at). She's kept her room in no bigger a mess (or smaller) than any other seventeen-year-old; she has lots of friends and is frequently out but always calls to say where she is and when she'll be home. We've hardly had a raging fight and she's never slammed her door; she watches the usual (inordinate) amount of TV and spends more time online than drinking in back alleyways. She's planning her university studies, considering whether to work a year in between, and knows how to clean up the dishes.

Selfishly, I get tempted to believe it's the real thing and tell myself that it could be a fluke. Having provided a violent and unhealthy home environment, as Dr. Byrd and the Vatican ably point out, I nevertheless have been blessed with a happy, sane, achievement-oriented, socially conscious, *normal* human being for a child. Maybe some wily stork delivered to me the A-model, Teflon-coated, guaranteed-not-to-fail-nine-times-out-of-ten, super-absorbent, crack-proof, heat-proof, shock-resistant, rust-resistant

proto(zoic)type. Or maybe it's the heritage and influence of having an Anglican minister for a grandfather, in the old "skip a generation" theory of how talents and abilities show up in offspring when they're completely absent in the parents.

But even if those speculations were true, they don't really account for the phenomenon, quite pronounced by now, of healthy, high-functioning children of queer parents seemingly well on their way to realizing their full human development. Can't be their upbringing, which is clearly in direct contradiction to no lesser a document than the *United Nations Convention on the Rights of the Child*. It has to be something innate, inherent. If we dare speculate that children of queer parents are, in fact, turning out perfectly fine (or at least no less fine than children of other parental persuasions) it must be entirely biological — a child's temperament, demeanour, and ultimate level of maturity fated from some pivotal embryonic moment. Perhaps a horror movie watched at four months (instilling an ability to face difficult and traumatic events); or an infuriating conversation with an Internet service provider at six months (resulting in a capacity to see negotiations through to the end); or a very neglectful beer at eight months (producing an eventual teenager who can find her way home from a party).

But that can't be right either. Such a theory flies in the face of all good, solid, right-wing doctrine that a human being actually needs heterosexually coupling parents in order to fully and soundly develop. If it were a matter of chance, or of elements unrelated to pedigree, there would be no basis on which to object to whether a child has straight or gay or four-legged or nine-headed guardians.

So we're back to agreeing with the Vatican and the likes of Dr. Byrd — parenting seems to play a crucial role in the development and maturity of children. But then we are also left with a puzzle: why the heck are children of gay parents pursuing worthy interests of which even the doctor and the Vatican would no doubt approve? Why on earth has the daughter of a close friend of mine whose mother recently married her girlfriend in a lovely and romantic ceremony just embarked on pre-med studies? What could possibly have motivated her brother to set his sights on becoming a lawyer? How come the daughter of another two friends, who have been co-parenting as out lesbians since the girl's birth, devotes such enthusiastic time and energy to her dance and performance career? And can anybody tell me why *my* daughter does not have a criminal record?

An absurd possibility is that we immoral, sex-crazed, and transgressive queer parents are actually making a wholesome contribution to society. Take my case again: I'm a rule-breaker, an authority-questioner, a non-conformist, a political-agitator and a jaywalker; my daughter has, since about the age of three, wanted to uphold the law.

Here we are at an indoor swimming pool when she was four: she's too scared to go down the slide by herself so I offer to go with her, but she makes me check with the lifeguard to see if it's allowed. Which, of course, it's not. At five, she's taken to objecting to my use of colourful language and invents her own substitutes so as not to sound like me. At six, she grills me with suspicion about whether we're in a legal zone every time I park the car. At ten, she informs me she will not accompany me to any more dance or theatre events, especially on weeknights, as she needs to get her homework done. When she's old enough to stay home by herself, she doesn't fail to call and remind me when I said I'd be in.

By some small miracle, and against all odds, my daughter seems to have developed and adopted all the habits and behaviours of a normal child raised by normal heterosexual parents.

But wait a minute, that's *me*. I was raised by normal heterosexual parents but by some small disaster, and against all odds, I didn't turn out to be normal. How do Dr. Byrd and the big white Vatican account for that? Statistics would no doubt show (if I knew where to look them up, but I have slothful research habits) that the majority of homosexuals on the planet were raised in normal heterosexual families. In fact, until our current gayby boom, there really wasn't any other option. *Most* deviant, undesirable folks throughout history must have been raised in normal heterosexual families.

Take Senator McCarthy or reality TV's mean judge Simon Cowell on *American Idol*. Undoubtedly raised in a heterosexual manner. Professional playgirl Pamela Anderson? Heterosexual parents. Robert Oppenheimer? Same. Canadian prime minister Stephen Harper? Same. The dude who invented car alarms? The people responsible for Paris Hilton's vapid existence in the world? Anyone who owns a Hummer? (Well, that one I can't guarantee but I'd still say odds are likely.)

It's highly improbable that the person who first ground up animal remains as an inexpensive feed for cattle was raised Brokeback-Mountain style. Or what about the troubled young man who shot all those people at Virginia Tech in April 2007? Or the guy who opened fire at Montreal's Dawson

College in 2006 in the first fresh days of a new term? Or Marc Lépine who killed fourteen women? They all had heterosexual parents. The fervent, fanatical volunteers who flew those planes into the World Trade Center and the Pentagon? The idiot who launched those terrible wars on Afghanistan and Iraq? Yep, also from heterosexual parents.

Iranian President Mahmoud Ahmadinejad absolutely did not come from a gay family since, as he has astutely pointed out, there are no gay people in Iran, and I'd bet top dollar that members and leaders of the military junta in Burma (who, as I write, are arresting, beating, and jailing peaceful Buddhist monks) had normal heterosexual families. Adolf Hitler? Adolf Hitler's administration, staff, and members of his Nazi army? Ninety-nine percent likely to have learned to walk, talk, ride a bike, and recite the alphabet in normal heterosexual families. Paul and Karla Homolka? Colin Thatcher? Margaret Thatcher? Robert William Picton and his siblings? The people who messed up the evidence in Steven Truscott's trial? Whoever it was who really did kill Lynne Harper? NHF.

The truth is, leaving children to be raised in NHFs can have disastrous consequences for any society and for our planet. If Dr. Byrd had carried out only as much research as I have (basically, read the newspaper, cruise the 'Net, think of disastrous events and who caused them), he would have more astutely observed: "Many children raised by heterosexual couples exhibit poor outcomes not so dissimilar to those raised by harsh, unloving and small-minded parents."

And the Vatican, with all its scholars and its unassailable grasp on historical events, could far more credibly conclude, "Allowing children to be adopted by persons living in [heterosexual] unions would actually mean doing violence to these children and to society at large ..."

Gay families are good for the world, whether it's because we teach our children to think for themselves and to respect the dignity and humanity of every other person they share this planet with, or because we love *well* and are committed in our desire to see our children grow to be the best they can be. The Vatican, in all its robust and antiquated authority, and Dr. Byrd, along with his ilk of ill-trained academics, might as well admit that the health and sanctity of our world may in fact be hanging on the integrity and fortitude of children raised in the gravely immoral environments of our queer homes.

REFERENCES

Byrd, Dr. Dean. "Children Need Mothers and Fathers." *Christian Concern for Our Nation* (March 5, 2007). Retreived February 2008 from www.ccfon.org/view.php?id=26.

Vatican, The. "Considerations Regarding Proposals to Give Legal Recognition to Unions Between Homosexual Persons" (March 28, 2003). Retrieved February 2008 from www.vatican.va/roman_curia/congregations/cfaith/documents/rc_con_cfaith_doc_20030731_homosexual-unions_en.html.

Is Queer Parenting Possible?

Shelley M. Park

"Our family is weird, Mom ... and I wouldn't have it any other way."

My American daughter first made this comment when she was eleven years old. The occasion was Christmas Day, the first winter holiday following the summer in which her father and I separated. Present on this day were the following members of my daughter's family: her twelve-year-old (adopted, biracial) sister, her biological mother (myself) and mother's girlfriend (Canadian and German, atheist and Buddhist), her biological father (still legally my husband) and his girlfriend (both Americans, both atheists), and her biological grandfather who had travelled from Canada to join us in Florida for the holidays. We had all spent the previous evening together celebrating a slightly belated Chanukah/Solstice/Christmas Eve with my daughters' Jewish godmother (or "grandmother") and her children and grandchildren (known to my daughters as their aunts, uncles, and cousins). My dad, the girls, and I would be departing in a few days' time to spend part of our holidays with my elder daughter's extended birth family (Guyanese and Jamaican Americans of Indian descent). At the moment, we were all playing a slightly risqué and somewhat silly game of charades and having a good time.

Our family is, in my daughter's words, "weird" and, as her mother, I am gratified to know that she not only recognizes our difference from "normal" families but indeed embraces this difference. In parenting our children queerly, I hope that we teach them the value of non-normativity. Queer parenting is not easy, however — and, indeed, on some days I am not even certain it is possible. In this essay, I explore what queer parenting means,

whether it is, indeed, possible, and if so, how it is best enabled. My theoretical reflections on these questions are both personal and political. They are prompted in part by my own experiences of mothering within a family characterized by open adoption, separation/divorce and re-partnerings, unorthodox living arrangements, and permeable family boundaries. My reflections are also prompted by consideration of the current movement for the legal recognition of same-sex marriages and homoparental rights. While not unsympathetic to the desire for an expansion of civil rights for members of the LGBT community (of which I consider myself a part), I am painfully aware of the fact that securing these rights will not address the needs of complicated families such as my own and may further the norm of the nuclear family, thus neutralizing more promising and more radical queer politics. At the same time, I am uncertain as to whether more radical queer politics can make room for families, such as my own, which include childbearing and childrearing. We are a "weird family," as my daughter suggests, but are we "queer?" Can one be a queer parent and what would it mean to claim this?

Queer as an Adverb

Is queer parenting possible? In one sense of this term, yes it is. The lesbian baby boom, together with a steadily increasing number of homoparental families created by adoption, attests to the fact that members of the LGBT community are able to parent (as if there were ever any question). This is not the "queer parenting" I have in mind, however. There are undoubtedly good reasons (in a cultural climate still marked by homophobic stereotypes of LGBT persons as selfish, immature, and even pedophilic) to highlight loving, caring, competent parenting by gay, lesbian, bisexual, and other ambiguously gendered and/or ambiguously sexed persons. However, to refer to this phenomenon as queer parenting, is to engage in a form of identity politics that equates "queer" with any non-heterosexual identity. Although identity politics might be a useful strategy in certain contexts, I am using the term "queer" not as an identity marker but instead as an adverb qualifying the activity of parenting itself. A queer parent, in this sense, is someone (regardless of sexual or other identity) who parents queerly. The question then becomes whether parenting is the sort of activity that can be practised outside the bounds of the normal. This is a question that can and should be asked by both heterosexual *and* same-sex parents. To what extent does parenting perpetuate normalization?

Breeders and Reprosexuals

The irony of trying to enlist queer theory in the task of thinking about parenting is that "queer" is frequently defined in opposition to institutions of family and reproduction. Consider, for example, the disparagement of heterosexuals as "breeders." If one views reproduction as the antithesis of "queer," then the term "queer parenting" becomes an oxymoron. We could address this by ignoring, downplaying, or rejecting this critique, pointing out that not all heterosexuals are breeders, nor are all breeders heterosexual (to wit, the lesbian baby boom), but I do not wish to do this. In fact, I think it is a fair characterization of the "straight" personality. Most people grow up simply assuming, or succumb during early adulthood to the widespread cultural assumption, that maturity includes "settling down and raising a family." I grew up with these notions myself. And this "playing it straight" (whether played out by those of heterosexual or other sexual identities) embodies an inability to imagine or enact other forms of living — an inability deserving of critique.

Closely related to the "breeder" identity are the presumptions and practices of reprosexuality which Michael Warner (1991, 1993) contrasts to queer theory and practice. "Reprosexuality," as defined by Warner, is an "interweaving of heterosexuality, biological reproduction, cultural reproduction, and personal identity" (1991: 9). A "breeder identity" is linked by Warner to a self-understanding that is tied to one's status as procreative. The difficulties with reprosexuality as a norm are threefold: (1) it characterizes "normal" sexuality in terms of its openness to reproductive utility, rather than in terms of erotic pleasure (see, for example, Winnubst, 2006); (2) it privileges "given" biological families over families of choice (Modell, 1994; Weston, 1991); and, related to this, (3) it presumes and values homogeneity in family composition, drawing rigid boundaries around those who "belong" to a family and excluding others who may be different biologically or hold different cultural values.

Is reprosexuality a necessary part of parenting? I think not. It is true that some heterosexuals mate solely in order to reproduce and many homophobes continue to believe that sex without reproductive possibilities is "unnatural" or "deviant." Yet lesbian and gay parents as well as heterosexuals who create families through adoption or by use of reproductive technologies are proof against the notion that reproduction and (hetero)sexuality are inextricably

intertwined. And of course there are heterosexuals who take pleasure in non-procreative sex. There are queer (non-"natural") ways of becoming a parent for those who are into queer (non-reproductive) sex and one's status as a parent does not entail that one privileges bio-families over families of choice or that one assumes or promotes family homogeneity.

When my daughter claims our family is "weird," she is referring, in part, to our queer family composition. We are a transracial, multi-ethnic, inter-generational family extended across cities, states, and countries. We embody differences in sexual identities and politics, and the lifestyles and values connected to differences in social class and rural vs. urban living. Our kinship is largely constructed and voluntary, not biologically given or legally protected. This is currently true of the parent–children relationships, as well as extended kinship networks of aunts, uncles, and grandparents. Neither my eldest daughter's birth mother, nor my daughters' other mothers (parental partners) have any legal parental status, although they choose to be in our daughters' lives and my daughters choose to be in theirs. My daughters' father and I have a biological connection to only one of our daughters and, until recently, legal status with regard to each that was precarious. For over four years, we were separated, but not divorced, and our custody arrangements were not legally sanctified, but instead self-invented and dependent upon our mutual good will.

The heterogeneity of our family, the permeability, flexibility, and ambiguity of its boundaries, and its grounding of kinship in voluntary choices all deviate from cultural norms governing "traditional" families that are biological and nuclear. However, we are far from unique. In our composition, we represent attributes of other transracial, transnational, and multicultural families created through adoption, interracial couplings, separation and remarriage, geographical dislocation, and so forth. As Cheshire Calhoun (1997) notes on postmodern families, we cannot "[describe] families that depart substantially from traditional family forms as distinctively gay" because many heterosexual families have also "queered ... family composition norms" (146). If "queer confuses the very basis of kinship systems, leading us to resignify the meaning of family away from its biological moorings" (Winnubst, 2006: 134), the childrearing that takes place within such "confused" kinship systems is, in this sense, a queer parental practice.

Queering Domestic Space

As Judith Halberstam (2005) notes, "Much of the contemporary theory seeking to disconnect queerness from an essential definition of homosexual embodiment has focused on queer space and queer practices." "Queer," she suggests, "refers to nonnormative logics and organizations of community, sexual identity, embodiment, and activity in space and time" (6). I have thus far suggested that parents need not have a reprosexual identity, and that families can be organized in non-normative ways, as postmodern families frequently are. Here and below, I want to suggest that such non-normative organization extends beyond queer family composition to postmodern re-configurations of domestic space and parental time.

In addition to considering the heterogeneity of our family, when my daughter calls us "weird" she also refers to the strange ways in which we inhabit the physical space(s) known as "home." Home, for us, is currently fragmented across several counties. There is the "suburban home," in which only my daughters consistently reside; their father and I rotate in and out on a somewhat predictable, but also flexible, schedule — sometimes with and sometimes without our partners and/or other family who may share the resi-dence with us for a few hours, or days, or weeks, or longer. There is a "beach home" — a small rental unit sixty miles away from the suburban home — where my husband and I each live separately during some of our non-custodial weeks and where various permutations of our family may convene for a day or a weekend. And there is the "downtown home" (my girlfriend's) where I frequently reside and where one of my daughters will sometimes stay if she wants to enjoy a weekend of theatre with us or just go on re-treat from her sister. My husband, thus, regularly commutes between two homes, I frequently commute between three (as does my girlfriend), and our daughters have the opportunity for flexible domestic space, stretched across urban, suburban, and rural locales. As teenagers, this flexibility for my daughters includes the homes of their friends, where they are frequently invited to stay. Indeed, my youngest daughter spends enough time with the families of two of her girlfriends that she refers to these spaces as her "other homes" and the adult women who inhabit these spaces as her "other moth-ers." None of us view home as a fixed and sedentary locale; home is a shift-ing, transitory, and de-centred place for each of us.

Such de-centring provides important challenges to normative material,

psychological, and epistemological assumptions, opening up sites of resistance. In her well-known article "Coalition Politics," Bernice Johnson Reagon (1983) contrasts the space of coalition politics to that of a home, noting that the former is not a safe or nurturing space where unsettling differences can be locked out, as they can in a home. Similarly, postcolonial theorist Teresa de Lauretis (1990) advocates "leaving or giving up a place that is safe, that is 'home' — physically, emotionally, linguistically, epistemologically — for another place that is unknown and risky," depicting family, self, and home as "held together by the exclusions and repression that enable any ideology of the same" (22). These conceptions of "home" (whether the subject of longing or the subject of critique) as a safe and uncontested space and of the self as a unitary and fixed identity are largely imaginary in the postmodern era. Many homes — and not just my own — are coalitional in structure, requiring adjustments, flexibility, and negotiations among different persons and places.

Shared parental custody after a divorce typically involves de-centring "home" (for children, parents, or both). The re-partnering of separated or divorced parents extends the network of adults sharing childrearing responsibilities, as do other practices such as open adoption, othermothering in African-American communities, and communal childrearing as practised by extended families, co-operative neighbours, friendship networks, and other intentional communities. Such non-nuclear family formations open up the possibility of distributing "home" and responsibility for childrearing among many persons. This distributed responsibility has two important consequences. First, it enables a form of parenting that is not about the reproduction of sameness. The adults involved may — and often do — embody different values and practices, enforce different norms, and encourage different types of non-normativity. Secondly, it enables parents to distribute time differently than would be possible were any one (or cohabiting two) of them solely responsible for childrearing.

Queering Bourgeois Time

Queer theorists and activists have critiqued several ways in which straight families inhabit and use time. The subjects of critique include the following interrelated embodiments of time: reproductive time, family time, generational time, and reproductive futurism. As my remarks will suggest, I think each of these may be possible for parents to resist, thus rendering queer

parenting possible, but the former embodiments of time are easier to resist than the latter, which make queer parenting difficult.

Reproductive time

Reproductive time is "ruled by a biological clock for women and by strict bourgeois rules of respectability and scheduling for married couples" (Halberstam, 2005: 5). In being taught to "grow up, get married and have children," we are encouraged not only to participate in the institutions of marriage and parenting, but also to participate in these activities in a particular order and according to a particular timeline. Nonetheless, there are parents who do not follow the proposed reproductive schedule. Resisting rule by their biological clock are older women, often placing education, career, travel, or other pursuits ahead of pregnancy, and who may have children by means of adoption or reproductive technologies. Moreover, teen mothers, lesbian mothers, and single mothers who have children outside of marriage each embody resistance to bourgeois rules of respectability.

Family time

Family time is defined by Halberstam (2005) as "the normative scheduling of daily life (early to bed, early to rise) that accompanies the practice of childrearing." This scheduling is determined by "an imagined set of children's needs" and "beliefs about children's health and healthful environments for childrearing" (5). We have all met — or perhaps even been — those parents of infants who cut visits short because it is the baby's scheduled nap, feeding, or bath time. Friends, acquaintances, and colleagues who were once flexible and spontaneous frequently transform into rigid sticklers for a precise schedule upon becoming parents. The situation may not improve much as children become older; scheduled naps give way to scheduled play dates as infants become toddlers; these, in turn, give way to scheduled music and dance lessons, softball practices and swim meets as toddlers become school-age children. However, while such overscheduling is a familiar element of contemporary, Western, urban, middle-class parenting (Warner 2005), it is not a necessary part of parenting. In earlier generations, and still in many rural communities, children might accompany their parents to a dance or other adult social gatherings on the assumption that if and when they were tired, they would simply curl up and fall asleep somewhere. In poorer urban as well as rural communities, spontaneous games of pick-up baseball, basketball, tag, or hide-and-seek still prevail over scheduled games and lessons,

enabling children to develop skills and community on their own, independent of significant adult assistance. It is not necessary to — and indeed may be antithetical to — children's well-being that parents arrange their lives around a rigid schedule of arranged children's activities.

At the same time, anyone who says that "having a child will not change my life," is likely in for an awakening. In choosing to parent, one takes on time-consuming responsibilities for a dependent other — one's days and weeks frequently include domestic, academic, social, and medical tasks centred around children's needs. Whether rigidly or flexibly scheduled, these tasks consume time that might have once been spent in other ways. Doctor and dentist appointments and parent-teacher interviews, as well as children's ill-health require time away from work; leisure time once spent at the gym or the bar or simply reading a good book may, at times, give way to shopping for school supplies, arranging children's birthday parties, or simply playing a game with one's children. It is important to note that shifts in how one spends one's daily time are not always changes for the worse. Celebrating the birth or accomplishment of my children is a joyful activity, as are celebrations of the birthdays or accomplishments of adult friends and family. Making up silly songs or playing pointless children's games with my girls when they were young was at least as much fun as playing adult games. It was the playfulness itself, not winning or losing that mattered. In helping my now-teenage daughters with their homework, when and only when they want it, I am learning new things myself, which currently include Spanish and sign language. These parts of my past and present domestic routines have replenished me and helped me to grow. They remove me from, rather than chain me to, a ticking clock. By having children in my life, I have learned the necessity of putting work aside to make room for pleasure. Parenting has, in this sense, enhanced my ability to inhabit time queerly.

At the same time, parenting is undoubtedly also work, and not all of it is joyful or satisfying. It is important that the work be distributed among as many adults as possible. Cooking, cleaning, laundering, shopping, chauffeuring, and keeping scheduled children's appointments can become overwhelming if one attempts to do it all within a nuclear (two-parent or single-parent) family, leaving little time for play, with or without one's children. Inhabiting time queerly as a parent thus relates to inhabiting domestic space queerly and queering family composition to include as many other caretakers as possible.

Generational Time

Generational time — or what Halberstam (2005) refers to as the "time of inheritance" is "the time within which values, wealth, goods, and morals are passed through family ties from one generation to the next" (5). This is closely connected to what Michael Warner (1991) refers to as "repro-narrativity" or the notion that "our lives are somehow made more mean-ingful by being embedded in a narrative of generational succession" (7). Generational time connects the politics of the family to the politics of na-tionalism, as it "connects the family to the historical past of the nation, and glances ahead to connect the family to the future of both familial and na-tional stability" (Halberstam, 2005: 5). In this category, Halberstam also includes the time of "what if" — that "demands protection in the way of insurance policies, health care, and wills" (5).

Whether or not families embody generational time as described here — and thus whether or not queer parenting is possible — is again, in part, a function of family composition. Preceding my biological daughter's verbal declaration of our family's "weirdness," my adopted daughter encountered considerable confusion and anxiety over a Grade 2 homework project in-volving pasting pictures of her family onto a family tree. Her tree had no single originating trunk as did the template provided by her teacher. When kinship networks are created, in part by choice, they do not embody stan-dard generational time well. And when families are multicultural and inter-racial, embodying the values of disparate branches on a family tree with no singular originating trunk, children inherit diverse — and sometimes conflicting — values from which they must choose to graft together their own traditions and practices. Similarly, in kinship networks that are transna-tional, it is unlikely that they will be connected to the politics of nationalism. While born and raised in the U.S., my daughters have a complicated and queer relationship to their national identity. Neither I nor their father nor my current partner were born in or raised in the U.S. Thus, my daughters are accustomed to critiques of the U.S. government, its policies, and its histori-cal narratives emanating from other national perspectives. Moreover, while my adopted daughter's birth mother was born and raised in the U.S., her lin-eage traces one generation back to Guyana, thus opening a connection not to an uncritical nationalism but instead to the politics of postcolonialism.

Whether or not parents can completely resist generational time is, how-ever, questionable if we consider the sorts of hypothetical temporality (the

"time of what if") as alluded to by Halberstam (2005). There are no parents I know and few I can imagine who would actively resist protecting their children by virtue of insurance policies, healthcare, wills, or other methods at their disposal. There are, of course, those who are unable to provide these things for their children — but I suspect that they, too, would wish to do so if they were so able. To this extent, all parents may be implicated in what Lee Edelman (2004) refers to as "reproductive futurism."

Reproductive Futurism and Political Struggles

Edelman (2004) refers to lesbians and gay men working "for the right to marry" and "to adopt and raise children of their own" as "comrades in reproductive futurism" with the political Right (19). Members of this movement, he claims, cannot be considered queer because "queerness names the side of those *not* 'fighting for the children'; the side outside the consensus by which all politics confirms the value of reproductive futurism" (3; italics in original). Reproductive futurism has several dimensions. Among these are "the fetishism of the Child," the protection of the Child, and an inability to live in the present.

I am not anti-child, but do have sympathy with Edelman's anti-Child perspective and thus also with his and others' criticisms of the current movement for homoparental rights and same-sex marriage. To place the right to adopt and raise children at the centre of the movement against heterosexism, rather than, for example, the celebration of diverse pleasures, is to "sacrifice the queer" by appealing to a symbol (the sacred Child) that "represents the social order" (28). Moreover, the appeal is frequently made in a way that damages the solidarity of the LGBT community. Seeking to appease conservative fears about threats to the Child posed by homoeroticism and other queer pleasures, the movement for homoparental rights sometimes distinguishes those stable, loving, hardworking, nurturing, future-oriented, monogamous couples seeking adoption rights from those queer, pleasure-seeking, promiscuous, risk-taking, immature, unfit others who cannot be trusted with children (Lehr, 1999; Winnubst, 2006). In this context, Edelman (2004) is correct in noting that "our enjoyment of liberty is eclipsed by the lengthening shadow of a Child whose freedom to develop undisturbed by encounters, or even by the threat of potential encounters, with an 'otherness' of which its parents, its church, or the State does not approve" is considered paramount (21).

I have tried to suggest here that parenting queerly is possible, but may *require* providing children with encounters with otherness — including other parents, other values, and other ways of living in and thinking about domestic space and familial time than those privileged by traditional, bourgeois families. Providing real children with such "encounters with otherness" will require abandoning images of the Child as pure, innocent, and vulnerable to contamination from impure sources. It will also require giving up the notion of children as private property with regard to whom only one dyadic couple, whether same-sex or opposite-sex, has rights and responsibilities. If we can do this, then perhaps parents would also be able to live more fully in the present as well. Concerns about our children's future — and hence parental obsessions with wills, insurance, and healthcare, for example — would be greatly alleviated if providing for children were not the sole responsibility of their legally recognized parents. Universal healthcare coverage (sadly lacking in the U.S.), for example, might alleviate considerable parental concern with the future well-being of their children, allowing them — as well as those who care for adult dependents — to live more fully in the present. A society in which ill, disabled, and indigent persons were cared for, rather than disdained and thrown aside, is a society in which wills and insurance are much less necessary.

Shannon Winnubst (2006) suggests that queer freedom is closely related to "having no fixed idea of who or what you are or might become and finding this pleasurable" (199). A truly queer parent might celebrate this freedom for her child as well as for herself. But such freedom, whether for the adult or the child, is much more easily enjoyed in a place and time where all persons — regardless of who or what they are or will become — are valued and provided for. If then we are to enable queer parenting as a fully realized possibility, these are the political struggles to be engaged. Unfortunately, these struggles are not adequately engaged by fighting for the legal rights of same-sex couples to marry and rear children according to already established bourgeois norms. Nor are they adequately engaged by an anti-family politics that excludes the very possibility of non-normative, nurturing relationships between adults and children. What is needed is a queer politics — such as that embodied by, for example, Queers for Economic Justice, Beyond Marriage, the Family, Community and Sexuality Project, and the Sylvia Rivera Project — a politics that recognizes that gender self-determination is intimately tied to issues of economic, racial, and

social justice. Such justice is necessary for effective resistance to the hegemony of the privatized nuclear family, presently presumed to be responsible for those who cannot support themselves, including those who are seriously ill or disabled, unemployed or indigent, very old or very young. Such justice is, thus, a grounding condition for the creation of alternative kinship systems that transgress bourgeois norms — kinship systems that enhance, rather than restrict, the freedom and agency of both adults and children.

REFERENCES

Calhoun, Cheshire. "Family's Outlaws: Rethinking the Connections between Feminism, Lesbianism, and the Family." In Hilde Lindemann Nelson, ed., *Feminism and Families*. New York: Routledge, 1997.

de Lauretis, Teresa. "Eccentric Subjects: Feminist Theory and Historical Consciousness." *Feminist Studies* 16, no. 1 (1990): 115–150.

Edelman, Lee. *No Future: Queer Theory and the Death Drive*. Durham, NC: Duke University Press, 2004.

Halberstam, Judith. *In a Queer Time and Place: Transgender Bodies, Subcultural Lives*. New York: NYU Press, 2005.

Lehr, Valerie. *Queer Family Values: Debunking the Myth of the Nuclear Family*. Philadelphia: Temple University Press, 1999.

Modell, Judith S. *Kinship with Strangers: Adoption and Interpretations of Kinship in American Culture*. Berkeley: University of California Press, 1991.

Reagon, Bernice Johnson. "Coalition Politics: Turning the Century." In Barbara Smith, ed., *Home Girls: A Black Feminist Anthology*. New York: Kitchen Table Press, 1983.

Warner, Judith. *Perfect Madness: Motherhood in the Age of Anxiety*. New York: Penguin, 2005.

Warner, Michael, ed. *Fear of a Queer Planet: Queer Politics and Social Theory*. Minneapolis: University of Minnesota Press 1993.

—. "Introduction: Fear of a Queer Planet." *Social Text* 29 (1991): 3–17.

Weston, Kath. *Families We Choose: Lesbians, Gays, Kinship*. New York: Columbia University Press, 1991.

Winnubst, Shannon. *Queering Freedom*. Bloomington: Indiana University Press, 2006.

Sex and the Formerly Single Mom

Jaime Grant

In June of 2006, at the ripe old age of forty-six, I did what I swore I'd never do: I had a child inside of a committed, queer partnership. Nearly ten years earlier, I'd had my first child "on my own," at least according to the mores of the census and the larger culture. In reality, I birthed him into a huge Village of largely childless queer aunties and uncles that included a thrilled and respectfully distant sperm donor, an army of dependable ex-lovers, a fuck-buddy or two, and a few significant blood relatives. For the next six years, Reilly and I lived a life of single-mommy-and-son bliss, eating popcorn in bed to our hearts' content, accepting the many indulgences of his loving villagers, and generally marching to our respective, unusual drummers. Throughout this period, I had sex with various lovers when I felt the urge, periodically attracting that rare and wonderful species of queer: the lesbian who desires sex without a future.

I would like to say this was a simple recipe — I'd put the word out in my network when I had the sex Jones, and here and there, a simple, no-strings sexual encounter would present itself. But the truth is, sex without entanglement is not a particularly lesbian construction, and often I'd find myself mired in "process," or explaining to an ambivalent butch that s/he couldn't be "using me" if I were perfectly willing. More often, it felt as though I was "using" my various playmates, despite being completely upfront about the parameters of our connection: new mom, sex-on-the-fly, no "partners."

So, it came as a complete shock to the entire Village — me most of all — when, as I entered my sixth year of "single" motherhood, I fell hard and deeply for a friend for whom I'd harboured a monstrous crush for nearly a

decade. Not only did I find myself in the thick of the hottest sexual relationship of my forty-plus years, but I was also serious about keeping her around.

*

Sex and parenting are generally thought of as akin to oil and water. No matter how you approach it, they just don't mix. As a feminist and a lesbian activist who came to understand queer activism as a movement for *sexual liberation*, I determined from the outset of my parenting journey that I would not bury myself as a sexual being for the sake of "good motherhood." As both a survivor and a counselor for victims of sexual abuse, I well understand the importance of keeping one's adult sexual life to oneself in the presence of dependents of any kind. Nonetheless, I also believe that part of a "good mother's" job is to sustain a vibrant sexuality that my children will come to understand as an important part of any person's life. Navigating this terrain — fraught with internalized sexism and homophobia and governed by a woman-hating, anti-sex, and anti-queer culture — is no small thing.

Before falling for M., I was clearly a mommy anomaly in my Village. Six months into my pregnancy with Reilly, relentlessly horny and on the prowl — and to the horror of all onlookers — I went to a huge community party in a dog collar and picked up a sweetheart FTM several years my junior. After Reilly arrived, the visible revolving door on my single-mommy sex life was thinly "tolerated" within and beyond my queer Village because, despite whatever judgements people held — and there seemed to be many — my son was thriving by every measure. Whatever "bad mommy" sentiment there might have been out there, I was fortunate to be presiding over a "good" outcome.

Nonetheless, various judgements managed to wind their way back to me. One of my bedmates reported that a friend exclaimed: "You can't date her! She goes out with, like, six people at a time!" Another noted that my refusal to limit my son to gender-prescribed primary colours in his wardrobe was seen as "dangerous social experimentation." When I had an affair with an acquaintance's ex-lover, she expressed her dismay to a co-worker who said: "What else would you expect from *her*?"

And while the chattering classes were definitely distressed about both my apparent wantonness and my refusal to corral my son's extremely varied

gender expression, I was grateful that my conversations with Reilly about sexuality were entirely private. From as early as age two, my son and I have had an open dialogue about sex: How did the seeds and the egg come together to make him? Why do penises feel so good? Who can play with his penis? Does my vagina feel good? Why do I have sleepovers? Do I like sex? Is gay sex better?

My main organizing principle for these conversations has been to (1) let all questions be initiated by him, never me; (2) answer in an age-appropriate manner as factually and honestly as possible, no matter how freaked out I may be; and (3) maintain my privacy. For example, I have told Reilly that I like sex, and that as long as sex is consensual between people who respect and care about each other, it has the potential to be wonderful. But I have refused to comment on the specifics of my sexual life, especially my sex with M. I always tell him that I have no secrets around my sexuality, but I do have privacy, and that everyone deserves this; he certainly deserves it. And while, in the day-to-day, these conversations seem simple and casual, I realize they are their own small revolution: a mother acknowledging and supporting her child's sexuality without shame or judgement, and treating his sexual development as crucial to his overall health and well-being.

So, if by all traditional measures, I've "settled down," I'm perhaps not the most typically settled, white, urban mom. For one thing, I live in partnership with an unrepentant womanizer — a Black, queer Dom whose gender is contextual, whose sexual demands are off the charts, and whose political ferociousness matches the magnitude of his/her lion heart. Our marriage is open, our sex life is a vast and ever-changing canvas, and our home life is a chaotic, gorgeous project in "knitting" race, culture, politics, and family. Apparently, I've met my match.

*

It made some kind of insane sense two years back, in the euphoria of daily sex (often twice daily), to contemplate a child between us. In truth, I had foreseen the child the night of our very first tryst (I am a lesbian, after all), when she told me in low whispers in the dark that she'd recently located her brothers and sisters, siblings begotten by a deceased father she never knew, and they were enormously important to her. When she left my bed as dawn cracked, I thought: We'll have to hyphenate the last name of the baby, to

reflect her father's people. Then I thought: Get a hold of yourself! This boi can't sit still long enough for dinner, much less a family.

Enter Ella: two and a half years after our initial roll in the hay; following an arduous donor egg to in vitro process that required M.'s egg, my womb, our known donor's sperm, and nine months of heavy medical surveillance. Ella is a careening, unself-conscious joy bucket. She's the question lady *and* the answer man. She wakes up every morning and shouts hello to all of us, one by one, including the dog, until someone has the will to drag us out of our exhaustion and liberate her from the confines of her crib. She's got a mean hip and can carry the sweetest tune. We're all besotted with her.

And of course, we're tired — all of us. In the now four-plus years that we've been together, each family member has had to make monumental sacrifices for this to work. M. is a germ freak who has rented out her bachelor dwelling in the leafy 'burbs to live with a messy wife, two kids, and a dog in a house that's just doors away from the local drug dealer. Reilly, now ten, has had to give up his many nights of sleeping in Mom's bed, leaving clothes and toys strewn about the house, and living a life without chores — in short, our indulgent, anarchic life has been replaced by a much more nuclearized, scheduled existence. As a couple, we've gone from marathon nights of sex to shoehorning quickies in between serving dinner and unloading the washing machine. (The laundry room has taken on new significance.)

On my end, it's hard to complain. I could, but I'd rather knit. Because that's what I'm doing every day. Knitting together African, African-American, and Irish-American cultures. Knitting the Reilly villagers into the Ella family fabric. Knitting a host of blood-family lines into the picture, though they almost never meet. Knitting together aspects of Black working-class parenting (structure, discipline, limits, Black-is-Beautiful) and white lesbian-feminist parenting (question authority, smash patriarchy, promote gender and racial justice). Knitting an outrageous desire for my partner and a submissive femme sexuality into the daily demands of work, parenting, and our overlapping and independent social lives.

This sounds lovely, but it's hard work, the knitting. Some days, it feels like it's all unravelling. The house is a disaster. Reilly chafes at M.'s need for structure and order, until something boils over, erupts, and I yearn for the old days of falling asleep watching *I Love Lucy* reruns with him, empty cartons of ice cream beside the bed. I am working longer hours than I ever have and there's no room for impulsive buys or an extravagant vacation. Managing

the needs of four people is an unrelenting marathon of compromises.

And of course, there are places where the knit just won't take. I remain completely and utterly committed to providing an open, empowering dialogue for Ella around her sexuality. This, while I am married to a long-time organizer who has done countless hours of sexual empowerment work with LGBT youth, but maintains that Ella is likely to spend her teenage years "locked in the basement." M.'s life as a professional queer, and her survival as a charismatic Black butch girl who drew predators right and left, collide mightily in the discussion of Ella's sexuality. How will we resolve the chasm between my need to fully support a developmental process and M.'s need to protect and shelter at all costs? I have no idea. For now, whenever she talks about Ella's life in the basement, I simply reply: Yes, and I'll be down there with her, discussing her clitoris.

*

The reality is, I haven't really "settled." Forming a partnership has quelled judgements about my fitness as a parent and my wayward sexuality. But the truth is this relationship has driven me deeper into sexual "deviance" than any previous attachment. My submissive femme hungers have been given free reign with M., and as a result I've been able to be needier, greedier, and more articulate about my desires than ever before. As a Dom, she's pushed my sexual limits well beyond my own imaginings, including acting as a procurer of other femme girls for our bed, which has been bewilderingly satisfying. At four years in, utterly wasted with our responsibility load, we are still managing — in the wee dark hours of various mornings — to having head-banging, wall-shaking (though significantly quieter) sex.

*

Who cares? Why bother to even catalogue this series of events? What does any of it matter?

Most days, this all seems fairly simple: I am just happy to be living a life of my own choosing, with a partner who was well worth the long wait, and children I am honoured to be shepherding along their paths. And then I realize how extraordinary this is. I look back at the long line of Irish-Catholic women in my family and I can't imagine any of them having lived a life that hinged on the pursuit of their desires — most assuredly not their sexual

desire. I look from left to right at the queers in my life, and see a lot of sex-less partnerships, whether monogamous or open. This seems especially true among the couples with children.

I always knew that I wanted to parent; I wanted the specific intimacy that is wrought by being in charge of another being's growth process. I wanted both the responsibility and the unique connection. My own mother was smothered by her familial responsibilities and the lack of intimacy and support in her marriage; I could feel her yearning for life, for some spark of vibrancy, in all of her interactions with me. She let me know, in no uncertain terms, that she had given up her life for me, and in return, I was to walk a path defined by her values and her limits. My refusal to come through on my part of this bargain caused an estrangement that she held to until the final year of her life.

Having been through all this with my mother, I was determined never to lose myself this way as a parent, or to press myself on my children in such an overbearing, deterministic way. Instead, I have the daily miracle of letting go in the day-to-day, of helping them grow into themselves, whatever those selves might be. All this, while refusing to de-sex my life or shelve my desire in the service of being a "good mother."

And when I take that all in, then yes, my story feels pretty remarkable. Lucky. Rare. Worth talking about. Worth sharing. Worth lining up along-side lots of other remarkable family stories.

I realize, too, that it's still early in the game. Reilly is just finishing elementary school. He has ADHD. At times, he can be stubborn and self-centred. I don't believe he'll ever be able to answer the question: *Where are your shoes?* without a prolonged search and much ado. He's also got a brilliant, political brain, a fiercely loyal heart, a super-gay sensibility, and a passion for performing. Who will he be? Will his dialogue with me around sexuality protect him or set him up? Has this openness created a greater likelihood for responsibility or recklessness? Is he more likely to be queer as all of the right-wing, anti-LGBT parenting literature prophesizes? If so, is this a bad thing? Of course it isn't, but I can say with certainty that for some of my queer villagers, this is the outcome they most fear, and believe will "ruin it" for all queer parents.

And Ella is just perfectly herself, soaking up every bit of our love and hope and turning it back out hugely, unpredictably, with Ella aplomb. I understand that the limited tolerance accorded me for a somewhat transgressive

sexuality is likely to evaporate should any serious trouble surface in the development of the children. Some days, I think I can feel the withering gaze of the masses, waiting on certain disaster.

And then the feeling passes. I shake off whatever judgements I perceive and remind myself that there is no grand audience to my life, just my own concerns and misgivings. I grew up in the era of *The World According to Garp*, wherein the charismatic male protagonist flits through sexual indiscretions galore while the wife's singular affair results in the death of their son. From ancient literature to modern movies, women pursuing their desires are largely toxic, narcissistic, deadly, or undeserving. It makes sense to have a moment or two when one looks over her shoulder, with worry.

These are just fleeting moments. But my life! Ah, my incredible, rare, and wonderful life. Here it is.

In Defence of "Traditional" Families

Joanna Radbord

"First comes love, then comes marriage, then comes the baby in the baby carriage." While this grade school taunt makes fun of first crushes, it also recites the expected steps of romantic relationships in the dominant culture — coupling, marriage, and parenting. Same-sex couples have long been denied legal recognition of these major milestones in our lives. Our exclusion motivated me to become a lawyer, and the first decade of my legal career was consumed with seeking that the law equally acknowledge the love, marriage, and children of same-sex spouses.

In the same time period, I personally celebrated the familial events for which we sought acknowledgement in the courts: I settled down, got married and pregnant, and then was inseparable from my baby. I had great satisfaction in my private life, but in the public/professional realm, my family was under attack. We were warring against governments who had mounted an all-out litigation assault on same-sex couples. At the same time, many queer and feminist critics complained about our legal efforts. Some queers and feminists argue that formal spousal recognition and marriage are patriarchal, assimilationist, and, by their nature, necessarily oppressive. Those who think otherwise are deemed victims of false consciousness or deserters of the cause. Some suggest that lesbians in two-parent, married families are mimicking a heterosexual nuclear family model that's better criticized and dismantled. For some, motherhood should be avoided altogether; others see mothering as a site of empowerment — but only as long as a mother rejects dom-inant cultural scripts.

The queer and feminist communities are necessarily engaged in a project of critique, including within-group analyses. I agree that our desires

should be placed in their social and political context and interrogated. At the same time, queer and feminist communities are expected to offer some refuge from an unfriendly dominant culture. Moreover, as victims of discriminatory cultural proscriptions, these communities should be particularly careful not to create arbitrary rules around love and new hierarchies of families. I have often felt — and indeed still feel — marginalized within my "outsider" communities: my family is not queer enough; my mothering is not feminist enough.

This essay offers a feminist defence of coupled love, marriage, and intensive mothering. I engage the critics of spousal recognition and traditional mothering to argue there must be space in queer and feminist communities to honour those who find value and pleasure in many of the elements of the "traditional" family. I share my own experience to show that "ordinary" families may be potentially transformative and a legitimate means of seeking an end to oppression. For some lesbians, first comes love, then comes marriage, then comes the baby (nursing in the sling).

In Defence of Equal Spousal Recognition and the Right to Marry Litigation

As a law student in the late 1990s, I worked on *M. v. H.*, a landmark case eventually decided by the Supreme Court of Canada that first recognized same-sex couples as spouses.[1] After my call to the bar in 1999, I was co-counsel for the Ontario couples who had won the right to marry on June 10, 2003.[2] I also represented the lesbian families who successfully challenged the government's refusal to show both lesbian mothers' names immediately on their children's birth registrations,[3] and acted as intervener counsel on behalf of these same families in a case winning recognition of three parents at law.[4] Of course, working on these cases was fantastically fun and tremendously personally rewarding, but it was not easy to hear the recurring, discouraging message from some queer and feminist critics that I was wasting my time, or even working in service of evil ends.

There have been ongoing, serious complaints from within the queer community about these cases, particularly the pursuit of spousal status and the right to marry (Epstein, 2005; Cossman, 2002; Warner, 1999). Some argued that the goals themselves were wrong, damaging, and oppressive; that marriage and spousal status were intrinsically patriarchal concepts that ought to

be rejected. One activist shockingly said to me that the work for marriage rights was akin to that of the KKK and hissed that she hoped we lost.

In my view, feminists — whatever their views of the institution — have to support same-sex couples' freedom to marry as a fundamentally private choice. The critique of marriage as a sexist institution is generally a critique by straight women, from a straight perspective (Calhoun, 2000). To me, two women getting married, publicly promising to love, honour, and cherish each other with community affirmation and support, necessarily and profoundly challenges misogynist culture. Marriage is not intrinsically patriarchal; it is a cultural creation capable of multiple meanings and varied manifestations. Surrendering marriage to different-sex couples is essentialist, and it gives over the power of cultural definition to a history of discrimination.

Some opposed to the spousal and marriage recognition cases worried that the costs were too great. The concern was that the focus of the queer community would be stolen from more pressing issues. Again, I see this objection as one without merit. The lawyers and clients were contributing their personal time to the litigation because it was of fundamental importance to them and many in the community. Instead of criticizing those devoting thousands of free hours to equality cases, the detractors were free to work on issues they saw as more urgent.

Some critics insisted our pursuit was not just misguided but also dangerous. At a meeting of activists from across Canada after the marriage case started, my co-counsel and I were warned that — in less progressive towns and cities — there would be a serious backlash if we were successful with the case. We naive Toronto-based lawyers were going to be responsible for a hate crime murder in small-town Alberta. I rightly had more faith in my fellow Canadians. In any case, we should not abandon our equality efforts because of fear. Audre Lorde (2007: 41) answers so eloquently, "Your silence will not protect you."

Other naysayers felt our legal battles were an assimilationist strategy that threatened to advance the interests of those already most privileged in our community at the expense of more marginalized queers. The objection was that marriage sets up a hierarchy within the LGBT community — the married would be viewed as "good queers" and the unmarried as bad ones. But homophobia does not make nuanced distinctions — we are all despicable. I agree that there is discrimination based on marital status generally,

affecting different-sex and same-sex relations, but keeping lesbians out of marriage does nothing to change this. Do we all have to be fully and equally oppressed together? In any case, lesbian participation in marriage should reduce marital-status discrimination generally; marriage cannot be so privileged once the queers have access.

One gay man, debating me on CBC Radio, proffered that marriage was necessarily misguided for same-sex male couples because monogamy violated their "essential nature." This illustrates that the rejection of marriage by queer critics often depends, at root, on false stereotypes. Straight married couples are configured as fundamentally different, mundane breeders, contrasted with the superior, creative, sexual queers. It is the anti-marriage crusaders who create a hierarchy within the LGBT community — the good queer (who rejects the institution of marriage as "too straight") versus the bad, "assimilationist," and boring gay (who wants a wedding). The anti-marriage queers here become "real homosexuals" and the pro-marriage gays are reduced to supplicants looking for straight approval. This hierarchical dualism is both false and dangerous; it is founded on a discriminatory stereotype. After all, many married different-sex couples are sexually active and engaged in all sorts of "queer" activities, participating in swingers' clubs, and living in polyamorous relationships. Different-sex couples are not necessarily asexual by any means, nor are same-sex couples necessarily highly sexual.

Some of us are, quite simply, "boring," ordinary people trying to do the best for our children. We are part of the community, too. The insistence that we must all have group sex, attend demos, and go clubbing, or at least co-parent with multiple parties, surrenders power to the dominant community to define us as opposite/other, and marginalizes a segment of the community who hold dear to "traditional" family structures and behaviour.

One response to discrimination is to validate the other, indeed to glorify the other and belittle the dominant, but this keeps the dualism intact. I sense this is the approach of many who bemoaned the passing of the queer community with the advent of marriage. They wanted discrimination to continue, to be "outlaws" because that gave us a certain cachet. I feel no need to cling to discrimination to make us "special" or "different." I am already different in so many ways, in my mothering, feminism, and lesbianism. I do not need to hold on to stigmatization. Instead, I suggest, it is far more transgressive to show that these boundaries are all permeable, or, in fact, non-existent.

Practically speaking, I am tired of critics griping about the perils of pursuing equality. As a family lawyer, I witness first-hand the lived pain of discriminatory law. My clients include older lesbians separating after long-term relationships who are left without any default property entitlement as security for their old age. I work with non-birth mothers treated with utter disrespect by their former partners, their mothering denied. I have to explain to lesbian parents that their children are denied security by a statute that implies that all Ontario children must have one mother and one father.

After facing criticism for the legal work in support of equal marriage and spousal recognition, it was such a pleasure to witness huge crowds cheering these causes from a float in the Pride Parade. It seems that, in the real world, these legal victories have made a tremendous difference in the simple dignity of many people's lives. Our communities need critical thinking, but to create and build, we also need time and energy for celebration. For some of us, that means a wedding.

In Defence of Intensive Mothering

In addition to my suspect interest in bridal gowns, my credentials as a feminist are also questioned because of my choices about mothering. Certainly, many feminists are mothers, and lesbians have been having children within the context of our relationships for decades now. Mothering itself is accepted (Firestone, 1970, for example, questions biological mothering), indeed privileged, at the level of ideology (while so often unwelcome in practice), but traditional mothering is often maligned in queer and feminist communities.

Admitting that I desire to mother in many "old-fashioned" ways is a dangerous confession. The consensus seems to be that sacrificial intensive mothering is highly regrettable, if not anti-feminist (see O'Reilly, 2006). I am letting my sisters down, contributing to the dominant dis-courses that require women to surrender their autonomy to the care of children. I am allegedly denying myself intellectual stimulation and personal satisfaction. Friends complain how excruciatingly bored they would be staying at home full time, and when I venture to suggest that I find childcare mentally challenging, interesting, enjoyable, and actually more desirable than trudging off to the office for another day of litigating marital disputes, I see their eyebrows rise, no doubt with a corresponding drop in their assessment of my intelligence.

We must be critical of the extent to which motherhood remains an enforced social imperative. Still, we must recognize that, for some women, mothering, including personal sacrifice, is an intense desire that provides great satisfaction and that can be consistent with emancipation politics. Feminists should strive to support mothers and mothering, and not necessarily dismiss as retrograde the traditional mother who chooses mothering over all else, including her former liberal, individual, atomistic self.

Much has been written on the value of spousal recognition and marriage, less on the value of traditional mothering. In addition to defending old-fashioned mothering on the basis that, for many women, this represents a passionate personal desire, I argue here that my "traditional" mothering practice actually furthered my feminist and queer understanding. As never before, I realize that traditional mothering may advance our struggles for social justice. My feminism once understood the liberation task in far different terms. My mothering has forced me to re-evaluate my values and to radically reconceive my ideal feminist future.

It is not an overstatement when I say I was personally transformed by mothering, mind and body, at once. Starting from pregnancy, I remain fully myself but growing. Strange forms rise, stretching my already-protruding stomach, and move around, then disappear. I hear the heartbeat with a Doppler and look at a picture on an ultrasound screen, but there is no separation. We two are one.

Giving birth was an empowering journey that required me to believe in myself. Other women warned me I was "naive," foolish, and selfish to contemplate a home birth without drugs, and I had to overcome this negative cloud to birth a healthy baby boy. It gave me a sense that anything was possible, with faith. At the moment of his birth, I felt a pang of disappointment that I'd had a boy, and then immediate shame and regret that I was already limiting him. I promised myself and him that I would believe in his unfettered potential, knowing that he is capable of greatness.

Taking care of my infant son was at first highly unpleasant. He demanded constant physical contact. The widely accepted ideology of equal co-parenting rapidly gave way to the physical reality of breastfeeding as my singular responsibility. I did not have a moment to myself, my body to myself; his nursing was overwhelming, as was his attachment. All I had was his relentless need and, given his cries, what felt like my constant failure.

Then he smiled at me one day while breastfeeding, the corners of his

340·

mouth turning up, eyes sparkling, and I found myself actually enjoying him. I abandoned my attempts to accomplish something "productive" with my days, even to go outside my home. I gave up my meticulous charting of my son's feeding and sleeping patterns, my endless Internet research on sleep problems, and ultimately, my compulsive need to try to control, interpret, and analyze his feeling states and actions. I bid farewell to my former liberal self and surrendered to doing nothing more than being his mother, all day, every day, and found peace, and eventually great joy.

Before him, my days were measured in tenths of an hour — always generating time entries that could be charged to a client. Together at home, hours just passed, rocking him, and looking out the window, watching the wind in the leaves of a tree. I lost any sense of time — sometimes it moved slowly, stretching on endlessly, and there was no need for it to move faster. Then a day would go by in what seemed like a moment, with nothing accomplished other than the passing of a day. Categories of day and night ceased to have significance. I lived according to his simple rhythms of sleeping and nursing. This surely must be heaven, I thought — perfect love that takes you outside yourself, completely in tune with another.

I delayed my return from maternity leave, and then delayed it again. When I tried to return to work, my body absolutely demanded that I not separate myself from him. I ached for him, needing to be close to him, feeling utterly desolate and miserable. I could not do it. I took the "mommy track," reducing my billable-hour target, my salary, and my career prospects. I did not stop nursing even when it was impracticable, flying my son to conferences, courtrooms, and speaking engagements. Although I love my legal work and am (relatively) satisfied with the "work-life balance" I have achieved, I will confess that I fantasize about staying home with my child full time.

In him, I found love that takes me beyond myself. While I understood the feminist critique of dualistic thinking in the abstract, he took me physically, in pregnancy, birth, baby care, and nursing, beyond categories and through the bodily experience of losing any separation between self and another. He forced an abandonment of hierarchal, dualistic thinking, showing physically, through our bodies, that everything is in flux, leaky, the boundaries permeable. My "traditional" mothering was, for me, a lived postmodern queer theory primer.

Now he is three, and his succulent chubby legs have turned long and lean, strong and darkly browned in the sun. Often he inhabits his own world. I miss him, but am proud and happy as he tells me stories of his adventures, peppering his tale with big words — "glimpse," "discombobulated," "oesophagus." He is creative, funny, and smart, with the soul of an artist, singing a little song about the beauty of the woods, telling me how spider webs with dew are beautiful. He confides in me, smiling, that the goddess made him and I know, more than I ever have, that there is heaven and I have found it. We live apart from the "real world" in a place of magic, where bunnies are cooks at restaurants, cars turn into jet planes with the push of a button, and we lie in bed on a rainy day, all day, reading books together. I find my life's joy and purpose. What a surprise. I love, beyond imagining, a person with a penis, and every bit of him is beautiful.

I used to think that feminism was about judgement — all forms of oppression are wrong and our task is to end this misuse of power. But maybe it is more about love. Love does not grow from a place of judgement. Where there is discord, it explains with a kind heart. Feminism needs love — real love that is action, whatever action is necessary to advance the interests of the beloved. I would do anything, everything, for my child. Every person suffering is someone's child; another mother's heart is breaking. I feel a new sense of kinship and responsibility, tied together with all other mothers, all children, our hopes for our children's futures. For every child, and so for every person, whatever the nature of the oppression, maltreatment must be intolerable to us, motivating us through deep caring to bring about change. I want a feminism imbued by such love and kindness, instead of painful judgement about how our family connections look at first glance.

The Need to Pursue Pleasure While Engaging Politically

Feminist theory denies women's real world pleasures at its peril. Some women have strong personal desires for marriage and children, and feminist critique of marriage and intensive mothering seems, at minimum, strategically ill advised, if not disrespectful to the lived experiences of many women. Remember the salvo said to be the words of the feminist and socialist activist Emma Goldman: "If I can't dance, I don't want to be in your revolution."

Feminist communities have made the mistake before, I think, of condemning each other based on intimate associations. While the personal *is* political, the "sex wars" left many women feeling distanced from feminism,

without benefit of any obvious reduction in systemic inequality. I am reminded of a friend, "K," in first year women's studies. It was the late 1980s and we were reading authors such as Andrea Dworkin, Susan Cole, and Catherine MacKinnon. We learned that sex should involve two equals, and in patriarchal society, really, that meant two women. K was straight and she could not have an orgasm without misogynist "kink." She confessed that she felt guilt and shame. As a feminist, K wondered if she should permit herself to have an orgasm again. I suggested she might be "deprogrammed" from these hateful turn-ons through the love of a good woman, but even then, it hardly seemed fair. Like it or not, her sexual desire was not so readily changed. K should not have felt it necessary to choose between personal satisfaction and her identification as a feminist.

Fast-forward twelve years. I am listening to the oral argument at the Supreme Court of Canada in *Little Sisters*.[5] A gay and lesbian book-store, a cornerstone of the community, is seeking to explain the importance and value of pornography made by and for lesbians. I was on the Women's Legal Education and Action Fund (LEAF) committee intervening in the case; we were arguing that same-sex erotica is not the same as straight porn. Catherine MacKinnon is sitting behind me, loudly heckling the LEAF lawyer and salivating when counsel for Equality Now, a U.S. group with whom she is working, reads a lengthy and graphic passage of gay male porn to the judges. From my perspective, it was an obvious attempt to use homophobia to their advantage. There was no recognition of the specificity of lesbian sexual expression and the perspectives of our communities. I thought back to K and hoped she was enjoying sex, without regard to MacKinnon's writings. Judgement against personal pleasures may be a means to deny the experiences of, and further marginalize, already-marginalized women within feminism.

Similarly, the critical response to marriage and intensive mothering threatens to alienate some women from the feminist and queer communities. The pleasures of marriage and intensive childrearing are vitally important to many of us because they ground us in our values and connect us to our authentic selves. The dismissal of "traditional" family configurations also disregards the feminist and queer understanding that may flow from these attachments.

Discrimination requires an emotional distancing, whereas the best of family represents the practice of love and connection. By touching hearts

and minds, showing that ultimately we are all the same — human beings capable of love, seeking love — we can inspire care and overcome the dehumanization of discrimination. We learn these values in our families, even traditional ones.

My spouse and child give me the strength and support to confront the discrimination beyond our family home and transform me, making me a more loving, understanding, and better person, and that must mean a better feminist. I knew I had crafted a compelling passage in the marriage legal argument when I found myself crying as I wrote it. I cried because I thought of my love, denied by the State, for my own spouse and child. The success in all these family law equality cases stems, in part, from giving voice to our clients' love for their spouses and for their children. We ask the judges to "walk a mile in our shoes," so that they might feel the humanity that unites us all. This is love in action; this is my feminism, grown in part from inhabiting a "traditional" family.

I understand more, question more, and love more because of my family and child. I was trying to explain separatism to my three-year-old. I told him that, when you feel put down and silenced much of the time, it is very healing and positive to spend time with people like you, who will celebrate you. I asked him (a mixed-race, brown-skinned boy who lives in a predominantly white middle-class neighbourhood with two moms, one white, the other brown) whether he ever felt different from other people. He said, no, he feels the same. I reminded him of patriarchy and all the examples we had seen of the denial of women's equality. He suggested that men whose "sweeties" were other men would also feel left out. You're right, I said. While I understand the appeal of feminist separatism, having a boy, loving a boy who has a generous and open heart, who could not understand exclusions, caused me to reconsider my old ideas.

Feminism requires us to take risks and make sacrifices. Marriage and intensive mothering gives many of us the security and energy to do our work. It is important to valorize and celebrate unconventional families, in their myriad forms, but there is no need to disparage those who hold dear our "traditional" families. These, too, can change hearts and minds, and challenge us to live with more peace and love beyond our homes. Let us be kinder to each other, loving to each other, as we theorize about families, the most important loving relations in our lives.

NOTES

1 [1999] 2 S.C.R.3, 43 O.R. (3d) 254, 121 O.A.C. 1, 46 R.F.L. (4th) 32.

2 *Halpern v. Toronto (City)*, 2003 CarswellOnt 2159; 36 R.F.L. (5th) 127, 172 O.A.C. 276, 65 O.R. (3d) 161, 106 C.R.R. (2d) 329, 225 D.L.R. (4th) 529, 65 O.R. (3d) 201; *Reference Re Same-Sex Marriage*, 2004 SCC 79, [2005] W.D.F.L. 16, [2005] W.D.F.L. 17, [2005] W.D.F.L. 110, 246 D.L.R. (4th) 193, 328 N.R. 1, [2004] 3 S.C.R. 698, 12 R.F.L. (6th) 153. It is easy for me to remember the date of the decision because my spouse and I married the day of its release.

3 *Rutherford v. Ontario (Deputy Registrar General)*, 2006 CarswellOnt 3463; 270 D.L.R. (4th) 90, 81 O.R. (3d) 81, [2006] W.D.F.L. 3770, 30 R.F.L. (6th) 25, 141 C.R.R. (2d) 292 (S.C.J.).

4 *A. (A.) v. B. (B.)*, 2007 CarswellOnt 2; [2007] W.D.F.L. 1110, 83 O.R. (3d) 561, 35 R.F.L. (6th) 1, 220 O.A.C. 115, 150 C.R.R. (2d) 110, 278 D.L.R. (4th) 519.

5 *Little Sisters Book and Art Emporium v. Canada (Minister of Justice)*, [2000] 2 S.C.R. 1120.

REFERENCES

Calhoun, Cheshire. *Feminism, the Family, and the Politics of the Closet: Lesbian and Gay Displacement.* Oxford: Oxford University Press, 2000.

Cossman, Brenda. "Lesbians, Gay Men, and the *Canadian Charter of Rights and Freedoms.*" *Osgoode Hall Law Journal* 40 (2002): 223–248.

Epstein, Rachel. "Queer Parenting in the New Millennium: Resisting Normal." *Canadian Woman Studies/les cahiers de la femme*, Special Issue, *Lesbian, Bisexual, Queer, Transsexual/Transgender Sexualities* 24, nos. 2/3 (2005): 7–14.

Firestone, Shulamith. *The Dialectic of Sex: The Case for Feminist Revolution.* New York: Morrow, 1970.

Lorde, Audre. *Sister Outsider.* Trumanburg, NY: Crossing Press, 2007.

O'Reilly, Andrea. *Rocking the Cradle: Thoughts on Motherhood, Feminism and the Possibility of Empowered Mothering.* Toronto: Demeter Press, 2006.

Warner, Michael. *The Trouble with Normal: Sex, Politics, and the Ethics of Queer Life.* New York: The Free Press, 1999.

Houses Full of Love:
Bringing Up Children in Polyamorous Relationships

Alessandra (Alex) Iantaffi

BECOMING A PARENT, ESPECIALLY A MOTHER, SEEMS TO GIVE OTHER PEOPLE the right to scrutinize and often judge various aspect of one's life (Maushart, 1999). This is an experience shared by anyone who has been made to feel marginal — or "othered" — by mainstream society, particularly people who identify as queer or as polyamorous. Queer parents are sadly familiar with being closely scrutinized under the guise of child welfare. Similarly, polyamorous parents have often found themselves silenced in Western societies (Nearing, 1992; Pallotta-Chiarolli, 1995; 1996) as their relationship status seems somehow threatening to the monogamous mainstream. In my personal experience, being someone who is usually read as a woman and who is obviously living with a man and a child offers the opportunity to pass as straight and monogamous. However, my openness about polyamory, about being ethically involved in or open to having multiple romantic and/or sexual relationships, brings my queerness to the surface. Being engaged in different relationships with people of various genders makes my queerness visible and brings the above-mentioned scrutiny to the forefront. My own experiences, as well as my conversations with others, have led me to believe that parenting in an openly polyamorous context has the potential to expand and "queer" our understanding of family and leads to a more inclusive and authentic definition of our families, which often fall outside of the heteronormative model. It also invites mainstream society to review

its assumptions about what constitutes a healthy environment in which to raise children. For those of us who choose to stretch the walls of "family" beyond monogamy, one of the questions becomes: How can we orientate ourselves in a predominantly heteronormative society?

In this essay, I endeavour to explore both my own experiences and those of other parents (whom I have interviewed online) who identify as poly-amorous. Many of them are queer in some way or are in relationships with queer partners. The voices of children raised in poly households are also present where appropriate and possible. The overall aim of this narrative is to highlight the positive aspects of poly parenting and of being brought up in a poly household, while not forgetting the challenges that face any parent, especially when the parent deviates from the heteronormative paradigm consisting of two straight, heterosexual, monogamous, gender-normative parents and their children.

Setting the Context

As a feminist, I believe that certain types of empirical knowledge are both disembodied and dislocated. For example, people often see statistics as "objective truth," without questioning who generated the survey and who carried out the analysis of that information in a particular way. In this model, knowledge becomes divorced from those who produce it, and its production is often firmly placed "behind the scenes." Such knowledge has dominated academic discourse and is usually associated with what have been designated as masculine qualities in Western societies — objectivity, rationality, and expressions of "hard" sciences, such as numbers. This type of discourse has been labelled by authors such as Stanley and Wise (1993: 45) as "grand theories," which seek to explain rather than understand the world. Those theories also promote ideas of separation between the researcher and the phenomena investigated, in the search for "true" objectivity. Feminist research, on the other hand, seeks to foreground embodied and situated knowledge (Humm, 1995: 242–243). Social constructionism also regards knowledge as being always historically, culturally, and geographically specific, as well as being created and maintained through social processes (Burr, 1995). Adopting the frameworks of feminism and social constructionism means that I view research as yet another social process whose aim it is to open and participate in dialogue. Thus, as a researcher and a writer, I do not seek to uncover "true" stories or to depict the definitive picture of

poly parenting, as this would "close off options for dialogue" (Gergen, 1999: 223). Instead, I merely hope to create a forum for new conversations and dialogues to emerge within a context of openness to the wider range of human experiences (Gergen, 1999). As a family therapist working with families on a regular basis, including queer families, I am aware of how lines get drawn between "us" and "others," and how this can be used to reinforce the norm. Therefore, I choose to include my own story, alongside those of other participants, as an attempt to challenge the fictitious lines we often draw out of fear, propriety, habit, or convention, especially in academic and professional contexts.

I would like to briefly introduce the people who generously shared their stories with me. Eleven poly parents, one adult child and three younger children of poly parents from the UK and the U.S. responded to my appeal that I posted on various Internet-based communities and email lists. They shared some thoughts with me by writing about their experiences of parenting or being parented in a poly household. To maintain confidentiality, pseudonyms are used throughout this essay. Eight participants are women and three participants are men. All the men identify as straight and all the women identify as bisexual, though some use the label queer or kinky as well. Seven participants are legally married to one of their partners of the opposite sex. Some participants have also marked, or are about to mark, their commitment to other partners through non-legal ceremonies. One of the participants has identified as polyamorous for the past three years, but she and her partner had an open relationship before that. The discrepancy between how long the participants had actively identified as poly and how long they had been practising non-monogamy or living in an open relationship was a common theme. Several participants stated how, with hindsight, they have been poly for a very long time before actually finding a word that fit their belief system and choices. Two participants, for example, had been in a poly relationship for two years but had realized that is what they wanted ten years earlier. Three other participants had identified as poly for five years, and one had been non-monogamous for fourteen years but has only known the word "polyamory" for the past eight. The eleven participants parent a total of twenty-seven children, varying from households with two children to one household with ten children. Two participants parent one of their partner's children on a more part-time basis, such as during holidays and/or weekends. The adult child of poly parents is a woman in her early twenties

and the younger girls who shared some shorter insights are eight, six, and four.

Some of my story is provided in the brief biography contained in this book, but it is worth adding that I am also legally married to the father of my daughter; I have been pledged to have a pagan commitment ceremony (handfasting) with my other ex-partner; and that, although my preferred label is queer when describing my sexuality, I also use terms such as bisexual, genderqueer, polyamorous, and ethically non-monogamous to describe my identities. I have identified as polyamorous for the past seven years but, like some other participants, realized I wanted to be non-monogamous long before encountering the term. As ever, there is more I could add to the description of myself, such as being brought up Catholic, or living with a chronic illness. These, too, are connected with my identity as a poly parent, but it would take far more than a chapter to explore the intersections of culture, religion, and dis/ability with polyamory and parenting.

What is Polyamory and What Does It Look Like?

Ethical non-monogamy is not a new concept, and many people engage in open arrangements with their partners without ever knowing the term "polyamory." This term was introduced in the late 1980s by Morning Glory Zell, a pagan priestess, according to authors McCullough and Hall (2003), and it literally means "many loves." Polyamorous people engage in a variety of relationships and have a variety of agreements, but the basic tenet seems to be recognition that some people can love more than one person, including in romantic and sexual ways. I had always believed that definitions such as this were sufficient and clear until I attended a conference in May 2007. There, after giving a keynote paper on polyamory and parenting, I was asked by a puzzled sex and relationship counsellor: "What does it actually mean to be polyamorous, what does it look like and what are the rules?" This apparently innocuous question has been present in my mind ever since, and is there whenever I talk or write about polyamory. The world that has become so familiar to me and many of my friends is actually an uncharted territory for many others. However, it is not an easy question to answer since, as stated earlier, there are several types of polyamorous relationships and almost as many rules as there are poly people.

Some poly people, like me, may live with just one partner, where others may live in triads, quads, or even larger households. I choose to have

romantic and sexual relationships outside of my primary commitments to my life-partners, whereas others have a poly-fidelitous arrangement, which means they do not engage in sexual and/or romantic relationships outside their primary ones. There are people who identify as monogamous but are engaged in a polyamorous relationship because their partner is polyamorous. Although some terminology is commonly understood in poly circles, the "rules" developed within relationships and households do differ, as do the beliefs about and definitions of polyamory. Since it is near to impossible, and beyond the scope of this chapter, to provide a definitive picture of what poly-amory is, and there are other writings that fulfil this purpose (e.g., Easton and Liszt, 1997; Nearing, 1992), I will provide only a brief description of the participants' family set-ups here. Two participants live in a household with a V set-up, where they are the point of the V. This means that he/she has two partners but those partners are not involved with each other. Four participants live with one partner; two of these have other partners who live elsewhere and to whom they are committed. Finally, five participants live in quads, that is, four people living together and involved with each other romantically and/or sexually.

Parenting in Polyamorous Relationships

When I have come out as polyamorous, one of the most frequently asked questions I am asked is, "What about your daughter?" That question — "What about the children?" — has often been a battle cry to challenge choices and identities different from those of the speaker, especially when those choices and identities differ from those promoted within mainstream society. The question seems to imply that the concepts of childhood, chil-drearing, and family are somehow universal constructs based on unshakeable pillars of beliefs, such as the belief that children need two parents, usually a mother and a father. For example, in many Western societies, especially in an Anglo-American context, we have become accustomed to the idea of the nuclear family composed of a mother, a father, and a couple of children. This construct has become so familiar that some groups, such as the Christian right-wing in the U.S., have started to claim this as the "natural" context in which children are to be brought up. Such context, in their opinion, needs defending from the morally relativistic society we live in, which threatens the sanctity of the family with innovations such as the recognition of same-sex couples.

When people ask the question about my daughter, they are not simply asking about her well-being. In my view, they are questioning my queer identity and choices, comparing these to theirs, and struggling to understand how my identity and choices can be compatible with how they themselves have been parented and/or have chosen to parent. In the currently scant literature about polyamory, other polyamorous parents describe how their choices are queried by monogamous people and that they often find themselves silenced in our society (Nearing, 1992; Pallotta-Chiarolli, 1995, 1996). The relationship between polyamory and parenting is not necessarily an easy one, especially for mothers, who are still viewed as the primary caregivers in most Western societies and, as such, are saddled with disproportionate expectations once they give birth, both in emotional and financial terms (Crittenden, 2002; Rich, 1977).

The relationship between polyamory and parenting is also a mutual relationship, as highlighted by all participants. This means that both parenting and polyamory are vital components of their identities and, as such, influence each other. Being poly is, as Sailor stated, "part of who I am, I don't think it affects or influences me per se." Being a parent is also a vital part of many participants' identities and can sometimes influence choices made around relationships, as in Atl's case, who wrote: "My kids are my biggest, most important job, so any person who doesn't deal well with children, or whom my children don't like, is a goner as far as a relationship with me is concerned." Amanda echoed these feelings, stating that "being a parent affects poly experiences as the kids/family come first." Another parent, Ra, talked about how being poly and queer shaped her style of parenting, especially around values such as judgement and acceptance of others:

I do not tell jokes that are demeaning or degrading to *anyone*. I am also more "tough" than I think I would otherwise be on people who are in contact with my children, especially when they talk about "judging" others by what they look like, what/where/how they worship, their orientation, or where they come from. I work very hard at teaching my boys to treat everyone with respect and dignity ...

For one of the participants, who is not a biological parent, being poly opened up new possibilities around how to be a family and being an involved adult figure in a child's life. Pat wrote:

Poly has had a big impact on my decisions regarding parenting. In my first monogamous relationship, I assumed that we would have children

because that was the "norm" in opposite sex relationships. In my second relationship, I assumed that we would not have children because my partner did not want them (and that was both a relief and a bit of a sense of loss for me). Now I am able to explore various ways of having children in my life which do not involve me bearing children myself or being a primary caregiver. In the past, I have considered being one of several people involved with a woman who wanted children. I would certainly consider living communally in a house with children. I have some involvement with the children of my partner (seeing them twice a year or so) and I plan to be very involved in the lives of my nieces and nephews (some of whom are also likely to grow up in a poly household).

It is clear that being poly is not just about relationships among adults but also about exploring the meaning of established terms, such as "parent" or "family." It can also lead us to explore the depth and breadth of our emotions, as reflected in Atl's words: "Being poly has taught me about opening my heart up, not just to other adults but to their children as well."

In my own life, I have faced these questions when I realized that, despite my desire to have more children, my husband had no wish to father any more children of his own. We are currently exploring the possibility of me having more children with my other life partner. This seems unusual to some of my family and friends, yet blended families have become increasingly common in most Western cultures, due to the rising rate of divorce. Nevertheless, divorce, which is sadly often accompanied by acrimony and custody battles, seems somehow more acceptable than alternative family setups in which people strive to raise their children with integrity and commitment. For example, in her blog "Our Poly Life" (www.ourpolylife.org), the Laundry Goddess reflects on the challenge and the joy of forging new relationships without much of a map or compass beyond love:

> No one has a perfect marriage, but ours are committed and resilient; lasting over sixteen years each. The four of us have had many ups and downs along the way to life-long partnerships, but the relationships have endured and grown. From this experience, we garnered wisdom and confidence; we consider ourselves survivors. Together, we are positive the love and support we have for each other will weather uncertain times that lay ahead of us.

Of course, it would be unrealistic to paint a flawless picture of polyamory. Like some of the other participants, I too have experienced difficulties, such as break-ups, rows with partners, dealing with contrasting

values and beliefs, and, when realizing that my husband did not want any more children, I found myself on the other side of the room in couple counselling for a few months, dealing with grief and loss. Polyamory does not immunize anyone from the light and shadow of the human condition. Whereas, as Sailor writes, "it is fabulous having extra family to help with childcare; extra people to care for them, to love them, to teach them, to pay for them, and to support each other in caring for them," it is also true that there are extra people to take into account when it comes to decision-making and childrearing. For example, Atl writes about the tensions that can arise around the issue of raising children:

> I try to be stringently fair with the kids, and so far my partner's wife and I think we are both succeeding. My partner disagrees sometimes but he's got mother *and* stepmother issues, so sometimes he has to step back and realize I'm *not* being a horrible, evil stepmother (and his girls laugh when he starts heading in that direction) but that he's just scared of the past. I think children and money are the two biggest problems in most marriages and, in my relationships, that's turned out to be true as well. I believe my job is to help my children grow up to be intelligent, creative, whole-souled, *good* human beings, and me having stress and mess in my life isn't a good way to accomplish that. Poly can sometimes be both so you have to communicate very well, spread your love easily, and *really* think about what you are not only doing but saying. You can't tell some-one one thing, and really, inside be wanting something else (that is, "No honey, I'm fine, I didn't really want to sleep with you tonight anyway"). (original emphases)

Amanda adds how, as in any relationship, all sorts of issues are still there to be dealt with, such as being "overwhelmed with moving to a new home ... and exhausted from being a parent of two kids under five, plus still breast-feeding," while also trying to meet her girlfriend's needs. Like Amanda, I have also often found that, as a parent "I am not really into sex with men, women, myself or toys ... just into being a good mum, enjoying the children and trying to sort the home out and my life ..." regardless of acquaintances' innuendos that I must be out partying, dating, and having sex with any-thing that moves because I am poly. As Ann states, there are "variables in parenting which change as the child grows and changes," which also bring new challenges and opportunities for growth to any adult relationships in a household. All participants, however, seemed overall very positive, as exem-plified by Atl's statement: "With enough love, determination, and patience,

you can work through [those challenges just] fine."

Despite the love and commitment towards the children and amongst the adults, which can be found in most polyamorous families, many people still seem to struggle with the idea of multiple relationships and parenting. My experience of facing puzzlement, and sometimes hostility, is shared by others, such as Ra, who writes: "You would be amazed at how many people who are otherwise tolerant just do *not* 'get' the concept of sharing your life with more than one primary partner. They can get only one at a time, serial monogamy, and they understand dating several people at once, but to have people that you can love deeply without fear and jealousy and it's not hidden, they just don't understand" (original emphasis). The adult child of poly parents also found that "some of my friends found it strange how my father got on so well with my mother's partner. I don't know if it would have been easier for them to accept the situation if my mother had been having an affair and the relationships had been built with hate. Maybe that would have been more socially acceptable?" What is it, then, that is so socially unacceptable about polyamorous families?

On Polyamory: Queering the Family Unit

Stephen Hicks, in his response to the other papers in a special issue of the *Lesbian & Gay Psychology Review* devoted to lesbian, gay, polyamorous, and queer families, notes that "the idea of nonmonogamy or multi-parental relationships is hardly new" and warns the readers about the risk of "setting up lesbian, gay, or queer families as inherently radical" (Hicks, 2006: 95). I find myself straddling a both/and position when facing his challenge. That is, on the one hand, I think that queer, polyamorous families can be a radical challenge to the pervasive heteronormative discourses we face in our everyday lives in Western societies. On the other hand, I also know, as he states, that I and many others also "draw upon and use traditional ideas about gender, sexuality, biogenetics, class, respectability, knowledge, kinship and so on" (Hicks, 2006: 95). Being a polyamorous and/or queer family does not automatically mean that all members of the household reject all mainstream notions about gender, class, ethnicity, or dis/ability. These are issues with which my own family often grapples. Nevertheless, belonging to such a family set-up seems to be challenging enough to mainstream culture that people living in poly families feel the necessity, in some contexts, to hide their family structures. Despite the fact that all the participants

who wrote to me were open with their children and usually with some, if not all, of their friends and wider family networks, many poly families live in hiding, scared that their children could be taken from them (Easton and Liszt, 1997; Pallotta-Chiarolli, 2006). From discussions with poly-amorous parents at Polyday 2006 in London, England, as well as others, I have come to see that people who identify as queer and poly can easily fall into a cycle of secrecy, illustrated in figure 1, which "can have detrimental effects on the emotional and social health and well-being of polyparents and their children" (Pallotta-Chairolli, 2006: 49). This cycle can start from almost any point. Maybe there is reluctance to disclose one's polyamorous status because of where someone lives or because of having negative "com-ing out" experiences in the past. This leads to a lack of awareness in one's community, which can then turn into suspicion and potential discrimina-tion based on ignorance or prejudice. The latter would then lead to anxiety and fear about disclosing a polyamorous identity, which leads back to not disclosing that identity or doing so only to very few people. The cycle could also start from anxiety and fear as a result of internalized prejudice towards being polyamorous and/or queer (and therefore "not being normal") or be-cause of external circumstances (threats to have one's children taken away, from an ex-partner or family of origin). This is not a novel experience and certainly one that many queer people can recognize as leading to both being in the closet and to widespread ignorance and inaccurate myths about our actual lives and experiences.

In my opinion, the breaking of this cycle leads to a queering of the construct of family, even though some polyamorous families do conform to the heteronormative model of Mom, Dad, and children. Although polyam-orous families are certainly not a phenomenon belonging purely to

Figure 1: Cycle of Secrecy

the last twenty years, I would argue that developing language and identities that reflect our choices, and creating poly communities, are radical acts that create important dialogues within mainstream discourses of family.

The oldest polyamorous set up that I am aware of was a V-type relationship in southern Italy at the beginning of the 1900s in which six children were raised. I am certain that even older examples can be found and yet, one of the fundamental differences I am finding, as I talk with a range of poly parents and their children, is the degree of openness about their families and pride that many of them display. Two young girls, for example, told their mother, when asked what they thought about having poly parents, that "it's fun" and, that since one of them likes to "rough house," having "extra men in the family gives her extra people to 'beat up on.'" Personally, I enjoy the way the latter image challenges many of my own childhood constructs about both relationships and gender since, as I was growing up, girls were not supposed to be rough and extra men in the house were a sure danger, according to my grandmother. My own daughter clearly loves her father and me, as well as others who make up the stable relationships in my life, whom she often bosses about in play. She seems unruffled about who sleeps where, even though only the two long-term partners stay at our house overnight. She also proudly plays mommies and daddies games where there can be as many parents as there are people willing to engage in her role-playing, assigning the mommy role to the men and the daddy role to the women, since this better reflects our family set-up.

By going beyond the hegemonic model of the nuclear family, poly families introduce possibilities that differ from traditional constructs of family, parenting, and gender. Poly families challenge the culturally comfortable privatization of sexual discourses and depoliticization of personal relationships, which are pervasive in our societies because of liberal humanist attitudes (Kitzinger, 1989). The public existence of poly families queers the meaning of words such as "family," "mother," "father," and "parent" and subverts the way in which heteronormative, monogamous sex and relationships reproduce selves and reaffirm fixed sexual categorizations (Halperin, 1995: 95). Therefore, for me, poly families are inherently queer as they stand as outlaws, outside the bounds of mainstream definitions. Nevertheless, just as many queer people still live in fear, secrecy and isolation, many polyamorous families also fear being "out and proud" about their identities. Many of the families highlighted in this essay have some degree of

outness about their poly identities. When secrecy seems the only or the best option, the cycle of secrecy discussed earlier can kick in, leading to levels of distress similar to those experienced by LGBT individuals. Further research is required to thoroughly explore and document the particularities of this experience for poly families.

So, What about Those Children?

Widening the range of options beyond the nuclear family is, in my opinion, a laudable enterprise and yet, as a queer person, parent, and a psychothera-pist working with families, I am all too familiar with the sad reality that diversity can only have limited use against ignorance and fear. That is why I would like to conclude by reflecting back on a point raised in the introduc-tion: the scrutiny to which we can be subjected as poly parents, under the guise of child welfare. I hope that this chapter has highlighted how poly parents, although facing many of the challenges familiar to any other par-ent, such as growing children, differences in beliefs between parents, and blending families, do so from a position of honesty, openness, and integrity. As Pat wrote, "I think it is great for kids to have such a range of role-models as I imagine that it increases their sense of having multiple options in life." As a new parent, I recall reading Buzan's (2003) book *Brain Child*, which recommends surrounding your child with plenty of adults who have a vari-ety of skills and can act as role models and realizing that, as a poly mother, I already had a network of smart, dedicated, creative, loving adults who cared about my baby. Nevertheless, I had up to that point only met one adult child of poly parents, and I must admit that part of me did yield to societal arguments and wondered what effect this would have on my child as she grew up. Therefore, to conclude this brief exploration of the experiences of poly families, I would like to offer a quote from the adult daughter of poly parents. I know that if my daughter, in twenty years' time, writes about our family with as much love and pride that I will be one very happy poly par-ent indeed.

> My family isn't a typical family and neither a typical poly family. I have a mother, father, and younger sister but also an added female and male presence, although they do not all live under one roof. I have a family home where my two parents live most of the time with my younger sister. On some occasions, one parent may be there with their partner and sometimes all of them may be there, which can get a bit crowded!

This has been the case since I was about fourteen years old. Although some people may find this strange, I actually enjoyed the fact that there was always someone there when I need them. Each parent and partner had different skills and knowledge to help me throughout my childhood and adult life ...

I am extremely grateful for the way my parents decided to live. I believe their lifestyle has reflected onto me how being judgemental about someone's life when you don't know the facts can be extremely detrimental. I find it quite difficult to control my feelings when people say it can be harmful to children when parents aren't monogamous, although this may be the case in some families, in most the children are happy and secure, it's probably more detrimental when the parents divorce! I believe parents' choices in lifestyle do reflect on their children, but having poly parents is not a "bad" thing; if anything, it has allowed me to be more understanding and accepting of people's lifestyle choices. I have, and still have, a happy family life and extremely happy memories of my childhood with all my family.

REFERENCES

Burr, V. *An Introduction to Social Constructionism.* London: Routledge, 1995.

Buzan, T. *Brain Child: How Smart Parents Make Smart Kids.* London: HarperCollins, 2003.

Crittenden, A. *The Price of Motherhood: Why the Most Important Job in the World Is Still the Least Valued.* New York: Owl Books, 2002.

Easton, D., and C.A. Liszt. *The Ethical Slut: A Guide to Infinite Sexual Possibilities.* San Francisco: Greenery Press, 1997.

Gergen, K.J. *An Invitation to Social Construction.* London: Sage, 1999.

Halperin, D.M. *Saint Foucault: Towards a Gay Hagiography.* New York: Oxford University Press, 1995.

Hicks, S. "Empty Spaces, New Possibilities." *Lesbian & Gay Psychology Review* 7, no. 1 (2006): 85–99.

Humm, M. *The Dictionary of Feminist Theory*. 2nd ed. London: Prentice Hall/ Harvester Wheatsheaf, 1995.

Kitzinger, C. "The Regulation of Lesbian Identities: Liberal Humanism as an Ideology of Social Control." In J. Shotter and K.J. Gergen, eds., *Texts of Identity*. London: Sage, 1989.

Maushart, S. *The Mask of Motherhood*. London: Pandora, 1999.

McCullough, D., and D.S. Hall. "Polyamory — What It Is and What It Isn't." *Electronic Journal of Human Sexuality* 6 (27 February 2003). Available online from www.ejhs.org/volume6/polyamory.htm.

Nearing, R. *Loving More: The Polyfidelity Primer*. Hawaii: PEP Publishing, 1992.

Pallotta-Chiarolli, M. "Polyparents Having Children, Raising Children, Schooling Children." *Lesbian & Gay Psychology Review* 7, no. 1 (2006): 48–53.

—. "Only Your Labels Split the Confusion: Of Impurity and Unclassifiability." *Critical InQueeries* 1, no. 2 (1996): 97–118.

—. "Choosing Not to Choose: Beyond Monogamy, Beyond Duality." In K. Lano and C. Parry, eds., *Breaking the Barriers of Desire*. London: Five Leaves Publication, 1995.

Rich, A. *Of Woman Born*. London: Virago, 1977.

Stanley, L., and S. Wise. *Breaking Out Again. Feminist Ontology and Epistemology*. London: Routledge, 1993.

Who's Your Daddy?

Reflections on Masculinity in Butch-Parented Sons

Laurie Bell

THERE IS A SIGNIFICANT MOMENT IN THE COMING OUT PROCESS WHEN, caught in the stormy fear that we will lose our parents and families as a result of our sexuality, we are struck by an associated primal terror: "I will never have kids!" There may now be pockets of communities and families where the presence of LGBT people and/or the opposition to homophobia are prominent enough to create an atmosphere where young people can be spared this traumatic feature of embracing a queer sexuality. But still, for many, we know the torment of believing that our very essence could cause us to lose both our roots and branches, and that we will find ourselves standing alone, ruptured from the regenerative properties of our own lives.

Through hard-fought political battles, lesbian motherhood has become possible for some of us. There remains, for all of us, the necessity for ongoing vigilance to resist homophobic reactions to queer parenting that threaten our legal and human rights. Less tangible, but more worrisome, is a pervasive ambivalence about the effect queer parenting will have on the status of gender, particularly when it comes to the issue of male children being raised by lesbian women. There is a suspicion that we are inadequate to the task, that we are missing something critical to the process of instilling in our boys their masculinity and manhood.

In reality, it is not the women at home who threaten to emasculate a lesbian-parented boy, but the societal anxiety that he is suffering an essential

deprivation in his masculine development. It is chief among our responsi-bilities as lesbian parents to protect our sons from the lingering suggestion that he needs an *actual* man to show him how to be a *real* man.

The relationships my son has with the males in his life are influential, beneficial, and cherished, as relationships should be. He has always lived with the company of men and other boys who are an integral part of his family life and social relations. Yet, when lesbian parents are raising a male child, we assume the position of responsibility to nurture the child's gender as an organic feature of his childhood development. We cannot be expected to outsource his gender formation. In fact, one of the great adventures of lesbian parenthood is navigating the twists and turns in the development of our sons' masculine gender, sex, and sexuality. We make every effort to recover from the idea directed towards us, and internalized within us (and our sons), that the parenting we provide to them is impaired by the exclu-sion of a father. In asserting that no particular male figure is necessary for our sons, we are disrupting the assumption that men are the only, or always the best, people to promote masculine identities and sensibilities for boys.

It is not so much how we conceive our sons that is distinct about lesbian parenting, but rather how we conceive our gender. The day-by-day and year-after-year of parenting gives us the opportunity to make of our family constellation more than merely proving ourselves to be capable of raising boys who are no different than heterosexually reared boys. We claim our entitlement to also want for our sons that they should see and be seen as men in new ways. We strive for a new version of the age-old male identity that, as women, we strongly believe needs to be transformed in ways that will benefit boys and girls, women and men. This is why it is not so much sexuality — something essentially private — that is so threatening to the right-wing and other opponents of queer parenting. More troubling is that our boys should turn out to be men who are straight and *queer*, so that even our sons who have a heterosexual orientation will disturb conceptions of gender with sensibilities that do not strictly resemble traditional male roles.

My parenting, as a butch lesbian, has been driven by a determination that my son inherit a masculinity that enables and inspires him to participate intimately in relationships. I want nothing less than love to be the measure of this man. But experiencing and expressing love in all its vulnerable dimensions is overt-ly and unconsciously discouraged in boys and men, to everyone's detriment.

Boys from lesbian families possess a masculinity cultivated by women who are often conscious of these restraints, and devoted to overthrowing gendered social expectations that seek to define our sons' emotional and intellectual identities. Gay, straight, bi or trans, we will be proud of our sons. But for those who will partner with women, our mission as lesbian parents is to produce men who are fully equipped with a capacity for genuine equality in the creation of relational attachments. We hope that friends and lovers will find true companionship and camaraderie with our boys because our sons have received as much support for their emotional literacy as for their educational development.

We await our sons' forays into ever-evolving conceptions of gender. And, if their own reproductive choices should include fatherhood, the question will transition from "What's it like to be raised by lesbians?" to "What's a dad like who was raised by lesbians?" Our grandchildren, when it is their turn to respond to the question "Who's your daddy?" may ultimately be the ones to tell the tale of a masculinity that has been engendered by lesbians. They will have a fascinating vantage point from which to view this multigenerational movement towards a more integrated experience of gender and a greater appreciation of our common bonds and mutual responsibilities.

This year, my child has become an adult — he can vote, drink, and sign his own legal documents — and I am happy to report that he seems to have survived being one of the first crop of boys to be raised by lesbians as part of the wider social undertaking of queer parenting. He's going to leave home soon. He'll gather up his music and games, his sketchbook and paint brushes, his baseball glove and rollerblades, and he'll venture out independently. We will be watching to see how he approaches life as a straight guy with a queer eye. We will witness him assume responsibility for carrying on the family tradition of "queer-ing" gender, of confounding categories of masculinity and femininity, of exploring more just and creative ways of living as men and women.

As my son departs the family home and the 'hood where he has come into his own, and as he encounters diverse people in new places, he will often be asked, "Who's your daddy?" In his response, which he will no doubt offer with his conduct more than with words, as is his custom, what may speak most to his lesbian-parented masculinity is the deep sense of belonging he feels as a member of the queer tribe that raised him and will always cherish him as our own.

I Am My Father's Son

Jonathan Feakins

THIS WEEKEND I ATTENDED MY BROTHER'S WEDDING.

This is hardly as staid as it sounds: we're a family of freaks, geeks, and delinquents, and our parties are the stuff of legend. The wedding invitation was drawn by a local comic-book artist, the flower "girl" threw the petals from her cleavage, my brother and his wife walked down the aisle to the tune of "Where Is My Mind" by The Pixies, and then tossed a bouquet of dead flowers while "The Doom Song" from the *Invader Zim* cartoon played over the loudspeakers. Clear the floor, hit up the vegetarian buffet, and cue the New Wave dance party. Don't forget to take your gift basket, with the mandatory toy robot.

My mother had a blast planning the thing. She wept her tears of maternal joy — one son down, two to go! — and then got out of the way of the ensuing footloose. You'd have thought she didn't even notice my father was wearing a dress.

My father is long past awkwardness. She came out as transgender nearly five years ago, while I was finishing university. She overhauled her face with feminization surgery not long afterwards, and this same brother and I changed her bandages and fetched her water for the weeks that followed. We were there again for her two years later in Trinidad, Colorado, sharing in communal "smack-talk" all the way to the operating room, for my father's final leap into the gender-reassignment void.

My parents were divorced by this time. But there were never any changed locks, no armoires tossed out onto the lawn, no flurry of flying fondue sets. My parents are the kindest, most beautiful people that were ever chucked together by the hand of fate. My mother's only request after the divorce

was that she did not need to see the end result of my father's transition —
so while they speak on the phone all the time, my father did her best Invisible
Woman impression during my brother's post-ceremony bacchanal. My fa-
ther was always the diplomatic sort.

The father that raised me is transgender (or transsexual, or trans — take
your pick.) The fact that she — or for the first two decades of my life, he
— was in the closet from the time I was in daycare doesn't change that.
That goes for every closeted parent out there, of which there are plenty.
They may not be waving the pride flag high, or going to see *Hairspray* for
the third time. But then again, it's not what you say that raises a child, it's
who you damn well are.

By the time she was twelve, my father was winning tri-county mech-
anical-drawing championships and building fiberglass motorboats in the
garage. She reads books on string theory and Rembrandt, and went to
school for two things: aviation management and art. She grew up to work
as an air-traffic controller for thirty years, driving to work on a Kawasaki
Ninja motorcycle with leather pants and an urban camo T-shirt, and
coming home to do intricate airbrush drawings of the back tailfins of
1959 Cadillacs. To relax, she built spiral staircases and secret passages; my
childhood home was the bastard love child of an M.C. Escher painting and
MTV Cribs.

She, in short, has the brain of a neutron star and the emotional stability
of a cut diamond. That's the father who raised me, who nurtured me, along
with my beautiful mother, from mere *homo sapien* larva to the smartass
geek who writes before you today.

I, in part, have her transgenderism to thank for that. And to be proud of.

Let's look at it from the very beginning: a quiet boy in New Jersey
realizes before she's even verbal that she was born in the wrong body, and
that if she says a word about it to anybody, she'll be deemed a pint-sized
basket case. So how do you tackle a revelation like that? In my father's case,
she did it with logic, with self-control, and with Spock — not the bald
disciplinarian but the pointy-eared Vulcan — as her role model.

You can't make this stuff up.

She tried to become a paragon of calm, a Zen master in toddler form.
Corral the confusion; stem the tide of bizarre and unrealized urges. "My
mind to your mind, my thoughts to your thoughts ..."

She was, in short, the most socially awkward boy this side of the

Mason-Dixon Line, as extroverted as a black hole. But she stayed alive, didn't she? I'll take a Star Trek geek over a corpse any day.

Fast-forward thirty years. Gloss over the adorable Dad-meets-Mom story, in which my father's social awkwardness was her saving grace. Look instead into my father's day-to-day life: talking to 747s at 35,000 feet, in one of the most stressful and absurd jobs ever conceived by God or man.

You think air-traffic control is easy? No, you don't, because you know that 99.99 percent of the population would be driven to leap into traffic after five minutes of what my father did for thirty years. One hour in the control tower would turn your gut to quicksand, your confidence to jelly, and your head so inside out you'd think that hammer pants were hip again.

My father did it every day, on nothing but a handful of Ritz crackers and a tuna sandwich. She did it by using the same mind that she developed for her survival: the discipline, the focus that in lesser mortals appears superhuman, otherworldly. My father played 3-D chess with several hundred pieces, each flying 400 miles an hour and carrying more people in a single day than the population of Winnipeg.

Even by air-traffic controller standards — and trust me, most of them are as average as a Rorschach blot, from survivalist nuts to concert cellists to outright friggin' loons — she was stellar, a king among men (so to speak). And it was her skills that put food on the table, books in our hands, and college in our future.

Mr. Spock would be proud.

By this point, some of you are probably wondering if I'm queer. Don't worry too much, it's not like I mind the question — it's sensible enough, even expected. So I'll tell you this: No, I am not gay. I just happen to dress well.

*

When I think back about how my father's transgenderism affected my own sexual orientation, I come up with ... zilch. Nada. Goose egg. A great, resounding zero. Armchair psychology aside, my father's transgenderism doesn't mean a whit about which Gyllenhaal sibling — Maggie or Jake — I find myself fancying in the wee hours.

(Although, a starring role in *Secretary* means plenty. But that's neither here nor there.)

So let's lay this old canard to rest, shall we? Gay parents, trans parents, whatever. Doesn't matter. Your kids will be kids, and they will in turn be obnoxious, self-righteous, naively adventurous, and, sometimes, outright arrogant pricks. They'll sneak out of the house once or thrice, probably smoke pot and think they got away with it because they're so clever, and eventually they'll start to make plans — horrible, incompetent, ill-executed, and often hopeless plans — to kiss and/or bang a classmate or two. They may also be gay, or not. But who gives a damn about that?

What matters is that my transgender father taught me how to be a man.

Men open doors for strangers and spend quiet alone time with a good book. Men come to bat for the people they love, dive into a new challenge brain first, and do the dishes without being told. Men know how to wear a fine suit, preferably one with pinstripes. Men sneak up behind their wives of twenty years in the hardware store, pull out a white rose from behind their back and tell them, "Happy Friday."

My father built cars, but was never gruff. She was quiet, but not taciturn. She was a breadwinner, but not a master of the house. She embraced archetypally male interests with a full-blown passion, but cooked dinner and did the laundry afterwards. My mother, meanwhile, was the hardscrabble saint: a working woman, a den mother to us and every friend we ever brought home, a lover of football and ten-yard lines, and the prospective executioner of anyone who would ever try to harm her babies.

My father never hit on women. Makes sense in retrospect, doesn't it? And consequentially, my brothers and I somewhat suck at that little social nicety. Not a single one of us is an ass-man, or a thigh-guy, or whatever myopic preferences men are supposed to have these days. We couldn't tell a dirty joke to save our lives. And yet, somehow, we're still invited to parties.

Gender is a crapshoot, a toss-up, a game of Blind Man's Bluff with hormones. And that's all a gay or lesbian or trans parent is liable to teach a kid: that maybe the world isn't as colour-coded as it first appears, maybe they're free to be a figure skater or a bricklayer if it makes them happy. You might want to make note of which restroom you wander into — decorum, and all that — but otherwise? Do what you will.

And as for whom my brothers and I fancy? Strong, brilliant, beautiful women — nothing less. Fancy that.

My father remains, to this day, the best father a boy could ask for. But being transgender is part of who she is — on top of being a race-car driver,

a sci-fi fan, a bookworm, a tinkerer, and a calm and fundamentally gentle human being on all fronts. I was raised by every portion of her, whether it took centre stage or not.

(I call her "father," by the way, because "mother" is already taken. I introduce her as such, and neither of us particularly minds. If it means that I have to give a Transgenderism 101 primer to an occasional stranger, so be it. You have to start somewhere.)

My father lives in New Jersey now with her mother, but thank God, no one has ever called her a Jersey Girl. She rides her bike in the morning, eats the same bowl of Raisin Bran she's eaten her whole life, and schleps Sheetrock into the back of a pickup truck like she used to — although she gets a lot more offers for help now than she ever did before. She spends a lot of time painting and remodelling. When she goes to the city, she gets cat calls, and she's still not quite sure what to do about them. I once took her out dancing to a 1980s night at a club downtown. And I don't think there's a word in the English language for the feeling you get when you see your transgender father getting hit on by an Alaskan fisherman named Dirk.

Dirk. Seriously, his first name might as well have been Punchline.

My friends still tell me that my father is hot. And for my brothers and I, it was actually a rite of passage growing up for our girlfriends to suddenly forget we existed as soon as Dad walked into the room. An interstate toll worker once dropped all her change in a flustered panic and asked my father if she (then a he) was a model. My brother's friend actually started a band called Shawn's Hot Dad. And that, of all things, will never get any less creepy.

Me? I survive like I always have. I do my best to read too many books, stay up too late, and eat like crap. I turn to both my mother and father for well-meant advice, and then ignore it to my own detriment. I am filled with verve and gusto and uncertainty about what I'll be doing tomorrow, or a year from now. I'll try my damnedest to do a fine job of whatever comes around the bend, even if it means screwing up every now and again. There's always tomorrow, and I look forward to it. And there's a very simple reason for that.

It's because I am my father's son.

Contributors' Notes

Scott Anderson is a research analyst whose work focuses on access to health care and social services for marginalized groups using community-based research. Most recently his work has focused on LGBT health and parenting issues. He is also a fan of little people and likes to connect with his inner eight year-old.

Laurie Bell practices psychoanalytic psychology in Toronto, writing clinical assessments in support of refugees seeking asylum in Canada. Together with Lesli Gaynor, she shares the joy of parenting their son Caleb, alongside his two younger brothers Kaveh and Cassra. Previous publications include "Ride That Wave: Queer Parenting in the Era of AIDS" in the edited collection *Homefronts* (2000) and *Good Girls/Bad Girls: Sex Trade Workers and Feminists Face to Face* (1987). She is located at www.lauriebell.ca.

Jess Dobkin is an artist, teacher, and mom to her three-year-old daughter Yael. They live in Toronto.

Emma Donoghue, born in 1969, is an Irish novelist, playwright, and literary historian who lives in Canada. Her books include fiction, both contemporary (*Stirfry*, *Hood*, *Touchy Subjects*, *Landing*) and historical (her prize-winning bestseller *Slammerkin*, as well as *The Woman Who Gave Birth to Rabbits*, *Life Mask*, and *The Sealed Letter*). For more information, go to www.emmadonoghue.com.

Allison Eady recently graduated with an honours BA in psychology from McMaster University in Hamilton, Ontario. She is interested in learning about the impact of identity and experience on well-being and access to services, and has worked on projects exploring bisexual mental health, LGBT adoption, and women's mental health as a research assistant at the Centre for Addiction and Mental Health in Toronto and at the Toronto General Hospital.

Jamie K. Evans was raised in the Bay Area of California by her queer family of five moms, her donor dad, and two younger brothers and a sister. She graduated from Hampshire College in 2008 where she studied psychoanalysis and queer theory. Jamie currently lives in Brooklyn, and spends her time cooking and baking, working as a sex educator, and spreading the joys of COLAGE! www.colage.org

Jonathan Feakins needs to slow down. He has spent the past year writing by night and wandering America and Asia by day, from New Orleans to Shanghai. He gets bored by navel-gazing discussions about gender, when all he really cares to know is your name. He has broken several pairs of shoes simply by dancing too hard. Diplomatic people call him "quirky."

LOIS FINE has two children who, even though they share no DNA, look exactly alike. She is a Certified General Accountant by day and a writer by the wee hours of the night. In between, she is grateful for the love in her life.

DIANE FLACKS is a writer/performer for TV and theatre. She has performed in theatres across Canada and the U.S. She's created, written for, and/or acted in dozens of Canadian television shows. She is the author of the book *Bear With Me: What They Don't Tell You about Pregnancy and New Motherhood*, which was adapted for the stage, and writes a biweekly feature column for the *Toronto Star* called "In the Thick of It." She has a longer list of accomplishments that she either left in the car or put in the recycling bin.

ANNE FLEMING is the author of *Anomaly*, a novel (2005), and the short-story collection *Pool-Hopping and Other Stories* (1998), which was short-listed for the Governor-General's Award. She teaches creative writing at UBC Okanagan.

JAIME GRANT is a femme and a feminist, a sex radical, and a mom. She received her PhD in women's studies from the Union Institute where she studied race, gender, and sexuality with Minnie Bruce Pratt, Barbara Smith, and John D'Emilio. Her articles on feminism, racism, and sex have been published in academic journals and major anthologies. Currently, she serves as director of the Policy Institute at the National Gay and Lesbian Task Force. She resides in the Petworth neighbourhood of Washington, DC, with her partner M'Bwende Anderson and their children, Reilly and Ella.

JOHN GREYSON is a film/video artist whose works include *Fig Trees* (2009), *Proteus* (2003), *Lilies* (1996), and *Zero Patience* (1993). He teaches film at York University in Toronto.

MELISSA HART is the author of the memoirs *Gringa: A Contradictory Girlhood* (2009), and *The Assault of Laughter* (2005). She teaches journalism at the University of Oregon in Eugene, where she lives with her husband and daughter. www.melissahart.com

TOBI HILL-MEYER is a genderqueer, trans dyke, colonized mestiza, transracially inseminated queer spawn. She is the board treasurer of COLAGE, a national movement of children, youth, and adults with one or more LGBTQ parents. She writes from Oregon, where she lives with her two partners. As a vociferous trans and sex-positivity activist, she is frequently diving into one project or another, and can often be found volunteering on political and legislative campaigns. She blogs at www.bilerico.com, and writes zines available at www.handbasketproductions.com.

CINDY HOLMES has worked for over twenty years with organizations on many social justice issues, but most specifically violence against women and violence affecting LGBTQ communities. She is currently a PhD student at UBC Okanagan.

ALESSANDRA (ALEX) IANTAFFI is a systemic psychotherapist, a writer, the editor in chief for the *Journal of Sexual and Relationship Therapy*, and an activist. She recently joined

the Program in Human Sexuality at the University of Minnesota to co-ordinate the "All Gender Health Online" research study. Alex is also queer, poly, kinky, Pagan, Italian, a parent, and a knitter who thinks labels can be powerful in certain combinations, as long as we can also laugh about them (rather than build walls around them).

BECKY IDEMS is completing her MSW at York University in Toronto. She works part-time in mental health and addictions counselling and co-ordinates a queer youth community development project with the Youth Line. Her work reflects her preoccupation with assumptions of "normal" in social work settings, the classroom, and the world at large. Becky lives in Toronto with her partner and their menagerie. In the future, she aspires to do less juggling of part-time gigs and to overcome her mountain of student debt.

CARLYLE JANSEN is a sexuality educator and founder of Good For Her, a retail store in downtown Toronto that makes it convenient to learn about and find sex products in a welcoming, women-positive environment. She is a hot bi mama of two adorable, active boys.

KARLEEN PENDLETON JIMÉNEZ is a writer and assistant professor of education at Trent University in Peterborough, Ontario. Most recently, she co-edited the book "Unleashing the Unpopular": Talking about Sexual Orientation and Gender Diversity in Education with Isabel Killoran, and wrote the screenplay for the animation short Tomboy.

N. GITANJALI LENA is a Sri Lankan Canadian queer woman of Tamil and Sinhalese ancestry. Gitanjali comes from a long line of rebels and dreamers. She is a writer of poetry, a cellist, a criminal defence lawyer, a baker, and a soap maker. Her son Zulfiqar Amuthan Lena Stewart is her absolute favourite. She likes to observe and express. One day she will go skydiving and try her hand at graffiti.

LORRAINE is exploring queer kinship with her amazing son. In her spare time she attends graduate school.

LUCY is a hip and innovative mother, teacher, and writer. She is mother to her four awesome kids. Currently, she is seeking to connect with strong queer Jewish Women in Toronto in an effort to find and build her community again.

ANN-MARIE MACDONALD is an author, actor, and playwright. Her work for the theatre is produced internationally and includes Goodnight Desdemona (Good Morning Juliet), Belle Moral: A Natural History, book and lyrics for the musical comedy Anything That Moves, the libretto for the chamber opera Nigredo Hotel, and the collectively created The Attic, The Pearls & Three Fine Girls. MacDonald's novels, Fall On Your Knees and The Way The Crow Flies, are international bestsellers and have been translated into twenty languages. Her work has won the Governor General's Award, the Chalmers Award, the Canadian Authors Association Award, the Dora Mavor Moore Award, and the Commonwealth Prize. Recently, she starred in Soulpepper Theatre's hit production Top Girls. MacDonald is the host of CBC Television's new series Doc Zone. She lives in Toronto with her family.

MATTHEW (not his real name) is a writer living in Toronto.

JULIE MOONEY-SOMERS spent her early years in Dublin, Ireland, her high school years in outback Australia, her undergraduate years in London, and she now lives in Sydney with her partner of fifteen years. She has a PhD in psychology (heterosexual men's experiences of their sexuality) and is currently facilitating three participatory action research projects with Indigenous young people on resilience and sexually transmitted and blood-borne viruses.

NANCY NICOL is a professor in visual arts at York University in Toronto and an award-winning documentary filmmaker. Her films have screened widely at international festivals and conferences and at community-based events. Her recent works focus on the history of LGBT organizing, relationship recognition, parenting rights, and same-sex marriage and include *One Summer in New Paltz: A Cautionary Tale* (2008); *The Queer 90s* (2009); *The End of Second Class* (2006); *Politics of the Heart/La politique du Coeur* (2005); and *Stand Together* (2002).

SHELLEY M. PARK is associate professor of philosophy at the University of Central Florida in Orlando where she teaches courses in contemporary epistemology and social and political theory (including a course on "family values"). Her recent scholarship analyzes the activities of mothering through the lenses of feminist theory, queer theory, and cybertheory. The author of several essays in feminist anthologies and scholarly journals, she is currently working on a book length manuscript on "Real Mothering." She is the mother of two teenage daughters who test her theories daily.

SERENA PATTERSON is a clinical psychologist and an instructor of women's studies at North Island College in Courtenay, British Columbia. Dr. Patterson's writings have appeared in the *Journal of the Association for Research on Mothering, Canadian Woman Studies/les cahiers de la femme,* and *The Island Word.* More of her work can be found at www.grunbergpatterson.ca.

SUZANNE PELKA is a psycho-medical anthropologist and postdoctoral fellow at the UCLA Center for Society and Genetics. She lectures on kinship and the new reproductive technologies in the Department of Anthropology. Her current research concerns how families are created by using the new reproductive technologies, such as gestational surrogacy or pregnancy using donor eggs, with a particular focus on surrogate-fetal interactions. Dr. Pelka is also a marriage and family therapist intern with a specialty in working with gay and lesbian couples and families.

BRENDA PONIC is a trauma psychotherapist, a Unitarian, and a woman striving to parent her four-year-old daughter Samantha with passion and wisdom.

JOANNA RADBORD is a lesbian feminist mother and a lawyer with the firm of Martha McCarthy & Company in Toronto. Her practice focuses on family law and equality rights; she has litigated cases addressing equal marriage, birth registration, and parental recognition. Joanna was the winner of the Canadian Bar Association 2008

Hero Award in recognition of her exceptional contributions made in the cause of equality for lesbian, gay, bisexual, transgendered, and two-spirited people.

DAVID RAYSIDE is a professor of political science at the University of Toronto and an associate of the Mark S. Bonham Centre for Sexual Diversity Studies (which he directed until July 2008). For most of the last twenty years, his writing has focused on the politics of sexual diversity in Canada, the United States, and Europe, his most recent book being *Queer Inclusions, Continental Divisions: Public Recognition of Sexual Diversity in Canada and the United States* (2008). He has also been an activist on queer and gender issues, in both academic and community settings.

LORI E. ROSS, PhD, is a research scientist in the Social Equity and Health Research Section of the Centre for Addiction and Mental Health and Academic Leader of the Reproductive Life Stages Program of the Women's Mental Health Program, Women's College Hospital in Toronto. She is an assistant professor in the Department of Psychiatry of the University of Toronto. Her primary research focus is on health and social services access for lesbian, gay, bisexual, trans, and queer people.

AVIVA RUBIN is a committed, intermittent, wanna-be more regular writer and the mom of two boys, Noah who is nine and Ari who is five. In her paid work life she manages a health policy shop at the Ontario Ministry of Health and Long-Term Care. Prior to that Aviva worked for the Ministry of Citizenship and Immigration focusing on enhancing the technological capacity of not-for-profit voluntary sector organizations, and for the Ontario Women's Directorate where she focused on education and economic equality for women.

ELIZABETH RUTH's debut novel, *Ten Good Seconds of Silence* (2001), was a finalist for the Amazon.ca/Best First Novel Award, the City of Toronto Book Award, and the Writer's Trust of Canada Fiction Prize. Her critically acclaimed second novel, *Smoke* (2005), was called "a virtuoso performance" by the *Globe and Mail* and was chosen as the official selection for the 2007 One Book, One Community program in the Waterloo Region. Ruth teaches writing at the University of Toronto and is a mentor with the Humber School for Writers Correspondence Program. She lives in Toronto with her partner and their daughter. www.elizabethruth.com.

MAURA RYAN is a doctoral candidate in sociology at the University of Florida. Her dissertation is on the queer cultural politics of femme organizations and queer femme burlesque, but she also has an academic interest in the politics of LGBTQ-headed families. She is a queer feminist cissexual ally to trans people who is fed up with the mainstream gay and lesbian plea for marriage and adoption, and who also simply loves the idea of LGBTQ people committing to each other and raising kids. She still believes that queer love can change the world.

ADINNE SCHWARTZ is a sexual health educator in Toronto. She has a master's degree in women's studies and education from the University of Ottawa and a Bachelor of Arts (Honours) from York University. Her enthusiasm for feminist, bi, queer, and trans

politics makes the distinctions between her personal life, work, academic interests, and activism pretty darn blurry. She is passionate about smashing sexual stereotypes, promoting sexual health education, and the colour pink.

DEREK P. SCOTT is a dad and psychotherapist who has been out for thirty-two years, before that he didn't know he was in. He works out of his home and via the Web and the telephone and can be visited at www.yourtherapist.org. He teaches in the Department of Thanatology at the University of Western Ontario and has one kid and three dogs. He is fond of flowers.

MAKEDA SILVERA is Jamaican and has lived in Toronto for many years. She edited the groundbreaking collection *Piece of My Heart: A Lesbian of Colour Anthology* and co-edited *MA-KA Diasporic Juks: Contemporary Writing by Queers of African Descent.* Her essays have appeared in *Lesbian Subjects: A Feminist Studies Reader; Lesbians in Canada; Que(e)rying Religion: A Critical Anthology; Tongues on Fire: Caribbean Lesbian Lives and Stories;* and *Lesbian Parenting: Living with Pride & Prejudice.* Her fiction includes two collections of short stories and the critically acclaimed novel *The Heart Does Not Bend* (2003).

EAMON SOMERS is a project manager for Social Housing Providers in London, England, and a writer of fiction. He described his early married life in *Out For Ourselves,* published by the Dublin Lesbian and Gay Collective in 1982, although he fell out with the DLGC over its recollection of L&G history in Ireland. Eamon's fictional characters have an essential aloneness, even as they struggle to find the community in which they believe they belong. He recently led a creative writing workshop for the LGBTQ group during Rainbow Week at Trinity College Dublin.

SHIRA SPECTOR (www.shiraspector.com) is among other things a visual artist, writer, illustrator, non-biological co-mom, and high femme dyke drama queen. Choking on "baby dust" and unafraid to crack the confines of the picture-perfect queer family portrait, she is determined to make room for the voices of LGBTQ people who've struggled with infertility and pregnancy loss. She is well-suited to this job as she loves taking risks and accepts defying the mundane as her personal mission in life.

ANIKA STAFFORD holds an MA in women's studies from York University in Toronto. Along with bringing together anti-oppressive ideologies and children's literary criticism, her research focuses on queer theory and personal narratives from within queer communities. She is the author of the children's book *Aisha's Moonlit Walk* (2005).

CHRISTINA STARR has been a queer parent for seventeen of her daughter's nineteen years. She is an accomplished writer, playwright, and performer and for six years contributed a regular column on parenting to *Xtra! Magazine* for which she won an honourable mention for humour in 2000 from the North American Lesbian and Gay Journalism Awards. She lives in Toronto and is currently enjoying the

satisfaction of having sent a well-adjusted child off to pursue her full human development at university.

SUHAIL works with newcomers, youth, and queer populations within a community development and human rights context.

REBECCA TROTZKY-SIRR recently graduated from medical school and will start The Best Family Medicine Residency ever (location TBA.) She is a single mom to a sassy fourth grader. They host regular potlucks in Minneapolis for all kinds of families. Email Rebecca at revolution.is.medicine@gmail.com to let her know what you're bringing to the potluck!

LOLA TURNER is active in the LGBT community with her films, which have travelled around the world and appeared at the Inside Out Film Festival. More recently, Lola has been "directing" all of her creative efforts towards her adoptive son who is two ... and she is crossing her fingers for another ...

CHRIS VELDHOVEN is the Queer Parenting Programs Co-ordinator at The 519 Church Street Community Centre in Toronto. In addition to facilitating Daddies & Papas 2B, he co-ordinates a variety of programs and initiatives for LGBTTQ-led families and prospective parents, including family planning courses, family support programs, and family affirming events. He provides support, advocacy, and information to families, students, and service providers; and collaborates on a variety of educational and research projects. He has been an LGBTTQ community educator and developer since 1989.

THOM VERNON, a queer refugee from Los Angeles, is currently the director of Education and Participation at Toronto's Lorraine Kimsa Theatre for Young People, the largest theatre for young people in Canada. Thom is the author of short stories, plays, and scholarly works and is active as a community leader, arts educator, and artist. At Wordpress.com, he writes the blogs Notes on Arts Education and American Refugee.

SYRUS MARCUS WARE is a researcher, visual artist, and educator. He helped to initiate the Trans Fathers 2B course at The 519 Community Centre, one of the first parenting courses for trans dads in North America. Syrus is the author of *Assessing the HIV/AIDS Service Needs of Trans Communities in Toronto*, published by the AIDS Committee of Toronto in 2004. Syrus is a member of the G/B/Q Trans Men's HIV Prevention Working Group, the Prisoners Justice Action Committee, and the programming committee for Mayworks Festival. For the past ten years, Syrus has hosted the weekly radio segment *Resistance on the Sound Dial* on CIUT.FM, the University of Toronto's radio station.

Resources
LGBTQ Parenting & Related Websites

Listed below are some of the key Canadian and American websites on LGBTQ parenting and related issues. The list is not comprehensive, but the websites included do contain links to most of the relevant local, national, and international organizations.

CANADA

ADOPTION COUNCIL OF CANADA
www.adoption.ca

AROUND THE RAINBOW, OTTAWA
www.around-therainbow.com

BINETCANADA
www.binetcanada.ca

COALITION DES FAMILLES HOMOPARENTALES
 (LGBT FAMILY COALITION)
www.familleshomoparentales.org

ÉGALE CANADA
www.egale.ca

GAY AND LESBIAN EDUCATORS (GALE) – BC
www.galebc.org

GAY FATHERS OF TORONTO
www.gayfathers-toronto.com

LESBIAN MOTHERS ASSOCIATION OF QUEBEC/
ASSOCIATION DES MÈRES LESBIENNES DU QUÉBEC
www.aml-lma.org

LGBTQ PARENTING CONNECTION
www.lgbtqparentingconnection.ca

OTTAWA'S GENDER MOSAIC SUPPORT GROUP
FOR TRANSGENDER PEOPLE
www.gendermosaic.ca

QUEER FAMILIES VANCOUVER
www.queerfamilies.ca

RAINBOW HEALTH ONTARIO
www.rainbowhealthontario.ca

TEN OAKS PROJECT
www.tenoaksproject.org

T.O. PARENT: ONTARIO LGBT
PARENT MATCHMAKER
groups.yahoo.com/group/to-parent

TRANSEXUAL MENACE TORONTO
www.themenace.net

UNITED STATES

BEYOND MARRIAGE
www.beyondmarriage.org

BINET USA
www.binetusa.org

FAMILIES LIKE MINE
www.familieslikemine.com

FAMILY EQUALITY COUNCIL
www.familyequality.org

FENWAY HEALTH:
LGBT FAMILY & PARENTING SERVICES
www.fenwayhealth.org

GAY, LESBIAN, AND STRAIGHT EDUCATION
NETWORK (GLSEN)
www.glsen.org

HUMAN RIGHTS CAMPAIGN (HRC)
FAMILY PROJECT
www.hrc.org

THE LESBIAN, GAY, BISEXUAL, AND TRANS-
GENDER COMMUNITY CENTER ("THE CENTER")
www.gaycenter.org

— Mary Daniel

About the Editor: *Rachel Epstein* has been a queer parenting activist, educator, and researcher for close to twenty years and co-ordinates the LGBTQ Parenting Network at the Sherbourne Health Centre in Toronto, Ontario. She has published on a wide range of queer parenting issues, including assisted human reproduction, queer spawn in schools, butch pregnancy, and the tensions between queer sexuality, radicalism, and parenting. Rachel is the 2008 winner of the Steinert & Ferreiro Award (Community One Foundation), recognizing her leadership and pivotal contributions towards the support, recognition, and inclusion of queer parents and their children in Canada.